Tradition and Innovation
in New Deal Art

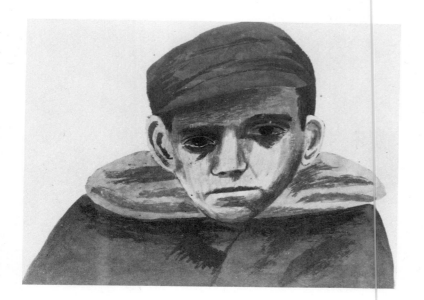

Tradition and Innovation in New Deal Art

Belisario R. Contreras

Lewisburg: Bucknell University Press
London and Toronto: Associated University Presses

Associated University Presses
440 Forsgate Drive
Cranbury, N.J. 08512

Associated University Presses
25 Sicilian Avenue
London WC1A 2QH, England

Associated University Presses
2133 Royal Windsor Drive
Unit 1
Mississauga, Ontario,
L5J 1K5, Canada

Library of Congress Cataloging in Publication Data

Contreras, Belisario R., 1926–
 Tradition and innovation in New Deal art.

 Includes bibliographical references and
index.
 1. Federal Art Project. 2. Art, American.
3. Social realism. 4. United States—Cultural
policy. I. Title.
N8838.C6 1983 709'.73 81-65861
ISBN 0-8387-5032-X

Printed in the United States of America

This book is dedicated to Dorothy C. Miller Cahill,
to the memory of Margaret S. Bruce,
and *to the memory of my parents,* Maria Teresa and Belisario Contreras

Contents

List of Illustrations

Acknowledgments

This book could not have been written without the special talents extended to me by many people.

I am deeply indebted to Rudolph von Abele for giving unstintingly of his scholarly background—intellect and spirit—which carried me through my travail. Because of his confidence, my commitment to this unique period never faltered. I also owe much to Francis V. O'Connor, who generously shared with me his knowledge of and enthusiasm for the New Deal art programs. Without his keen direction and scholarly insights, I could not have found the leitmotiv of a vastly complex subject. To Bernard P. Kiernan I extend my deepest gratitude for his warm response and lucid thought in clarifying my own thinking.

Other individuals have contributed to this study. My thanks to to archivist Garnett McCoy, who guided me through the rich resources of the Archives of American Art; to William Walker, director of the NCFA/NPG Library, for showing me important WPA/FAP documentation; and to the staff of NCFA, especially Lois Fink for her encouragement, and to Richard Murray for his assistance. William Agee, former director of the "New Deal and the Arts" program, under the Archives of American Art, gave me strong support, with assistance from staff member Marian Owens, while using the association's archival records in Detroit.

I wish to express my appreciation to the staff of the National Archives—especially to William Lind and to Robert Kvasnicka for providing me access to the RG 121 and RG 69 textual records; and to James Moore, chief of the Audio-Visual Division, for facilitating my use of photographs from RG 121 and RG 69 collections. My thanks also go to the staffs of the Columbia University Oral History Research Office and the Library of Congress.

I extend special gratitude to Ann Conover Carson, who believed in my endeavor and encouraged me with her invaluable technical advice. I also offer my appreciation to Marie Slingland Cumberland for her invaluable help. For those spirited talks about the New Deal art programs, my thanks go to Jane De Hart Mathews, Karal Ann Marling, Richard McKinzie, Gerald M. Monroe, Greta Berman, and Selma Rein, and

to Archie Green for sharing his faith about the New Deal. My heartfelt thanks are tendered to Marta Minerva Contreras for her support during my travels to Albion. Finally, I wish to thank Cynthia R. Fell of Bucknell University Press and Thomas Yoseloff of Associated University Presses for their kind considerations. With appreciation to all who have helped, and others, I, alone, take responsibility for any errors or inadequacies.

Albuquerque, New Mexico

Introduction

Background

Beginning with the Wall Street crash of 1929, the cruel sickle of the Depression reached down, down, down into every stratum of American life. Small wage earners, school teachers, insurance salespersons, dentists, and retired farmers saw their security vanish, their life savings disappear. In every town well-to-do families dropped from showy affluence into debt; "down-and-outers" shuffled hopelessly through bread lines. Banks failed at an alarming rate. Farm prices dropped to disastrous lows. Cities were unable to cope with their relief problems. The old concept that there was something in America for everybody who worked went down the drain, ending the American dream of a better life for every individual.

Americans soon found themselves living in an altered world—unemployment, bread lines, relief rolls—and during the last months of President Herbert Hoover's administration fear of a revolution became wider. Hunger marchers from large industrial centers and farmers from various agricultural states convened in Washington, D.C., demanding emergency legislation to alleviate their distress. "There is almost as much bitterness on the part of these farmers against the Government and constituted authority as there is on the part of the hunger marchers from the industrial sections," stated a news report. Talk of social revolution was common. Surely, thought the average citizen, the dispossessed and the hungry will revolt against the government and the economic system that brought them to their desperate situation. Even bankers talked in irrational tones. "You have more Bolshevism among the bankers today than the hod-carriers," a reporter commented, ". . . and I think something should be done and done immediately."

No revolution occurred, as many anticipated. Instead, the electorate switched its allegiance from Herbert Hoover's "New Order" to Franklin Delano Roosevelt's "New Deal." In this void of bewilderment and despair, two men appeared to save the American artist from economic destruction and establish a significant historic prece-

dent for federal support of the arts. Edward Bruce—lawyer, businessman, and professional painter—and Holger Cahill—writer, museum curator, and art expert—organized New Deal art programs to create jobs for destitute artists.

Bruce and Cahill, however, differed in viewpoint as widely as did their backgrounds; their concepts about ideal programs for unemployed artists took different forms. Bruce, in his traditional approach, reflected a European experience from his early years as an artist in Italy and France under the tutorship of the American artist Maurice Sterne. Although he was influenced by the modernism of his mentor, Bruce's version was modified by traditional patterns of his past. For instance, the period of the Italian Renaissance aroused his admiration. Moreover, his religious family background, his formal education as a lawyer, and his venture into business tended to strengthen his traditional outlook.

Bruce, who was born to an upper-middle-class family, based his plan to help artists on the harsh realities of the Depression, which had seriously threatened artists throughout the country. As a professional artist, Bruce saw his own career disrupted by the economic crisis. To establish a permanent government organization to preserve professional artists from economic destruction became his goal. Yet, there was an inherent contradiction in his concept. Bruce's preference for realistic representational art discouraged abstractionists and academicians, among others, from participating in his programs.

Cahill, in his innovative approach, reflected an American experience. His parents brought him over as a child from Iceland to the United States; and later he traveled extensively throughout the country, becoming acquainted with the social and cultural conditions of the American scene. This American experience, evolving out of a synthesis of Icelandic origins and native development, formed a basis for his imaginative approach to setting up art programs for unemployed artists.

Growing up in an impoverished, immigrant family, Cahill based his concept on changing the social environment in which the artist found himself or herself isolated from society. He hoped to return to the social climate that had existed in the pre–Civil War period, when the artist was not exiled from the community. His social experiment—to unite artist and society through participation in the arts—encouraged artists of *all* persuasions to participate.

If the goals envisioned by Bruce and Cahill seemed impossible to achieve, the reasons were twofold. First, the federal government had never supported the arts on a national scale. Traditionally, the government was responsible for the agrarian, business, and industrial life of the nation, but not for culture. Second, there are inherent contradictions in the relationship between artist and government that any political administration is reluctant to confront. For example, it appears that President Roosevelt did not intend a fundamental transformation of American society under his New Deal, but the sheer quantity of social legislation enacted under his administration reveals the boldness of his leadership and his activist nature. Likewise, the artist in any sociey is seldom compatible with government bureaucracy; he or she more often assumes the role of questioner and critic.

Modern history offers many precedents for the contradictions faced by the New Deal. For example, in Russia during the 1920s the sculptor Naum Gabo created innovative forms freed from all past traditions. During the same period Mexican muralists expressed the social ideals of the Revolution of 1910. In the United States, however, such extreme philosophies were rejected by the slightly left-of-center New Deal administration. However, the severe Depression sharpened the American artist's

dilemma and posed questions about viable solutions to the socioeconomic problems of the 1930s.

The New Deal eventually set in motion the mechanics of a massive relief program. Yet it was Bruce—followed by Cahill—who articulated the artists' goals to the administration and who guided the specific direction of the federal art programs. The pilot Public Works of Art Project (PWAP), initiated by Bruce under the aegis of the Treasury Department and financed by relief funds from the Civil Works Administration (CWA), was an emergency measure that functioned only from December 1933 through June 1934. A second program, the Section of Painting and Sculpture (hereafter referred to as the Section), also established by Bruce within the Treasury Department, operated from October 1934 through June 1943. (The Section was only indirectly involved with the employment of artists; its funding came from the Treasury building program.) A third measure—the Treasury Relief Art Project (TRAP)—organized by Bruce and funded by the Works Progress Administration (WPA)—operated from July 1935 through June 1938. The fourth measure, the WPA Federal Art Project (WPA/FAP), established by Administrator Harry L. Hopkins and directed by Holger Cahill, continued the federal program from September 1935 through May 1943.

Within the organizational structure of the New Deal, Edward Bruce, with credentials acceptable both to the Administration and the art world, was the catalyst best equipped to carry out these programs. Bruce's view of a well-ordered, almost Platonic society assigned a clearcut role to the artist—not as a rebel but as a professional worker in his or her chosen field. Hence, Bruce's art programs assumed officially approved and socially useful forms, as decorative art to transform public buildings, not as propaganda to transform society. This traditional approach, however, placed some constraints on the creative artist and caused inevitable conflicts between artist and government. Yet, Bruce's ideal was to obtain the best work available from the most notable and promising artists, and he faced this difficult task with great courage and foresight.

In like manner Holger Cahill avoided political controversy between the New Deal and the artists, not only by assigning to the artist a role of creative worker but also by making available to the artist enough diversified projects to carry on his or her work. He perceived art as an official function of society or as an integral part of an administration seeking to maintain the highest contemporary cultural values. In Cahill's view, art should not be a luxury available to the rich—art belonged to all people. In his innovative projects he stressed community participation in the arts. Hence, the New Deal, inspired by Bruce's patrician vision and Cahill's egalitarian ideal, provided new opportunities for all Americans to integrate the fine and utilitarian arts into their daily lives.

Although in the end some limitations were imposed on the authority and freedom of Bruce and Cahill to carry out these programs—and although they were confronted by some irreconcilable problems in achieving their goals because of political, economic, and bureaucratic conflicts—the art programs continued to function for a decade. In pursuit of their objectives they received the strong support of the president and Mrs. Roosevelt. Others within the executive branch of the government who contributed their efforts to the program were Harry L. Hopkins, administrator of the Federal Emergency Relief Administration (FERA), the Civil Works Administration (CWA), and the Works Progress Administration (WPA); and Secretary of the Treasury and Mrs. Henry Morgenthau, Jr. The Treasury programs under Bruce placed art in federal

buildings throughout the country; the WPA/FAP under Cahill brought art into the lives of Americans in many small communities. Hence, both programs could be considered successful.

The advent of World War II marked the end of this experiment in federal support for the arts. In spite of his efforts to convert the program to wartime objectives, Bruce was unable to bring about crucial changes. Cahill modified his program to meet the emergency of wartime needs. By 1943, however, their original goals were unrelated to the shifting priorities of the administration. It became evident that the programs espoused by Bruce and Cahill under the New Deal had become anachronistic during the new crisis posed by totalitarianism. In the end the New Deal art programs became a casualty of World War II, extraneous to the daily concerns of the American people.

Although the art programs did not continue under the wartime administration, at least they had expressed the New Deal objective of providing "a more abundant life for all." Besides, they marked a watershed in American art history and a significant human adjustment to the grim reality of economic depression, while sustaining— through the ideals of their founders—the "American Dream."

Bruce and Cahill, however, left an impressive legacy that established a precedent for federal patronage of the arts in the post–World War II period. Government sponsorship of the arts did not take the form of a ministry of fine arts in the United States, as did similar programs in European countries. Yet, through the legacy of Bruce and Cahill, the Government Services Administration (GSA) and the National Endowment for the Arts (NEA) have actively supported programs to make the best American art available to the public and to preserve the finest traditions in the native crafts.

Cultural Origins

New Deal art was derived from three basic cultural sources: the Depression era; the contemporary American scene; and the Mexican mural movement. Perhaps the single most important influence was the Depression of 1932, the worst economic crisis in American history. In response to this debacle, the Roosevelt administration directed its energies to alleviating the "hard times" of a sorely disillusioned people.

The historic artistic concept of nature assumed different forms during the Depression of the 1930s. In the philosophical works of the nineteenth-century poet Ralph Waldo Emerson, the natural wilderness was viewed as the mystical handiwork of God, before which humans stood in awe. These ideals the traditional painter George Inness expressed. By the 1930s, however, the artist interpreted the wilderness theme in terms of the migrant worker, the dust bowl, and the homeless families "hard travelin'" on an open road to find the promised land. The artist witnessed—and suffered—the human despair experienced by all Americans.[1]

Moreover, many feared that the Depression marked the end of the "American Dream." The historian James Truslow Adams raised this disturbing question. His vision was of a better, deeper, richer life for *every* individual, not a fixed position defined by the accident of birth. This dream, Adams emphasized, appeared to lie shattered under the debris of the economic crash.[2]

On the other hand, the socialist writer Aldous Huxley touched on the need for a new course of action. In discussing the bewilderment caused by the crisis, he declared that America had been without a generally accepted faith and philosophy: "We need a faith because we need to act, and because faith provides us with a motive for action, a

stimulus, and an incentive. We need a philosophy because it is intolerable to us to live blindly from hand to mouth."[3]

Edward Bruce had personally experienced the effects of economic dislocation. The community of artists with which he chose to ally himself was just as uprooted as the "Okies" of John Steinbeck's novel *The Grapes of Wrath*. Steinbeck noted that where the government established camps for the "gasoline gypsies" of the road, hope prevailed, in contrast to where government assistance did not exist. In a sense PWAP offered a similar haven for the American artist.

The artist watched the dismal progress of the Depression spread across the country, ushering in a different way of life for millions of Americans. By the spring of 1930 at least four million persons were unemployed. Bread lines appeared in large cities for the first time since 1921. The year 1930 also introduced thousands to a new and humiliating mode of existence, as numbers on the relief rolls. In the summer of 1930 a prolonged "drought lies over the land like a pall," a troubled reporter from Arkansas wrote. "It is not vibrant with action, like a flood or an earthquake," he commented, "but even in its negation of action and effort, it becomes visible and spectacular. It is the brown and barren fields, the gaunt trees, the dust blowing in dry creek beds, in the thin side of animals plucking hungrily at grass roots and leaves, in the apathy and listlessness of a discouraged people."[4]

As the nation moved into the second winter of the Depression, the number of the unemployed grew from four million in March 1930 to eight million in March 1931, who were forced to settle into a new way of life. Local fiscal sources were drying up, and communities found the problem of relief beyond their capacity to handle. An estimate of one million and a quarter homeless persons included approximately 125,000 children of migrant families in the West and the Southwest. Adult males constituted the largest number on the road, and they included representatives from all sections of the country. One despondent wanderer described their plight: "If only I could get a job, so I wouldn't have to beg any more. Men like us aren't human beings. We're animals just like rats, hunting for food and shelter."[5]

In one relief shelter in New Orleans the migrants slept on a cement floor with newspapers as mattresses. These improvised beds became known as "Hoover mattresses." Wandering across the forty-eight states in search of work, a red-faced Scotsman retorted, "From what I hear, people think more of Al Capone than they do of a penniless man out of work; on the street they look at us as if we were vermin."[6] An inquiry into unemployment relief in thirty-seven large American cities showed that if no actual starvation existed, there was misery and despair everywhere. In reply to the question "What will those towns look like if the crisis goes on two years longer?" the answer was, "God only knows, but there will certainly be bloodshed and complete misery unless the federal government steps in."[7]

The shadow of the Depression also fell heavily on the countryside. Farmers had drawn extensively on their savings before the Crash of 1929. Net farm income in 1932 was $1.8 billion, less than one-third of the figure three years earlier. This appalling slump left most farm families with little income, and many with no income at all. The farmers' mutual fire-insurance companies despaired about increased arson. As one reporter observed, "If you were so desperate for money as they are, you'd burn a chicken house or a garage or a barn or even your house, as they sometimes do, to get clothes and shoes for your children." A Superior Court judge remarked, "We are never going back into the Republican Party, we Iowa farmers; it is dead, dead, dead!" No longer afraid of the word "socialism," farmers frankly stated that there would have

been thousands of votes for Norman Thomas in the farm belt, had they not felt that the most important thing was to sweep Hoover out of the presidency. They were deeply disturbed, but they had no desire to turn against the flag.[8]

This human despair in a wilderness of social and economic desolation experienced by the artist formed a basis for the artist's iconography. The new idealism of the Roosevelt administration, however, presented the artist with a contrasting theme—the hope that the American dream could be revived. Thus, the harsh realities of the Depression produced the kind of environment that acted as a catalyst in bringing together diverse cultural forces.

The second cultural source was the concept of the American scene. The Depression artist's emphasis on native themes pointed to the rejection of the European influences that had dominated American art during the 1920s. The art writer Holger Cahill observed signs of rebellion against the French and a demand that the United States free itself of foreign entanglements to "cultivate its own garden." When the new season of the Stone City Colony and Art School in Iowa was launched in August 1933, the directors announced that if American art were to be elevated, it could not remain a pale reflection of European painting.[9]

In the 1930s, American realism was emphasized by Thomas Hart Benton in his murals for the New School for Social Research in New York City. In trips throughout the country Benton sketched an immense amount of Americana. In response to criticisms about the project Benton retorted, "Conservatives whaled me for 'degrading' America, purists for representing things, and the radicals were mad because I didn't put in Nikolai Lenin as an American prophet." Benton added, however, that his painting was "good news" and was well received by many.[10]

The Benton murals were not an isolated phenomenon. In 1929, John Steuart Curry made countless farm studies, which provided material for his dramatic painting *Tornado over Kansas*. In 1930 the Whitney Club in New York presented Curry's first one-man show. Previously, critics had called Curry's work "provincial satire," but now it was regarded as a new expression of dramatic power. A "young Lochinvar from the West"—convincing, blunt, and refreshing in his techniques, the art critic Margaret Bruening of the *New York Evening Post* described Curry. Edward Alden Jewell of the *New York Times* praised Curry as one of America's foremost painters, commenting that "Kansas had found her Homer."[11]

Grant Wood also assimilated material from his native Iowa. *American Gothic* (1930), a realistic painting of a farmer and his wife, typified the vital change that American painting was undergoing. After returning from Europe with the "Lost Generation," Wood viewed the American scene through new eyes. His neighbors in Cedar Rapids, Iowa—their clothes, their homes, their tablecloths and curtains, even their tools—were seen in a new light. "I suddenly saw all the commonplace stuff as material for art—wonderful material," Wood commented.[12]

Ben Shahn's search for social realism gave new authority to his painting. With roots in the social protest of the late 1920s, his work reflected the legitimacy of social content in art, not "art for art's sake." After Shahn returned from Europe in 1929, he remarked, "Here I am, 32 years old, the son of a carpenter. I like stories and people. The French school is not for me." Shahn searched for themes to express new emotions of poverty, despair, sacrifice, and martyrdom. He found such a theme in the Sacco-Vanzetti case, saying, "Here was something to paint."[13]

The writer Thomas Craven dramatized the American theme while criticizing that which he termed "the curse of French trivialities." Although critics protested his

strong views, the changing scene appeared to revitalize American art, and Craven contended that "art for art's sake"—or for the sake of *any* abstraction—could not thrive in contemporary America. If Americans were to have an indigenous expression, he declared, it would have to come from strong native impulses, simple ideas, and the popular taste. [11]

Craven's viewpoint was shared by Holger Cahill, who commented that society was living in a time of critical reevaluation, and that "art for art's sake" was a tattered symbol. He concluded that contemporary painting, with its emphasis on social and collective expressions, gave a fresh and vital interpretation to the American way of life. The artist Louis M. Eilshemius offered an ingenuous answer to the question, What is American art?

> The answer is rather simple. An artist who glorifies our scenery's beauties and charms, who illustrates in a noncommercial manner our history from the Revolution; who does not imitate the foreign galaxy in technique; who has mastered the fine arts and who is a poet in feeling, subject matter, and in rendering the atmospheric, truly American effects, can be worthy of the title, an American artist, implying the United States, North America. [15]

The need for nationalistic expression in art forms was voiced by museum directors and art critics. Europe was losing its hold on American artists, Homer St. Gaudens, the director of the Carnegie Institute in Pittsburgh, declared. It was not solely the Depression that brought about the change, he contended, but a growing awareness among artists that it was not necessary to go to Paris to paint. Edward A. Jewell remarked that there was a new feeling in the air: "One mark of the new idea in America's mural art is employment of something more substantial than windy abstractions. Enough of sterile symbols like Justice and Virtue and Truth! We need for this age, more solid fare."[16] For those who were bored with the same Parisian names, the art critic Lloyd Goodrich recommended the work of Thomas Hart Benton. Goodrich conceded that flag waving was a perilous business in art, but it was a corrective to the indiscriminate worship of *The Judgment of Paris*, and a reminder that a native quality in art was a good thing. After the art critic Elisabeth Luther Cary reviewed the Americans' work at the Carnegie International Exhibit in Pittsburgh, she observed that they were expressing Simon-pure Americanism; they had not gambled away their birthright. The writer E. M. Benson viewed the American artist as more self-sufficient; the cup of inspiration, although not always brimming over, at least, was the artist's own—not Pablo Picasso's. Perhaps because of the recent social and economic eruption, Benson commented, the American artist had been lured out of the studio into the marketplace where, astonishingly, he or she discovered a world teeming with plastic and human material. [17]

In New York artists publicly debated the issue of nationalism versus internationalism. It was essential for an American artist to depict the things that he or she loved in his or her own style, Richard Lahey believed—in this manner, the artist's work would become national in spirit. Joseph Pollet, however, insisted that art was simply communication through symbols like line, color, and space. In reference to Paul Cézanne's well-known dictum about the cube, cylinder, sphere, and pyramid, he questioned that a difference existed between an American cube and a French cube. Only an international art was significant, Maurice Sterne stated, but William Zorach insisted that an artist found roots among his or her own people and belonged to his or her national life. [18]

Edward Jewell raised the same issue during the founding of the Museum of Modern Art and the Whitney Museum of American Art in New York City. After seeing a bird's-eye view of the first exhibit of contemporary American art at the former museum—which included work by Lyonel Feininger, Jules Pascin, and Yasuo Kuniyoshi—he was not tempted to exclaim, "Why, it's America!"[19]

However, when the Whitney Museum of American Art opened, Jewell wrote: "At last our art is to have a home of its own." In his view the Whitney's opening officially marked "a native American Renaissance."[20]

If this native American Renaissance meant the revival of the "American scene," it was to be reflected throughout the New Deal art programs. Whether realism, surrealism, or abstraction dominated the work the American scene proved influential in formulating the iconography of the New Deal art.

The third cultural source was the Mexican mural movement of the 1920s, which evolved out of the Mexican Revolution of 1910 and the new social ideals it depicted. The concept of "a people's art" on public walls, exemplified by the work of the Mexican muralists Diego Rivera, José Clemente Orozco, and David Alfaro Siqueiros, exerted a strong influence on the New Deal art.

The direct impact of this Mexicanism was first felt when Orozco and Rivera came to the United States to paint murals on public walls. In 1927, Orozco painted *Prometheus Bringing the Gift of Fire to Mankind* at Pomona College, California, and it was highly praised by the critics. In 1930 his murals for the New School for Social Research in New York—depicting the revolutionary unrest smoldering in the nonindustrial countries of India, Mexico, and Russia—drew favorable comment.[21]

Orozco was thereafter invited to Dartmouth College, New Hampshire, as artist-in-residence and given complete freedom to paint a series of murals in the Baker Library there. His broad themes, beginning with the Indians of the New World, encompassed the impact of technology on modern society. After completing the Dartmouth murals in 1934, Orozco returned to Mexico.[22]

Diego Rivera's fame spread across the Rio Grande when the first reports of a great Mexican mural revival filtered northward. In 1929 the American Institute of Architects in New York awarded Rivera the Fine Arts Gold Medal for his contributions to fresco painting and to architecture. Rivera first came to the United States in 1930, to paint a mural for the San Francisco Stock Exchange. Then he was commissioned to design murals for the Detroit Institute of Art, depicting the epic of industry. He completed the work in 1933, but the critics reviewed it with mixed emotions. Some of the civic and religious groups wanted the murals destroyed because Rivera had ignored the "spiritual values" of the city. He, however, received enough support to save his murals.[23]

Rivera then left for New York to begin a new mural, *Man at the Crossroads*, in Rockefeller Center. However, adverse newspaper publicity, such as the article entitled "Rivera Paints Scenes of Community Activity and John D., Jr., Foots Bill," caused the Rockefellers to request changes because a controversial portrait of the Communist leader Vladimir Ilyich Lenin had been introduced in a citadel of capitalism—Rockefeller Center. When Rivera refused to make any changes in his unfinished mural, he was paid in full and dismissed. Later, after Rivera learned about the destruction of his mural, he sent a cable of protest from Mexico, declaring the Rockefellers had committed an act of cultural vandalism. Protest meetings were held in New York, attended by outstanding American artists, such as John Sloan, William

Gropper, George Biddle, and Ben Shahn, but the mural was never restored.[24]

Orozco and Rivera, however, made important contributions to the idea of "a people's art," which expressed itself in the New Deal art. The vitality of their work was widely acclaimed by such critics as Lewis M. Mumford and McKinley Helm as being among the most important murals painted in America. Moreover, American artists, influenced by this Mexican precedent with its social ideals, created a mural art that depicted the people's determination to revive the American dream.[25]

In sum, these cultural origins—the Depression scene, the American scene, and Mexicanism—were reflected in the art of the New Deal programs. The American artist, imbued with the mood of social consciousness engendered by the Depression, painted themes that expressed a commonplace sensibility, such as society on welfare, society at play, society working, and society sustained by the new idealism of the Roosevelt administration.

Notes

1. Ralph Waldo Emerson's "Transcendentalism" viewed nature as transcendental and asserted the presence of the divinity in nature. See O. B. Frothingham, *Transcendentalism in New England* (New York: Harper & Brothers, 1959). George Inness, an artist of a deeply spiritual nature, was influenced by the doctrines of the theologian Emanuel Swedenborg. In his landscapes he sought to express the "visible works of God." See Samuel Isham, *The History of American Painting* (New York: MacMillan, 1927). Edward Bruce also viewed the landscape as a supreme expression of God's handiwork. See Frederick Lewis Allen, *Since Yesterday* (New York: Harper & Brothers, 1940) pp. 45–50.

2. James Truslow Adams, "America Faces 1933's Realities," *New York Times*, January 1, 1933, sec. 6, p. 1.

3. Aldous Huxley, "The Problem of Faith," *Harper's Magazine*, January 1933, p. 211.

4. "Where Drought Sears Land and People," *New York Times*, February 15, 1931, sec. 5, p. 3.

5. James Rorty, "Counting the Homeless," *The Nation*, June 21, 1933, p. 692; John Kazarian, "The Starvation Army," *The Nation*, April 12, 1933, p. 396.

6. Kazarian, "The Starvation Army."

7. "Plight of the Cities," *New York Times*, April 24, 1932, X3, p. 1; Oswald Garrison Villard, "Hammond and Gary Face the Disaster," *The Nation*, March 29, 1933, p. 343.

8. Oswald Garrison Villard, "Issues and Men," *The Nation*, March 1, 1933, pp. 223–24.

9. Holger Cahill and Alfred H. Barr, Jr., eds. *Art in America* (New York: Reynal & Hitchcock, 1934) p. 42; "Field Notes: Stone City's Second Season," *American Magazine of Art*, August 1933, pp. 390–91.

10. Thomas Hart Benton, *An Artist in America* (New York: Robert M. McBride, 1937), p. 247.

11. Laurence E. Schmeckebier, *John Steuart Curry's Pageant of America* (New York: American Artists Group, 1943), pp. 61–62; Review in the *New York Evening Post*, February 1, 1930; Review in the *New York Times*, December 7, 1930.

12. Darrell Gar Wood, *Artist in Iowa* (New York: W. W. Norton & Company, Inc., 1944), pp. 180–84.

13. James Thrall Soby, *Ben Shahn* (New York: George Braziller, Inc., 1963), pp. 10–11; Nicola Sacco and Bartolomeo Vanzetti, two Italian laborers of anarchist persuasion, were charged with murder by the Commonwealth of Massachusetts and on dubious evidence were sentenced to the electric chair on August 23, 1927.

14. Thomas Craven, *Men of Art* (New York: Halcyon House, 1931), p. 506.

15. Cahill and Barr, *Art in America*, p. 43; Louis M. Eilshemius, "Letters to the Editor on American Art," *New York Times*, March 13, 1932, sec. 8, p. 11.

16. *New York Times*, June 11, 1933; Edward Alden Jewell, "Mural Art Picks Up," *New York Times*, December 8, 1929.

17. Lloyd Goodrich, "New Benton Drawings," *New York Times*, October 27, 1929, sec. 9, p. 13; *Judgment of Paris* (1916) by Pierre Auguste Renoir can be interpreted to symbolize the concept of "art for art's sake." Such a concept was expressed in the avant-garde movements of the "Paris School," which included the cubist and abstract work of Georges Braque and Pablo Picasso. See Elizabeth Luther Cary, "Americans at Carnegie," *New York Times*, November 2, 1930; E. M. Benson, "Carnegie International— 1933," *American Magazine of Art*, December 1933.

18. Edward Alden Jewell, "In the Realm of Art," *New York Times*, February 28, 1932; Paul Cézanne's dictum about expressing the depth of cubic form refers to a method of abstraction by which the visual relevancies of nature are eliminated to rebuild the natural scene as an independent painting.

19. Edward Alden Jewell, "Contemporary American," *New York Times*, December 22, 1929.

20. Edward Alden Jewell, "What Is American Art?" *New York Times*, November 15, 1931; Edward Alden Jewell, "A Season Dominantly American," *New York Times*, May 29, 1932, sec. 8, p. 7.

21. Bernard S. Myers, *Mexican Painting in Our Time* (New York: Oxford University Press, 1956), pp. 100–101; MacKinley Helm, *Man of Fire* (New York: Harcourt, Brace and Company, 1953), pp. 46–49; Alvin Johnson, *Notes on the New School Murals* (New York: International Press, n.d.), pp. 1–3; "Orozco Has Begun New York Murals," *Art News*, November 29, 1930, p. 20.

22. Albert I. Dickerson, ed. *The Orozco Frescoes at Dartmouth* (Trustees of the Dartmouth College, 1934), p. 3; "A Synthesis of Life in America," *Survey Graphic*, March 1934, p. 119; *New York Times*, February 17, 1934.

23. Bertram D. Wolfe, *Diego Rivera: His Life and Times* (New York: Alfred A. Knopf, 1939), pp. 314–16, 339–40, 347–48; Editorial in the *Detroit News*, March 19, 1933; "Will Detroit, Like Mohammed II, Whitewash its Rivera Murals?" *Art Digest*, April 1, 1933, p. 5; *Detroit News*, April 12, 1933; *New York Times*, March 21, 1933.

24. Wolfe, *Diego Rivera*, p. 362; *New York Times*, May 10, 1933, pp. 1–3; February 13, 1934; February 19, 1934.

25. Belisario R. Contreras, "The Impact of Mexican Revolution Art upon the United States, 1930–1934," unpublished research project (Washington, D.C.: American University), pp. 21–23, 41–42.

Tradition and Innovation
in New Deal Art

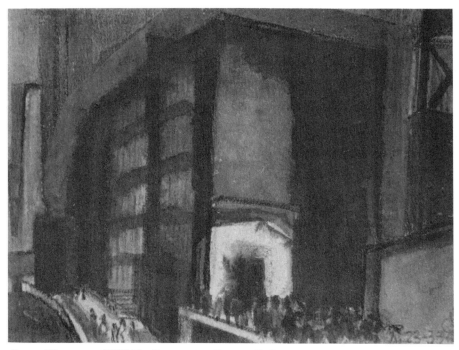

Oscar Bluemner (PWAP), *Depression Scene.* **(Belisario R. Contreras)**

1

New Idealism

"The country demands bold, persistent experimentation. It is common sense to take a method and try it; if it fails, admit it frankly and try another."[1]

Such was the philosophy of the first "One Hundred Days" of the Roosevelt administration, marking the massive effort to put Americans back to work in the Depression year of 1933. The Civilian Conservation Corps (CCC) was established on March 31 to provide jobs in National Forests for 250,000 unemployed young men. On May 12 the Federal Emergency Relief Administration (FERA) was organized to make grants to the states for direct relief. The Public Works Administration (PWA) was set up on June 16 to provide employment for skilled workers in the construction of public buildings, roads, and other traditional federal projects. In a larger sense, the Roosevelt administration was setting the national tone for the new idealism and was providing the stage for Edward Bruce and Holger Cahill to develop programs under the New Deal that would respond to the needs of artists during this "worst of times."

American artists suffered during the economic crisis no less than any other citizens. Thousands of artists were unemployed, and art galleries went out of business. Moreover, the limited federal support given to the arts in the past offered little precedent for the government or the public to help destitute artists.[2] For instance, the art critic Suzanne LaFollette believed that the society would continue to neglect the artist and would salve its conscience by deluding itself that artists needed to starve to achieve greatness. Pending a solution to the general labor problem, which, according to LaFollette, seemed to be almost as far away as ever, the artist must continue to take vows of poverty.[3]

While the general labor problem awaited a solution, in the private sector efforts were made to alleviate the artist's misfortunes. In April 1932, five hundred impoverished artists in Greenwich Village, New York, asked for and were granted permission to set up an open-air market for their works in Washington Square. In one instance an artist fortunate enough to sell two paintings quickly left to pay his rent.[4] Elsewhere, different solutions occurred. A barter show was held at the Syracuse Museum, at

which four bushels of apples were exchanged for pottery and an obstetrician's services for an oil painting.[5] In St. Paul, Minnesota, a group of forty artists opened a cooperative exhibit of paintings and etchings.[6] The College Art Association (CAA) in New York extended its activities to help artists. The president of CAA, John Shapley, outlined a program that included a College Art Artists' Cooperative to provide exhibit space. The CAA also advocated a rent-a-painting plan, which was adopted by the Art Alliance in Philadelphia and the Dayton Art Institute in Ohio.[7] However, a broader relief plan, the Gibson Committee, was organized and privately financed in New York by a group of wealthy, civic-minded persons. The Emergency Work and Relief Bureau of the Gibson Committee, in cooperation with the College Art Association, established a program for unemployed artists to paint murals in churches and neighborhood centers and to teach art in settlement houses.

However, as unemployment increased, the Gibson Committee's funds were depleted, and its art program was absorbed by the New York Emergency Relief Administration (ERA). Later, the ERA became the Temporary Emergency Relief Administration (TERA), and it received federal grants from FERA. The ERA art unit was transferred to TERA, and the employment of artists increased as more funds became available. Audrey McMahon, executive secretary of the CAA, headed the ERA art unit.[8] Yet, despite the efforts of TERA and CAA, these art programs did not meet the urgent needs to alleviate unemployment.

On November 8, 1933, the federal government responded to the nationwide emergency situation by establishing the Civil Works Administration (CWA) under Harry L. Hopkins to put four million unemployed persons to work immediately on federal projects that included repairing roads, improving schools, and maintaining parks. Hopkins, a graduate of Grinnell College, Iowa, with extensive experience in social work, had directed TERA in New York state under Governor Franklin D. Roosevelt, and he later became FERA administrator under the New Deal. However, in spite of the progress made by the New Deal to help unemployed laborers through the CWA, no similar attempt was being made to ameliorate the plight of the artist.

The private efforts of the CAA, which, in cooperation with the Gibson Committee, had provided temporary jobs for artists, were praised by the *American Magazine of Art*. Yet the Roosevelt administration was criticized because it had not even reached an experimental stage of relief planning for artists.[9] In New York several professional organizations, including the Society of Independent Artists, the National Academy of Design, the Whitney Museum of American Art, and the CAA, met to discuss the worsening plight of artists. (In New York City alone, there were 9,000 artists registered with the CWA Relief Bureau.)[10] This group drafted a proposal and sent a copy to Hopkins, asking his support of a program to include mural painting in public buildings, the teaching of the arts and crafts, and the purchase of art works by the federal government.[11] Meanwhile, Audrey McMahon was moved to voice this poignant plea for the unemployed artist:

> Shall our walls remain blank, and blank the minds of our people to act, and blank of hope the lives of our artists? Shall our children, who could be taught so much, to wield a brush, to enjoy a line, or love a color, learn nothing, while those who could teach them starve?
> Shall this age be known to posterity as a dark era, during which we turned our thoughts to material fears and closed our minds to the hope and relief offered by beauty?[12]

Perhaps the fears of "a dark era" raised by McMahon could be met by federally supported art programs, similar to the ERA and CAA. At least, she presented a challenge to the Roosevelt administration, which had pledged a "New Deal" for all citizens.

In May 1933—after the first "One Hundred Days" of New Deal legislation were set in motion—President Roosevelt received a letter from George Biddle, a well-known artist and his friend since their school days at Groton. Citing the example of the Mexican muralists in the 1920s, who depicted on public walls the social ideals of the Mexican Revolution, Biddle suggested that American artists could also produce a mural art of vital, national expression under the New Deal.[13]

Biddle's recommendation to depict the ideals of the New Deal on public buildings aroused the president's interest. The president, in turn, proposed that the plan be discussed with Assistant Secretary of the Treasury Lawrence L. Robert, administrator of government properties throughout the United States. The plan also was discussed with Harry Hopkins, PWA administrator Harold Ickes, and other New Deal leaders, all of whom expressed enthusiasm for it.[14] Biddle's idea of a new nationalism in art to capture the spirit of the New Deal proved exciting. Yet there still remained the question of how the administration could effectively organize an art program to best fulfill the national aims of the New Deal. Biddle's plan, for instance, utilized fewer than a dozen of the most notable artists in America—it was an elitist venture not likely to ameliorate the plight of artists during the Depression. Although Biddle's concept did not address itself to the wider unemployment problem, his letter to the president did focus the administration's attention on the possible function of the artist under the New Deal, a role still to be clearly defined.

Nothing concrete developed from the preliminary talks between Biddle and Robert until the assistant secretary, on the recommendation of Representative Florence Kahn of California, turned to Edward Bright Bruce for advice about the support and development of the fine-arts program.[15] Bruce—who was born in Dover Plains, New York, on April 13, 1879—had been a successful lawyer and entrepreneur before becoming disenchanted with the crassness of the business world. He gave it up altogether at the age of forty-three, to become a professional artist.[16] Why would an American businessman unexpectedly dedicate himself to the art world? Of course, the French painter Paul Gauguin had turned from banking to art. In the case of Bruce, he may not have fully understood the basis for his decision. However, to say that he is a Renaissance man comes close to defining his many talents. Certainly, Bruce would have been comfortable living in the civilization of the Renaissance in Italy. He, however, did not live during a great flowering era like the Renaissance but during "the Great Depression" in America, which for many meant the end of the American civilization. Yet Bruce, with great courage and imagination, initiated what could be described as an American Renaissance in the arts, through the New Deal programs during the worst depression in United States history.

Bruce's Background

After Bruce had graduated with honors from Columbia Law School in 1904, he practiced in New York City and in Manila, where he was a member of the prestigious firm, Bruce, Lawrence, Ross and Black. While in Manila, he acquired a leading daily, the *Manila News*. Bruce next moved to China, where he established the Pacific

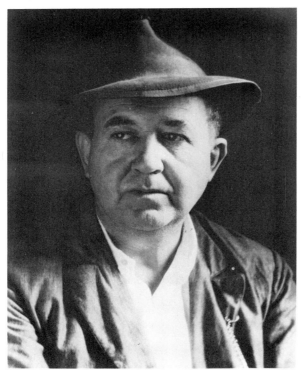

Portrait photo of Edward Bruce: Forbes Watson Papers. (Archives of American Art, Smithsonian Institution)

Development Corporation, and from 1915 to 1922 he engaged in foreign trade and banking activities throughout China and the Far East.[17]

In his business relationships Bruce established a reputation as a man of unusual character. One evening, enroute to Manila on the Pacific Mail ship *Venezuela*, Bruce's own ethics came out remarkably in a card game. He drew a pat royal flush, but, not willing to play an unbeatable hand, he discarded his royal flush and stayed out of the jackpot. An observer dubbed Bruce's generous action "the milk of human kindness."[18]

During his China residence Bruce studied Chinese art and acquired a fine collection of paintings, bronzes, and porcelains. However, his business suffered a severe setback when the ruthless competitive practices of J. P. Morgan and Company ruined his trading enterprise.[19] This loss resulted in deep personal conflict between the religious idealism inherited from his father, a Baptist minister, and the materialistic values of the business world. Because Bruce found it impossible to reconcile himself to this ideological conflict, he never went back into business again.

On one of his trips between the Orient and the United States, Bruce met Maurice Sterne, one of America's best contemporary painters. When Bruce decided to leave China in 1922, he went to Anticoli Corrado, Italy, because Sterne was there, and he studied art with him. Painting landscapes in Italy and France, Bruce eventually

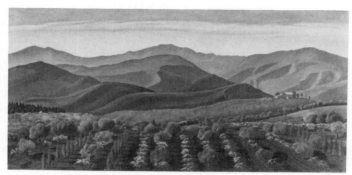

Edward Bruce, *Tuscan Hills*, n.d. (Collection of the Newark Museum)

gained international recognition as a professional painter, with one-man exhibits in New York and Paris. [20]

Through these successes Bruce renewed his faith in himself and in his future as an artist. In 1925 he held his first show at the Scott and Fowles Gallery, and the next year he exhibited at the New Gallery in New York. The *New York American* art critic William McCormick described Bruce's paintings at the New Gallery as follows:

> They are extraordinarily simple because they are so fine—technically and fine as subjects. In respect to pure landscape painting, I can recall no American artist— and no European for that matter—who achieves what Edward Bruce has accomplished in these paintings. [21]

The art writer Leo Stein (Gertrude's brother) also wrote that Bruce's work was so good that his taste in subjects appealed to "the man in the street who likes pictures," as much as it did to "the crabbed, crusty, cruel critic." [22]

In 1929, Bruce held a one-man exhibit at the Galerie Briant in Paris. His painting *A Savoie Farm* was purchased by the French government for the Luxembourg Museum in Paris, shortly after the exhibit opened. B. J. Kospoth, a reporter for the *Chicago Tribune*, observed that Bruce's Italian and French landscapes excited the interest of French artists and critics to an unusual degree. "They are just beautiful to look at; that is all. And that is everything, and explains his extraordinary success, which seems to point to a revival of classic realism in modern painting." [23]

The impact of Bruce's art on the French capital also was assessed by Stein: "The painting of Edward Bruce seems to me important. Even in Paris, the present center of the art world, it shows itself as important." Stein judged Bruce's landscapes to be more significant than those of Maurice Utrillo, André Segonzac, or André Derain, because in his work, art and nature were compatible: "The result is art in the best sense of the word, and nature is not sacrificed. Therefore, Bruce is important." [24]

In 1929, Bruce left Italy for America because of oppressive Fascist conditions. He experienced the high achievements of the Renaissance, but he also witnessed the brutality of the Fascist regime. "With my own eyes I saw a group of simple young peasants beaten to insensibility. I saw one of them fatally shot. Their only crime . . . failure to fall in with the Fascist Regime." [25] He never returned to his beloved Anticoli Corrado, but he always retained nostalgic memories of the scene of his rebirth as an artist. [26] Bruce continued with his artistic career, painting landscapes in California

and urban scenes in New York. In 1929 his painting *The Pear Tree* received first honorable mention at the Carnegie International Exhibition in Pittsburgh. During the same year he held a one-man show at the Reinhardt Gallery in New York, and the following year, at the Carnegie Institute, Pittsburgh. In 1931 the exhibit of Bruce's California and European work at the S. and G. Gump Galleries in San Francisco aroused much favorable comment and was among the outstanding art events of the year.[27]

However, the impact of the Depression on the art market brought another critical setback for Bruce; the economic chaos threatened his second career. Although his exhibit at the Houston Museum of Fine Arts in 1931 was acclaimed as an artistic triumph, not one sale was made.[28] Bruce had little choice but to return to law. He ruefully observed, "I have been spending four months in New York trying to do some pictures of New York, as well as a lot of business matters, and the net result is not a very large output, which, however, doesn't seem to be important these days as the art business is completely dead. I shall continue my business activity in Washington this winter, and after that I don't know what will happen."[29]

In 1932, Bruce came to Washington, D.C., as a lobbyist for the Calamba Sugar Estate of San Francisco, which had sugar interests in the Philippines. He hoped to get favorable sugar quotas from the United States, pending the outcome of the Philippine Bill granting independence to the Philippines. Bruce soon developed contacts with important officials and became familiar with the complicated workings of the bureaucracy. Although Congressional leaders were impressed with his legal work, Bruce was eager to resume painting as soon as possible.[30]

During his stay in the capital, Bruce abandoned his political affiliation with the Republican party and became a Democrat. He believed that there was wisdom and courage in Roosevelt's New Deal, which would provide a better and richer spiritual life for every American. Calvin Coolidge's precept, "The business of the nation is business," was sorely discredited during the Depression, and Bruce's about-face was no exception to the general aura of disillusionment during this era. The historian James Truslow Adams soberly commented in 1933: "What we dread, unless civilization breaks down entirely, is not lack of food from drought or pest, but the ending of what I have elsewhere called 'the American Dream'." However, Bruce and others of his persuasion saw an enhancement of the American Dream in the New Deal because of their confidence in Roosevelt, who advocated "a more abundant life for all."[31]

Continuing his involvement with the Washington political scene, Bruce was appointed by President Roosevelt as U.S. delegate to the London Economic Conference, which convened in London in June 1933. As assistant to Senator Key Pittman, vice-chairman of the monetary commission, Bruce advised on monetary matters, especially silver, a field that he had studied in the Orient. Bruce averaged eighteen hours of work a day during the conference, but he never lost contact with the art world. One evening, however, he fell asleep when Leo Stein visited him, his guest continuing with a one-sided conversation throughout the night. The next morning, after Bruce awoke, he observed that Stein apparently had a "great Niagara of talk" to get out of his system![32]

In July, before returning to the United States, Bruce held an exhibit of his paintings at the Leicester Galleries, acclaimed by art critics and U.S. Secretary of State Cordell Hull, who paid tribute to Bruce's unique talents as a financial expert and distinguished artist. Unfortunately, the results of the London show were similar to the 1931 Houston exhibit—a great artistic success but a financial disaster.[33] Back in the

United States, Bruce experienced the same setback before he decided to plan art programs for unemployed artists under the New Deal.

To assess Bruce's unusual contributions to New Deal art, one cannot overlook the importance of his artistic development. The clarity, simplicity, and rhythm of Oriental art, reflected in Bruce's work, prompted one critic to comment that Bruce rendered landscapes as the great masters of China would have done had they lived in the 1930s. The Chinese approach of not using traditional laws of perspective interested Bruce, but he did not entirely reject those laws in his work. He believed that an illusion of space could be created by using the atmospheric perspective of Renaissance painting and Cézanne's interplay of planes. [34]

Yet the tradition in Bruce's aesthetic philosophy was derived from his European experience, particularly in Italy, where he was influenced by such Italian masters as Michelangelo, Piero della Francesca, and Andrea Mantegna. The traditional role of patron—such as the Medici—played an important part in his relationship with New Deal artists. Although the kind of accuracy and classic composition seen in Renaissance painting was required, he did not insist that artists in his programs be dully naturalistic and unimaginative. [35]

Maurice Sterne, the noted American painter, who had first encouraged Bruce to exhibit, was a significant influence in Bruce's artistic life. [36] In Anticoli Corrado, Italy, where Sterne's own art matured, it followed the traditions of the Italian painters Mantegna and Antonio Pollaiuolo, as well as the modernism of the French contemporaries, Edouard Manet and Cézanne. Bruce readily absorbed from Sterne his aesthetic principles: instinct, as a guide to an individual approach; nature, to be carefully observed; and craftsmanship, to be thoroughly studied. [37]

Bruce's view of art coincided with that of the Renaissance scholar Bernard Berenson, who advocated the theory of "Tactile Values," in which such artists as Masaccio and Raphael depicted a world of solid things, imparting a sense of distance, space, and mass. [38] Yet Bruce also held that realism depended on rhythm in a composition. He concurred with Leo Stein's definition: "Rhythm is a movement that tends to come to rest, that is taken up and carried on despite partial assimilations, and which is concluded only when the vibrations are stilled by their diffusion through the whole. In such a case the composition is alive." [39]

The Anticoli Corrado interlude is seen as a rebirth in Bruce's life. Just as Sterne succeeded in escaping from his Dante's "Inferno" of doubt as a mature artist, Bruce put aside his self-doubt because of his new role as an artist. By 1928 he looked to a wider horizon of accomplishment. Bruce agreed with the philosopher William James, who wrote, "I have often been surprised to find what a predominant part in my own spiritual existence it [nature] has played, and how it stands out as almost the only thing the memory of which I should like to carry over with me beyond the veil, unamended and unaltered." Bruce himself looked on landscape as perfected expression of beauty, a supreme statement of God's handiwork. Nature gave him a sense of well-being and personal peace that nothing else could offer. He had, at last, come to terms with his ill-fated business past. Bruce now viewed painting as an adventure of high endeavor and fresh discovery. He hoped that the international recognition he gained as a painter would inspire others to see the beauty he tried to capture in his art and, hence, to leave behind a lasting memorial. [40]

The philosophy of William James also molded Bruce's life. In effect, James's work provides a good index to Bruce's personality. James commented that in science and in daily affairs one could postpone a decision until complete objective evidence was

available. On moral questions, however, the action could not be delayed because moral issues were concerned not with a condition that exists but with a condition that would be good *if* it existed.[41] After Bruce's business failed in 1922, his former college friend Royal Victor attempted to dissuade him from becoming an artist. He suggested that Bruce delay his final decision until he discussed it with New York colleagues. However, it appeared that Bruce had already made his decision because a moral issue was at stake. He told Victor that he suffered a serious loss of self-confidence because of his shattering experience in business, which is parallel to James's analogy of a man climbing a mountain and reaching the point at which he either leaps into the deep abyss or nerves his feet, through faith, to complete his climb.[42]

There is a close correlation between James's concept of truth in life and Bruce's view of truth in art. James declared that there was no concrete test to determine truth. Standards were never based on objective evidence alone, but on man's aspiration to establish an ideal. Bruce applied the same Jamesian yardstick to measure quality in art, in which the artist embraced an ideal in the hope of achieving it. On the other hand, Bruce realized that quality varies because each individual sees life from a different perspective. Hence, he encouraged each artist to achieve quality on his or her own terms. James's pragmatic philosophy coincided with Bruce's realistic approach to art. For instance, James believed that it was necessary to combine the ideals of rationalism with the facts of empiricism. Similarly, Bruce synthesized design and facts, thus returning to the great realistic tradition. He contended that Mantegna and Jan van Eyck had not only painted the "facts"—that is, realistic scenes—but that their work elicited special delight because of its design quality.[43]

The philanthropic idealism that permeated Bruce's New Deal art program was derived not only from his business ventures and family background but also from Andrew Carnegie's *Gospel of Wealth*. Carnegie urged the business person to use capital in enterprises that would give employment to others. The effort to gain wealth required the entrepreneur to view his or her activity as a noble pursuit. If the business person worked for those around him or her, and not for himself or herself alone, daily labor became a virtue. Bruce believed that he himself was put into the world to be of service to his fellow human beings. He once observed, "I spring from eight generations of good people, all of whom have lived their lives as devout Christians." He had worked hard to develop a trading business so that he could bring about closer ties between the peoples of China and the Philippines.[44]

In his *Gospel of Wealth*, Carnegie stated that surpluses should be held in trust for the common good of society. Bruce, too, viewed the New Deal resources as potential wealth to give employment to artists and to benefit all Americans through their art. For that matter, he saw himself in the benevolent role of administrator of an activity that enhanced the common good of American life.[45] Bruce particularly cherished a letter from Basil V. Jones, postmaster in Pleasant Hill, Missouri, who endorsed the value of Bruce's art program and suggested that similar works be used to benefit other small towns. He wrote, ". . . may I beseech you and the Treasury to give them some art, more of it, whenever you find it possible to do so. How can a finished citizen be made in an artless town?"[46] Nat Schick, postmaster in Big Spring, Texas, also declared, "Another thing I would like to say that makes the mural so outstanding to me and the other citizens of Big Spring is the fact that dear old Peter Hurd put his very life right into his work, to do for us the very best he could, and you can see it so plain, it was not just another job with him."[47]

Although Bruce's philanthropic idealism generally squared with Carnegie's ideas,

his "Law of Competition," which stated that an individual had no other choice than to commit himself or herself totally to the accumulation of wealth, was inconsistent with Bruce's viewpoint.[48] Such a tenet denied those religious values inculcated in early childhood. Bruce described his father as "the most Christ-like man I have ever known. I honestly don't believe that he ever did an unkind thing in his life. I was brought up in very devout surroundings and acquired a very deep and abiding faith."[49] While serving as minister of the Memorial Church in Washington Square in New York, Bruce's father used his personal wealth to help the poor. Although Bruce was never independently wealthy, he gave generously of his private resources to support his programs, becoming poorer financially but richer in the affection and admiration of his fellow artists. Perhaps Bruce was sustained by what Carnegie described as "an inner voice," whispering that one small segment of a vast world was made better because he had lived.[50]

Bruce's early life suggests the kind of religious experience that James described as the essential organ of life. Hence, it is not unusual that Bruce would react to the aggressive traits of most business persons as unfavorably as did Charles Francis Adams, who observed: "Not one that I have ever known would I care to meet again, either in this world or the next; nor is one of them associated in my mind with the idea of humor, thought, or refinement."[51]

The new idealism of the Roosevelt administration encouraged the American people to believe that the American dream could be salvaged out of the chaos of the Depression. The new idealism of the New Deal, moreover, also gave Bruce a unique opportunity to revive the tradition of his father's social gospel: to help his fellow artists survive the Depression.

Notes

1. Franklin D. Roosevelt, *The Public Papers and Addresses of Franklin D. Roosevelt*, comp. Samuel I. Rosenman (New York: Random House, 1938), vol. 1, p. 646.

2. Ralph Purcell, *Government and Art* (Washington, D.C.: Public Affairs Press, 1956) p. 3. For a fuller account of the rise of patronage in the arts, see Lillian B. Miller, *Patrons and Patriotism* (Chicago and London: University of Chicago Press, 1966).

3. Suzanne LaFollette, "The Artist and the Depression," *The Nation* (September 6, 1933), pp. 264–65.

4. *New York Times*, May 29, 1932.

5. "Art for Articles," *American Magazine of Art* (April 1933), p. 209.

6. "Artist's Society—St. Paul," *American Magazine of Art* (June 1933), p. 307.

7. Francis V. O'Connor, ed., *The New Deal Art Projects: An Anthology of Memoirs* (Washington, D.C.: Smithsonian Institution Press, 1972), pp. 52–53.

8. "College Art and Emergency Relief," *American Magazine of Art* (April 1933), p. 208.

9. "Millions for Laborers, Not one Cent for Artists," *American Magazine of Art* (December 1933), p. 521.

10. Max Spivak to Harry L. Hopkins, November 29, 1933, in Record Group 121, Entry 105, National Archives, Washington, D.C. All unpublished documents in the possession of the U.S. government which are cited in these notes are to be found in the National Archives in Washington, D.C. An index to these records can be found in the *Preliminary Inventory of the Records of the Public Buildings Service* (Record Group 121). The main divisions of Record Group 121 are given entry numbers 104 to 160. Hereafter, records in the National Archives are cited by Record Group and Preliminary Inventory Entry Number, thus RG121/105.

11. Minutes of Meeting of the Regional Chairmen of the Public Works of Art Project, February 19, 1934, RG121/105.

12. "Millions for Laborers, Not One Cent for Artists," p. 522.

13. George Biddle, "An Art Renascence under Federal Patronage," *Scribner's Magazine* (June 1934), p. 428.

14. Edward Bruce to Fred P. Keppel, November 10, 1933, RG121/105.

15. Edward Bruce to Alfred Ehrman, June 30, 1934, in the Edward Bruce Papers in Archives of American Art (Washington, D.C.), microfilm reel D86. Hereafter all microfilms of the Archives of American Art are cited as AAA Reel.

16. Olin Dows, "Bruce: An Appraisal," *American Magazine of Art*, January 19 1937, p. 8; "Personnel Information Sheet," U.S. Civil Service Commission, Washington, D.C., August 15, 1942, Bruce Papers, AAA Reel D83.

17. Edward Bruce to Father LaFarge, July 15, 1940, RG121/124.

18. Victor S. Clark to Edward Bruce, March 8, 1938, Bruce Papers, AAA Reel D84.

19. Bruce to LaFarge, July 15, 1940, RG121/124.

20. Charlotte Leon Mayerson, ed., *Shadow and Light: The Life, Friends, and Opinions of Maurice Sterne* (New York: Harcourt, Brace & World, Inc., 1952), pp. 183–84.

21. *New York American*, December 13, 1926, Bruce Papers, AAA Reel D86.

22. Ibid.

23. B. J. Kospoth, "The Landscapes of Edward Bruce," *Chicago Tribune*, February 23, 1929, Bruce Papers, AAA Reel D86.

24. Leo Stein, "Edward Bruce," *Creative Art*, 3 (November 1928), p. 1.

25. Transcript of 1940 NBC Broadcast of Bruce's Speech, Bruce Papers, AAA Reel D84.

26. Edward Bruce to Leo Stein, April 30, 1940, Bruce Papers, AAA Reel D89.

27. *Santa Barbara Daily News*, March 9, 1931, and *New York Evening Journal*, November 17, 1932, Bruce Papers, AAA Reel D86; "Edward Bruce—Painter," *The Index of Twentieth Century Artists*, vol. 2, December 1934, pp. 290–91; "Paintings by Bruce on Exhibition," *San Francisco Chronicle*, February 22, 1931, Bruce Papers, AAA Reel D86.

28. Adelene Wellborn to Edward Bruce, January 21, 1931, RG121/122; Edward Bruce to John O'Hara Cosgrave, October 21, 1933, Bruce Papers, AAA Reel D85.

29. Edward Bruce to Victor Hammer, October 17, 1932, Bruce Papers, AAA Reel D85; Edward Bruce to Leo Stein, December 3, 1932, Bruce Papers, AAA Reel D89.

30. Edward Bruce to Harlan F. Stone, July 3, 1932, and Harlan F. Stone to Edward Bruce, May 30, 1932, Bruce Papers, AAA Reel D89; Edward Bruce to Alfred Ehrman, April 7, 1933, and Edward Bruce to Alfred Ehrman, October 21, 1933, Bruce Papers, AAA Reel D86.

31. Edward Bruce to Harold Mack, October 11, 1933, RG121/122; James Truslow Adams, "America Faces 1933's Realities," *New York Times*, January 1, 1933, sec. 6, p. 1.

32. Edward Bruce to Maria Ealand, May 25, 1933, Bruce Papers, AAA Reel D86; Edward Bruce to Maurice Sterne, July 24, 1933, Bruce Papers, AAA Reel D89.

33. *New York Times*, July 5, 1933; Edward Bruce to Irene Sterne, July 25, 1933, RG121/122.

34. Kospoth, "The Landscapes of Edward Bruce"; Leila Mechlin, "Notes on Art and Artists," *Sunday Star*, Washington, D.C., May 1, 1932, Bruce Papers, AAA Reel D86; Edward Bruce, "What I Am Trying to Do," *Creative Art*, (November 1928), pp. x/vii–x/viii.

35. Forbes Watson, "The Return to the Facts," *American Magazine of Art*, March 1936, pp. 151–53; Memorandum: "The Public's Reaction to Murals and Sculpture Executed under the Section of Fine Arts," by Edward Bruce, n.d., RG121/119.

36. "Edward Bruce—Painter."

37. Horace Kallen, *Maurice Sterne and His Times*, catalog, (New York: Museum of Modern Art, 1933) pp. 9–15; Bruce, "What I Am Trying to Do," pp. x/v–x/ix.

38. R. G. Collingwood, *The Principles of Art* (New York: Oxford University Press, 1958) pp. 146–47.

39. Bruce, "What I Am Trying to Do."

40. Ibid.

41. William James, *The Will to Believe* (New York: Modern Library, 1936), pp. 20–22.

42. Royal Victor to Edward Bruce, August 29, 1923, Bruce Papers, AAA Reel D89; James, *The Will to Believe* p. 59.

43. James, *The Will to Believe*, pp. 15–16; Edward Bruce, "Friedsam Award Speech," April 8, 1938, Bruce Papers, AAA Reel D87, p. 1; William James, *Pragmatism* (New York: Modern Library, 1936), p. 33; Watson, "The Return to the Facts," p. 152; Edward Bruce to Olin Dows, November 12, 1935, RG121/119.

44. Andrew Carnegie, *The Gospel of Wealth and Other Timely Essays*, ed. Edward C. Kirkland (Cambridge, Mass.: Belknap Press of Harvard University Press, 1962), p. 72; Bruce to LaFarge, July 15, 1940, RG121/124.

45. Carnegie, *The Gospel of Wealth*, pp. 12–15; Edward Bruce, "Implications of the Public Works of Art Project," *American Magazine of Art*, March 1934, pp. 113–15; Edward Bruce to Maurice Sterne, November 14, 1933, Bruce Papers, AAA Reel D89.

46. Basil V. Jones to Edward B. Rowan, June 6, 1939, RG121/124.

47. Nat Shick to Edward B. Rowan, September 7, 1938, RG121/124.

48. Carnegie, *The Gospel of Wealth*, p. 4.

49. Bruce to LaFarge, July 15, 1940, RG121/124.

50. Forbes, Watson, *The Edward Bruce Memorial Collection*, catalog (Washington, D.C.: Corcoran Gallery of Art, 1943), pp. 4–7; Carnegie, *The Gospel of Wealth*, pp. 43–44; Bruce to LaFarge, July 15, 1940, RG121/124.

51. William James, *The Varieties of Religious Experience* (New York: Modern Library, 1936), p. 51; Edward Bruce to William F. Carey, February 18, 1941, Bruce Papers, AAA Reel D84.

2

Edward Bruce's Treasury Programs

As administrator of the first federally supported arts program, Bruce was given unprecedented responsibility to plan work projects for unemployed artists throughout the country. First, he rented a large house in Northwest Washington, D.C. with a library for conferences and a ballroom for larger meetings. Then, planning sessions were held with Harry Hopkins and other New Deal leaders.[1] At one point, Bruce commented, "I think I have got the movement pretty much underway, and I hope that I can get a lot of work for American artists, although the amount of work that it entails for me to get the thing going is quite fantastic."[2] On November 17, Bruce sent Assistant Secretary of the Treasury Lawrence L. Robert a memorandum outlining his broad plan to employ artists to embellish tax-supported buildings with murals, sculpture, and easel works. He suggested the appointment of an advisory committee, consisting of museum directors and cultural leaders, but he did not advise appointing artists because antagonisms against the project would arise among those excluded. Bruce offered his services without compensation.[3] (Later, as chief of the Section of Painting and Sculpture, he would receive an annual salary.)

Public Works of Art Project

By working fourteen to sixteen hours per day, Bruce formulated a plan that met his exacting criteria. Organizing the Advisory Committee on Fine Arts under the general supervision of Assistant Secretary Robert, Bruce, as secretary, directed its functions.[4] On November 29, Robert issued the following press release: "We have called a meeting of the Committee for Friday, December 8, and have invited a number of directors of art museums and others, interested and qualified to ascertain the ways and means of carrying the work forward."[5]

Bruce wrote to Mrs. Eleanor Roosevelt, "I do hope that the skies will be propitious on Friday so that you may come to the luncheon at our house to inaugurate the movement in support of the fine arts."[6]

While Mrs. Roosevelt knitted and listened, Bruce outlined his nationwide work program to support a vital movement in American art that had largely disappeared with the Depression, which the members endorsed and thereafter returned to their respective cities to implement. That evening Bruce gave a dinner at the 1925 F Street Club to celebrate the event, which, he firmly believed, marked a milestone of progress for American art.[7]

After the December 8 meeting, Harry Hopkins announced the approval of CWA relief funds of $1,034,754 to organize the Public Works of Art Project (PWAP) under the Treasury Department. The plan called for the employment of 2,500 artists and 500 laborers at craftsmen's wages to execute art for the embellishment of public buildings and parks.[8]

A PWAP central office in the Treasury Department was staffed by Forbes Watson, technical director, and Edward E. Rowan, assistant technical director. Bruce personally selected Watson, an outstanding art critic and writer for *The Arts* magazine and the *Brooklyn Eagle*. Watson was so impressed by Bruce's program that he became, in effect, Bruce's alter ego. In newspaper and magazine articles he furthered Bruce's artistic goals throughout the New Deal era. Rowan, who gained considerable recognition as director of the Little Gallery in Cedar Rapids, Iowa, and Olin Dows, artist and neighbor of the Roosevelts in New York state, were also influential in carrying out Bruce's goals under the Treasury program.

Sixteen regional committees were organized under the existing CWA provisions, headed by chairpersons chosen by Bruce. The regional committees reviewed all applications and selected the artists in their respective areas.

Edward Bruce and the PWAP Regional chairmen in Washington, D.C. (National Archives)

Bruce established policy procedures in which he instructed the regional chairpersons that the "American scene" should be regarded as subject matter—a view reflecting his preference for realistic, representational art. Moreover, Bruce's Renaissance ideal for quality art was expressed by Rowan: "one solitary masterpiece would be worth the whole project."[9]

Watson described the program as "The greatest artist relief work ever undertaken by a government and absolutely vital to the American artist."[10] His view, however, pointed to the contradiction between Hopkins's relief criteria to help destitute artists and Bruce's requirement to get quality art—a problem that was never resolved in PWAP. Nevertheless, the appeals from unemployed artists to the Central Office apparently confirmed Watson's view that PWAP was vital to the American artist. One artist wrote, "I am almost ready to give up. I have one hope left—the CWA, and it'll probably fizzle out the way all other hopes did. In that case it is eight-bells for me. I'll go below and get more sleep. I'm tired."[11]

Another artist's application noted: "It is true that I am only one of the many thousands of artists caught in this maelstrom of want and despair. I have two children and a wife to provide for, and for that reason, I take the liberty of appealing directly to you for work."[12]

In New York City the PWAP committee received urgent appeals for help from many outstanding artists. William Zorach, presenting a plea in behalf of William Gropper, explained, "Both Gropper and his wife have always worked hard. She has just lost her job, and the publications for which he works are unable to pay for his work. They have two small children and feel quite desperate about the whole situation."[13]

The committee also received urgent pleas from the Soyer brothers, Isaac, Moses, and Raphael. "At present," Isaac wrote, "I am teaching ancient Hebrew and am payed [sic] very inadequately and irregularly for it. Therefore, my painting is done under the worst possible conditions," Moses implored, "I find it very difficult under the present circumstances to paint and at the same time support my wife and child. Hoping to hear from you soon." Raphael wrote to Juliana Force, "I, therefore, take this opportunity to mention my brother Moses Soyer, whose work you probably know. . . . he has a wife and child and has been unemployed for many months. He cannot afford a studio in which to work. I write this unofficial letter to you because you've always been unofficial in your dealings with artists and because of the high esteem in which I hold you."[14]

While PWAP was offering work and hope to the unemployed artist, the public had different views about the PWAP artist as an interpreter of contemporary life. The *Washington Daily News* commented that any society, by isolating the artist, tended to limit him or her and to deprive itself of the full value of the artist's work. Sculptor Jo Davidson observed that the program had taken the artist off a pedestal as an eccentric character and made him or her a part of the living organism of society. PWAP was providing an outlet for undiscovered American genius and driving the wolf from the doors of the nation's studios, contended the *Detroit News*."[15]

The "Ivory Tower" artists had ceased to exist, the *San Francisco Daily Herald* reported, because artists preferred painting for the government to starving in garret studios. Artists now had a definite role in society, like the butcher, the baker, and the candlestick maker, according to the San Francisco artist Nils Gren.

Howard Vincent O'Brien of the *Chicago Daily News* conceded that he had come to scoff but remained to cheer PWAP. He admired "the great flexibility of the project." For instance, if radical Mr. X, late of the Left Bank, did a nude descending a staircase

for District School Number Ten and the parents objected, *Breaking Home Ties* by the conventional Mr. Y could be substituted. O'Brien concluded that art previously had been a plaything of the rich; now, for the first time, a democratic art was being bought and paid for by the American people.[16]

Public acclaim of the project notwithstanding, in PWAP a conflict, unforeseen by Bruce, developed between two different philosophies. Bruce's idea was to employ superior artists in the project, "worthy of their hire."[17] Hopkins, on the other hand, had the attitude of a social worker who thought of the artist primarily as an unemployed worker, needing a fair wage to survive, regardless of his or her ability. He noted that "artists have been hit just as hard by unemployment as any other kind of producing workers."[18] These initial viewpoints are germane to the later development of the New Deal art programs, all of which adopted the characteristics of either Bruce's traditional concept of professional artist or Cahill's innovative concept of creative artist.

When Bruce directed his regional chairpersons to emphasize the use of the American scene in their projects, it discouraged some of the abstractionists and was inconsistent with Hopkins' aim to provide for every artist who needed relief work, regardless of subject matter.

George Byron Browne spoke for the abstractionists who were cut off from relief funding:

> In the first place, the subject matter is dictated to the artist. As my work contains little or no emphasis on subject matter, I was ignored for a long time after the PWAP began to function and then put off after a period of four weeks. This has also happened in many other cases. So here we have a great art movement in the country with the idea of aiding the artist. As far as I and many others are concerned, we might be at the North Pole.

Browne concluded, "God knows, I need it and would gladly take it [relief work] at half the sum now being given out.[19]

The same dilemma confronted the abstract sculptor Isamu Noguchi, who failed to please the New York committee when they asked him to submit practical sculptural ideas. Noguchi's proposed "Play Mountain," designed for Manhattan children in Central Park, was composed of a steel incline, water chute, swimming pool, and sledding ramp. The New York committee sent the diagram to the Central Committee in Washington for a decision. Watson replied, "Noguchi designs have just arrived and the Technical Committee in the Central office turned their thumbs down on them so hard that they almost broke their thumb nails. The designs will be in your hands shortly."[20]

Noguchi, faced with the loss of his employment, wrote to New York Regional Chairperson Juliana Force (director of the Whitney Museum of American Art):

> May I ask of you the great kindness to allow me to once more work for the CWA. I propose to model weather vanes for public buildings. I have plans for musical and illuminated weather vanes. I will also be most pleased to make them according to your specifications. Please give me an opportunity to explain to you that God must come to me thru the C.W.A.[21]

Mrs. Force agreed to let him continue on the project if he proposed something of a more practical nature. Noguchi consented to the committee's wishes, but he was

disappointed that they were unsympathetic to "the birth and fostering of new ideas."[22]

Still a third role was advocated for the artist by Rexford Tugwell, member of the Treasury Advisory Committee on Fine Arts, who suggested that the New Deal consider the painter not as a professional or creative artist but as an individual allowed to experiment freely.[23] This approach was not encouraged by the government, however, because it permitted the artist undue freedom and implied support of revolutionary art.

Bruce, however, faced the dilemma of the radical artist when some PWAP artists, working on the Coit Memorial Tower project in San Francisco, became embroiled in an incident that caught the regional committee by surprise. A few of the artists incorporated Communist propaganda in their murals, such as books by Karl Marx, Erskine Caldwell, and other proletarian writers, and the Soviet hammer and sickle emblem, with the motto "Workers of the World, Unite!" Clifford Wight, who painted the Russian symbol, explained his position in this manner: "The paramount issue of today is social change—not industrial or agricultural or scientific development."[21]

Although the commission remained undecided on a course of action, the Artists and Writers Union of San Francisco threatened to fight any form of censorship. Their position was militantly supported by the Artists Union of New York, which insisted that the artist had the sole right to choose the form and content of his or her work. Yet, counterpressures were strong. One outraged citizen demanded that the mural be removed because artists who advocate subversive ideas should not be paid for their offensive work. The editorials in the *Stockton* (California) *Record* and the *San Francisco Examiner* suggested the removal of the work because it was the unrepresentative work of a few artists that jeopardized the employment of many others.[25]

Regional Chairman Walter Heil wrote the committee in Washington for advice, and Director Watson suggested that the artist complete the mural according to his original design. Bruce concurred with Watson and advised Heil that it would seriously hurt American art and discourage further federal patronage. The artist, Glenn Wessels, believed that artists had the right to express personal views but hardly the right to accept federal funds for that purpose. Bruce couched Wessels's viewpoint in stronger terms: "I hope they don't fool around with this socialistic thing any longer, and wipe the damn painting out of the Tower!" The Coit Tower controversy was finally settled when Wight, despite his earlier protestations, removed the Soviet emblem from his mural.[26]

Although some unexpected radicalism appeared in the Coit Tower project, the murals also revealed that this group of twenty-five artists had carefully developed an iconography of the American scene that was relevant to PWAP throughout the country. In fact, this broad conceptual scheme—running the gamut from realism to abstraction—was to be used by artists in subsequent New Deal art programs.

The Coit Tower project shows a contemporary America, reflecting agricultural, industrial, and urban themes. At the entrance of the Coit Tower, Ray Boynton's (1883–) murals—*Animal Force* and *Machine Force*—establish the basic motif for the other murals on the first floor. On the right, murals depict such industrial subjects as oil wells, transportation, and manufacturing. On the left, agricultural themes, such as a meat-packing plant, dairy farms, and lumber camps, are shown.

Victor Arnautoff's (1896–1979) *Metropolitan Life* depicts the meeting of agricultural and industrial activities in an urban setting. Nearby, six huge figures symbolize the various roles of the individual in contemporary American society: surveyor, steelworker, farmer, cowboy, stockbroker, and scientist. In the vestibule there are views of San Francisco.

Ray Boynton (PWAP), *Animal Force,* **detail of mural in the Coit Tower, San Francisco. (National Archives)**

Victor Arnautoff (PWAP), *Metropolitan Life,* **detail of mural in progress in the Coit Tower, San Francisco. (National Archives)**

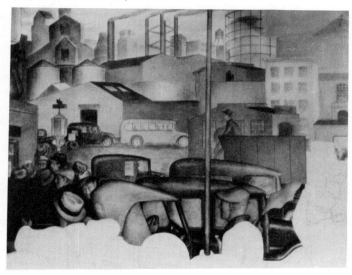

On the walls leading up to the second floor, Lucien Labaudt (1880–1943) repeats Arnautoff's visual statement about metropolitan life, establishing a thematic transition between the first and second floors. The second floor depicts the recreational life of the society: a family picnic; a children's playground; sports; and an American home.[27]

The realistic style and technique of Arnautoff's work is representative of the major-

ity of the Coit Tower murals. The influence of Diego Rivera's brilliant color, simple modeling, and refined brushwork is seen in Arnautoff's mural. His handling of complex, monumental groups in the foreground, contrasted with the deep perspective in the background, is strikingly reminiscent of Rivera's Detroit frescoes.

In Arnautoff's *Metropolitan Life* the theme of social consciousness pervades, as it does in the work of the other muralists. People from all walks of life dominate the human drama: scenes include an auto accident and a well-dressed man relieved of his money at gunpoint. A public newsstand, stocked with radical publications, such as the *New Masses* and the *Daily Worker*, protests the economic shortcomings of the capitalist system. A magazine stand promotes *Screen Play*, a popular magazine of the era, with Hollywood actress Mae West on its cover. A theater marquee advertises Charlie Chaplin's film *City Lights*, another expression of the popular culture of the period. Roosevelt's "forgotten man" is implied by the portrait of Charlie Chaplin on the marquee, a popular cult figure outside of the "System" who managed to survive. A hint of a Soviet banner motif is suggested by a workman holding a red flag in Arnautoff's mural.

Bernard Zakheim (1898–) articulates a stronger note of social protest. In his fresco *Library*, blazing headlines reveal the scandals of the Republican administration and the riots in Austria, the result of the excesses of capitalism. Solutions to the exploitation of the masses are proposed: a reader takes Karl Marx's *Das Kapital* off of a library shelf, above a volume of Hegel (whose philosophy shaped Marxism). Zakheim not only disparages the conservatism of the San Francisco Art Commission but criticizes the destruction of Rivera's Rockefeller Center mural in New York. One of his newspaper headlines cites the protest action taken by the San Francisco Writers' and Artists' Union, branding the Rivera incident as "outrageous vandalism."[28] In the mural Zakheim reflects the incisive drawing and strong coloring of Mexican muralist José Clemente Orozco; the mood of social protest is emphasized even more by Zakheim through the use of constricted placement of figures in the composition.

The Coit Tower Artists Group carefully organized subject matter, mural scale, and color palette so that each work related to the other, but several exceptions are noted. Moya del Pino paints a representational view of San Francisco, using the easel painter's technique of birds-eye perspective to dramatize his theme. Jane Berlandina (1898–), however, completely departs from the realistic styles of the other muralists. She paints an abstract mural in the manner of the French painter Raoul Dufy, to depict scenes of American home life.

In January 1934, Assistant Secretary Robert asked Bruce to hold a national exhibit of PWAP work sometime in early summer. In turn Bruce advised his regional chairpersons to put aside their best PWAP work, to be exhibited on April 24 at the Corcoran Gallery of Art, Washington, D.C. In his view, the future of the New Deal art program depended on the success of the exhibit. More than 15,000 works of art were produced, but Bruce and his staff carefully selected a few more than 500.[29]

President and Mrs. Franklin Roosevelt spent one hour and a half at the preview, at which they selected 32 of the best easel paintings. (The list included 25 chosen by Bruce and his staff, to present to the White House.) Mrs. Roosevelt, who presided at the formal opening of the exhibit, said: "No country comes of age until it appreciates art. No one can really live without it." The president remarked that not a single picture in the exhibit reflected despair or despondency; moreover, he added, the pictures were honest, depicting American life in an American way. (This comment

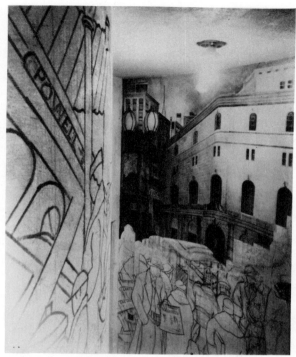

Lucien Labaudt (PWAP), *Powell Street*, **detail of mural in progress in the Coit Tower, San Francisco. (National Archives)**

Bernard Zakheim (PWAP), *Library*, **detail of mural in progress in the Coit Tower, San Francisco. (National Archives)**

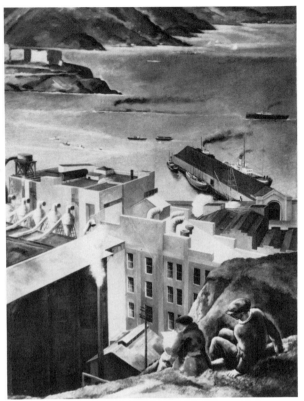

Moya del Pino (PWAP), *Bay Scene,* **mural in Coit Tower, San Francisco. (National Archives)**

was interpreted by some to mean that Roosevelt preferred realistic paintings.)[30]

The PWAP exhibition was reviewed favorably not only by the president but by the art critics as well. For instance, Edward A. Jewell wrote in the *New York Times* that he was impressed by the dramatic scope and creative impetus provided by a nationwide project. The works were so surprisingly good that the most captious of critics would be convinced that the taxpayer's money had not been squandered, commented Emily Genauer in the *New York World-Telegram*. The exhibit proved that federal patronage had stimulated the creative spirit and a new interpretation of American life, noted Helen Appleton Read in the *Brooklyn Daily Eagle*. Although the American scene predominated, Read added, it was a version of the American scene growing out of a deeply felt experience.[31]

When the president decided that he had to end the CWA to balance the budget, it also meant the liquidation of PWAP. On April 26, Harry Hopkins, FERA administrator, instructed the regional directors to transfer all artists to local divisions; and on April 28, FERA placed on its payrolls all of the artists whose PWAP projects had not been completed. PWAP officially ended on June 30, 1934, but the record revealed that the project had employed 3,749 artists.[32]

In a circular letter to former PWAP artists, Bruce declared that the artist had taken a place as a useful citizen, and his or her work had become an asset to the nation. He believed that much future good would come from the PWAP project.[33]

PWAP—after a short and dramatic six months—came to an end, but it was the first federal program in American history to support the fine arts on a national as well as local scale. The results of PWAP were to prove the accuracy of Bruce's forecast that future good and public interest would ensue. Having gained the president's support for future patronage, PWAP also became the prototype for subsequent federal art programs, reflecting a character, either traditional or innovative.

Just before PWAP was terminated, Bruce recommended to Robert that a Division of Fine Arts be organized under the Treasury Department to extend the work of PWAP and to utilize one percent of the Treasury funds to embellish new buildings. Based on Bruce's recommendation, the Treasury Department submitted an allotment application to the PWA to organize the proposed division, and the PWA approved initial funding of $5,000, to be increased later. (Concurrence by the comptroller general was required for release of these funds.)[34]

Jane Berlandina (PWAP), *Home Life*, **detail of mural in the Coit Tower, San Francisco. (National Archives)**

President Roosevelt expressed an interest in a program to include art, music, theater, and literature; and Bruce asked some creative writers for their views. The responses revealed either skepticism about federal support or uncertainty about the artist's role in government. Archibald MacLeish, for instance, commented: "If you are going to keep them alive as artists, you'll have to let them use your money to do their own work. And their work may be terrible or it may be wonderful and strange."[45] Such a liberal approach had been advanced by Tugwell, but MacLeish's view suggested the kind of repercussions seen in the Coit Tower incident. Yet William Carlos Williams questioned whether the Administration would allow the creative artist the freedom he required. In his view, some of the writers might be considered too radical or too obscene to qualify. Still, Williams hoped to see some form of federal support for the arts: "Letters are the wave's edge in all cultural advance, which God knows, we in America ain't got much of."[46] On the other hand, Hamlin Garland saw no way that the New Deal could help the creative artist except to improve the nation's economy. In this way, writers, artists, and musicians could be employed by natural means. Garland wryly observed, "It seems to me that this artificial aid to production is in direct conflict with the Henry Wallace plan of discouraging production. To be consistent, the Government should pay us a bonus for *not* writing or painting."[47] Apparently, Garland had been disenchanted by the agricultural policies of the New Deal.

While Bruce was getting mixed responses from the writers, he learned that Comptroller General J. R. McCarl had disapproved the allotment application because special funds for the proposed division had not been approved by the president. Bruce informed Secretary of the Treasury Henry Morgenthau that such compliance meant the complete disruption of the proposed division, but the secretary replied that it was necessary to close PWAP without incurring further expense. In a postscript to Bruce, Morgenthau added an appreciative note, "This note sounds very cold and business-like. It goes without saying, I greatly appreciate the work you did."[48]

Despite this setback, Bruce proposed other ways to establish an art program in the Treasury Department, which interested Morgenthau personally because of the success of PWAP. Besides, the plan to embellish federal buildings proposed by Bruce was consonant with the president's desire to place murals in federal buildings, which could be commissioned more economically than classical motifs, such as Corinthian columns and gold-leaf scrolls. Moreover, from Roosevelt's viewpoint, such national mural art represented a definite shift from the old order to the New Deal.[49]

Bruce had wanted to bring about this definite shift under PWAP, when he tried to stop the installation of a large academic mural by Gilbert White in the new Department of Agriculture building in Washington. White, who was awarded the commission under the Hoover Administration, painted the mural in Paris. On this issue Bruce wrote to William M. Millikan, chairman of Region Nine (Ohio, Indiana, Kentucky, and Michigan):

> The mural in question is to go in the most important spot in the new Agricultural Building, and is a picture painted in Paris of a group of ladies draped in cheese-cloth and undraped, garnered [*sic*] in sheaves of wheat and sitting on pumpkins to represent American agriculture, and it is certainly a beauty. It is not doing our Project a bit of harm as I am trying every day to have placed a really splendid mural by a group of artists from Iowa headed by Grant Wood which really does represent American agriculture.[40]

Meanwhile, White strongly denied that living abroad made his work less American.

He had been a sheriff in Utah and could rope a heifer as well as Will Rogers, he contended. Apparently, White was defensive about his credentials as an American artist, "I mention these things to show I am steeped in Americanism and that I am permeated with the soil and atmosphere of my country even while I am working in a Paris studio."[41]

Assistant Secretary of Agriculture Rexford Tugwell supported Bruce's objection to the White mural, but Secretary of Agriculture Henry Wallace fully endorsed White's work because of its excellent composition and classical spirit.[42] Although Bruce failed to prevent the installation of the White mural, his effort marked the initial direction of the New Deal to change from classicism to realism in the subsequent decoration of federal buildings.

Section of Painting and Sculpture

On October 16, 1934, Bruce organized the Section of Painting and Sculpture under the Treasury Department, by order of the secretary. The duties of the Section were (1) to secure the best quality art to embellish public buildings; (2) to stimulate the development of American art in general; (3) to employ local talent where possible; (4) to secure the cooperation of the art world in selecting artists for this work; and (5) to encourage competition project proposals wherever practicable, although certain established artists were entitled to commissions *hors concours*.

The terms of the executive order reveal the nature of Bruce's tradition. For instance, his use of quality criteria to get the best art for public buildings and his desire to stimulate an art movement in America show the influence of his European experience. Also, the procedure of competitions and the use of art leaders to select the finest artists available reflect his traditional approach.

The Section was situated in the Office of the Supervising Architect, which came under the Procurement Division of the Treasury Department. Bruce acted as the consulting expert. Edward Rowan and Olin Dows, former members of the PWAP Central Committee, and four clerks were detailed to the Section.[43]

Bruce succeeded in setting up an organization that proved more acceptable to the New Deal than Biddle's earlier plan, which had called for a select group to paint murals in the Justice Department building in Washington and a coordinator to handle the contractual details with the government. For example, when the president had sent Biddle's proposal to the Commission of Fine Arts in Washington, it was rejected, pointing up the contradiction the New Deal was reluctant to face—that in government an artist was not free to question current social values. The commission had informed the president that Biddle's painters professed a social faith not shared by the general public.[44] Unlike the decentralized activities of PWAP, those of the Section were centralized, providing for a close supervision of the artist's work; in theory, it avoided artists choosing radical themes embarrassing to the New Deal. This concern of the New Deal about the role of the rebel artist had been revealed by President Roosevelt's reply to Biddle: "I can't have a lot of young enthusiasts painting Lenin's head on the Justice Building. They all think you're communists. Remember my position. Please!"[45] The controversial incident referred to Diego Rivera's portrait of Lenin in the Rockefeller Center mural in New York, which still lingered in the memory of the general public.[46]

In the Section's first national project to embellish the newly constructed Post Office

and Justice Department buildings in Washington, Bruce, in March 1935, used competition procedures and an Advisory Committee of outstanding art leaders to select the best artists for the work. The painters commissioned for the Post Office were Thomas H. Benton, Rockwell Kent, Reginald Marsh, Eugene Savage, Grant Wood, Ward Lockwood, Alfred D. Crimi, William C. Palmer, George Harding, Karl Free, Frank Mechau, and Doris Lee. The winning Post Office sculptors were Stirling Calder, Concetta Scaravaglione, Berta Margoulies, Louis Slobodkin, Heinz Warnecke, Sidney Waugh, Chaim Gross, Oronzco Maldarelli, Attilio Piccirelli, Carl Schmitz, Gaetano Cecero, and Arthur Lee.[47]

For the Justice Department the commissioned painters were George Biddle, John Steuart Curry, Leon Kroll, Henry Varnum Poor, Boardman Robinson, Maurice Sterne, John R. Ballator, Emil Bisttram, and Symeon Shimin.[48]

In later mural projects for federal buildings the competition procedure became a keystone of Bruce's program. Under the system artists were required to submit anonymous entries before they could be considered for mural work by the Section. Artists picked by this selective process were paid in three installments, contingent on approved stages of their work. The process included a review of the artist's work by Bruce, Rowan, and Watson. Their recommendations were then submitted to Louis Simon, supervising architect, and to Admiral Christian J. Peoples, director of the Procurement Division, for concurrence.[49] On the whole, when changes were required the commissioned artists generally agreed, whether it meant modifying a theme, composition, or figure drawing.[50]

Nevertheless, in carrying out his goals Bruce became embroiled in ideological issues that threatened his program. The case of Thomas Hart Benton's dropping out of the program exemplified the contradiction between Bruce's tradition and an artist's freedom. Somehow, Benton could not continue and still feel free to create under the close supervision of the Section.[51] Of course, his action suggested the Coit Tower issue, where a rebel artist free to paint had found capitalism wanting and communism a possible alternative to the New Deal.

This conflct broke out in the Section when the harmonious relationship Bruce envisioned was disrupted by Rockwell Kent's radical protest against the impoverished conditions in Puerto Rico in his Post Office mural. Kent's mural, which called for the transformation of society, was intolerable to the New Deal. Although the New Deal era called for social adjustments, Bruce refused to allow his program to be used as an instrument of propaganda. Moreover, he charged Kent with breach of contract for introducing material that was not included in the approved design.[52]

Kent had visited Alaska in 1935 and Puerto Rico a year later to collect material for his mural on the subject of the United States mail in the Tropic and Arctic territories.

The Kent mural portrayed a group of Puerto Rican women receiving a letter from Eskimo friends:

Puerto Reco miuniera ilaptiumum. Ke Ha Chimmeulakut angayoraacut. Anna Kitchimmi Atummin Chuli Wapticum itti cleoraatig ut.

The message was translated to mean:

To the people of Puerto Rico, our friends. Go ahead. Let us change chiefs. That alone can make us equal and free.[53]

The newspapers carried the story that Kent had made an impassioned appeal to the Puerto Rican people to throw off the bonds of American rule.

In voicing his political and social convictions, Kent was expressing the view of the rebel artist:

Art is always propaganda for the beauty of life. And there can be little beauty in life when existence is ridden with tyranny, when the fundamental democratic principles of freedom are revoked, when poverty, suffering and exploitation prevail. That is the reason the artist must be a visioned social idealist: to preserve the kind of life in which beauty is possible. [54]

The Section, however, was getting more than the contract called for. If the message in Kent's mural was removed, the Nationalist party in Puerto Rico would use this fact as propaganda. However, the president of the Puerto Rican Senate, Rafael Martinez Nadal, complained that his people were represented as African bushmen. On the other hand, Alaska delegate Anthony J. Dimond protested Kent's effrontery in implying that loyal Eskimos wanted to rebel against the government. [55]

In the meantime, the secretary of the treasury viewed the inclusion of an Eskimo dialect as a departure from the original design; and Rowan told Kent to bring brushes and paint to wipe out the Eskimo message. Bruce, of course, was doubly concerned because the controversy could cause the U.S. government to "kick out the entire program." The Treasury officials tried to get Kent to substitute another text, preferably in English, but the conference resulted in an impasse over an acceptable message. Nevertheless, Kent received full payment for his work without the required changes because officials decided not to continue with an embarrassing issue. A final irony to the incident occurred when Kent asked the Treasury Department for a duplicate check because he had lost the original in a fire. [56]

In the Gilbert White mural controversy in Washington, Bruce had initiated an effort to substitute realism for classicism in federal buildings. His goal, however, was strongly challenged by the Commission of Fine Arts. The principal protagonist was Charles Moore, chairman of the commission, who extolled the values of classicism. His views, of course, were in direct conflict with Bruce's bent toward realism. Moore had informed Bruce, while serving on the Section's National Advisory Committee, that all of the art to be used in federal buildings in Washington required the review and advice of the commission. At that time Bruce had foreseen no problems with the commission. [57]

Moore had long believed that the Chicago World's Fair of 1893 was the most momentous event in American art history, and he greatly admired its architects—Daniel Burnham, Richard Morris Hunt, and Charles McKim—who used classical motifs in the design of the exhibition buildings. Even the artists under Frank Millet, in Moore's view, had contributed to the unsurpassed grandeur of the fair's classical theme. In 1901, Burnham, McKim, and others were summoned by the Senate Park Commission to Washington to discuss architectural planning for the city. As a result, on May 17, 1910, Congress had created the Commission of Fine Arts. The original members of the commission included Burnham, Millet, and Moore, who were authorized to review and advise on questions of art in the nation's capital. [58]

The first signs of a rift had appeared in July 1933, when Biddle's mural proposal was rejected by the commission. That issue presaged conservative opposition to the contemporary realism espoused by Bruce. [59] The inevitable conflict between the Sec-

tion and the Commission of Fine Arts occurred over Biddle's mural designs for the Justice Department building. His sketches were approved by the Section in July 1935, but the commission rejected them altogether. The commission considered Biddle's designs unacceptable because they were crude and disturbingly fussy in pattern and scale. Moreover, his concept was judged to be intrinsically un-American and ill-adapted to expressing American ideals because its style was French and its theme Mexican in character.[60]

In October 1935 an advisory committee of painters, acting for the Section, endorsed twelve designs by six artists for the new Post Office. The Section approved the selections, but the commission disapproved six of the mural designs. Advisory Committee member Bancel LaFarge partially agreed with the commission's criticism, but not with its decision to reject any of the work.[61]

Bruce angrily described the commission as being "so hopelessly welded to their dried out and dead academic traditions that they haven't any eye to see here is a chance to give the country something vigorous and alive, and significant, so personally I see nothing to do but to go to the mat with them."[62]

Admiral Peoples counseled patience, but Bruce suggested opposing the authority of the commission. Moreover, Biddle's mural designs represented the high standard that would justify the Section's program, he contended.[63]

Relations between the Section and the commission finally erupted in November 1935 when the commission reviewed forty-eight mural sketches, including Biddle's revised designs, in the short period of twenty-five minutes. Obvious hostility to the work was expressed by Egerton Swartout and other commission members. The Section jury might have done better under the influence of alcohol, Swartout declared, concluding that Biddle was not qualified to work in fresco.[64] Peoples, however, after consulting with Bruce, decided to set aside the commission's advice and authorized Biddle to proceed with his mural.[65]

Bruce's own code of fair play, or the "milk of human kindness," which he had displayed some years back in a card game, surfaced again in another phase of the Biddle controversy. While Bruce was in Key West, Florida, the Section decided to ask Biddle to make changes in his Justice Department murals. To show the plight of a sweatshop and poor tenement living with a contrasting theme, the figures in the central panel required a "happy expression," according to Rowan and Watson. Learning of the pending problem, Bruce came to Washington and reviewed the murals. He then overruled the proposed action because the Section, in the beginning, had accepted Biddle's concept and now should completely support his work.[66]

However, the advisory powers of the commission were not invalidated by Peoples's action because the Biddle case was an exception, not a precedent. Bruce continued to be frustrated by the commission. At one point he commented: "the longer we work with the Fine Arts Commission the madder I get. Here is a group of people presumably dedicating their lives to developing the art movement by the Morgenthaus, and here is the Art Commission showing no sympathy or desire to cooperate with us. I would like to poke them all on the jaw."[67]

Undoubtedly, it would have been unwise for the Treasury Department to risk a serious breach with the commission because the commission had congressional statutory authority. Yet Bruce held the majority support of professional leaders in the art field, and his policy poised a counterweight to the commission's conservatism.[68] In the end, the Section and the commission managed to work together, despite the fact that they were still very much divided over the question of aesthetic principles.

From another direction, Bruce faced a difficult religious conflict, when the Roman

Catholic church found offensive a stanza in a mural painted by Ben Shahn for the Bronx Post Office in New York. The following Walt Whitman quotation had been introduced in the mural:

> Brain of the new world! What a task is thine!
> To formulate the Modern out of the peerless
> grandeur of the Modern
> Out of Thyself—comprising science to recast
> Poems, Churches, Art
> (Recast—maybe discard them—end them—maybe
> their work is done, who knows?)
> By vision, hand, conception, on the background
> of the mighty past, the dead,
> To limn with absolute faith the mighty living
> present.[69]

The issue implied that the government was violating the historic separation of church and state, a precedent established in Colonial days by Roger Williams in Rhode Island. The fact that Whitman's writings were listed as heretical on the Catholic Index only served to intensify the conflict. Moreover, the particular stanza gave the connotation of rejecting the moribund influence of the church in favor of scientific experiment. In a Brooklyn church, Reverend Ignatius W. Cox, S.J., denounced Shahn's mural as an insult to Christianity before a congregation of 3,000. The conflict caused Peoples to warn Bruce that this controversy would be more extreme than the Kent episode and that corrective action was essential. Fearful that the public would believe that the administration was embracing a Communist precept of recasting religions, Peoples concluded, "when one suggests to the average American that we recast their religion, or that the government endorse such a suggestion, it is certainly offensive, for our Constitution itself guarantees free speech and all liberty of religious thought."[70]

Bruce was extremely reluctant to make any changes, and when he received a telegram from a citizen, protesting the interference of the Catholic church in national affairs, he immediately brought it to Peoples's attention. Peoples refused to be drawn into this complex issue; he wrote: "Acknowledge receipt only. We can't take any sides in a religious controversy. The quotation was so unpolitic as to create this." So Bruce had no other choice but to ask Shahn to select a new stanza.[71]

In a related incident, Bruce found particularly disturbing a religious controversy that involved his former mentor, Maurice Sterne. The Section and the Fine Arts Commission had approved Sterne's work, but the Catholic church, represented by Monsignor Michael J. Ready, director of the National Catholic Welfare Conference, strongly criticized Sterne's mural panel for the Justice building entitled *Cruelty*. Ready viewed the mural as an attack on Catholic traditions by a Jewish painter. On the other hand, the philosopher John Dewey characterized the church's position as anti-Semitic. In Bruce's view, the whole matter was one "hell of a world."[72]

The panel in question showed the pope intervening in behalf of an accused person who had collapsed after carrying hot irons in a trial by ordeal. The Catholic church protested because the clergy in the composition appeared to be condoning the torture instead of protecting the accused. The Justice Department requested the Treasury to consider a change in the panel to preclude any controversy with the Catholic church. Meanwhile, the Section was ordered not to install any of Sterne's twenty panels, pending a settlement.[73]

Bruce notified Sterne that a rather complicated situation had developed because of his murals. Sterne was amazed at the church's position:

> It is absolutely impossible to alter this panel. As you know the main importance of my job is the composition—each panel, though complete in itself is integrally only a part, a detail of the whole—changes would throw the whole thing out of gear and if I made any change in one, I would have to repaint all the twenty panels—not a very pleasant prospect especially since I put in four years on this job and four years is quite a slice off the outer edge of my age![71]

Thus, Bruce was caught between strong counter pressures over the church issue. In the meanwhile, Sterne faced the predicament of being almost without funds; he had to await installation of his murals to receive final payment.[75]

Bruce then discussed the dilemma with John Dewey, who suggested getting support from a liberal group of Catholics to quiet the opposition.[76] Bruce finally told Sterne that there was some merit in Dewey's plan, which he had once thought impractical: "I have literally gone through Hell trying to get this matter straightened out and my experience with the Church will leave an open scar for the rest of my life."[77] Fortunately, George Biddle had asked his brother, Francis, the solicitor general, to intercede for Sterne. An informal committee—composed of Justice Harlan Stone, Solicitor General Francis Biddle, Attorney General Robert Jackson, and Justice Felix Frankfurter—met to arbitrate the controversy, and in the end Monsignor Ready agreed to the installation of Sterne's murals.[78]

However, despite ideological pressures and bureaucratic contradictions that threatened the Section, Bruce kept the organization intact. Based on a tradition that reflected his European experience, he successfully pursued his goal of preserving the professionalism he considered essential and getting the best American art under his program.

The Treasury Relief Art Project

There were 2,500 buildings constructed under the Treasury Department, but funds had not been reserved for decorative artwork. To meet this problem, and to expand the program of the Section, Bruce requested funds from the Emergency Relief Appropriations Act of 1935–37 to organize a new project.[79]

On July 21, 1935, Bruce established the Treasury Relief Art Project (TRAP) under the Treasury Department, funded by the Works Progress Administration (WPA), to employ artists on relief. The Section and TRAP combined were designated as the Treasury Department Art Program. They were under the general direction of Bruce, and Watson acted as advisor. Olin Dows was named chief of TRAP; Henry LaFarge, assistant; and Cecil H. Jones, assistant chief. Bruce required that relief artists meet the high standards of the Section, although TRAP was funded by relief monies. TRAP, however, differed from the Section because it included not only murals and sculpture but the broader activities of easel painting, posters, portraits, and decorative hangings.[80]

The grand scheme of initiating a movement of contemporary realism in federal buildings through the two projects was finally achieved. However, the WPA relief rules impeded Bruce's goal. Complete exemption was expected, but WPA Administrator Harry Hopkins insisted that 90 percent of the TRAP artists come from the relief

rolls. Under those conditions, Dows believed that it was impossible to obtain high-quality work, and it would reflect unfavorably on the Section. Bruce, however, confident that the rules could be changed, went ahead with TRAP, but Hopkins persisted. The Secretary of the Treasury sought a waiver, and when it was only partially granted to include 75 percent relief, Mrs. Morgenthau suggested dropping TRAP to concentrate on the Section. Dows decided to remain with TRAP, however. [81]

Bruce's traditional approach in operating TRAP brought about a confrontation with the powerful Artists Union, reviving the quality-versus-relief issue first encountered in PWAP. Like Hopkins, the Artists Union was concerned less with producing masterpieces than with helping artists to survive. Hence, TRAP was criticized for discriminating against needy artists and failing to employ enough persons.

Stuart Davis, executive secretary of the Artists Union, questioned Dows about not filling the TRAP quota of 450 artists and not spending relief funds by June 30, 1936. Dows came up with an employment figure of 298 artists and added that there was no time limit on spending the funds. Davis described the TRAP policy as truly miserable and insisted that without decent living conditions for artists no quality work could be achieved. [82]

The Union and Dows met again on the question of employing more relief artists. While Dows argued for quality standards, the Union protested the use of an arbitrary yardstick to decide eligibility in TRAP. Davis angrily exclaimed, "What you have said, in short, amounts to: 'To hell with the artist!'" The meeting ended in a stalemate, but not without Dows's temporizing assurance to employ more relief artists. [83]

In the end, the conflict between TRAP and the Artists Union over quality standards reveals the same dilemma that Bruce had faced in PWAP. Only the Section, unencumbered by relief criteria, could fulfill Bruce's quality standards. Also, it is apparent that Bruce's grand scheme was flawed because it became impossible to function with contradictory objectives. In fact, the Treasury officials questioned the idea of having a relief program in the Treasury Department because they were not in the relief business. Hence, TRAP was liquidated in June 1939.

Notes

1. Forbes Watson, "Edward Bruce," undated manuscript, RG 121/133, pp. 2–5; Edward Bruce to Harry L. Hopkins, November 14, 1933, RG 121/105.

2. Edward Bruce to John O'Hara Cosgrave, November 16, 1933, Bruce papers, AAA Reel D84.

3. Edward Bruce to L. W. Robert, Jr., November 17, 1933, RG 121/105.

4. Watson, "Edward Bruce," The Advisory Committee to Treasury on Fine Arts: Frederic A. Delano, director of the National Planning Commission, chairman; Charles Moore, chairman of the Fine Arts Commission; Rexford G. Tugwell, assistant secretary of agriculture; Harry L. Hopkins, civil works administrator; H. T. Hunt, general counsel for the Public Works Administration; and Edward Bruce, secretary.

5. Press release, statement of L. W. Robert, Jr., November 29, 1933, RG 121/106.

6. Edward Bruce to Eleanor D. Roosevelt, December 5, 1933, RG 121/106.

7. Olin Dows, "The New Deal's Treasury Art Programs: A Memoir," *Arts in Society*, 2, no. 4, pp. 6–7; Watson, "Edward Bruce."

8. Press release, no. 464, Federal Emergency Relief Administration, December 11, 1933; Forbes Watson to L. W. Robert, Jr., December 20, 1933; and Forbes Watson and Edward Bruce to J. J. Haverty, December 10, 1933, RG 121/104. The regional chairpersons were as follows: Region 1 (Boston), Francis Henry Taylor; Region 2 (New York), Juliana Force; Region 3 (Philadelphia), Fiske Kimball; Region 4 (Washington, D.C.), Duncan Phillips; Region 5 (Atlanta), J. J. Haverty; Region 6 (New Orleans), Ellsworth Woodward; Region 7 (St. Louis), Louis La Beaume; Region 8 (Pittsburgh), Homer St. Gaudens; Region 9 (Cleveland), William Milliken; Region 10 (Chicago), Walter Brewster; Region 11 (Denver), George E. Williamson; Region 12 (Dallas), John Ankeney; Region 13 (Santa Fe), Jesse Nussbaum; Region 14 (Los

Angeles), Merle Armitage; Region 15 (San Francisco), Walter Heil; Region 16 (Portland), Burt Brown Barker.

9. PWAP Bulletin no. 1, RG 121/105.

10. Forbes Watson to Edward B. Rowan, December 10, 1933, RG 121/105.

11. George Franklin to Juliana Force, January 9, 1934, RG 121/117.

12. Alexander Dux to Juliana Force, December 13, 1933, RG 121/117.

13. William Zorach to Juliana Force, January 18, 1934, RG 121/117.

14. Isaac Soyer to the New York Regional Committee, January 2, 1934; Moses Soyer to Juliana Force, December 19, 1933; and Raphael Soyer to Juliana Force, December 20, 1933, RG 121/117.

15. *Washington Daily News*, December 26, 1933; *Detroit News*, December 12, 1933.

16. *Mer* (California) *Herald*, January 24, 1934; *Chicago Daily News*, January 10, 1934.

17. Edward Bruce to Juliana Force, December 14, 1933, RG 121/105.

18. Press release, no. 464.

19. George Byron Browne to Ann Craton, n.d., RG 121/108.

20. Lloyd Goodrich to Forbes Watson, February 27, 1934; Isamu Noguchi to Juliana Force, February 23, 1934; and Forbes Watson to Lloyd Goodrich, February 28, 1934, RG 121/108.

21. Isamu Noguchi to Juliana Force, February 28, 1934, RG 121/108.

22. Juliana Force to Isamu Noguchi, March 2, 1934, and Isamu Noguchi to Juliana Force, April 12, 1934, RG 121/108.

23. Press release, no. 464.

24. Clifford Wight to Walter Heil and the San Francisco Art Commission, n.d., RG 121/114.

25. Statement of the Executive Committee of the Artists' and Writers' Union on the threatened disfiguration of paintings in the Coit Memorial Tower, n.d.: Hugo Gellert to Edward Bruce, July 5, 1934, RG 121/114; editorials from the *Stockton* (California) *Record*, July 3, 1934, and the *San Francisco Examiner*, July 9, 1934.

26. Forbes Watson to Edward Bruce, June 2, 1934; Edward Bruce to Walter Heil, June 2, 1934; Glenn Wessels, "The Art World," *San Francisco Argonaut*, July 13, 1934; Edward Bruce to Edward B. Rowan, July 27, 1934; and George J. Calogrea to Cecil H. Jones, September 25, 1934, RG 121/114.

27. Radio interview with Maxine Albro, February 22, 1934, p. 3, RG 121/110.

28. Steven M. Gelber, "The Irony of San Francisco's Commie Art," *City of San Francisco*, February 4, 1976, vol. 10, no. 30, p. 28; Walter Heil to Edward B. Rowan, January 5, 1934, RG 121/110; second meeting of the Regional Committee, District #15, Public Works of Art Project, December 18, 1933, p. 4, RG 121/110.

29. L. W. Robert, Jr., to Edward Bruce, January 8, 1934, RG 121/105; Edward Bruce to the Regional Chairpersons of the Public Works of Art Project, March 20, 1934, RG 121/105; *New York World Telegram*, April 28, 1934.

30. *New York Times*, April 24, 1934; *Washington Post*, April 25, 1934; *Washington Post*, April 26, 1934.

31. *New York Times*, April 24, 1934; *New York World Telegram*, April 28, 1934; *Brooklyn Daily Eagle*, April 29, 1934.

32. Harry L. Hopkins to Frederick I. Daniels, April 26, 1934; and press release, statement of L. W. Robert, Jr., May 14, 1934, RG 121/109.

33. Edward Bruce to the artists, June 5, 1934, RG 121/109.

34. Edward Bruce to L. W. Robert, Jr., April 23, 1934; L. W. Robert, Jr., to Harold L. Ickes, May 11, 1934; and Edward Bruce to Julius F. Stone, May 19, 1934, RG 121/105.

35. Edward Bruce to Henry Morgenthau, Jr., June 5, 1934; Edward B. Rowan to Archibald MacLeish, August 25, 1934; and Archibald MacLeish to Edward B. Rowan, n.d., RG 121/107.

36. William Carlos Williams to Edward B. Rowan, August 28, 1934, RG 121/107.

37. Hamlin Garland to Edward B. Rowan, September 9, 1934, RG 121/107.

38. Cecil H. Jones to Edward Bruce, August 15, 1934; Edward Bruce to Henry Morgenthau, Jr., August 18, 1934; and Henry Morgenthau, Jr., to Edward Bruce, September 6, 1934, RG 121/109.

39. Edward Bruce to Henry Morgenthau, Jr., September 11, 1934; RG 121/109; *Washington Post*, April 26, 1934; *Washington Post*, April 21, 1934.

40. Edward Bruce to William M. Milliken, March 28, 1934, RG 121/109; *Washington Post*, May 16, 1934.

41. *Washington Post*, April 30, 1934.

42. Ibid.

43. Treasury Department Order, PWB no. 2-C, October 16, 1934, pp. 1–2, RG 121/123.

44. Commission of Fine Arts to the President, July 28, 1933, RG 121/122; George Biddle, *An American Artist's Story* (Boston: Little, Brown, and Company, 1939), pp. 268–72.

45. Biddle, *An American Artist's Story*.

46. *New York Times*, May 11, 1933.

47. Treasury Department, *Bulletin no. 8*, 1936, p. 19; Treasury Department, *Bulletin no. 10*, 1936, p. 9, RG 121/130.

48. Form letter of January 1935 to proposed Advisory Committee; and Edward Bruce to William A. Delano, March 13, 1935, RG 121/122. For a detailed account of Edward Bruce's procedures for the combined Post Office and Justice building project in Washington, D.C., see Edward Bruce and Forbes Watson, *Art in Federal Buildings* (Washington, D.C.: Art in Federal Buildings, Inc., 1936).

49. Treasury Department Announcement of National Competition for Mural Decoration in the Department of Justice and Post Office Department Buildings, Washington, D.C., n.d., RG 121/130.

50. Forbes Watson, "The Return to the Facts," *American Magazine of Art*, March 1936, pp. 151–52.

51. Thomas H. Benton to Edward B. Rowan, n.d., RG 121/133.

52. Edward Bruce to Leon Kroll, September 24, 1937, RG 121/133.

53. Forbes Watson to C. J. Peoples, September 24, 1937, RG 131/133; *Washington Daily News*, September 10, 1937.

54. Les Finnegan, "Rockwell Kent Defends His Use of U.S. Walls for Propaganda," *Washington Daily News*, November 1, 1937.

55. Watson to Peoples, September 24, 1937, RG 131/133; Anthony J. Dimond to James A. Farley, October 11, 1937, RG 121/133.

56. Edward Bruce to Leon Kroll, September 24, 1937; W. E. Reynolds to Rockwell Kent, October 22, 1937; Forbes Watson to C. J. Peoples, November 1, 1937; and C. J. Peoples to Rockwell Kent, November 4, 1937, RG 121/133.

57. Edward Bruce to Frank Vittor, November 22, 1933, RG 121/118.

58. Charles Moore, *Personalities in Washington Architecture* (Washington, D.C.: Columbia Historical Society, 1937), pp. 2–9; Data on the Executive Powers of the Commission of Fine Arts, n.d., p. 3, RG 121/118.

59. Commission of Fine Arts to the President, July 28, 1933, RG 121/122.

60. Edward B. Rowan to Charles Moore, July 19, 1935, and Charles Moore to Edward B. Rowan, September 18, 1935, RG 121/122.

61. Memorandum of the Section of Painting and Sculpture to the Director of Procurement, n.d., pp. 2–4; Bancel LaFarge to Olin Dows, November 6, 1935, and Olin Dows to Bancel LaFarge, December 6, 1935, RG 121/119.

62. Edward Bruce to Mrs. Henry Morgenthau, Jr., December 7, 1935, RG 121/122.

63. Edward Bruce to C. J. Peoples, November 24, 1935, RG 121/118.

64. Memorandum of the Section of Painting and Sculpture to the Director of Procurement, n.d., exhibit F, pp. 1–2.

65. C. J. Peoples to Charles Moore, December 4, 1935.

66. Edward Bruce to Louis Simon, August 18, 1938, RG 121/122.

67. Edward Bruce to Olin Dows, December 12, 1935; Edward Bruce to Olin Dows, December 16, 1935; and Edward Bruce to William Zorach, January 24, 1936, RG 121/122.

68. Edward Bruce to William Zorach, February 21, 1936, RG 121/122.

69. *Binghamton* (New York) *Press*, December 13, 1938. Cf. Walt Whitman, *Leaves of Grass* (Boston: Houghton Mifflin Co., 1959), p. 318.

70. Ben Shahn to Edward B. Rowan, December 9, 1938, RG 121/122; *Washington Evening Star*, December 12, 1938; C. J. Peoples to Edward Bruce, December 10, 1938, RG 121/122.

71. Florence P. Engleton to Edward B. Rowan, December 14, 1938; Edward Bruce to C. J. Peoples, December 15, 1938; and Edward Bruce to Albert I. Dickerson, December 16, 1938, RG 121/122.

72. Edward G. Kemp to W. E. Reynolds, February 29, 1940; John Dewey to Edward Bruce, October 16, 1940; and Edward Bruce to Maurice Sterne, May 24, 1940, RG 121/144.

73. Kemp to Reynolds, February 29, 1940, RG 121/144.

74. Edward Bruce to Maurice Sterne, March 18, 1940, and Maurice Sterne to Edward Bruce, March 21, 1940, RG 121/124.

75. Ibid.

76. Edward Bruce to William V. Griffin, June 10, 1940, and Edward Bruce to Felix Frankfurter, July 29, 1940, RG 121/124; Dewey to Bruce, October 16, 1940, RG 121/144.

77. Edward Bruce to Maurice Sterne, December 23, 1940, RG 121/124.

78. Edward Bruce to Maurice Sterne, January 25, 1941, and Edward Bruce to John M. Carmody, January 23, 1941, RG 121/124.

79. Treasury Relief Art Project, *Interim Report*, May 1, 1936, p.– 1, RG 121/122.

80. Treasury Department, *Bulletin No. 8*, 1936, pp. 12–13.

81. Olin Dows to Edward Bruce, July 15, 1935; Edward Bruce to Olin Dows, July 17, 1935; Edward Bruce to Olin Dows, November 2, 1935; Edward Bruce to Harry L. Roosevelt, January 12, 1936; Mrs. Henry Morgenthau Jr., to Edward Bruce, December 3, 1935; and Olin Dows to Edward Bruce, December 13, 1935, RG 121/118.

82. Report of the American Artists' Congress, March 15, 1936; Stuart Davis to Olin Dows, April 29, 1936; Stuart Davis to Olin Dows, April 3, 1936; and Olin Dows to Stuart Davis, April 8, 1936, RG 121/122.

83. Minutes of the Coordination Committee's meeting with Olin Dows, June 11, 1936, and Stuart Davis to Olin Dows, June 18, 1936, RG 121/122.

3

Bruce's Quest for Permanency

During the time when Edward Bruce was planning the Treasury Relief Art Project (TRAP), a major personal tragedy occurred in his life. On June 2, 1935, he experienced a severe stroke that resulted in a complete paralysis of his left side.[1] At the Emergency Hospital in Washington, he was in a coma for six weeks: "The whole thing being a complete blank to me, I felt as if I were continually coming out of the fog."[2] He admitted that he had driven his body too hard.[3] Bruce never fully recovered, and the stroke ended any hope of his fulfilling his commitment as a professional painter.

The general reaction of the art world was expressed by Edward Laning in a letter to Bruce:

> I was deeply shocked to learn of your illness and I sincerely hope that your recovery will be complete. I am convinced that this is only a part of the enormous sacrifice of your time and energy that you are making in the cause of art in America, and as a fellow-artist, I want to express my sympathy and gratitude for the splendid work you are doing.[4]

Following this setback Bruce dedicated his remaining energy to a quest for permanency. His new commitment was to preserve the values of his tradition: quality criteria; the competition system; and the Section of Painting and Sculpture program— all of which were vital to his life. To counteract the erosive effects of the Depression, Bruce's quest—if realized—would assure the permanency of his tradition, despite any chaotic, temporal conditions.

Supporting Program Activities

In subsequent years Bruce strengthened his program so that he could "leave a not unworthy memorial" of his achievements.[5] As chief of the section, various honors came to him for having advanced the cause of American art, such as the Columbian Medal for Excellence; an honorary Ph.D. degree from Yale University; and the

Friedsham Medal of the Architectural League of New York, for outstanding achievement in the arts. These honors were viewed by him not as personal triumphs alone but also as a means of getting public support for his program.[6] Bruce considered the Section the keystone of his activities. In one instance, when he thought of resigning because of his illness, he observed, "I feel as if I had attended the funeral of my only child."[7] His personal disabilities notwithstanding, he stayed on to strengthen his program.[8]

Under his direction a monthly bulletin was started to inform artists about the opportunities available to them in mural and sculpture competitions. This publication to disseminate information about the Section and TRAP activities, included biographical data on the winners awarded commissions. By giving open and unbiased information Bruce hoped to gain the cooperation of artists throughout the country.[9] In a related activity, he produced a volume, *Art in Federal Buildings, Mural Designs, 1934–1936* (Washington, D.C.: Art in Federal Buildings, Inc., 1936), to bring the work of artists under the program to a wider public audience and stimulate greater interest in American mural painting.[10]

An artist-in-residence plan sparked Bruce's interest. This scheme was inspired by the experiment of Dartmouth College in New Hampshire, where the Mexican muralist José Clemente Orozco had been invited as a visiting professor. Bruce asked Professor Artemas Packard of Dartmouth about the experiment. The purpose, Packard explained, was to break down the isolation that existed between the artist and society. Bruce agreed that the artist could significantly contribute to community life through art. After getting the cooperation of the Guggenheim Foundation and the Carnegie Corporation, he set up an Artist-in-Residence Program, whereby artists would be established as resident professors and be provided studio space in colleges throughout the country.[11]

In 1936, Bruce planned some public exhibitions at the Corcoran Gallery of Art in Washington and the Whitney Museum in New York as a progress report on the accomplishments of his program. The fact that it was the first art program to coordinate painting, sculpture, and architecture, Watson asserted, gave the Treasury Art Program its essential character of permanence and social force. Bruce definitely exerted a profound influence on American culture, Eugene Savage, a member of the Fine Arts Commission, informed President Franklin D. Roosevelt.[12] Roosevelt replied:

> From the first exhibition of the Public Works of Art Projects, I have followed the work of the Treasury Department Art Projects under the direction of Mr. Edward Bruce with enthusiastic interest and have noted the evidence in our public buildings of the fine contributions to our national culture which have been made by the artists of the country.[13]

During the preplanning of New York's 1939 World's Fair, Bruce told Theodore Hayes, executive officer of the U.S. Commission, that he had a scheme to provide artwork for the U.S. Building. However, Edward J. Flynn, commissioner general of the fair, had other plans and appointed his own art director. Undaunted, Bruce asked Secretary of the Treasury Henry Morgenthau for his support and urged him not to compromise with the "Old Order." He deplored the mere repetition of the work of the old, "You-pat-me-and-I'll-pat-you" group of official painters from New York. The president also interceded, and Hayes approved funds for the Section to develop decorative plans for the U.S. Building.[14]

The World's Fair venture reveals that Bruce's supporting activities were not always successful. For instance, he met with the Guggenheim Foundation, which was willing to provide funds for an abstract mural. The plan did not materialize, however, because the Guggenheim wanted the European abstractionist Rudolf Bauer to paint the mural, whereas Bruce preferred to hold an anonymous competition limited to the works of American artists.[15]

However, the Section held a national competition for two mural designs. George Harding's design received a unanimous vote, but James Owen Mahoney's concept aroused bitter controversy. The jury-member artist Eugene Savage and four jury lay persons voted for Mahoney, while the four artist members opposed. The propriety of the award was questioned, however, because Savage and Mahoney held a joint mural contract for another fair building.[16] Some critics seriously doubted that the Section could impartially judge quality art.[17] In the case of artist member Reginald Marsh, he expressed strong reservations about the Sections' competition system to get quality work. These disputes deeply disturbed Bruce, especially one statement by Marsh that he viewed as "Marsh's outpourings" to the press; ". . . even Coney Island freaks are far more real and original than the World's Fair murals."[18] Marsh continued his protest by writing to Bruce:

Cannot vital art and sculpture be encouraged? To be sure, the Section has directed a number of jobs to painters who say something, but the great proportion, including some of the major commissions, will not live in history.[19]

Bruce, however, refused to go on with the controversy. Instead, he invited Marsh to calmly look at the Section's files and see for himself what good work had been accomplished. Meanwhile, one of the competitors, Kindred McLeary, spoke out in support of the Section and praised Bruce's record in furthering the cause of American art.[20]

Permanent Section of Fine Arts

The gradual decline of TRAP, beginning in December 1937, suddenly made Bruce realize that the Section could be wiped out overnight by an economy-minded Congress. This concern was revealed when he wrote to Admiral C. J. Peoples, "Since the installation of the Section, I have been acutely conscious of the fact that the Section was on a temporary and experimental basis."[21]

But on October 14, 1938, Bruce convinced Secretary Morgenthau that he should make the Section permanent under the new title the Section of Fine Arts. Artists were enthusiastic about the news—among these Alfred Crimi, who believed that Bruce would always be remembered by the work of established as well as younger artists who created, through the Section, a truly democratic art.[22] Likewise, former Public Works of Art Program (PWAP) committee members applauded the news of a permanent Section. "Accept my heartiest congratulations for one of the most important results of your labors," wrote Juliana Force.[23] Bruce has finally realized his dream, Burt Brown Barker observed; and Theodore Sizer called the official action a hundred years overdue.[24]

At long last Bruce felt that he had found the firm ground for his program. He informed the Section staff, "With the setting up of the permanent Section of Fine Arts, our position has been very much strengthened."[25] By 1938, Bruce had every reason to

be confident about the permanency of his program. Unfortunately, the Section was liquidated in 1943, when it failed to survive the changing priorities of a wartime administration.

Proposed Smithsonian Gallery of Art

An unexpected event occurred, which caused Bruce to believe that he could, in fact, realize his quest for permanency. Dr. Charles G. Abbot, secretary of the Smithsonian Institution, informed Bruce that Senator Thomas Walsh of Massachusetts had presented a bill to Congress, asking for $12 million to build a national American portrait gallery. Bruce immediately saw that a permanent home for the Section could be located within the proposed gallery because it would be established under legislative statutory law. Hence, he asked Dr. Abbot to persuade Senator Walsh to substitute a counterproposal bill, calling for a gallery of contemporary American art, which the Senator agreed to do.[26]

Bruce's quest for permanency was supported, in part, by a concept that Roosevelt, himself, expressed about the federal role of art in the American society. It was the president's idea that a good collection of artworks from various museums in the United States and abroad, representative of the world's art, could be gathered together and transported throughout the country, accompanied by art lecturers. Bruce then planned how the president's idea could be carried out by the Section under the proposed Smithsonian gallery.[27]

Bruce advocated the idea of the proposed gallery as "something genuinely simple and beautiful—no classical column of any kind. He saw the relationship of the gallery to the planned Mellon Gallery of Art in Washington in the same light as the Luxembourg Gallery to the Louvre in Paris. The Smithsonian Gallery would support contemporary American art, and the Mellon Gallery, the traditional art of Western culture.[28]

In March 1937, Congress passed Joint Resolution 99, the Enabling Act that provided land on the Mall for the proposed gallery. Also included was an appropriation of $40,000 to hold a national competition for an architectural design.[29] In May, Joint Resolution 599 was approved, providing for a Smithsonian Gallery of Art Commission to select a gallery design. In June 1939 a jury selected by the Smithsonian Commission picked as winner of the national competition Eliel Saarinen, who was associated with Eero Saarinen and Robert Swanson of Bloomfield Hills, Michigan. The commission recommended that his firm design the proposed gallery.[30]

Despite the ambiguities of the Depression, Bruce succeeded in establishing a permanent Section. Yet, he revealed the anxieties of the contemporary period—looking for a solution to escape the despair of all temporal chaos. Bruce's gallery concept—a structure to preserve his tradition—is closer to the ideal of Filippo Brunelleschi's cathedral in Florence: a proud monument to a specific man in history. This renascent individualism relates to Bruce's ideal to perpetuate his artistic activities through the Smithsonian Gallery plan.

However, before the gallery could be built, there still remained the question of raising private funds and obtaining the approval of the Fine Arts Commission. Bruce decided not to request federal monies because he felt that the building could be funded by private sources. Moreover, because he feared bureaucratic interference, private support was preferred. Yet, Bruce did not foresee any difficulty—either to get private funding or approval of the Fine Arts Commission—in fulfilling his quest for permanency and leaving a "not unworthy memorial" of his achievements.[31] Un-

fortunately, World War II ended Bruce's hope of having the proposed Smithsonian Gallery of Art built.

Notes

1. Edward Bruce to John Cosgrove, June 20, 1935, Bruce Papers, AAA Reel D85.
2. Edward Bruce to Fran Weiger Briun, November 21, 1935, Bruce Papers, AAA Reel D85.
3. Edward Bruce to Fillipo De Fillipe, January 23, 1935, Bruce Papers, AAA Reel D89.
4. Edward Laning to Edward Bruce, June 17, 1935, RG 121/123.
5. Edward Bruce, "What I Am Trying to Do," *Creative Art* 3, November 1928, H. xlix.
6. Edward Bruce to Ward Lockwood, January 5, 1938, RG 121/123.
7. Edward Bruce to Maurice Sterne, November 13, 1937, RG 121/123.
8. Edward Bruce to Maurice Sterne, November 23, 1937, RG 121/125.
9. Edward Bruce to C. J. Peoples, November 14, 1934, and Edward Bruce to Olin Dows, January 10, 1936, RG 121/125.
10. Olin Dows to Frank Kent, November 28, 1936, and Edward Bruce to Arthur C. Friedricks, December 16, 1936, RG 121/118.
11. Albert I. Dickerson, ed., *The Orozco Frescoes at Dartmouth* (Trustees of the Dartmouth College, 1934), p. 3; Edward Bruce to Artemas Packard, August 24, 1934; Artemas Packard to Edward Bruce, August 31, 1934; and Edward Bruce to Artemas Packard, April 22, 1935, RG 121/122; Edward Bruce to Maurice Sterne, November 3, 1937, RG 121/124.
12. Treasury Department Art Projects, *Sculpture & Paintings for Federal Buildings*, October 6 to November 6, 1936, Whitney Museum of American Art, New York, 1936; Treasury Department Art Projects, *Paintings & Sculpture for Federal* Buildings, November 17 to December 13, 1936, Corcoran Gallery of Art, Washington, D.C., 1936; *Sculpture & Paintings for Federal* Buildings, Whitney Museum of American Art, New York, 1936; Franklin D. Roosevelt to Henry Morgenthau, Jr., November 12, 1936, and Eugene Savage to Franklin D. Roosevelt, January 15, 1937, RG 121/119.
13. Franklin D. Roosevelt to Eugene Savage, n.d., RG 121/119.
14. Edward Bruce to Theodore Hayes, December 4, 1937; Edward Bruce to Franklin D. Roosevelt, December 19, 1937; Edward Bruce to Henry Morgenthau, Jr., December 19, 1937; and Edward Bruce to Theodore Hayes, February 17, 1938, RG 121/138.
15. Edward Bruce to Francis H. Brownell, February 26, 1938, and Inslee A. Hopper to William Higgins, March 24, 1938, RG 121/138.
16. Treasury Department Art Projects, *Special Bulletin no. 16*, June 1938, RG 121/130; Inslee A. Hopper to Edward Bruce, September 26, 1938, RG 121/124.
17. Edward Bruce to Maurice Sterne, September 18, 1938, and Mural Artists' Guild 829 of the United Scenic Artists to Edward Bruce, October 18, 1938, RG 121/124.
18. *New York World Telegram*, September 22, 1938.
19. Reginald Marsh to Edward Bruce, September 18, 1938, RG 121/124.
20. Edward Bruce to Reginald Marsh, October 5, 1938, and Kindred McLeary to Edward Bruce, October 23, 1938, RG 121/124.
21. Treasury Relief Art Program, *Final Report*, n.d., RG 121/119; Edward Bruce to C. J. Peoples, August 19, 1937, RG 121/124.
22. Edward Bruce to Maurice Sterne, October 15, 1938, RG 121/124; Alfred D. Crimi to Edward Bruce, October 23, 1938, RG 121/122.
23. Juliana Force to Edward Bruce, October 17, 1938, RG 121/122.
24. Theodore Sizer to Edward Bruce, October 17, 1938, and Burt Brown Barker to Edward Bruce, October 19, 1938, RG 121/122.
25. Edward Bruce to the Staff of the Section of Fine Arts, December 25, 1938, RG 121/122; Edward Bruce to Paul Manship, April 12, 1935, RG 121/124.
26. Maria Ealand to Olin Dows, March 9, 1937, Bruce Papers, AAA Reel D85.
27. Edward Bruce to Suydam Cutting, December 13, 1938, Bruce Papers, AAA Reel D85.
28. Edward Bruce to Olin Dows, September 11, 1940, Bruce Papers, AAA Reel D86; Edward Bruce to M. Laws, February 18, 1938, and Edward Bruce to Hari Lindeberg, May 17, 1938, RG 121/133.
29. Frederic A. Delano to Daniel W. Bell, May 24, 1937, RG 121/133; 75th Cong., 1st Sess. S. J. Res. 99, March 11, 1937.
30. 75th Cong., 3d Sess., H. J. Res. 599, May 17, 1938; Smithsonian Gallery of Art Commission, "Announcement to Architects," January 21, 1939, RG 121/133; Joseph Hudnut, "Smithsonian Competition Results," *Magazine of Art*, August 1939, p. 457.
31. Edward Bruce to Frederic A. Delano, July 17, 1939, Bruce Papers, AAA Reel D85.

Ben Shahn (Section), *Child Labor,* **detail of mural. (Belisario R. Contreras)**

4

Tradition and Art of the Treasury Programs

Public Works of Art Project (PWAP)

The 1930s was an introspective period, and PWAP artists generally focused on native subjects, exploring a broad vista of the American scene. For that matter, PWAP became a prototype for later New Deal programs. In a unique way the tradition of the Treasury art programs and the innovation of the WPA Federal Art Project had their origins in the diversified art of the PWAP.

Easel Painting

A carefully developed realism with industrial subjects is revealed by some of the easel art. For example, Roland Monsseau (1889–) depicts a railroad roundhouse, a coal loading dock, and other buildings in his *Industrial Landscape*, with a fair degree of precision, enhancing what he considered "the dramatic possibilities of my subject." Austin Mecklem's (1894–1951) rendering of a typical American theme—railroad yards, machine shops, and locomotives—also employs realistic techniques.[1]

Urban America is represented by the work of John Sloan (1871–1951), one of the original "Eight" who initiated the Ashcan school—an art movement expressing the life of the people in the streets. The realistic tradition of the Ashcan school is seen in Sloan's *Fourteenth Street and Sixth Avenue, New York City*, about which he commented, "The artist thinks it's going well—an easel picture comes and goes during the progress of working—unless in the hands of a mechanic." The scene of New York City, with its crowds of people, store signs, and elevated railway, reveals a symbol of the New Deal on one of the buildings: The NRA blue eagle poster. Sloan voices his great enthusiasm for the project: "Long live the P.W.A.P."[2]

Daily life in urban America, painted by Isaac Soyer (1907–) and Ilya Bolotowsky (1907–), follows the tradition of the Ashcan school. Soyer depicts women in a beauty shop, using birds-eye perspective to emphasize the solidity of the

67

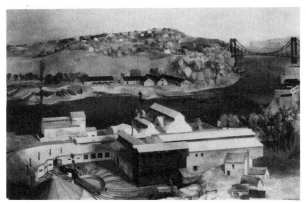

Roland Monsseau (PWAP), *Industrial Landscape.* **(National Archives)**

Austin Mecklem (PWAP), *Engine Houses and Bunkers.* **(National Archives)**

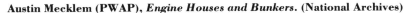

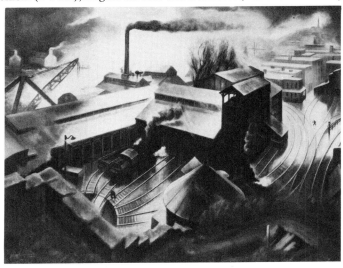

figures within the bold checkerboard pattern of the floor. The constrictive boundaries of the room are relieved by a window overlooking a church and a skyscraper. In *In a Barbershop*, by Bolotowsky, the artist also employs bird's-eye perspective to repeat a circular motif. Enhanced by the movement of the barber, the circular rhythm is echoed throughout the composition by a pictorial pattern on the left wall, a spittoon, and a vase.

The works of Francis Criss (1901–), Theodore Roszak (1907–), Thomas Hunt, and Norman Chamberlain (1877–) employ a decorative and, in some instances, cubistic design in their versions of the American scene. Criss, for example, uses a geometric pattern of contrasting shades to depict buildings for sale or for rent; the word "Trust" is emblazoned on a bank facade, implying the sterility of the

John Sloan (PWAP), *Fourteenth Street and Sixth Avenue, New York City.* **(National Archives)**

Isaac Soyer (PWAP), *Art Beauty Shoppe.* **(National Archives)**

business world. In a cityscape devoid of people but reflecting a suspended sense of time, his theme suggests the inability of business persons to cope with the economic crisis.

Roszak sees industry as a series of geometric structures, boldly imposed on the American scene. Sharply angled forms of bridge and railroad tracks seem to lead nowhere; nonfunctioning smokestacks and factories appear to lack workers. In a rigid composition Roszak implies the inactivity of industry during the Depression. Hunt, on

Ilya Bolotowsky (PWAP), *In a Barbershop.* **(National Archives)**

Francis Criss (PWAP), *Cityscape.* **(National Archives)**

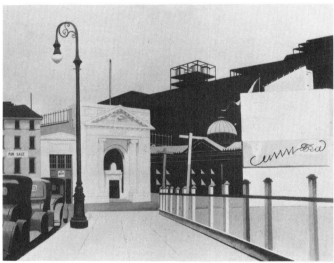

the other hand, depicts the speed and complexity of New York City. He detaches the skyscrapers, trains, bridges, automobiles, and people from context, redesigning their elements in patterns, to create vivid rhythms of a dynamic modern America.

In contrast to Roszak's dehumanized landscape, Chamberlain's stylized but organic-related forms are shown in a ritualistic scene, *Corn Dance*. There is human drama and ceremony: women with corn offerings, men in costumes, and musicians participating in a ritual harvest dance. In the center of the composition a large

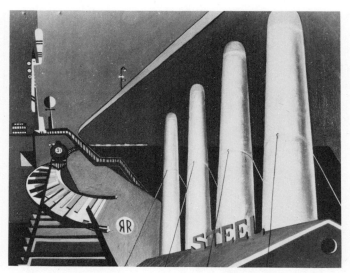

Theodore Roszak (PWAP), *American Industry.* **(National Archives)**

Thomas Hunt (PWAP), *Modern City Life.* **(National Archives)**

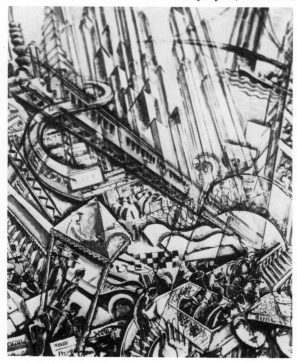

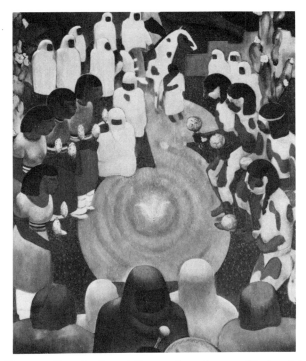

Norman Chamberlain (PWAP), *Corn Dance.* **(National Archives)**

symbolic motif dominates, denoting the spirit of harvest. Chamberlain employs a flat treatment of contrasting light-and-dark patterns in the decorative manner of Diego Rivera.

What the writer Thomas Craven had advocated—an indigenous expression, having strong native impulses, simple ideas, and popular taste—is suggested by the work of Francis Robert White (1907–) and Thomas Savage (1908–). In White's *Hog Fight*, a fierce encounter between the two animals takes place in a pen, which a farmer attempts to stop. His hapless effort is reiterated by a small duck trying to escape. The bold shape of the hog dominates the scene. The strong, inner-contained conflict is heightened by the sweeping curved back of the animal, counterbalanced by the horizontal boards of the pen. Savage's *Butchering* lacks the simple, dramatic elements of White's work. It reveals rather than the constricted setting of *Hog Fight*, the endless expanse of agrarian America. The dominant motif of Savage's concept is a farmer with a suspended animal. The never-ending and timeless aspect of butchering activity, reinforced by the concentric forms of farmer and animal, is repeated in the landscape by similar forms of barrel, pail, and kettle.

Another kind of American scene is depicted by Helen Dickson (1905–), Milton Avery (1893–1965), and Josephine Crawford. They use a poetic approach to convey a romantic realism to their work. In the case of Dickson, she paints the tilling of the dark, fertile earth, contrasted by a team of white horses led by a farmer. Using a bird's-eye perspective, she emphasizes a diagonal movement of a man and horses in a

rolling landscape. In her *Spring Plowing*, Dickson evokes a romantic mood, implying the New Deal hope of "a more abundant life" for the nation. Avery treats his subject, *An Industrial Plant*, with a disarming simplicity. The severe forms of industry usually seen on a waterfront Avery renders with a naiveté that evokes a poetic mood. In Avery's painting a dark, vertical architectural mass controls the center of the composition, buttressed on one side by white silos and on the other by distant white skyscraper buildings. In *Trucking Cotton*, Crawford also handles her theme with sensitivity and poetic rendering of interior space. From a bird's-eye view, in juxtaposition to the four workers the cotton bales form two right-angle relationships, unifying the space and form. In her theme Crawford reveals the kind of naiveté employed by Avery to create a romantic realism.

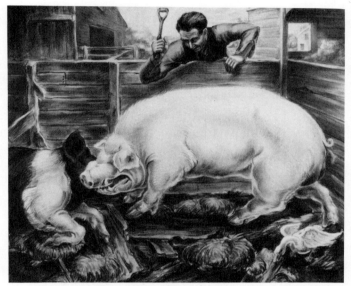

Francis Robert White (PWAP), *Hog Fight*. (National Archives)

Thomas Savage (PWAP), *Butchering*. (National Archives)

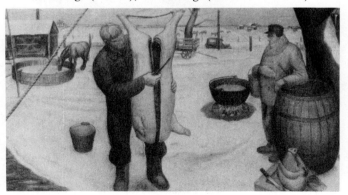

By way of contrast to a poetic mood, the works of John Graham (1881/90–1961) and G. S. Price (1874–1950) offer a vigorous approach to the American scene. Using a style that is purely expressionistic, Graham's painting closely relates to the emotional style of the French painter Chaim Soutine. In *Landscape on Lake George*, Graham utilizes a bold technique to depict turbulent tree forms, balanced by the simple, abstract shape of the lake. The work of Price, although not as emotional as that of Graham, is no less dramatic in depicting the American scene. His design is strongly conceived, with large, simplified shapes to portray the arduous journey of the settlers. A vital expression of pioneer life is solidly built up with bolder brush strokes. Price develops a strong contrast between the family in the enclosed space of an ox-drawn covered wagon and the open spaces of an untamed landscape.

A primitive style is used by Lawrence H. Lebduska (1894–) to depict, perhaps, the lost innocence of the American scene. The landscape in his work *Original Horse Power*, contains the traditional elements of a Western film: cowboys, Indians, and wild horses. Designing those elements with a flat, decorative pattern, he indicates a loss of freedom in a bleak landscape: a black horse roped by two cowboys; a third cowboy blocking the escape route; other horses wildly seeking to escape; and Indians, passively watching. Lebduska's painting reveals exotic and haunting qualities similar to those seen in the work of the French primitivist Henri Rousseau.

Some of the PWAP artists, encouraged by the new idealism of the New Deal, commented, "In a material era, it has made us feel no longer set apart, labelled impractical, but instead able to transmit through our labor a new vitality, fulfill a destiny that we had come to believe was unconcerned with our individual grail-seeking."[3] Others, however, felt that it was their duty to point out the contradictions of capitalism. Social protest and social consciousness emerged from that background in the paintings of Joseph Pandolfini (1908–), Santos Zingale (1908–), Misha Rezinkoff (1905–), Raymond Breinin (1910–), and Ivan Le Lorraine Albright (1897–).

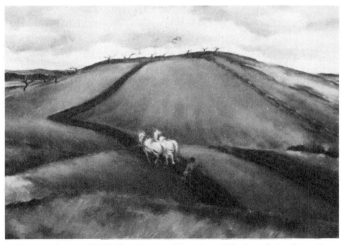

Helen Dickson (PWAP), *Spring Plowing.* **(National Archives)**

Milton Avery (PWAP), *An Industrial Plant.* **(National Archives)**

Josephine Crawford (PWAP), *Trucking Cotton.* **(National Archives)**

The evils of the capitalist system are underscored by Pandolfini in depicting the Sacco-Vanzetti case, the lynching of a black American, and the quelling of workers' rights by state troopers. He presents capitalism as an avaricious group, wearing top hats and clutching their money, which suggest that they exploit law and order to create injustices in society. Zingale is no less explicit in his work *Lynch Law*. The gross injustices of the period are seen in the tragic hanging of a migratory worker. Zingale's use of simple forms and expressive manner to portray tragedy shows Rivera's influence.

Rezinkoff's *The End of the Horse, or the New Deal* is not as explicit as Zingale's painting, but it questions no less the values of a Republican era. Rezinkoff implies

John D. Graham (PWAP), *Landscape on Lake George.* **(National Archives)**

C. S. Price (PWAP), *Pioneers.* **(National Archives)**

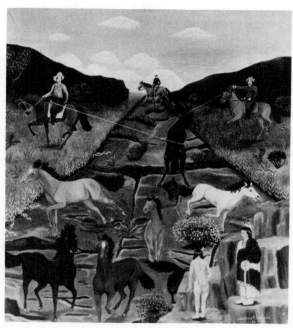

Lawrence H. Lebduska (PWAP), *Original Horse Power.* **(National Archives)**

Joseph Pandolfini (PWAP), *Composition.* **(National Archives)**

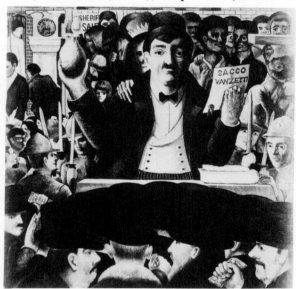

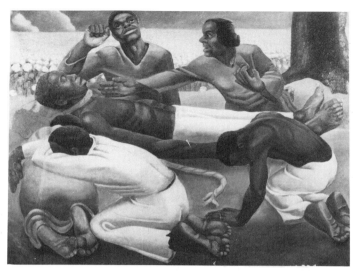

Santos Zingale (PWAP), *Lynch Law.* **(National Archives)**

Misha Rezinkoff (PWAP), *The End of the Horse, or the New Deal.* **(National Archives)**

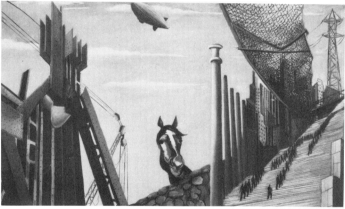

that with the arrival of the New Deal the horse-and-buggy days of the Hoover Administration came to a close. His surrealistic composition depicts a lone horse behind a stone wall; a dirigible hovering over a steel skeleton of a skyscraper under construction; a classical column—symbolic of the past—surrounded by a series of factory smokestacks; and workers enroute to their jobs. The Mexican muralist José Clemente Orozco also had used classical architecture in his work to symbolize a dead past, while workers looked toward a new society. Rezinkoff's motif of a lone horse seems to be derived from an image in the Russian film *Earth,* directed by Alexander Dovzhenko in 1930—a film that portrays a new society of workers, emerging out of the upheaval of the old order.

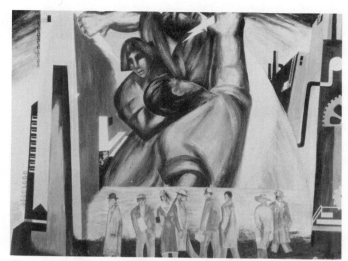

Raymond Breinin (PWAP), *New Order.* **(National Archives)**

In an easel work on the theme of social consciousness, Breinin envisions a new society for workers from all walks of life. A facade of figures represents the different elements of society. Rising above them, however, are three giant-size symbolic figures, harnessing the forces of nature and technology to create a modern society. Industry and science are expressed in an abstract style. By contrast, the rising figures are rendered in an expressionistic style; a powerful thrust of ascending figures is reminiscent of Orozco's approach, particularly in the Prometheus mural for Pomona College in California.

The precise realism of a self-portrait by Albright portrays the individual sense of social consciousness. The haunting face that has witnessed and experienced the human suffering of the Depression confronts the viewer. In the foreground is a still life of beautiful objects: a glass vase with flowers and a glass bowl—staples of the artist— are lovingly painted. Yet the eyes of the artist seem to long for another staple—the daily bread of life. Albright's self-portrait, in short, strongly suggests the spiritual anguish of the Depression.

Not unlike what had occurred in the Coit Tower project when Jane Berlandina composed an abstract work, other artists also painted themes that are experimental and abstract in style. This approach was used by Harry Holtzman (1912–) and Burgoyne Diller (1906–65). Holtzman, for instance, employs a figurative abstraction to paint a linear facade of persons in an urban setting. A flattened perspective contrasts vertical figures with the horizontal planes of the streets. His composition *The Democrat* suggests the equality of individuals in a new society. Holtzman's handling of human figures with simple outlines is reminiscent of an Egyptian composition, employing figurative frontality and minimal perspective. However, Diller uses purely abstract shapes, consisting of dark rectangular masses, circles, and linear triangular forms. By balancing solid shapes and linear forms, he creates rhythmic movements throughout the painting. Also, different tensions of movement are established by

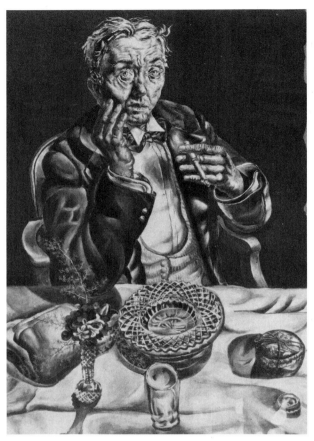

Ivan Le Lorraine Albright (PWAP), *Self-Portrait.* **(National Archives)**

Diller, such as the use of dotted lines that cut across the verticality and horizontality of his schema.

Other abstract styles are used by Kathleen Taylor, Yvonne Wood, Elise Seeds (1905–), and Paul Kelpe (1904–). In the case of Taylor, her work *Abstraction, No. 1,* shows organic growth. From a seed the form expands through a series of transformations until it breaks the upper earth line to reach the open space. Taylor's concept is derived from organic forms, but Yvonne Wood's composition, unrelated to nature, is composed of large circular shapes that contrast with rectangular forms. From a rectangular base a number of serpentine lines penetrate large circular shapes, unifying the two contrasting structures. Wood's purely geometric style in her *Abstract in Oil* is handled two-dimensionally in space.

Although geometric in structure, the works of Paul Kelpe and Elise Seeds are derived from machinelike forms. Kelpe's painting, for example, composed of rectangular and curvilinear forms, shows a geometric abstraction of industrial machinery. The work, conceived within a two-dimensional space, is devoid of social comment.

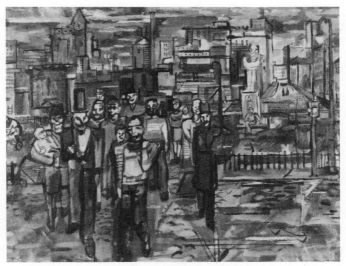

Harry Holtzman (PWAP), *The Democrat.* **(National Archives)**

Burgoyne Diller (PWAP), *Abstraction.* **(National Archives)**

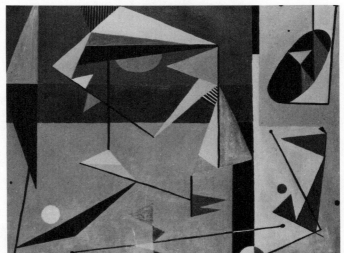

Instead of the individuals being at odds with the modern industrial society—the theme of Charlie Chaplin's film *Modern Times*—Kelpe portrays the individual in harmony with the machine world or as part of an abstract pattern, showing gears and turbines against a background of flatly rendered industrial buildings. Also machinelike in concept, Seeds's *Composition* is less literal than Kelpe's work. Her painting, conceived as a simple, bold construction, contains a gearlike shape on a neutral background. Seeds had submitted her *Composition* to the Central Office in Washington for

Kathleen Taylor (PWAP), *Abstraction, No. 1.* **(National Archives)**

Yvonne Wood (PWAP), *Abstract in Oil.* **(National Archives)**

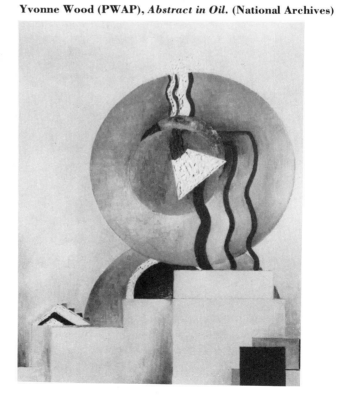

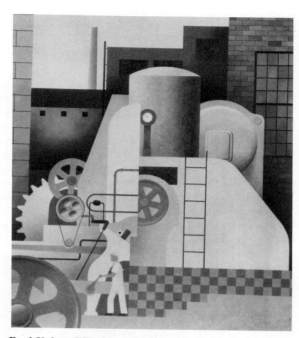

Paul Kelpe (PWAP), *Abstraction.* **(National Archives)**

Elise Seeds (PWAP), *Composition.* **(National Archives)**

a traveling exhibit, which PWAP never used for that purpose. Perhaps, her work was too abstract to qualify as "American scene" painting.

Mural Painting

Similar to what had developed in the Coit Tower mural project, the PWAP artists elsewhere were enthusiastic about planning murals that would relate to the society. The mood was expressed in this manner: "They are all doing the very best that is in them to help perpetuate for public buildings examples of their interpretations of life in body and spirit."[1] Stimulated by the impact of the Mexican muralists and the New Deal support of artists, the public became interested in murals as a people's art form. Ben Shahn's (1898–1969) "Prohibition" series is one example of the buoyant new spirit, breaking free from past traditions and ushering in a new era of social response. President Roosevelt himself highlighted this artistic climate: "We have broken away from the Republican regime in other particulars, why not in art."[5] Shahn's approach reflects a style that had been dominant in Mexican art: social realism—expressing the social consciousness or the ideals of the people.

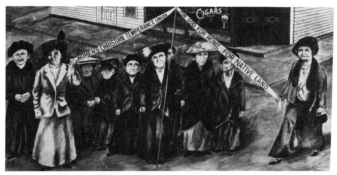

Ben Shahn (PWAP), *W.C.T.U.* (National Archives)

Shahn's *Prohibition Era* celebrated a national milestone—Roosevelt's signing of the Beer-Wine Revenue Act that made 3.2 percent beer legal. In his letter to Lloyd Goodrich, a member of the New York City regional committee, Shahn anxiously wrote: "I enclose a clipping from the *Times*, which has sent my hopes for a wall to fever heights. Please tell me there are prospects. Yours for an endless wall."[6]

New York City officials were planning some beer gardens for the city and Long Island, according to a *Times* article. Each time the phrase *beer garden* appeared in the *Times* clipping received by Goodrich, Shahn had underlined it to impress him with the exciting mural possibilities. In the beer-garden plan his WCTU (Women's Christian Temperance Union) panel reveals a group of women around a standard-bearer, carrying streamers with the legends "Women's Christian Temperance Union" and "For God, for home, for native land." (Shahn, with sly humor, had depicted a saloon in the background.)

In another panel Shahn shows a New York parade with Central Park in the background. Displaying an American flag and a winning grin, Mayor Jimmy Walker is surrounded by men holding flags and banners reading "Beer for Taxation" and "18th

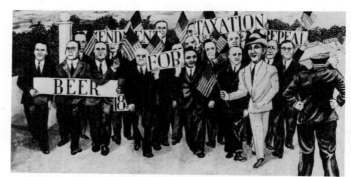

Ben Shahn (PWAP), *18th Amendment Repeal.* **(National Archives)**

Amendment Repeal." In sum, these two panels dramatize Shahn's primary motif—the beginning and end of the Prohibition era.

Other Shahn panels reveal the curious and contradictory phenomenon of Prohibition. In one sketch federal agents destroy liquor and dump endless beer barrels into sewers; in another a shop, "The Charred Keg," sells malt, hops, and utensils necessary for illicit stills.[7] Shahn's Prohibition sketches, a frank, amusing study of "a great error," reveal biting humor, imaginative use of visual detail, and sharp characterization of human nature.

An ambitious cooperative project, similar to Coit Tower in San Francisco, was organized by Grant Wood (1892–1942), Iowa state chairman, to design murals for the Iowa State College of Agriculture at Ames and the Iowa State University at Iowa City. So enthusiastic was the university about Wood's project that they offered working space and named Wood art lecturer. In conjunction with the project work, he taught a course in mural design at Iowa State University, and class members received university credit.[8] While fulfilling his duties as administrator, supervisor, mural painter, and teacher, Wood suffered continual frustrations. He arose at 5:30 A.M., drove from Cedar Rapids to Iowa City, returned home at 5:30 P.M., and wrote PWAP reports until midnight, which his wife typed the following day. He commented wryly, "It is the life—18 hours a day." Wood also supervised five sculptors working on CCC bronze tablets for state parks. He was moved to jest ironically, "I plan to make room right in the swimming pool with us. The sculptors and the muralists, then, will sink or swim together."[9]

Under Wood's supervision fourteen artists worked on a group project based on Daniel Webster's axiom, "When tillage begins, other arts follow; the farmer therefore is the founder of human civilization." The artists used each other as models to develop the mural themes planned for the Ames library at Iowa State College. These panels show the meticulous style of realism that Wood had contributed to the regionalist movement during the 1930s. The central panel shows a farmer with a hayfork, dominated by a Gothic pattern that unifies the panels on either side. In the outer panels, figures in a hayloft pause in their strenuous tasks, suggesting the symbolic "American Adam" (who assures the survival of the society through his daily toil).

Wood's project represents the kind of "American scene" that Bruce encouraged under PWAP. A comment in the *Cedar Rapids Gazette* sums up Wood's approach: ". . . no suggestion of pretty pictures or fairy tales or modernistic cubes and squares in the preliminary sketches of farmers adjusting hay forks and loading grain."[10]

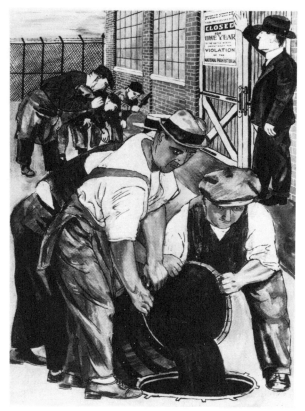

Ben Shahn (PWAP), *The Charred Keg.* **(National Archives)**

Ben Shahn (PWAP), *Federal Agents.* **(National Archives)**

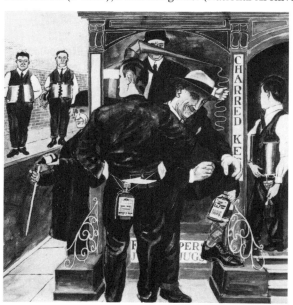

Grant Wood (PWAP), *When tillage begins, other arts follow.* **(National Archives)**

Because a smooth, harmonious relationship had existed between the Iowa State and Nebraska State projects, Wood traded his two conservative artists for two Nebraska realist painters who wanted to work on his project. This transaction pleased the Nebraska state chairman, T. R. Kimball, a man of conservative taste. Yet Wood was deeply concerned about meddling in these problems; he felt like a stationmaster for an underground railway in pre–Civil War days.[11]

The theme of social consciousness, reflecting a people's aspirations, interested Elton Fax (1909–) and James M. Newell (1900–). Fax planned a triptych mural scheme about evolutionary phases of black history: the first panel, primitive society; the second, the plantation system; and the third, contemporary society, where the black participates in the arts, science, industry, and education. The figurative rhythms and expressionistic style of Fax's theme evoke a ritualistic mood. Unlike the progressive phases of history used by Fax, Newell utilizes the central concept of a large, heroic figure, seen as a generated force or perhaps a symbolic New Deal—set to destroy the evils of society. These evils express New Deal objectives—unemployment, farm foreclosures, lack of family welfare, and the denial of miners' rights. In the mural sketch Newell portrays a distant horizon, where a happier, planned society—the kind envisioned by the New Deal—would come about in the future.

Elton C. Fax (PWAP), *Phases of Negro History.* **(National Archives)**

James Michael Newell (PWAP), *Science Destroying the Past and Building the Future.*
(National Archives)

The abstract work of Stuart Davis (1894–1964) and Arshile Gorky (1904–48)
represents another kind of social consciousness. Inspired by the new idealism of the
Roosevelt administration, Davis experimented with themes redefining democracy.
Describing his mural scheme as an "Analogical Emblem," he explained, "The polit-
ical analysis is Democracy, in that figures and objects are assumed to have equal
importance in the organization of the design, whether they be of great or small
importance in a social scene." Viewing the American scene from a new visual per-
spective, Davis presents typical imagery that is selected for its intrinsic visual inter-
est. A radio station, a typewriter, a ship's rigging, and the arm of a citizen raised at a
political rally form part of this imagery. Davis's sense of social awareness is revealed
by a desire to integrate this idea of the mural scheme into community life. Thus, the
American people would be aroused by new aspects of the commonplace objects in
their daily lives. His seriousness about the project was succinctly stated: "I am trying

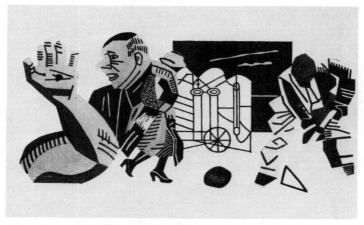

Stuart Davis (PWAP), *Analogical Emblem.* **(National Archives)**

Arshile Gorky (PWAP), *1934.* **(National Archives)**

to develop my ideas on this project as I would for my own exhibition and not simply make a picture."[12]

Gorky's mural, *1934*, conveys an imaginative approach to the social consciousness of the Depression. He employs a poetic approach to the renewal of the American pioneer spirit that enables the country to move ahead in a period of crisis.

This also was revealed in his very perceptive verse:

> My subject matter is directional
> American plains are horizontal
> New York City which I live in is vertical
> In the middle of my picture stands a column which
> Symbolizes the determination of the American nation
> Various abstract scenes take place in the back of this column
> My intention is to create objectivity of the articles
> Which I have detached from their habitual surroundings
> To be able to give them the highest realism.[13]

In a detailed pen-and-ink mural study, Gorky combines three-dimensional perspective and two-dimensional organic forms to give an interplay of complexity. This abstract theme he felt was suitable for an engineering school or the New York Port Authority building.[14]

Charles H. Kassler II (PWAP), *The Bison Hunt*. (National Archives)

Hideo Date (PWAP), *Young America*. (National Archives)

Mural concepts by Charles H. Kassler (1897–), Hideo Date, James Redmond, and Olinka Hrdy reveal a decorative approach. PWAP officials praised Kassler's mural *Bison Hunt* for the Los Angeles Public Library because it was "contemporary in spirit." The library walls, covered with lively and rhythmic masses of bison, capture the linear quality of prehistoric cave paintings in Altamira, Spain.

Date's *Young America* makes use of an Oriental tradition. Linear forms and rhythmic movements are accentuated by a flat treatment of forms throughout. Redmond's

James Redmond (PWAP), *California Horsemen.* **(National Archives)**

Olinka Hrdy (PWAP), *Design.* **(National Archives)**

California Horsemen, too, owes much to Oriental origins. A flattened linear treatment and foreshortened perspective stress the rhythmic masses throughout the composition.

Other decorative work that was experimental but unrelated to the subject matter of the American scene appeared in the program. *Design*, by Hrdy, is conceived as an abstract mural, consisting of transparent, overlapping planes and vertical and horizontal rows of circles.

Sculpture

Some of the sculptors were relating their work to architectural forms, making them more accessible to the public. In the case of John Flannagan (1898–1942), his group *Mother and Child* was planned for the garden court of a contemporary building and was conceived as an integrated mass so that it could be seen as well from the fourteenth floor as from the ground level.[15] He commented, "Having always considered the architectural aspect of sculpture as the apotheosis, I am interested in this government project, and sculpture, being the stepchild of the arts, any material influence manifested would be perfectly swell."[16] Chaim Gross (1904–) designed his bas-relief of basketball players for the facade of a school building. This unified and stylized sculpture expresses not only his vigorous technique but the activism of the New Deal as well.

The new idealism of the administration other sculptors also took as a theme. The

John Flannagan (PWAP), *Mother and Child*. (National Archives)

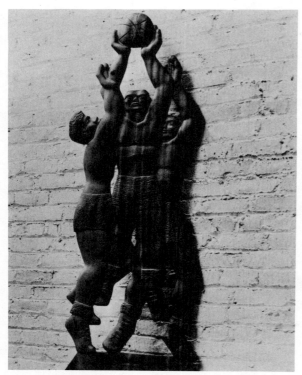

Chaim Gross (PWAP), *Basketball Players.* **(National Archives)**

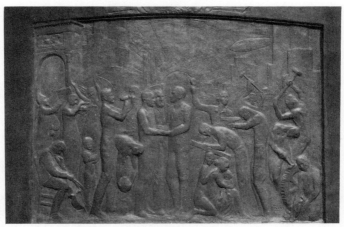

Marco Zim (PWAP), *United America in the Spirit of Progress.* **(National Archives)**

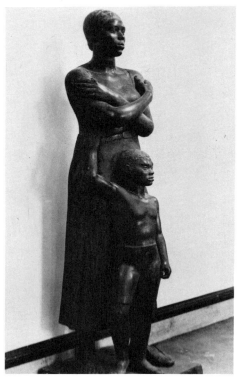

Maurice Glickman (PWAP), *Negro Mother and Child.* **(National Archives)**

Julian Lee Rayford (PWAP), *American Mythology,* **sketch for bas-relief. (National Archives)**

Here is a hasty sketch of the Totem Pole

You have said "devote the whole summer to this one piece if it is ambitious enough". I feel it is — and profound, too.

From the bottom, we see the world supported on a turtle's back. Then, Paul Bunyan and Mark Twain and Casey Jones. These three stand for the civilization of the continent and the transportation. The last three figures are the Thunderbird and the Great Spirit and the Butterfly Women, who symbolize the spirituality of the nation. I have placed the white men in the center between the Indian beliefs because "in the beginning" were Indians. Then came white men, and now, I feel it is only through a return to Indian belief, to its meaning, that we can understand America's soil.

The great spirit
Butterfly Women
Thunderbird
3 Plumed Serpents
Pilot Wheel
Mark Twain and Casey Jones
Locomotive
Paul Bunyan
axe
Paul's hand
Panther
Turtle
Turtle

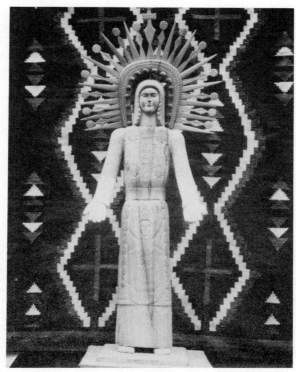

José Dolores Lopez (PWAP), *Our Lady of Light*. (National Archives)

bas-relief *United America in the Spirit of Progress* by Marco Zim (1880–)
shows the aspirations of society to recover from the Depression. Zim's academic style
is seen as a contrast to Maurice Glickman's (1906–) modern approach to a
similar theme. The will of a people to survive and to look toward a future with quiet
determination is brought out by Glickman's strong, direct modeling of his *Negro
Mother and Child*. The open frontal structure of the child and the enclosed repose of
the mother's arms reinforce the concept of inner strength.

Folk mythology interested sculptors Julian Lee Rayford and José Dolores Lopez
(1868–1938). Rayford portrayed American folk heroes: Paul Bunyan, the legendary
lumberjack; Davy Crockett, the frontiersman; and Casey Jones, the locomotive engi-
neer. Indian motifs were included, showing that the mythology of the white race was
grounded in the deeper roots of the native American. An enthusiasm for Rayford's
concept was expressed by the chairman of Region 4, Duncan Phillips: "We feel that
there is a survival of the pioneer spirit; that the pictorial images are plastic equiva-
lents of folk songs, folk dances, negro spirituals, and other manifestations of the
emotional life, which has [*sic*] gone into the making of America since the days of the
covered wagon."[17]

The Anglo-Saxon–Indian culture is defined by Rayford's mythology, but the
Hispanic-Indian culture is expressed by José Dolores Lopez's theme. Lopez imparts
an exotic, baroque quality to his *Our Lady of Light*, particularly in the motif of an

elaborate headdress with its illuminated lightrays. The decorative designs—angel, moon, and flower—are repeated throughout in the long robes of the figure.

Graphic Arts

An ambivalent mood, either that of despair or of hope, expresses some of the social themes. Michael Gallagher's (1898–) woodcut *Mammy Hawkins*, with its contrasting lights and darks, symbolizes the strength of a society looking toward a new life with quiet hope. The lifeless body of a miner being carried out of a mine emphasizes the depressed and helpless mood of the period in Irwin Hoffman's (1901–) etching *Mine Tragedy*. A man in a subway, reading the *Daily Worker*, dominates a crowded scene in a woodcut by Hendrick Glintemkamp (1887–1946). The hammer-and-sickle masthead on the newspaper not only suggests the tone of social unrest in the country but a possible solution to the economic chaos in Glintemkamp's work *Traffic—7th Avenue*.

Michael J. Gallagher (PWAP), *Mammy Hawkins.* **(National Archives)**

The human distress in the American scene underscores some of the Depression themes. Elizabeth Olds (1897–) delineates the social blight of an urban society in her lithograph *Employment Lines for CWA Labor*. Gaunt faces in the waiting lines reflect their desperate plight. *Night Prowlers*, an etching by Carl Cozination—in which men and an elder with a cane, also carrying a sack, forage in trash cans—indicates that all levels of society were affected by "Hard Times." The impact of the Depression on society is also revealed in *Vagabonds*, an etching by Mildred B. Brooks (1901–). The caravans of people gathered around a forest campfire appear to be no better off than the communities confronted by urban or agrarian distress.

The New Deal recovery programs caught the interest of Clem D. Adrian and Aimée

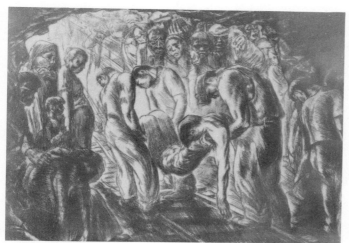

Irwin D. Hoffman (PWAP), *Mine Tragedy*. (National Archives)

Hendrick Glintemkamp (PWAP), *Traffic—7th Ave. Subway*. (National Archives)

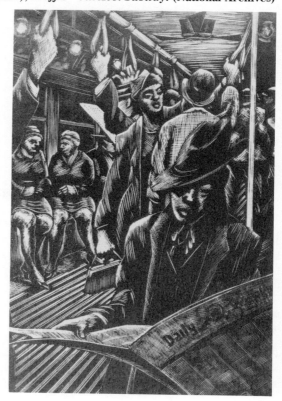

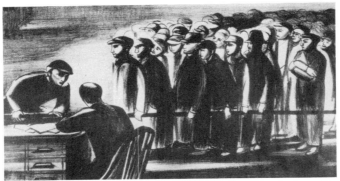

Elizabeth Olds (PWAP), *Employment Lines for CWA Labor.* **(National Archives)**

Carl Cozination (PWAP), *Night Prowlers.* **(National Archives)**

Gorham. The large projects under the Public Works Administration (PWA) are boldly depicted by Adrian's lithograph of Boulder Dam, the steep rise of which is reminiscent of the ancient Babylonian walled facades created by D. W. Griffith in his epic film *Intolerance*. The Civilian Conservation Corps (CCC) fighting a forest fire is delineated in a print by Gorham. The fire fighters, starkly silhouetted against the billowing smoke and flames, symbolize the determination of the New Deal to confront the Depression.

The American landscape is a pictorial source to Mary Huntoon (1896–) and William J. Dickerson (1904–). Huntoon's etching *Kansas Harvest* captures the wide sweep of the Western plains. Unlike the dramatic approach of a regionalist like John Steuart Curry, her work reveals a more personal version of the American scene. A

Mildred Bryant Brooks (PWAP), *Vagabonds.* **(National Archives)**

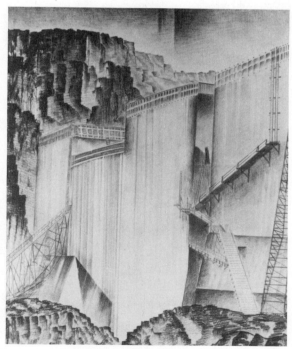

Adrian D. Clem (PWAP), *Boulder Dam.* **(National Archives)**

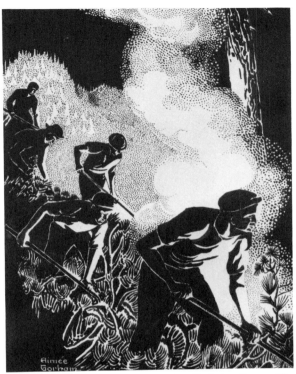

Aimée Gorham (PWAP), *CCC Men Fighting Forest Fires.* **(National Archives)**

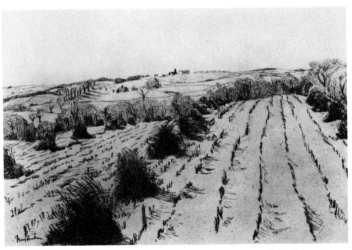

Mary Huntoon (PWAP), *Kansas Harvest.* **(National Archives)**

William J. Dickerson (PWAP), *Lithograph,* **#2. (National Archives)**

graphic work by William J. Dickerson, *Lithograph, No. 2,* portrays railroad and industrial buildings joining to form a lonely vista of urban life.

Despite the diversity of PWAP art, Bruce's tradition prevailed in the Project. Significant to his aesthetic philosophy was the influence of his mentor, Maurice Sterne. The elements of good drawing, careful observation of nature, and the development of instinct to assure an individual approach—all of which influenced Bruce—were derived from Sterne. Because PWAP was decentralized, some of the artists, including Stuart Davis, Milton Avery, Arshile Gorky, Jane Berlandina, and Elise Seeds, were able to do experimental work. However, Bruce's tradition emphasizing Sterne's principles and contemporary realism dominated the art in his later programs under the Treasury Department.

Section of Painting and Sculpture

The theme of the "American Scene," which governed Bruce's new program, stressed traditional American values. This trend focused not only on contemporary America but on the past to dramatize the full sweep of American history in murals throughout the country. Because Roosevelt's new idealism produced a different mood, replacing the chaos of the Hoover administration, social protest had no place in Bruce's program, and experimental art forms (abstraction, surrealism, and cubism) were discouraged in deference to representational art.

Aesthetics of the Section

The decentralization of PWAP operations into sixteen regions provided for a diversity of artistic styles. The centralization of the Section, however, exerted a closer

supervisory relationship between government and artist—a procedure not conducive to some of the experimental work produced under PWAP. Forbes Watson summed up Bruce's artistic viewpoint in his apt phrase "The Return to the Facts," a backward look toward traditional American realism. Watson, who became Bruce's advisor, pointed out that during periods of great painting "it is not uncommon for the patron—state, church, or prince—to tell the artist what is required and set down certain conditions that govern the artist's creation." In Watson's view, the United States government, through the Treasury art programs, willy-nilly, became a patron, much akin to the patrons of the Renaissance and other great periods of artistic expression in the past.[18] Watson cited the example of Henry Varnum Poor, who was well trained to depict realistic scenes the public appreciates. If the Treasury Department employed more painters of that caliber, Watson declared, federal buildings would be enhanced by a superior art to enrich American civilization. His premise rested on the concept that without design, facts become mere facts; and that without the facts, design becomes mere abstraction. Even when depicting historical subjects, Watson claimed that the aim is not to glorify but to create a realistic representation of the subject. In his view, "the pendulum had swung too far toward purely intellectual painting. It always swings back. This time it has swung back to the facts."[19]

Watson's dictum closely reflected Bruce's own views. In trying to recruit artist Paul Sample for the program, Bruce remarked:

He, like 99 percent of all the other artists I know, does a darn sight better job when he is actually looking at what he is doing and not relying on the imagination. The older I grow the more convinced I am that visual material is necessary for the production of the best art.[20]

When Maurice Sterne sent his mural designs to the Section for consideration, Bruce commented:

He is a fellow that is very good when he gets down to it, but lately he had reached the point where he felt that he didn't need models; and my observation has been that any artist when he does reach that point immediately goes back in his work.[21]

In referring to Waldo Pierce's abilities as a muralist, Bruce echoed Watson's criteria of the artist as a good worker who does not create problems but solves them.

Pierce is a nice fellow, but he is gradually driving me nuts. He painted a typical Pierce, sloppy and indefinite; and every day he sticks on a few spots of paint and then brings it back to me to look at and admire. But when it comes down to the real discipline of doing a mural which is going to be effective he hasn't any conception of it, and apparently none of the discipline in his make-up to do it.[22]

Nevertheless, the patron-artist relationship cited by Watson as essential to the program at times proved difficult to maintain. Because the designs required approval of the Procurement Division, the architects of the respective federal buildings, government officials, and the Commission of Fine Arts, the artists were faced with revisions which at times proved frustrating to them—to cite one example, Henry Varnum Poor's mural designs. His series of Justice Department activities evoked the enthusiasm of the Section. Ultimately, however, Justice Department officials opposed placing prison subject matter they considered "sordid and depressing" near the office

of the solicitor general. The Section suggested other subject matter, but Poor was firm in his intention to depict vital, contemporary themes.[23] He replied to Rowan: "Its simply a crime to let it all slide and fall back to the symbolic, heroic or whatever you call it subjects that you have for Curry, Biddle, Robinson and all. These will all be well done, but basically when all's said and done, they'll present no new spirit or style or point of view."[24] Fortunately, Rowan settled the issue by having Poor's designs reviewed and approved by the attorney general and the solicitor general. Poor commented: "A load is certainly off my mind—or spirit—and I look forward to a fine productive time of work. . . . I really feel very relieved, very glad, and endlessly grateful."[25]

In a case involving Reginald Marsh, the Fine Arts Commission disapproved his Post Office mural because the design lacked linear and geometric interest. The Section then advised Marsh to follow his own bent, based on his greater experience with the subject matter. The Section, however, rejected the new work because it did not fulfill the mural requirements.[26] (Marsh also concluded that the Fine Arts Commission would have turned down his designs.) He regretted the time spent on laborious sketches but began anew, studying the Postal Service under Pennsylvania Station in New York. Marsh commented, "The skeleton idea must be right, because I will not spend days polishing up the wrong thing."[27] The new designs finally convinced the Section and the commission that Marsh was on the right track.[28]

In another case, the patron-artist relationship failed completely when Bradley Walker Tomlin wanted to be relieved of his mural assignment. The Department of Labor had requested a mural for its Executive Dining Room in Washington, and TRAP had asked Tomlin to develop a lively, well-painted design. The Labor Department officials, however, were not enthusiastic because they preferred a theme showing labor-saving machines instead of garden tools. That field was unrelated to his experience, but he decided to do as much research as possible.[29]

The Labor Department officials, however, never saw Tomlin's revised sketches because his theme was considered too abstract by the Section and TRAP.[30] Tomlin asked to be released from his mural project: "I am very conscious of being a painter with a very limited range. Within it, I can function successfully. If I attempt to go outside of it, I am a total failure. I have lost all confidence in myself in regard to this particular job."[31] TRAP then asked Charles Trumbo Henry to tackle the project. Henry's realistic theme, depicting construction, power, and transportation, was approved.[32]

At one point, when Treasury artist Boardman Robinson chose to question the validity of a patron-artist relationship in government projects, Rowan rebutted:

> We feel that we are allowing the artist a great deal of freedom in his conception and approach, but in the final analysis the members of the Section will be responsible for the work that goes up and we should certainly have our conviction before we proceed with it.[33]

Yet the aesthetic problems encountered in the Treasury programs did not prove inimical to Bruce's tradition. Because of the patron-artist relationship, elitist in nature, artists under Bruce's programs were accorded a professional status that they and the New Deal found acceptable. Hence, the Treasury artists generally supported Bruce's criteria to get the finest art to embellish federal buildings.

Section Art in Washington, D.C.

The departmental activities of the U.S. government and aspects of the New Deal ideology were depicted in federal buildings. Similar to the Coit Tower cooperative venture, the Post Office and Justice Department programs were designated as a single project, and a select group of artists were assigned mural spaces—to paint broad phases of the American scene.

The "History of the Post—in the United States and its Territories" comprised the theme of the Post Office murals. Suggested by the Section, the artists studied Dunbar's *History of Travel in the United States,* a superior illustrated reference for their mural designs.[31] The early history of the post is represented by the work of Karl Free (1903–47) and George Harding (1882–1959). *The Arrival of the Mail in New Amsterdam,* by Free, shows Captain Vandergrist of the Dutch ship *Zwolle* delivering the mail to Peter Stuyvesant, director-general of the Dutch colony. Free asked for more time to adjust his painting style to the larger mural scale. The results of the mural, realistically rendered, pleased the Section.

Harding depicts the Colonial and Revolutionary War periods. Post riders, on weekly trips, deliver mail to Benjamin Franklin, Colonial postmaster; Franklin signs the post receipt book. In the other panel the Revolutionary War dispatch riders make their appointed rounds.[35]

Many of Bruce's criteria are revealed in Free's work: sound artistry; the scene carefully studied; and distinctive rhythm in a balanced classic composition. Whereas Free's representational art expresses formal attributes of Bruce's criteria, Harding's

Karl Free (Section), *Arrival of the Mail in New Amsterdam.***(National Archives)**

George Harding (Section), *Franklin and His Administration of the Philadelphia Post Office.* **(National Archives)**

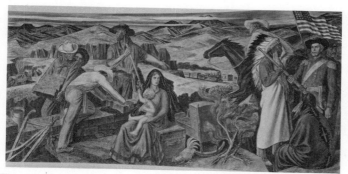

Ward Lockwood (Section), *Opening of the Railroads in the West.* **(National Archives)**

art not only includes those standards but also the element of instinct that Bruce thought important because it individualizes the approach of the artist. For example, the Section observed, ". . . we see at a glance that George Harding uses subject matter as a starting point from which to develop his deeper concern with the abstract problems of mural paintings."[36] Thus, the work of Free and Harding exemplified the basic aesthetic criteria that prevailed in the Treasury art programs.

The Western and Southwestern post paintings employed the kind of accuracy and realistic detail encouraged by Bruce. The Section's penchant for facts was revealed by Ward Lockwood's (1894–1963) comment: "Everything in the designs is authenticated by authoritative research . . . in designing the beaver trapper, I secured from the State Fish and Game Department an actual beaver. He is pictured being pulled out of the water, hind-end first, because the best method of catching the beaver was to trap him by one of the hind legs."[37] The progressive development of the postal service from stagecoach to pony express and railroad Lockwood depicted in *Opening the Railroads in the West*. Also revealed in the mural are early settlers constructing an adobe house; a child held by its mother, symbolizing the future of America; and soldiers and Indians holding a peace meeting.

Typical episodes of the rural mail delivery were depicted by Doris Lee (1905–) in *General Store and Post Office*. Local characters sitting around a potbellied stove swap stories while a mother with a young child inquires about the mail. Charm and gentle humor were expressed in Lee's work. Lee, however, was confronted by Bruce's

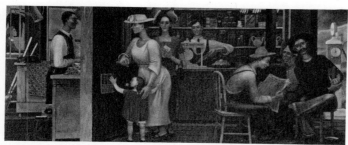

Doris Lee (Section), *General Store and Post Office.* **(National Archives)**

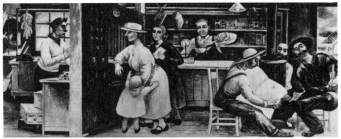

Doris Lee (Section), *General Store and Post Office,* **mural sketch. (National Archives)**

requirement of a monumental mural design—harking back to his Renaissance ideal. Her early elements of caricature and ill-proportioned figures aroused the objections of the Section, which demanded a mural quality from her work. Lee later eliminated these objectionable qualities and achieved the dignity desired by the Section, at the same time retaining the whimsical charm of her early studies.[38]

Alexander Brook (1898–) introduced an activity of the New Deal in his mural concept. In the work *Reading the Family Letter* a father reads a letter from home in a CCC camp. The choice of a CCC camp scene was particularly apt, Rowan observed, because it represented one of the most important New Deal projects. In its complement, *Writing the Family Letter,* a young daughter writes a letter, while the mother holds a baby. Painted in low-key colors of sienna and ocher, Brook's elongated figures evoke a muted mood of hope for the end of the Depression. "I like them and think there is a nice direct simplicity . . . and that they tell their story," Bruce commented about Brook's designs.[39]

Complementary approaches to the theme of the contemporary postal services were offered by Alfred D. Crimi (1900–) and Reginald Marsh (1898–1954). Crimi's *Post Office Work Room* shows the methods used to receive, assort, and distribute mail, about which he makes the following comment: ". . . a post office is not the most inspiring place for human interest, but it is in its grand mechanical organization and in the knowledge of its function that this is found. This, I carefully considered when I developed my sketch, which led me to make the horizontals and perpendiculars of outstanding importance."[40] Yet it was this approach that the Commission of Fine Arts at first rejected because they considered the concept monotonous. Crimi's work, however, reveals the same kind of uncompromising realism seen in Ward Lockwood's murals. Also, one sees in his work the realism of William Harnett, whom he greatly admired. To develop a heightened sense of realism, Crimi not only read about the history of the Post Office but carefully observed the employees used as models for his panels.[41]

Whereas Crimi's work shows the serenity of daily routine in the mail room, Marsh's murals reveal the vital rhythms of busy postal workers handling mail, taken from hundreds of on-the-spot drawings at the office under New York's Pennsylvania Station. *Sorting Mail* shows the interior, with its tangled mass of human activities and complex system of chutes, belts, and conveyors. At one point, Marsh was required to restudy the mail chutes because he had not carefully observed the facts—rendering the chutes in such a swirling manner that they ceased to function mechanically. The

Alexander Brook (Section), *Writing the Family Letter.* **(National Archives)**

Alfred D. Crimi (Section), *Post Office Work Room,* **detail of mural. (National Archives)**

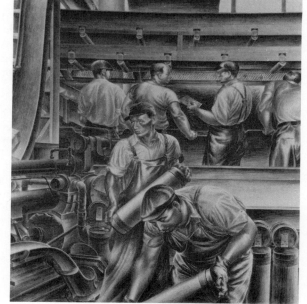

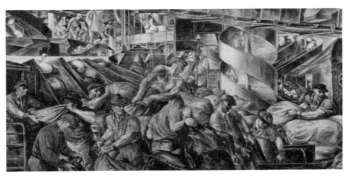

Reginald Marsh (Section), *Sorting Mail.* **(National Archives)**

swirling rhythms of the postal workers remained, but now the redesigned chutes worked to the satisfaction of the Section.

The two styles of realism show that if Crimi's figures are Apollonian—classical and logical—then Marsh's are Dionysian—expressionistic and emotional in concept. This vigorous realism of Marsh's work the Section described as "art fresh out of modern life."[42]

The Post Office program included sculpture. A marble statue of Samuel Osgood, first commissioner of the U.S. Treasury (1785–89) and first postmaster general (1789–91), stands in the reception room of the postmaster general. This work by Paul Manship (1885–1966) is formal and classical in style, appropriate for the handsomely paneled room. Aluminum statues by other sculptors present a contrasting style—less formal but more individual in concept. Placed in wall niches, these works symbolize different types of mail carriers. For example, Gaetano Cecere (1894–) chose *A Rural Free Delivery Mail Carrier*, in which he portrays a tall, rawboned figure looking into the distance. The left hand rests on a rural mailbox nailed to the top of a hand-hewn post, contributing to the simplicity and fluidity of the posture. The *Hawaiian Postman* is a sinewy figure by Louis Slobodkin (1903–); a pineapple at the base of the structure represents the second largest industry of the islands. The figure imparts grace and strength, achieved by Slobodkin through the carving of apparel tightly clinging to the mail carrier's body.[13]

For the Justice Department mural project "the development of Justice in the United States" was the broad theme chosen. Among the various ideas sent to the Section, Roscoe Pound, professor of law at Harvard, suggested:

> . . .five or six panels representing the development of our constitutional guarantees. They would be first, Magna Carta; second, the Petition of Rights; third, the Bill of Rights of 1688; fourth, the Declaration of Independence; fifth, the Virginia Bill of Rights of 1776; and sixth, the Constitution of the United States.[44]

Bruce was pleased but quite concerned about the outcome of too many suggestions. He noted, "one of these days we have got to sit down with all these suggestions and work them into a definite program or I am afraid our artists will begin to get balled up with the variety that is given them."[45]

The murals reveal a wide range of subject matter from historic lawmakers to contemporary law designed to eliminate the inequalities of tenement life. Such theo-

Paul Manship (Section), *Samuel Osgood.* **(National Archives)**

Gaetano Cecere (Section), *A Rural Free Delivery Mail Carrier.* **(National Archives)**

Louis Slobodkin (Section), *Hawaiian Postman.* **(National Archives)**

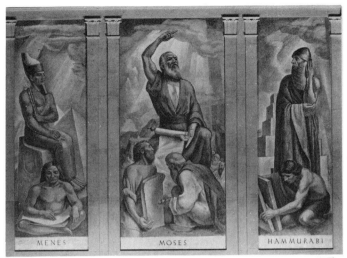

Boardman Robinson (Section), *Theocratic Lawgivers.* **(National Archives)**

George Biddle (Section), *Society Freed through Justice.* **(courtesy of Rudolph von Abele)**

George Biddle (Section), *Society Freed through Justice.* (National Archives)

George Biddle (Section), *Society Freed through Justice.* (National Archives)

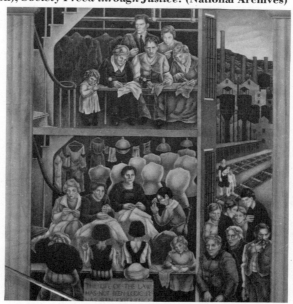

crats as Moses, Menes, and Hammurabi are depicted by Boardman Robinson (1876–1952), and the work includes such milestones as the Magna Carta and the signing of the Constitution, themes suggested by Pound. Robinson's subject matter is traditional, but George Biddle's (1885–1973) *Society Freed through Justice*, a contemporary theme, relates to the social philosophy he had proposed to the president. The central panel, with a bucolic farm scene of family life, clearly states Roosevelt's credo: "a more abundant life for all." His other panels propose that the evils of tenement and industrial life can be eradicated through enlightened law and social justice.

Biddle was so obsessed with his mural project that in a dream he saw himself as the Italian fresco master Piero della Francesca.[46] Yet his use of taut, attenuated figure drawing resembled more the style of the Italian primitives than that of della Francesca. A solid draftsmanship was seen in Robinson's work, but Biddle employed distortion, creating a poignant mood and emphasizing social realism in his murals. The minute brushwork and rich, muted coloring of Biddle's art owed much to the influence of Rivera's style.

In contrast to Biddle's social realism, Maurice Sterne (1877–1957) developed symbolic themes from jungle-law origins or "survival of the fittest" to the legal codes of contemporary society. The art critic Royal Cortissoz shrewdly observed that Sterne, in his murals, mixed "brain-stuff" with his colors. The visual patterns of his central panel, *The Search for Truth*, depict the human traits apt to obstruct justice: Brute Force, Greed, Cruelty, and Red Tape. In one of the compositions the Law is shown as Custodian of the Past, Present, and Future. In another the figure of "Truth" rises from the dead, suggesting that truth never perishes.[47]

Both Emil Bisttram (1895–) and Symeon Shimin (1902–) employ themes that show the influence of contemporary justice in the lives of individuals. The allegory of Justice liberating women is illustrated in Bisttram's *Contemporary Justice and Women*. In the foreground a hooded figure symbolizes Tradition-Ignorance. In the middle distance a woman holds in her hands the yoke and chain severed by the Sword of Justice under the guidance of the Law. Another female figure passes into the Light of Freedom, a precursor of contemporary "Women's Liberation." Also introduced are smaller panels that contrast women engaged in traditional occupations with those of women in modern occupations since emancipation.[48]

Maurice Sterne (Section), *Search for Truth.* **(National Archives)**

Maurice Sterne (Section), *Search for Truth,* **mural sketch. (National Archives)**

Emil Bisttram (Section), *Contemporary Justice and Woman.* **(courtesy of Rudolph von Abele)**

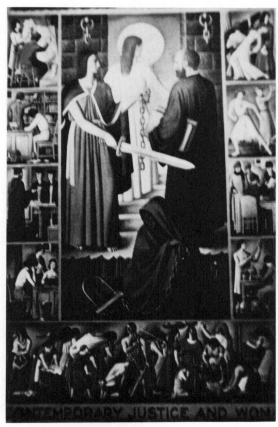

The concept of *The Child and Justice* is described by Shimin in the following manner:

> In planning my design, I based it on the theme of the Constructive versus Destructive elements in the life of a child. The Constructive: through intelligent planning—study and sport—all that helps to build a healthy body and mind ready to cope with vital problems when coming into manhood. The Destructive: being stumped in growth—willed through toil—destroyed by it—so that within the folds of a great country there exists, perhaps, the saddest and most tragic blight.[19]

In the painting a youth about to leave home finds himself at the crossroads of life; directly below, two huge hands hold a triangle and compass, symbols of planning and building. On the left side, in a factory's shadow, a group of underprivileged children appear in a downtrodden condition; on the right another group is shown under ideal conditions, given a chance for study and recreation.

A future idealistic concept of life for liberated women is delineated by Bisttram. The allegorical figure of a young woman moving toward a distant horizon expresses this bright promise. However, Shimin presents a realistic contemporary crisis. Youth—in a dramatic frontal portrait—confronts society with the question "Whither the Future?"

Symeon Shimin (Section), *The Child and Justice*. (National Archive

Leon Kroll (Section), *The Victory of Justice*. (National Archives)

A contrast of concept underscored Leon Kroll's (1894–1974) contemporary classicism and Henry V. Poor's (1888–1970) contemporary realism. Justice as an abstract idea, simply stated, was Kroll's approach. Yet he believed that its profundity could only be expressed by plastic means, giving an emotion through its design and color.[50] The new idealism of the New Deal was clearly stated in his *The Victory of Justice:* "The idea is justice through law, leading the people to a more abundant life. It is in a way, a graphic statement of the philosophy of the present administration."[51] In the tradition of the Renaissance—espoused by Bruce—Kroll's work revealed a clarity of form and balanced, classic composition. This aesthetics was further enhanced by Kroll, using the features of Justice Harlan Stone to define the ideal judicial figure, leading the underprivileged out of misery to the promised land.[52]

Whereas Kroll used an allegorical approach, Poor found his subject matter in the actual activities of the Justice Department. In the *Bureau of Prisons* he depicted a prisoner entering jail, learning a trade, and returning to society. His style was reminiscent of Orozco's art: strong drawing, somber coloring, and harsh figurative composition. The Section, in fact, was greatly impressed by Poor's contemporary realism. "In my estimation, these designs come nearest to being the type of work which I want the Section to stand for than anything that has been presented to date," Rowan informed Bruce.[53]

Kroll's theme showed an ideal concept of figure and landscape, clothed in "Life as it might be"; but Poor's theme revealed a harshly rendered environment: an uncompromising "Life as it is." This approach was readily seen by Poor's own intention to develop his sketches in a simple, realistic way, instead of using what he considered the so-called symbolic way.

Henry V. Poor (Section), *Bureau of Prisons.* **(National Archives)**

In a decorative program for the Interior Department, Bruce faced an unexpected dilemma—confrontation with the "Old Curmudgeon," Secretary of the Interior Harold L. Ickes. Perhaps the conflict may not have been as traumatic as the church issue over Sterne's murals, but neither did Bruce consider it lightly. The Section developed plans for the themes—conservation of natural resources—but Ickes intervened and arbitrarily decided on the artist and work to be used in the building. He lacked the qualifications, but—much of Bruce's distress—he chose to be the art arbiter. At the outset Ickes organized his own art committee. After an interim period, however, he dismissed the committee, insisting that the final selection of work would be subjected to his approval.[54]

When the secretary rejected Millard Sheets's (1907–) four sketches, "Air, Fire, Sand, and Water," Bruce resented Ickes's autocratic manner. That he disliked dealing with a "complete vulgarian" like Ickes is indicated by this correspondence with Rowan:

> I personally feel that Sheets' designs, particularly for the flood control, is [sic] about the most distinguished, imaginative and creative work which has yet been contributed to the Section, and unless you see some reason against it, I am inclined to go back to the Secretary . . . urging him to reconsider Sheets' design.[55]

Millard Sheets (Section), *Flood Control*, mural sketch. (National Archives)

Sheets' initial sketch of *Flood Control* showed a swirling bird's-eye perspective of water, mountain, and dam control activity, strongly reminiscent of Oriental art with its abstract, rhythmic qualities that Bruce so admired during his early years in China. Ickes, however, was not inclined to change. Having observed that Sheets could paint figures, however, he suggested a theme dealing with minorities, either a black or an American Indian. Bruce voiced concern when he wrote to Sheets:

> The Secretary of the Interior is a complete Tsar in the situation. He has as much power over the situation as if he were spending his own money and if he got annoyed all he would have to do would be to cancel the whole project by a stroke of his pen.[56]

Because Ickes could not be swayed and Bruce did not care "to take it on the chin" any longer, he turned the program over to Rowan to deal with "the Old Curmudgeon." Meanwhile, Sheets decided on the theme of the black culture, depicting accomplishments in religion, science, education, and art.[57] The formally constructed interiors, showing persons engaged in sociocultural pursuits, offer a sharp contrast to the freedom of the early sketches. Sheets's theme on religion, however, stresses emotionalism through the expressive use of hands and elongation of figures, effecting

Millard Sheets (Section), *The Negro's Contribution in the Social Development of America.* **(National Archives)**

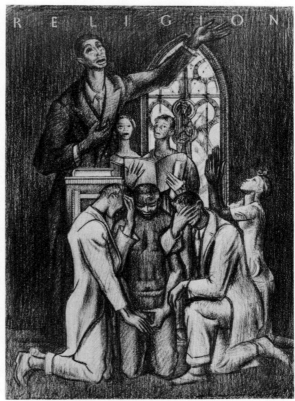

a sense of moving and swaying. In the foreground a pyramid composition of figures in prayer is echoed in the background by the Gothic form of a stained-glass window.

Ernest Fiene (1894–1965) had so much factual data to consider that he requested detailed photographs of grazing, fire desolation, and reforestation. As the work developed, the secretary sharply criticized one of the figures in *Reforestation*, declaring that it looked like somebody's idea of "a pretty boy with good strong muscles." Instead, he demanded to see some Western character in the work. In the design for *Forest Fire Control*, Ickes wanted more flames, "running tongues of red and yellow all over the ground."[58] In exasperation Fiene told Rowan, "I believe altogether the realistic elements are overstressed. The story can be told better through the imagination of the artist."[59] Apparently, Ickes was never convinced because Fiene's work failed to satisfy him completely.

Yet some of the artists were able to escape the so-called slaughter of the other designs incurred by Ickes. In the case of William Gropper (1897–), his sketches for *Reclamation and Construction of the Dams* were only tentatively approved because in the foreground a partially completed dam was required instead the rockpile Gropper depicted. The secretary also requested the workmen's heads to look more like "typical American" workmen. Apparently, Ickes's fetish for Americana caused him to be overly critical. However, he was quite pleased with Gropper's completed work.[60]

John Steuart Curry's (1897–1946) concept referred to the historic opening of Ok-

Ernest Fiene (Section), *Reforestation.* **(National Archives)**

Ernest Fiene (Section), *Forest Fire Control.* **(National Archives)**

William Gropper (Section), *Reclamation and Construction of the Dams.* **(National Archives)**

lahoma Territory in 1889. When Ickes questioned that a train had entered the Territory (as depicted in Curry's design), the Section—not daring to offend the secretary—asked that it be eliminated. The portrayal of the army holding back the pressing multitude also was questioned. Yet, Curry insisted that he was right about depicting the railroad entering the Territory—and he proved his point by citing from such historical sources as *The Formation of the State of Oklahoma* by Roy Gittinger; *History*

John Steuart Curry (Section), *Opening of Oklahoma,* **mural sketch. (National Archives)**

Woodrow Crumbo (Section), *Buffalo Hunt,* **mural sketch. (National Archives)**

of the State of Oklahoma by B. Luther and A. B. Hull; and *A Standard History of Oklahoma* by J. B. Thoburn. With such scholarly data Curry was able to convince both the Section and Ickes of its verisimilitude.[61]

Because Ickes had an interest in American Indian art, native American artists were invited to do murals. The Section paid the Indians the same rate as the other artists because discrimination was not permitted by the secretary. The designs they developed—ceremonial dances, legends, and hunting scenes—met with the secretary's total approval.

The cultural differences between "red man" and "white man" the Indian artist Woodrow Crumbo curiously noted while on the project:

. . . a nation's development is gauged by its art but personally I think our advancing civilization is a great deterrent to culture—what culture has a machine? What I mean is this culture is based on tradition, tradition on legends, and legends are made by people who are free in spirit and mind.[62]

When the Interior Department decorations were completed, the secretary summed up his relationship with the Section in a letter to Rowan:

I take this occasion also to express my appreciation of your uniform courtesy and understanding in the matter of our murals. You have been very patient with a man

who doesn't know anything about paintings other than that he likes what he likes.[63]

He never justified his one-man review procedure in any other way.

Unlike the Interior Department project, Bruce had better success in planning murals for the Social Security Building because he had no Ickes to frustrate him. He asked Arthur Altmeyer, chairman of the Social Security Board, for a definition of Social Security that artists would find useful for their mural concepts. Altmeyer replied: ". . . one purpose is constant—the American people are always striving for the kind of life that will assure to themselves and to their families and their neighbors, a chance to make their own way in the world."[64] President Roosevelt's message to Congress of June 8, 1934, however, best expressed the ideological theme of Social Security:

> Among our objectives, I place the security of the men, women and children of the Nation first. This security for the individual and for the family concerns itself primarily with three factors. People want decent homes to live in; they want to locate them where they can engage in productive work; and they want some safe-guard against misfortunes which cannot be wholly eliminated from this man-made world of ours.[65]

Bruce also requested an aesthetic statement from the member of the Fine Arts Commission Henry V. Poor:

> I think that the basis of any great mural, as of all great painting, is a sense of the pictorial necessity, a visual freshness and reality, which speaks more clearly than any other thing.

> In Masaccio's "The Tribute" you will find the simplest possible illustration of the figures, in their grouping, in their types and in their gestures. These things hold the finest wisdom, but it is created out of visual sensibility, not out of ideas.[66]

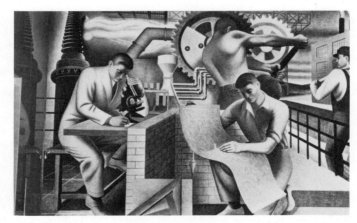

Seymour Fogel (Section), *The Wealth of the Nation,* **detail of mural. (courtesy of Rudolph von Abele)**

Seymour Fogel (Section), *The Security of the People*, **detail of mural. (courtesy of Rudolph von Abele)**

The statement aptly echoed Bruce's own sense of tradition, which governed his program.

The three artists commissioned to decorate the Social Security Building were Seymour Fogel (1911–), Philip Guston (1913–), and Ben Shahn (1898–1969). In the building lobby, *The Wealth of the Nation*, contrasting manufactured resources—industry, planning, and construction—with natural resources—irrigation, grain, and farmers—was painted by Fogel. The other panel, *The Security of the People*, depicted the family and security in old age. Fogel explained that his murals "function as an introduction to the other artistic material in the building."[67] His mural designs were carefully constructed in color, drawing, and composition. Also clearly stated was Fogel's concept, reflecting the traditional approach advocated by Bruce.

Of Philip Guston's three-panel decoration in the auditorium, *Reconstruction and the*

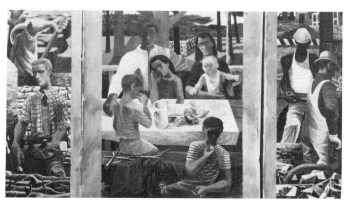

Philip Guston (Section), *Reconstruction and the Well-Being of the Family*. **(National Archives)**

Well-Being of the Family, the central panel showed a picnic scene so beautifully conceived that the Section asked that it be retained as a concept. It was suggested that the side panels depict rural workers and city workers, but Rowan assured Guston, "Under no circumstances is it the wish or intention of the Section to dictate to you what your designs should be."[68]

During the progress of Guston's work the Social Security Board wanted to see a more realistic treatment of the people. (The boy at the picnic table, for instance, looked more like a clay figure than a human being.) Guston refined his drawing, but he was more concerned about the color tonality of his work; "I visualize the finished mural as having a mellow blonde quality about it," he wrote. He added, "The delicate balance between a strong realism and an all-over decorative pattern is what I'm after."[69] Guston's family at a picnic table is similar to Biddle's *Justice*—each shows the family sharing "in a more abundant life," one of the principle themes of the New Deal. Unlike Biddle, however, who contrasted his agrarian idyllic scene with the urban evils of tenement life, Guston suggested that security for the family can be achieved through the New Deal Social Security Act.

Excited about his mural commission, Shahn told Bruce: "To me, it is the most important job that I could want. The building itself is a symbol of perhaps the most advanced piece of legislation enacted by the New Deal, and I am proud to be given the job of interpreting it, or putting a face on it." He concluded with the good news of his hometown vote in the 1940 elections, ". . . and Jersey Homesteads went 93 percent for Roosevelt!"[70] The same outgoing enthusiasm formerly expressed for his PWAP *Prohibition* mural sketches was reiterated by Shahn: "It seems to me that in all my work for the past ten years, I have been probing into the material which is the background and substance of Social Security . . . all of it having to do with the problem of human insecurity."[71]

Shahn developed his theme for the east and west walls in the entrance of the north-south corridor. The insecurity of society is portrayed on the east wall. *Unemployment* is presented as an endless waiting, heightened by the desolated mood of man and boy disappearing into a receding perspective bereft of hope. Against the background of a stark company house, discouraged men and discarded machines point up the inability of technology to solve human problems. *Child Labor* dramatizes the insecurity of childhood, showing a crippled boy worker emerging from a mine. In the panel *Old Age* the insecurity of dependents—the aged and the sick—is depicted.[72]

On the west wall Shahn developed three themes: *Work*; *The Family*; and *Social Security*. While the figures on the east wall show unemployment and child-labor

Ben Shahn (Section), *The Meaning of Social Security: Unemployment*, mural sketch. (National Archives)

Ben Shahn (Section), *The Meaning of Social Security: Child Labor,* **mural cartoon. (National Archives)**

Ben Shahn (Section), *The Meaning of Social Security: Old Age.* **(courtesy of Rudolph von Abele)**

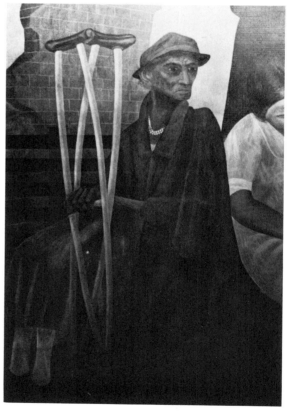

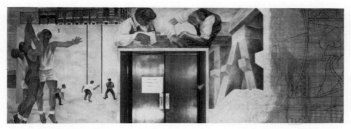

Ben Shahn (Section), *The Meaning of Social Security: Recreation and Work,* **detail of mural in progress. (National Archives)**

abuses, the figures on the west wall, engaged in work and recreation, exemplify the new hope of Social Security.

Although the painter member of the Fine Arts Commission, Henry V. Poor, reacted against these "strangely photographic, and pieced-together details," he praised Shahn's work because of its strong technique and personal vision.[73] In their social realism the murals revealed unexpected power and poignancy (particularly, the *Child Labor* panel). The problem of human insecurity that had long interested Shahn was successfully probed and powerfully expressed in his Social Security murals.

Section Art in the States

In Washington the departmental activities of the federal government were depicted, but in the states the murals reflected unique characteristics of the American scene. Bruce's concept of bringing beauty to U.S. communities through local post office murals goes back to his travels in France. Citing the French painter Camille Pissarro, who had brought beauty into the lives of villagers in Acquins, France, Bruce commented:

> This, to me, is the essence of the service that an artist can render to the people. It is the business of the artist to seek for beauty and record it, and if through him, others come to see it, and by seeing it, gain that sense of well-being and contentment that beauty gives, he has had his reward.[74]

Hence, Bruce's "Acquins" dictum became his goal in the states—that of making communities across the country aware of their own American scene through murals in local post offices.

In Washington the Section program was broader, but in the states the work often consisted of a single panel for a post office. This work, however, provided for a flexibility of styles not realized in Washington, such as the abstract art of Karl Knaths, Lloyd Ney, and Niles Spencer. The artist was advised to visit the locale where his or her mural would be installed and discuss his or her ideas with the postmaster and other community leaders. This procedure reiterated the patron-artist relationship used by Bruce for his Washington projects.

Historic pioneer themes were developed by Karl Knaths (1891–1971) and Ward Lockwood, but their concepts differed in focus and style. Knaths did sketches for the post office in Rehoboth Beach, Delaware, that contrast the mail of pioneer days with modern delivery. He was asked by the Section to expand his pioneer theme, but after

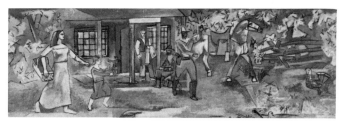

Karl Knaths (Section), *Frontier Mail.* **(National Archives)**

visiting the locale, Knaths sent another idea: "The whole life and existence of the town is in its beach. They have a boardwalk on piles and at each corner a step leads to the beach."[75] The Section preferred his original pioneer theme, however, so Knaths depicted a rural setting in which mail is delivered at the county store.[76]

When Lockwood submitted sketches for the post office in Lexington, Kentucky, he commented: "Blue-prints, marble bases, doors, acoustic tile, thorough-breds, Daniel Boones, Henry Clays, etc., have kaleidoscoped through my head until the wee hours."[77] His theme shows Daniel Boone and his party arriving in the spring of 1769 at the future site of Lexington, Kentucky. The research comes from a quotation in Stewart Edward White's *Daniel Boone: Wilderness Scout:* "Long they stood leaning on their rifles. . . . Perhaps, it was from this point that Boone received his inspiration that he was ordained by God to open an empire to a people." The Section removed a clock from the post office after Lockwood complained, "I would hate to have it balanced right on the top of Daniel Boone's head."[78]

Knaths develops a left-to-right linear rhythm in his design. In the foreground a mother and child approach the store—a bird hovering above emphasizes the forward movement of the group. In the middle distance the movement of a pony-express rider about to depart is stressed by the placement of a triadic group. The frontal plane of horse and rail fence completes the linear rhythm. To express his cubist, semiabstract theme, Knaths uses shifting, flat areas of color within a structure of black lines. The subject of Knath's work indicates no particular moment, but Lockwood's theme deals with a specific time in history. The use of strong realism in Lockwood's mural serves to stress the particular historic event. In contrast to Knaths's horizontal, changing patterns of movement, Lockwood places the dominant figure of Boone within a triadic structure, which emphasizes the speculative mood described in White's quotation.

The same era in United States history—the period of the 1840s—is depicted by Sheffield Kagy (1907–) and John Sloan (1871–1951). For the post office in Luray, Virginia, Kagy researched old records and maps to reconstruct the antebellum scene of *Luray in the 1840's.* He not only wanted to convey those traditions to the townspeople but also to depict the historical setting in a way that was different from what they see every day. "One of the colt's legs is too short" was Rowan's only comment on Kagy's design.[79]

Sloan also researched the 1840s to develop his theme *Arrival of the First Mail in Bronxville,* for the Bronxville Post Office near Yonkers, New York. After submitting his designs he expressed a deep concern about waiting too long for a reply: ". . . two weeks or more have gone by—and I'm over sixty years old."[80] When the assignment was completed, Sloan decided to rest in Santa Fe, New Mexico, but first he told Rowan, "I am at your service for further murals."[81]

Ward Lockwood (Section), *Daniel Boone's Arrival in Kentucky.* **(National Archives)**

Sheffield Kagy (Section), *Luray in the 1840's.* **(National Archives)**

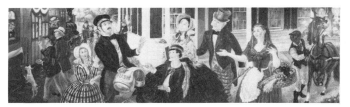

John Sloan (Section), *Arrival of the First Mail in Bronxville.* **(National Archives)**

A careful, realistic American scene in an agrarian setting was rendered by Kagy. Although he did not experiment with linear space as Knaths did, a solid approach to good design is seen in Kagy's composition. Sloan, on the other hand, painted an urban setting—sentimental and nostalgic—a yearning for the past. "A good-natured representation—it tells of good days, of sunshine and progress," wrote one critic.[82] This Sloan revealed by showing the varied expressions of citizens gathering around the postmaster for their mail; and a carriage scene, where the horse, frightened by the smoke and sound of a train, is about to run away.

In a case contrary to expectations the Section asked Lloyd Ney (1893–) to design a mural for the New London Post Office in Ohio, not realizing that they would be getting an abstract mural concept. Previously, he had submitted a realistic sketch for a St. Louis competition. The New London mural design was rejected by the Section because of its abstract design. Believing that the public would never understand it, Rowan suggested that Ney work toward some objective clarity: "Your design seemed more fitting as a theatrical back-drop than a single mural decoration in a Federal building."[83] Ney, however, got the support of the townspeople and former St. Louis jury members, which caused the Section to reconsider its decision. One of the jury members wrote to the Section, "Although his designs are on the abstract side I believe that as far as artistic standards are concerned, they surpass some of the more realistic work that has been done."[84] "I am only fighting to present a new form of decoration— that is in tune with the period we are living in," Ney commented.[85] Later, Rowan became a firm supporter of Ney's work and attempted to interest New York museums in his abstract art.[86]

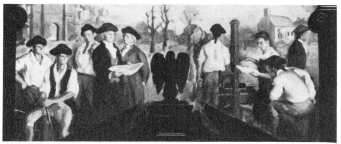

Lloyd R. Ney (Section), mural design for St. Louis mural competition. (National Archives)

Lloyd R. Ney (Section), *History of New London.* **(National Archives)**

A curious blend of three elements comprises Ney's theme: first, historic incident—the betrayal of Benedict Arnold; a local character who walked to New York, leading a goat; and Civil War veterans returning home; second, contemporary scene—the depiction of C. C. Word Company, supplier of caps and gowns; and third, abstract shapes—a square, circle, and triangle, symbolizing the spirit and activities of the post office (near the top of the triangle, an eye represents the observing eye of the postmaster.)[87] Ney's work suggests some of the experimental, abstract trends seen in PWAP, such as the art of Burgoyne Diller and Stuart Davis. For instance, in what Ney calls his "Composite Picture," he combines some of the typical figures reminiscent of Davis's mural scheme *Analogical Emblem* and the purely abstract shapes in Diller's art.

Two very contrasting approaches were used by Doris Lee and Niles Spencer to depict the contemporary American scene. Lee introduced the local flavor of an agrarian community in her mural for the post office in Summerville, Georgia. This includes fieldworkers, a girl holding a Cherokee rose (the state flower), corn, cotton, peaches, and the red soil of Georgia. In Washington, Lee had encountered a problem about using caricature in her Post Office project, which she modified. In Summerville a similar incident occurred when Rowan warned her: ". . . all of the figures have the same stemlike necks and skinny arms and there is a danger that the people of Summerville will regard this as your personal characterization of them and will, no doubt, resent being presented as though they were half-fed."[88] Again, she made the changes that not only pleased the Section but herself as well.[89]

After the Section commissioned Niles Spencer (1893–1952) to develop a mural design for the post office in Aliquippa, Pennsylvania, he requested and received this information: "There are steel mills and dairy, poultry, fruit and truck farms in the vicinity." Later, he spent three weeks in the town, gathering on-the-spot data for his subject matter, which emphasizes the industrial American scene.[90]

Doris Lee (Section), *Landscape of Summerville, Georgia.* **(National Archives)**

Niles Spencer (Section), *Western Pennsylvania.* **(National Archives)**

Lee infuses the agrarian scene with a kind of popular folk culture: a man carrying a fishing pole, the fish catch, and a musical instrument. This folklore approach is similar to what she had done in the Post Office project in Washington. A decorative design is prevalent throughout the Summerville mural, reflecting a nostalgic innocence of nineteenth-century America. Spencer also stresses a decorative design, but unlike Lee's theme he shows an unpeopled industrial landscape. Using a highly formal approach, he carefully constructs his steel mills, factories, train, bridge, and mountains into a stylized classic design. Spencer's theme emphasizes twentieth-century America—a highly efficient industry that imposes itself on the landscape; even the steel mills, centrally placed, dominate the towering mountains in the background.

The cotton industry in a contemporary setting is depicted by Philip Evergood (1901–) for the post office in Jackson, Georgia. Because the postmaster in Jackson expressed an interest, Evergood wrote: "In preparing the designs for the mural in the Post Office at Jackson, Georgia, I have been concentrating on the theme of cotton—treated in a pictorially progressive way from the fields and picking, to the mills."[91] In preparing his concept, however, Evergood's progress reveals a curious evolution. In the first place he showed a distortion of human figures characteristic of social protest art, which in the opinion of the Section would never be understood by the public. Rowan advised, "I do not believe . . . you are very conscious of the fact that you are painting not for the Section of Painting and Sculpture, nor for an artists' group, but rather for the people of Jackson, Georgia."[92] Evergood then changed his drawing, and it was approved. The Section, however, objected to another element in the new design. Evergood introduced a woman and child in the foreground, but Rowan believed that the people of the South would be morally offended: "She frankly looks a little too much like a tramp that is accompanying the workers."[93] To solve the problem Evergood substituted shrubbery for the two figures.

Evergood's work *Cotton—From Field to Cotton*, employs the literal, contemporary

Philip Evergood (Section), *Cotton—from Field to Mill,* **mural sketch. (National Archives)**

Philip Evergood (Section), *Cotton—from Field to Mill.* **(National Archives)**

realism of the American—not the nostalgic longing for a plantation South. The contemporary approach he explained in this manner: "The subject is treated decoratively and is conceived as a work of art, being a frieze of figures representing cotton pickers depicted in a typical cotton growing landscape."[91]

TRAP Art in the States

One of the most impressive series of murals under the Treasury Relief Art Program (TRAP) was painted by Reginald Marsh for the rotunda of the Customs House in New York City. He commented, "Here is a chance to paint contemporary shipping with rich and real power, neither like the story telling nor propagandist painting which everybody does."[95]

When Marsh and his three assistants commenced work, he asked TRAP chief Cecil Jones what he intended to do about the condition of the walls in the Customs House that were already half-demolished. Marsh anxiously wrote:

Well, what next? If nothing happens, my head is hanging in despair and I will give birth to kittens. I am anxious to do this job fast, cheap and efficiently, and we will save the American people money in the end—but give me a good wall—and I will give you a good picture.[96]

Jones assured Marsh that the plastering problem was being worked out and added, ". . . I hope your duties as liaison officer, foreman, clerk, and what have you, will be over and you can once more practice your occupation as painter."[97]

Marsh, in turn, explained that they were mending wire lathe, and his assistants were getting physical culture. Jones, later, postponed his vacation because of increased problems with the Customs House:

We have had to replaster the whole dome of the rotunda. This has been a hell of a job, and we had to get a special Presidential order on it, in order to get it done. There has been all kinds of trouble. One of the men fell from the scaffolding, which is no patsy of a scaffold being 14 feet high and was seriously hurt. Now since the downpour of last night the darn roof is leaking. I have to go to New York tonight and try to straighten things out.[98]

These problems were alleviated, but Marsh unexpectedly encountered a new issue when controversy erupted between the U.S. Maritime Commission and the Treasury Department. Joseph P. Kennedy, chairman of the commission, informed Secretary of the Treasury Henry Morgenthau that the use of a foreign vessel in Marsh's mural did not help the government to develop and encourage support for U.S. carriers. The new U.S. passenger liner should be the focal point, he contended. Morgenthau replied, however, that any revision would seriously jeopardize completing the assignment. Bruce informed Morgenthau that Marsh had asked for but received no information about the new U.S. liners. Because the murals were already half-finished, Bruce recommended completion without delay, and Morgenthau agreed.[99] When Marsh completed the work, Jones wrote:

Reggie, sincerely and from the bottom of my heart, congratulations on a wonderful job. I can truthfully say it is the best mural job that I have ever been in contact with and I am proud to have been just one of the clerks on the job.[100]

The various stages in the arrival and docking of a vessel in the Port of New York are represented by Marsh. In one example, as the H.M.S. *Queen Mary* approaches the Battery, the press interviews a celebrity on the deck of the vessel. The project also includes black-and-white grisaille panels which are interspersed with the murals, showing portraits of such great explorers as Christopher Columbus, John Cabot, Amerigo Vespucci, and Henry Hudson.[101] Marsh's vigorous realistic style, accented

Reginald Marsh (TRAP), *Activities of New York Harbor.* **(National Archives)**

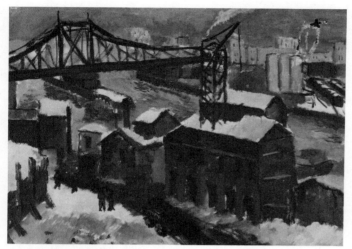

Sol Wilson (TRAP), *Harsh Winter.* **(National Archives)**

Joseph Raskin (TRAP), *Modern City.* **(National Archives)**

by rich colors and rhythmic patterns, is well-adapted to the rotunda of a building in classic architecture.

While TRAP augmented the Section's mural work in the states, it also provided easel works for federal agencies and embassies. The paintings, in general, depicted realistic urban and rural American scenes. Experimental and controversial themes were not encouraged, but sometimes an implied social comment appeared in the TRAP art.

Contrasting styles were used by Sol Wilson (1894–) and Joseph Raskin (1887–) to paint urban scenes. A free, vigorous style captured the solidity of form and aspects of a harsh winter in Wilson's painting. Raskin, however, carefully constructed his urban scene. In the middle distance, the verticality of buildings is stressed by a series of foreshortened rooftops, emphasizing the grandeur of the city. But in the foreground an anonymous picket line points to the human protest in the streets.

In a cityscape devoid of human activity or perhaps, of human hope, George Ault (1891–1948) renders in bird's-eye perspective buildings bordered by a long diagonal of a street. The architectural detail of each building is developed to convey a precise, decorative rhythm.

Aaron Bohrod (1907–) and Faust Azzaretti approached the American scene differently in their rural themes. A haunting sense of desolation was painted by Bohrod, using vividly stated details. The elements of his social comment include empty vegetable stalls, a lonely black dog, and stark trees pitted against a depressing gray sky.

George Ault (TRAP), *Urban View.* **(National Archives)**

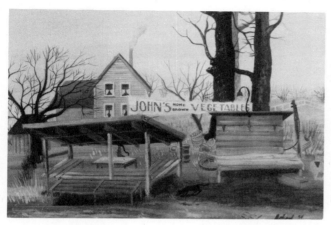

Aaron Bohrod (TRAP), *John's Vegetables.* **(National Archives)**

Faust Azzaretti (TRAP), *Bleak Sky.* **(National Archives)**

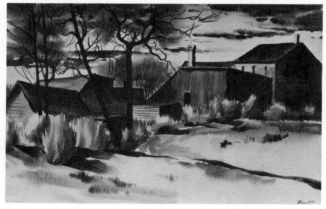

Azzaretti also revealed a similar bleak American scene, but without Bohrod's implicit social consciousness. Farmhouses are painted with a vigorous, realistic technique, showing bold contrasts between foreground and middle ground. Dark, leafless trees are silhouetted against a sky that contains strong cloud accents.

Bradley Walker Tomlin (1899–1953) fared better with his easel work than with his mural designs because his color and abstraction pleased TRAP. Agricultural products are depicted in an experimental style. Shapes of growth within a two-dimensional composition by Tomlin relate to a series of rectangular forms, and movement is created by diagonal strips. A bottom, horizontal band seems to represent an earth line for organic forms.

Bruce's tradition successfully governed the Treasury art programs—expressing the Renaissance ideal that formulated his aesthetic philosophy. Not without reason,

Bradley Walker Tomlin (TRAP), *Composition.* **(National Archives)**

Bruce cited the work of the Renaissance painter Piero della Francesca as an example of the "supreme artistic creation" that he wanted artists to emulate under his program. This realistic, representational approach involved what the Renaissance scholar Bernard Berenson described as "tactile values"—the experience of exploring a world of solid things. Related to this dictum was the quality criterion, reflecting Bruce's goal to get the finest art for federal buildings. Berenson's advice to Bruce, "It's got to have the goods," aptly described the tradition of this quality standard. Bruce's "patron-artist" relationship—a concept going back to the era of the Renaissance Medici—also reflected this tradition to get quality art in the Treasury programs.

The keystone of Bruce's operations, however, was the competition system. This procedure, a variant of the juried system, had long been used by museums and art organizations throughout the country to judge anonymous entries. Some of the best known and most promising artists in the country were attracted to his anonymous competitions. If there was any question about Bruce's traditional approach producing outstanding work, at least it was never doubted by the eminent author and art collector Somerset Maugham. He declared that some of the finest contemporary American art was painted under the Section. Moreover, Bruce's competition system was warmly praised by George Biddle, who commented:

> . . . you could point to the dozen or so people like Maurice Sterne and Zorach and so forth, and Boardman Robinson, who did outstanding murals that probably are as fine as any murals that our country has done for Federal buildings, a dozen of them or so. Ned has that to show for it, and that wasn't just a lot of stuff that ought to be whitewashed off the walls.[102]

Nevertheless, despite Bruce's orthodox philosophy, a sound, almost symbiotic understanding existed between the artists and the Treasury art programs. Bruce's goal of getting quality art was shared by them—hence, the distinguished work that appears on the walls of federal buildings across the nation. The murals in Washington compare favorably with the best American murals commissioned before the Depression. Experimentation was not encouraged, but some very imaginative work appeared, and Treasury artists, including Karl Knaths, Philip Guston, Bradley Walker Tomlin, and Ben Shahn, among others—pioneered in new directions that subsequent artists would follow.

Notes

1. Roland Monsseau, Project Card, Public Works of Art Project, December 27, 1933, and Austin Mecklem, Project Card, Public Works of Art Project, December 19, 1933, RG 121/117.

2. John Sloan, Progress Report, Public Works of Art Project, January 19, 1934, RG 121/117.

3. Bradford Collins to Edward Bruce, April 10, 1934, RG 121/108.

4. Norman S. Chamberlain to Edward Bruce, February 1, 1934, RG 121/108.

5. Henry T. Hunt to L. W. Robert, Jr., October 25, 1933, RG 121/108.

6. Ben Shahn to Lloyd Goodrich, n.d., RG 121/117.

7. Ben Shahn to Juliana Force, January 8, 1934, RG 121/117.

8. Grant Wood, A Report On Iowa Art under Public Works of Art, January 20, 1934, RG 121/123; *Cedar Rapids Gazette*, January 21, 1934.

9. Grant Wood to Edward B. Rowan, January 15, 1934, RG 121/123.

10. Adeline Taylor, "CWA Art Project Proves to Be Practical Undertaking as Developed by Grant Wood," *Cedar Rapids Gazette*, January 21, 1934; Darrell Gar Wood, *Artist in Iowa* (New York: W. W. Norton & Company, Inc., 1944), pp. 180–84.

11. Grant Wood to Forbes Watson, March 3, 1934, RG 121/123.

12. Stuart Davis, Project Card, Public Works of Art Project, December 26, 1933, and Stuart Davis, Progress Report, Public Works of Art Project, March 7, 1934, RG 121/117.

13. Arshile Gorky, Project Card, Public Works of Art Project, December 22, 1933, RG 121/117.

14. Arshile Gorky, Progress Report, Public Works of Art Project, March 7, 1934, RG 121/117.

15. John B. Flannagan to Juliana Force, December 18, 1933, RG 121/104.

16. John B. Flannagan, Project Card, Public Works of Art Project, December 22, 1933, RG 121/104.

17. Duncan Phillips to Charles Moore, June 12, 1934, RG 121/105.

18. Forbes Watson, "The Return to the Facts," *American Magazine of Art* (March 1936), p. 51.

19. Forbes Watson, "Henry Varnum Poor," *American Magazine of Art* (July 1936), pp. 447–50; Watson, "The Return to the Facts," p. 153.

20. Edward Bruce to Olin Dows, November 12, 1935, RG 121/119.

21. Edward Bruce to Forbes Watson, November 22, 1935, RG 121/125.

22. Edward Bruce to Forbes Watson, March 31, 1936, RG 121/125.

23. Edward Bruce and Forbes Watson, *Art in Federal Buildings, Mural Designs, 1934–1936* (Washington, D.C.; Art in Federal Buildings, Inc., 1936), p. 286.

24. Henry V. Poor to Edward B. Rowan, November 6, 1935, RG 121/133.

25. Henry V. Poor to Edward B. Rowan, November 26, 1935, RG 121/133.

26. Charles Moore to Edward B. Rowan, June 25, 1936; Olin Dows to Reginald Marsh, July 8, 1935; and Olin Dows to Reginald Marsh, July 29, 1935, RG 121/133.

27. Reginald Marsh to Olin Dows, n.d., RG 121/133.

28. Olin Dows to Reginald Marsh, August 15, 1935; and Charles Moore to Edward B. Rowan, September 18, 1935, RG 121/133.

29. Olin Dows to William B. Owen, November 27, 1936, RG 121/133; Bradley Walker Tomlin to Henry LaFarge, January 17, 1937, and Bradley Walker Tomlin to Henry LaFarge, February 6, 1937, RG 121/119.

30. Henry LaFarge to Bradley Walker Tomlin, March 6, 1937, RG 121/119.

31. Bradley Walker Tomlin to Henry LaFarge, March 9, 1937, RG 121/119.

32. Henry LaFarge to Charles Trumbo Henry, March 9, 1937; and description of Charles Trumbo Henry's mural in the Executive Dining Room, Department of Labor, Washington, D.C., nd., RG 121/119.

33. Boardman Robinson to Edward B. Rowan, December 14, 1935; and Edward B. Rowan to Boardman Robinson, December 27, 1935, RG 121/133.

34. Treasury Department, *Bulletin No. 6*, October-November 1935, pp. 3–4; Treasury Department Announcement of National Competition for Mural Decoration in the Department of Justice and Post Office Department Buildings, Washington, D.C., n.d., pp. 6–7, RG 121/130.

35. *Art Guides*, no. 2, Post Office Department (Washington, D.C.: Art in Federal Buildings, Inc., 1938), p. 7; Karl Free to Edward B. Rowan, June 28, 1937, RG 121/133.

36. *Art Guides*, no. 2, p. 8.

37. Ibid., p. 11; Ward Lockwood to Edward B. Rowan, March 27, 1937, RG 121/133.

38. *Art Guides*, no. 2, p. 9; Edward B. Rowan to Doris Lee, October 24, 1935, and Doris Lee to Edward B. Rowan, November 27, 1937, RG 121/133.

39. Edward B. Rowan to Alexander Brook, October 8, 1936; *Art Guides*, no. 2, p. 5; Edward B. Rowan to Alexander Brook, July 28, 1937, and Edward Bruce to Edward B. Rowan, July 27, 1937, RG 121/133.

40. Alfred D. Crimi to Edward B. Rowan, January 4, 1936, RG 121/133.

41. Alfred D. Crimi, "Description of Murals in P. O. Department," n.d., RG 121/133.

42. Reginald Marsh to Olin Dows, n.d., RG 121/133; *Art Guides*, no. 2, p. 13.

43. *Art Guides*, no. 2, pp. 14–17.

44. Louis A. Simon to C. J. Peoples (memorandum on mural work proposed for the Department of Justice building, n.d.,), and Roscoe Pound to Harlan F. Stone, April 26, 1935, RG 121/106.

45. Edward Bruce to Harlan F. Stone, April 30, 1935, RG 121/106.

46. *Art Guides*, no. 1, Justice Department Building (Washington, D.C.: Art in Federal Buildings, Inc., 1938), pp. 7–15; George Biddle's Diary, January 1, 1936, p. 237, Archives of American Art.

47. Royal Cortissoz, "Maurice Sterne as Mural Decorator," *New York Herald Tribune*, December 31, 1939, p. 8.

48. *Art Guides*, no. 1, p.19.

49. Symeon Shimin to Edward B. Rowan, July 31, 1936, RG 121/133.

50. Leon Kroll to Edward B. Rowan, February 18, 1936, RG 121/133.

5l. Leon Kroll to Edward B. Rowan, October 29, 1935, RG 121/133.

52. Edward B. Rowan to Leon Kroll, January 17, 1936, RG 121/133; Daniel Catton Rich to Edward B. Rowan, November 14, 1936, and Holger Cahill to Edward B. Rowan, November 14, 1936, RG 121/122.

53. Henry V. Poor to Edward B. Rowan, November 6, 1935, and Edward B. Rowan to Edward Bruce, October 10, 1935, RG 121/133.

54. A. E. Demaray to W. E. Reynolds, February 21, 1935; Edward B. Rowan to Edward Bruce, June 2, 1936; and Harold L. Ickes to C. J. Peoples, May 20, 1935, RG 121/122.

55. Edward Bruce to Edward B. Rowan, July 9, 1937, RG 121/122.

56. Report of July 14 and July 16 meetings between Harold L. Ickes and Edward B. Rowan, August 4, 1937, p. 2, and Edward Bruce to Millard Sheets, n.d., RG 121/122.

57. Millard Sheets to Edward Bruce, March 30, 1938. RG 121/122.

58. Edward B. Rowan to Ernest Fiene, July 21, 1937; Ernest Fiene to Edward B. Rowan, July 27, 1937; and E. K. Burlew to Edward B. Rowan, May 2, 1938, RG 121/133.

59. Ernest Fiene to Edward B. Rowan, October 26, 1935, RG 121/133.

60. Inslee A. Hopper to Ernest Fiene, August 4, 1937; Edward B. Rowan to William Gropper, June 3, 1937; Edward B. Rowan to William Gropper, November 23, 1938; and Edward B. Rowan to William Gropper, February 23, 1939, RG 121/133.

61. Contract with John Steuart Curry of Madison, Wis., September 8, 1937; Edward B. Rowan to John Steuart Curry, March 18, 1938; and John Steuart Curry to Edward B. Rowan, March 23, 1938, RG 121/122.

62. Edward Bruce to C. J. Peoples, n.d.; Report of July 14 and July 16 meetings between Ickes and Rowan, pp. 1–5; and Woodrow Crumbo to Edward B. Rowan, n.d., RG 121/122.

63. Harold L. Ickes to Edward B. Rowan, July 12, 1938, RG 121/133.

64. Federal Works Agency, Bulletin no. 21, March 1940, pp. 3–11, RG 121/130.

65. Ibid.

66. Ibid.

67. Federal Works Agency, press release PBA-FA-95, October 30, 1940; Seymour Fogel to Edward B. Rowan, March 30, 1942; and Seymour Fogel to Edward B. Rowan, December 24, 1940, RG 121/133.

68. Edward B. Rowan to Philip Guston, October 31, 1940, RG 121/133.

69. Edward B. Rowan to Philip Guston, June 18, 1941; Philip Guston to Edward B. Rowan, July 17, 1941; and Philip Guston to Edward B. Rowan, June 2, 1942, RG 121/133.

70. Ben Shahn to Edward Bruce, November 6, 1940, RG 121/133.

71. Ben Shahn to Edward B. Rowan, November 7, 1940, RG 121/133:

72. Ibid.

73. Gilmore D. Clarke to Edward Bruce, July 2, 1941, RG 121/133.

74. Edward Bruce, "Public Works of Art Project," printed in the *Congressional Record* of January 17, 1934, by request of the Honorable Joseph T. Robinson, Washington, D.C., Government Printing Office; Edward Bruce to Olin Dows, April 11, 1936, Bruce Papers, AAA Reel D85.

75. Karl Knaths to Edward B. Rowan, March 21, 1939, RG 121/133.

76. Edward B. Rowan to Karl Knaths, March 29, 1939, RG 121/133.

77. Ward Lockwood to Edward B. Rowan, November 10, 1937, RG 121/133.

78. Ward Lockwood to Edward B. Rowan, December 9, 1937, and Edward B. Rowan to Ward Lockwood, December 17, 1937, RG 121/133.

79. Interview with Sheffield Kagy by the author, December 2, 1971.

80. John Sloan to Edward B. Rowan, February 5, 1939, and Edward B. Rowan to John Sloan, May 11, 1939, RG 121/133.

81. John Sloan to Edward B. Rowan, May 16, 1939, RG 121/133.

82. *Bronxville Review Press*, June 8, 1939.

83. Lloyd R. Ney to Edward B. Rowan, December 14, 1939; Edward B. Rowan to Lloyd R. Ney, December 27, 1939; and Resolution of the New London Rotary Club to Louis A. Simon, March 5, 1940, RG 121/133.

84. Ward Lockwood to Edward B. Rowan, February 16, 1940, RG 121/133.

85. Lloyd R. Ney to Edward B. Rowan, October 10, 1940, RG 121/133.

86. Edward B. Rowan to Baroness Hilla–Rebay, August 6, 1940, and Lloyd R. Ney to Edward B. Rowan, November 28, 1940, RG 121/133.

87. Ney to Rowan, October 10, 1940, RG 121/133.

88. Doris Lee to Edward B. Rowan, January 30, 1939, and Edward B. Rowan to Doris Lee, March 27, 1939, RG 121/133.

89. Edward B. Rowan to Doris Lee, May 4, 1939, RG 121/133.

90. Niles Spencer to Inslee A. Hopper, November 6, 1936, and Inslee A. Hopper to Niles Spencer, November 10, 1936, RG 121/133.

91. Philip Evergood to Edward B. Rowan, July 30, 1937; Philip Evergood to Edward B. Rowan, November 22, 1937; and Philip Evergood to Victor H. Carmichael, November 22, 1937, RG. 121/133.

92. Edward B. Rowan to Philip Evergood, February 18, 1938, RG 121/133.

93. Edward B. Rowan to Philip Evergood, May 28, 1938, RG 121/133.

94. Philip Evergood to Edward B. Rowan, October 16, 1939, RG 121/133.

95. Reginald Marsh to Olin Dows, August 8, 1936, RG 121/119.

96. Louis A. Simon to C. J. Peoples, June 25, 1937, and Reginald Marsh to Cecil H. Jones, June 29, 1937, RG 121/119.

97. Cecil H. Jones to Reginald Marsh, July 19, 1937, RG 121/119.

98. Reginald Marsh to Cecil H. Jones, July 20, 1937, and Cecil H. Jones to Bernard Roufberg, August 23, 1937, RG 121/119.

99. Joseph P. Kennedy to Henry Morgenthau, Jr., August 26, 1937; Henry Morgenthau to Joseph P. Kennedy, September 2, 1937; Joseph P. Kennedy to Henry Morgenthau, Jr., September 7, 1937; and Edward Bruce to Henry Morgenthau, Jr., October 23, 1937, RG 121/119.

100. Cecil H. Jones to Reginald Marsh, December 27, 1937, RG 121/119.

101. Booklet "The Custom House, New York," n.d., pp. 2–6.

102. Transcript (#3), George Biddle interview, Archives of American Art, n.d., p. 81.

5

New Horizons

During the early thirties President Franklin D. Roosevelt made a genuine effort to establish his New Deal on a national basis, but the hope of a unified country struggling to cope with the problem of recovery failed to materialize. By the end of 1934 the New Deal was still confronted by social unrest, millions were unemployed, and business confidence was unrestored.

After the Public Works of Art Project (PWAP) was liquidated in June 1934, no other relief project of comparable magnitude for artists was organized until the Works Progress Administration (WPA) established a new program in August 1935. Meanwhile, Americans still faced desperate problems of survival during the economic crisis. For example, Bruce received a poignant message from a daughter of one of the needy artists. Ruth Zakheim wrote:

> I am only 11½, but I felt I must write this letter to you. My father used to work for the CWA art projects in San Francisco. He did a frescoe in the Coit Tower. Now he is finished and I was wondering if there was another frescoe he might do. He needs the money so badly. I have heard him say you were the originator of the CWA for the artists. His name is Bernard B. Zakheim.[1]

(She asked Bruce not to tell her parents that she had written the letter.) In spite of his concern, Bruce could do nothing to help her father.

Although there was some federal support for artists, Zakheim's plight reveals that the New Deal was not meeting the extensive need during this difficult period. For example, in May 1934, Bruce submitted a proposal to Robert Techner, director of the Civilian Conservation Corps (CCC) that the CCC employ 100 artists for various camps throughout the nation. The plan—limited in scope—called for them to be assigned, each to a different camp, to depict CCC activities in murals and other art projects. Although the camps came under the military jurisdiction of the War Department, the artists were to be relieved of other camp duties to devote forty hours per week to their projects. In submitting his proposal, Bruce offered Techner this practical advice: ". . . I suppose it would be wise to start the artists where the weather would be less

rigorous at this time and gradually move them North with the ducks."[2]

For some of the artists the CCC program provided unlimited opportunities to observe the contemporary American scene. One artist was enthusiastic about wildlife and phenomenal sunsets; another with the democratic conditions of camp life.[3] For other artists, however, camp life did not provide such democratic conditions. In fact, their reactions underscore the ambiguous relationship between government and artist that Bruce had endeavored to resolve. From one artist's viewpoint, camp life was so regimented that he preferred a job washing dishes in a café on the outside. Another found the life so oppressive that he viewed it as a quasi-military atmosphere, and its inhabitants he described as the "coarsest children." With no hope of adjusting to camp life, one artist felt that he was being treated like "Humpty Dumpty," never be put back together again.[1] Another artist interpreted the curious glances of an ordinary laborer in a CCC barracks in this humorous vein: "Was it proper to toss him peanuts between meals? Would he purr or bite, if touched?"[5] While adjustments were being made on both sides of the fence, the CCC art program continued until September 30, 1937.[6]

Besides the CCC art program, other limited federal help came from the Federal Emergency Relief Administration (FERA), known in the states as the State Emergency Relief Administration (SERA). Funds were given for some individual projects but not for organized art programs per se because they required additional monies. By June 1935 most of the SERA projects had come to an end.[7]

The reactions of artists to the prevailing "Hard Times," however, revealed the inadequacy of the FERA program. With a meager income diminished further by family illness, Harry E. Burtaine was advised to seek FERA employment, but he met with no success. Dean Beslick considered even the $24 per month for two persons (the minimum wage under FERA) less than adequate. The strain of uncertainty in not getting relief confronted Aleth Bjorn: "The humiliation of living on loans from friends that have more heart than money has reached the limit of my resistance. I have not even had materials enough for my own work."[8] Marian Simpson reveals the same degree of despair: "Spiritually driven in upon ourselves, economically uneasy, it is hard to escape the impression that we are unwanted aliens in the scheme of things."[9] Marsden Hartley also held little hope for the future:

> I was never rich, as you may guess, for I was never a best seller, but with the passing out of the old style collector, there is little sense of security anywhere, so I have lived more precariously the last two or three years, than I have known since I began to be exhibited and the uncertainty adds no whit whatever to the peace of mind that is necessary for decent work, and with twenty pictures in American museums the effect is a bit disturbing.[10]

For that matter, Audrey McMahon wanted to plead the cause of the unemployed artist in Washington. However, Edward B. Rowan, assistant chief of the Section of Painting and Sculpture, discouraged her because no other relief project like PWAP existed, and he doubted that anything could be accomplished by her proposed trip from New York.[11]

The desperate situation of artists was dramatized by the efforts of the Artists' Union to get federal support. During PWAP the union had organized to arouse federal response to the artists' plight. This time, however, it advocated either an extension of PWAP or a new permanent government program. Of the thousands of unemployed

Portrait photo of Holger Cahill: Photographs of Artists—Collection Two. Photo: Soichi Sunami. (Archives of American Art, Smithsonian Institution)

artists in New York City, only 300 found jobs under SERA, which pointed out that the existing work-relief programs, indeed, were woefully inadequate.

On January 4, 1935, however, the president's Annual Message launched the "second New Deal." The national security of the men, women, and children of America would be his primary objective, Roosevelt avowed. First on the list of national priorities was the reorganization of the relief administration. The president requested $4.8 billion to provide jobs for those on relief rolls, and the federal government was to assume responsibility for relief through a public works program. In May 1935 the president asked Harry Hopkins, administrator of the newly created Works Progress Administration (WPA), "Will you and Bruce try to work out a project for the artists?"[12] Bruce's plan resulted in the Treasury Relief Art Program (TRAP), a limited relief program, but Hopkins designed a broader program, known as Federal Project Number One, which included art, theater, music, and writers' projects. Organized by WPA Assistant Administrator Jacob Baker in August 1935, it followed the guidelines the president had previously discussed with Bruce.[13]

Baker offered Bruce the position of director of the new art program, but Bruce refused it because professional criteria would be sacrificed under a relief project, he declared. Bruce expressed this idea again when he suggested a quality test for artists. However, no action was taken because of Hopkins's primary concern to preserve workers' skills and morale. Audrey McMahon also refused the position, not wishing to make the move from New York to Washington.[14]

In the end, four directors were appointed to head Federal Project Number One, each outstanding in his field: Holger Cahill (art); Hallie Flanagan (theater); Nikolai Sokoloff (music); and Henry Alsberg (literature). Cahill was selected as national director of the art program at the suggestion of Ann Craton, who worked in Jacob Baker's office and whose sister was married to Peter Blume the artist. Craton had mentioned Cahill's name on the recommendation of her distinguished brother-in-law.[15]

Bruce rejected the WPA/FAP offer because of its relief criteria. Cahill, however, entertained strong doubts about accepting the job for other reasons. In New York one cold, windy night he met with painter Stuart Davis at an Italian restaurant. Davis exclaimed, "For God's sake, what's the matter with you, why don't you take it?" Cahill replied, "I don't want to go in for that sort of business. Would you want to stop being a painter?"[16] He, of course, wanted to continue his writing career. Cahill received calls from Baker, but he still refused to consider the offer. Baker impatiently replied, "You're crazy. This is the most important art job in America."[17] He then discussed the situation with museum director Henry F. Taylor, who partially agreed: "You're quite right, it's the worst job in the world . . . but of course you've got to take the job" Cahill bristled, "Are you crazy? Am I going to walk into that serpent's nest?"[18] Taylor explained that a request from the U.S. government was like an order—"It's like being drafted." Nor did Cahill get much help from Davis, who warned that academician Jonas Lie might head the new program and discriminate against the more avant-garde artists. Because no one appeared to share his doubts, Cahill reluctantly accepted the job.[19]

Cahill's Background

Edward Bruce had come from a family of eighth-generation Americans. Holger Cahill—an Icelandic immigrant and total stranger to the American civilization—had become a wanderer in search of an American identity. These two men could not have been more completely different in their personalities, coming from such contrasting backgrounds. Yet, they both came together at a point in time—the era of the Depression—to establish art programs that deeply affected the American art scene.

Bruce was seen as a Renaissance figure: bold and blunt. What kind of a person was Cahill? Given the kind of background that ill-prepared him for the American civilization, he is not easy to define. He was a more complex personality than Bruce; his childhood experiences, as the only son of immigrants from Iceland, greatly affected his outlook. His father was a talented organist who could not find a niche in the frontier community of Pembina, North Dakota, to which the family migrated when Holger was a small boy. The father was a failure in almost everything he tried to do; there were family quarrels; eventually, the parents divorced. Those painful but poignant childhood memories profoundly affected Cahill. The broken speech of his parents somehow tested his loyalty to them. They were outsiders in the society of the Yankee trader and profiteer. The town boys did not like to play with Holger, who later recalled that these solitary memories of childhood were like the sound of wind blowing through a deserted house.[20]

Cahill later traveled to Vancouver, British Columbia, where he went down to the wharves and watched stevedores sweating in the bowels of steamers. He became enamored with the sea—a love affair from which he never fully recovered. As a coal

passer on the *Empress of China*, a British ship on the Canadian-Pacific line, he traveled to China. When he returned to the United States, he worked in a railroad office in Saint Paul, Minnesota, and later he went to Milwaukee, Wisconsin, serving as watchman on 700-foot ore boats plying the Great Lakes.[21]

The rootless Cahill then moved to New York City, where he lived in Greenwich Village and enrolled in writing courses at New York University. He also attended Columbia University and the New School for Social Research. Progressing in his career, Cahill worked in Bronxville as a reporter for the *Mount Vernon Argus* until he was drafted to serve in the army in 1918.

After World War I, Cahill returned to New York City as a free-lance writer and reviewer for the *New York Post*, *Nation*, and *Freeman*. He wrote articles and monographs on American art for such publications as *Shadowland*, *Creative Art* and *Parnassus*. The Society of Independent Artists hired him to do their publicity in 1920. Articles by Cahill about John Sloan, George Bellows, and Jonas Lie appeared in *Shadowland*.

Because of the success of these articles and favorable publicity for an exhibit of the organization of German Craftsmen and Designers (Deutschewerkbund), Cahill was hired by John Cotton Dana, director of the Newark Museum, to augment the museum's collection of contemporary American art.

Cahill visited folk museums in Sweden, Norway, and Germany in 1922; and from 1926 to 1930 he studied American folk and popular art forms, particularly indigenous materials in the eastern regions of the United States. In 1930 he organized an exhibition for the Newark Museum entitled "American Primitives," the first American folk and popular art show in America. This successful venture was followed by "American Folk Sculpture," also the first show of its kind in America. His growing list of accomplishments is impressive. He was a member of the committee that organized the "Atlantic City Exhibition of Contemporary American Art" in 1929 and "The Art of the Common Man," in 1932, for the Museum of Modern Art in New York; and he was director of exhibitions at the Museum of Modern Art in 1932–33, during which period he mounted two exhibits, a retrospective, "American Painting and Sculpture—1865–1933," and "American Sources of Modern Art." The last was one of the earliest shows to assess the aesthetic impact of the pre-Columbian art of Mexico on the United States and Europe. In 1933 he directed the "First Municipal Art Exhibition" in Rockefeller Center for the City of New York, sponsored by Mayor Fiorello LaGuardia. It was a great success, to be repeated in 1934.

In 1934 and 1935, Cahill worked for Mrs. John D. Rockefeller, researching American popular art in the collections of historical societies, local museums, and private collections throughout the South. This included searching for and buying folk art for the Abby Aldrich Rockefeller Museum in Williamsburg, Virginia.

At the same time, Cahill wrote prolifically. His *Profane Earth* (1927) and *A Yankee Adventurer* (1930), two book-length autobiographical works, were well received by the critics. His critique of American art included *George O. "Pop" Hart* (1928) and *Max Weber* (1930); *American Painting and Sculpture* (1933); *American Folk Art* (1934); *American Sources of Modern Art* (1934); and "American Art Today," an article for the symposium *America as Americans See It* (1932). With Alfred H. Barr, Jr., he edited *Arts in America in Modern Times* (1934), and he was editor and contributor on painting and sculpture for *Art in America* (1935).[22]

Perhaps Cahill's success may be viewed as an attempt to compensate for his early life, for he never forgot the painful experiences of his impoverished childhood. Most crucial was the divorce of his parents during the formative years. Although he had

taken his mother's part during family quarrels, the memory of his father's silence deeply disturbed him. (He observed later that there had been no way to come to terms with that issue.) Looking back, he traced his father's plight to the social phenomenon of the post–Civil War period, the rise of industrialism. The new and vigorous society that emerged lacked a long cultural tradition. The American artist, according to Cahill, was an alien in the community, and a new generation of patrons demanded grandiose, vulgar, and overembellished art, generally influenced by the socially powerful image of Europe. It is evident that the dilemma of the American artist also reflects the problem of Cahill's father, alienated in an American civilization that offered little opportunity for creativity.[23]

As a child, Cahill felt that his mother had encircled and sustained him; in effect, she was all he knew of eternity. When she remarried his family ties were severed, and Cahill viewed himself as an outcast. He became a religious skeptic, and he felt that in Pembina no other doors were open to him. After he completed high school, he left for Canada, but the face of his mother lingered in his thoughts, like a song that would always be part of himself.[24]

Later, in Saint Paul where he wrote the numbers of railroad cars and stations in office books nine hours a day, the monotony of the job made him feel as though his life was flowing away "through a pen point." He also said of this experience that he felt as constricted and lonely as he had in Pembina. He yearned for the life that reached a crescendo at night—in the hot tempos of cabaret orchestras and the lyric joys of black sopranos in church missions.

In the harbor towns of the Great Lakes, Cahill shared the boisterous life of his mates in bars, poolrooms, and cheap gambling houses, questioning and seeking something that always eluded him. His mother's prayers in the Icelandic language had stirred his curiosity about distant places in his youth. He developed a lively interest in the works of Joseph Conrad, with their exotic settings that evoked illusive, distant beauty. Cahill looked for the opening of new doors, but he found that there were walls around the lives of most people. Unable to enter their lives, he suffered with the poor in Tolstoi's novels. He did not equate them with people he knew intimately, such as the sailors on the lake boats or the farmers and laborers of Pembina. Yet he lived in and belonged to the world of wandering laborers, sailors, and hobos, those legions of drifters on the tides of unemployment.[25]

Although Cahill was lonely during the peripatetic years, university life introduced him to the world of ideas and nourished his passion to understand more about people through social theories and art concepts. Never again did he know the empty solitude of those Pembina nights. The dramatist Eugene O'Neill and other literary giants, who frequented cafés in Greenwich Village, were his teachers in the arts, literature, and socialist theories. The Village attracted a wide variety of people who had found no other place in a civilization dominated by the Calvinist ethic and the acquisitive impulse.[26] Cahill discussed with Horace Kallen, a professor at the New School for Social Research, the reasons that lured people from other communities to the Village. Kallen commented that they came to New York in flight. Cahill replied, "But Horace, a flight is also a search, and these people came searching for something that they would not find in their home towns."[27] In Pembina, Cahill had rejected the Babbittry of small-town prejudice and moneyed interests; his sympathies lay with the hard lot of farmers and laborers. Cahill himself had become alienated from American civilization, and the Village offered the refuge to explore new values and to find a niche for his creative personality.[28]

Cahill's newspaper reporting ran the gamut of New York life: accidents, deaths,

marriages, births, and divorces—the acrid chaff necessary to fill newspaper columns. On assignments he observed that the city reflected a dominant gray tone: big vacant spaces overrun with weeds; areas sinking into decay and utter abandon. He was disturbed about people in modern cities, leaving behind the cast-off rubbish of their activities—of lives that did not take root. Cahill had earlier experienced deserted farms and country homes, filled with empty memories. He viewed this as a phenomenon of dehumanized technology, which threatened community life and left empty land around empty houses.[29]

Even when he was a young watchman on the Great Lakes, Cahill had developed a critical eye for art. He was not enthusiastic about plaster classics, but painting was more difficult for a novice to approach and enjoy. He once described paintings in heavy gilt frames as "bankers' daughters at a church social." One could look at them but they felt that they were superior; they spoke only to select persons. He believed that art in museums reflected a genteel tradition and lacked relevance to the ordinary person.

Influences on Cahill's Life

The great Russian philosopher Count Leo Tolstoi fascinated Cahill. Tolstoi's essay *What Is Art?* developed the following thesis: (1) art has a vital relationship to human life; (2) art is created when one yields to one's feelings; (3) a work of art depends on form; and (4) art has to be good—in the sense that it serves for the betterment of humankind. In sum, Tolstoi defined art as the language of feeling, independent of academic canons of beauty. It is an activity through which a person experiences feelings he or she intentionally transmits to others.[30]

Cahill held a deep affinity for Tolstoi's ideas. Art must be concerned with honest, earthy pains and joys, he believed. The painting of the so-called Ashcan school, with its relevance to life and the people in the streets, was preferred by Cahill to the smoother technique of John Singer Sargent. In his view, such artists as John Sloan, George Luks, and George Bellows had rediscovered and brought into the staid salons of the era the gusty vitality of the city streets. Cahill declared that any artist worth his or her salt was deep in the very marrow of life. He saw art as the commonplace of common places, not as something separate from the "the daily muck of life." Art was a process of "eating and digesting the world," he contended. In El Greco, Cahill had sensed his own seeking and questioning, but he doubted that he could find his answers in religion. He wondered if anyone could answer the incoherent questions of a wanderer like himself.

His monographs about George O. "Pop" Hart and Max Weber the painter, however, reveal that he had resolved a few of his own uncertainties. Hart he describes as having "a magnificent appetite for life," a man in love with festivals, Easter parades, baptisms, weddings, and market fairs. To Cahill, passion was the moving force of art, which Hart expressed; and Cahill saw much of himself in Hart's vision. People who squeezed themselves into a pattern of machines and thrust their lives into hard, little geometrical crevices, he observed, differed from those who took to the road and freely gathered around jungle campfires. "Pop" Hart, according to Cahill, represented the free spirit, who remained outside of a mechanized civilization.[31]

Cahill also shared a common interest with Max Weber in indigenous art forms. Weber's childhood had been colored by the work of Russian folk artists; later, the art

of the Orient and the pre-Colombian cultures transformed Weber into "a child of the modern spirit." In a similar manner Cahill's own youth had been enriched by the folk stories of biblical events, such as the wondrous fables about the Ethiopians encircling the world seven times around and causing the walls to come tumbling down. Cahill also listened to ballads about cigarette trees and big rock candy mountains; and he heard stories about restless hobos, moving back and forth on trails without destinations. "Pop" Hart's art expressed a need to find basic roots, but Weber's work reflected the belief that art had to be "more than it is visibly." Weber, according to Cahill, had reached an understanding of the deeper needs of the spirit. Cahill wondered if the approaches of Hart and Weber would help him to better understand American civilization. [32]

At Columbia University and the New School for Social Research, Cahill audited courses, but he never pursued a degree. He, however, was greatly influenced in his social philosophy by the economist Thorstein Veblen, describing himself as "one of Veblen's favorite pupils." Veblen's early life in Wisconsin was not unlike Cahill's in North Dakota. Wisconsin farmers kept the customs of their Norwegian forebears; everyone worked to produce essential daily needs. The "Yankee" neighbors, however, were looked on as outsiders, who earned their living at the expense of the newcomers. Cahill also had viewed with suspicion the sharp practices of Yankee traders and land speculators that oppressed Scandinavian farmers and laborers. [33]

When prosperity flourished in primitive societies, Veblen theorized, surpluses tempted individuals to become predatory. In due time other classes emerged: robber barons, politicians, financiers, and captains of industry. This new "Leisure Class" exploited others by seizing wealth instead of coining it, Veblen contended. He viewed this parasitic activity—reflected by their medals, dress, and titles—as "conspicuous consumption" and "conspicuous waste." [34]

Veblen's influence is clearly seen in Cahill's outlook: "The rapid expansion of industrialism made for the dominance of social groups which had not the tradition of art patronage and little interest in art except as it might serve as the badge of a newly acquired social distinction or as an object of conspicuous display." Cahill also echoes Veblen's viewpoint on "conspicuous waste": "The American patrons turned to esthetic fragments torn from their social backgrounds,. but trailing clouds of aristocratic glory." [35]

Perhaps the most influential person in Cahill's life was John Cotton Dana, director of the Newark Museum. After Cahill's mother remarried, Cahill looked for a "new door" of close personal relationship to open. Dana filled this need in his life. He was a person of such complex traits that he could be described as pungent, provocative, critical, radical, intense, deeply sympathetic—and remarkably creative. Dana's roots were so deep in the American experience that he made it possible for Cahill to find a secure corner. When Cahill's parents divorced, he never saw his father again. Dana became a surrogate father figure for Cahill. By studying the background of Dana, Cahill's mentor, one can better understand Cahill's driving force as an innovator in the New Deal art programs.

John Cotton Dana—descended from the Reverend John Cotton, author of the first draft of the Massachusetts code—was born on August 19, 1856, in Woodstock, Vermont. After he graduated from Dartmouth College, Dana's ill health forced him to pursue legal studies in Colorado, and in 1880 he was admitted to the bar. In 1883 he returned to New York to practice law. He soon left again for Colorado, however, and in 1889 he was appointed head of Denver's new library. Later, Dana accepted the post

of librarian in Springfield, Massachusetts, where he initiated the "open shelf" system—unknown at the time—making books more accessible to the general public.[36]

When Dana left Springfield for Newark, that city realized the full flowering of his creative potential. In 1903 he organized a library exhibition of paintings lent by local citizens—the most newsworthy show ever held in New Jersey, according to critics. In Dana's view, art promotion was a proper function of the library in the community. He founded the Newark Museum Association and served on the City Planning Commission. Dana also became director of the Newark Museum in 1914. As the functions of the museum in the library increased, he suggested larger quarters. In 1922, after the city commissioners agreed to purchase a museum site, Dana recommended a central location that would best serve the public interest. Three years later, a fully equipped art museum building, at a cost of $750,000, was opened to the public.[37]

Dana's important contributions in the museum field added much to the education and enjoyment of the ordinary person. Moreover, his emphasis on contemporary art extended to artists such as Max Weber, who was practically unknown at that time. Dana arranged an exhibition for Weber at the Newark Museum.[38]

Much of Dana's idealism is reflected in Cahill's approach to art as an enhancement of qualitative life and a vital force in society. When Dana died on July 21, 1929, Cahill was at his bedside. Because of this unique relationship, Cahill acquired the secure harbors he had lacked during much of his life. Once Dana had observed:

> If American art does not flourish, it will not be because we are too rich, or unduly sordid, or insincere; but because we refuse to become discriminating patrons of the everyday good things our fellow citizens can produce if a kindly interest stimulates them thereto.[39]

Dana's ideal was carried out by Cahill, when he stimulated communities throughout the nation to be discriminating observers and patrons of American art under his WPA/FAP program.

Notes

1. Ruth Zakheim to Edward Bruce, April 7, 1934; and Edward Bruce to Ruth Zakheim, May 1, 1934; RG 121/108.

2. Robert Techner to Edward Bruce, May 22, 1934; and Edward Bruce to Robert Techner, December 12, 1933; RG 121/106.

3. Paul Riba to Edward B. Rowan, August 22, 1934; and Francis White to Edward B. Rowan, October 2, 1934; RG 121/106.

4. Julian Lee Rayford to Edward B. Rowan, August 30, 1935; Walter F. Bartsch to Edward B. Rowan, April 9, 1935; and Marshall Glasier to Edward B. Rowan, September 6, 1934; RG 121/107.

5. Edgar D. Hegh to Edward B. Rowan, October 10, 1934; RG 121/107.

6. James J. Short to Leonard Burland, August 9, 1937; RG 121/142.

7. Memorandum from Harry L. Hopkins to State Emergency Relief Administration, July 2, 1934, RG 121/133; Holger Cahill, "Record of Program Operation and Accomplishment," vol. 1, Art (Washington, D.C.: Federal Works Agency, 1943), pp. 7–8; Holger Cahill Papers in files of "Federal Support for the Visual Arts: The New Deal and Now," Library of the National Collection of Fine Arts, Smithsonian Institution, Washington, D.C., hereafter cited as Cahill Papers.

8. Dean Beslick to Mrs. Franklin D. Roosevelt, May 4, 1934; Aleth Bjorn to Edward B. Rowan, August 14, 1934; and Henry E. Burtaine to Forbes Watson, June 19, 1934; RG 121/108.

9. Marian Simpson to Edward Bruce, June 5, 1934, RG 121/108.

10. Marsden Hartley to Edward Bruce, September 8, 1935, RG 121/122.

11. Audrey McMahon to Edward Bruce, October 4, 1934; and Edward B. Rowan to Audrey McMahon, October 10, 1934; RG 121/108.

12. *Art Front* 1, no. 1 (November 1934), pp. 2–6; *Art Front* 1, no. 2 (January 1935), p. 2; *Art Front* 1, no. 3 (February 1935), p. 3; Memorandum from Franklin D. Roosevelt to Harry L. Hopkins, n.d., in Record Group 69, Entry 211.5, National Archives, Washington, D.C. All unpublished documents in the possession of the U.S. Government that are cited in these notes are to be found in the Economic Branch of the National Archives in Washington, D.C. An index to these records can be found in the "Preliminary Checklist of the Central Correspondence Files of the Work Projects Administration and its Predecessors: 1933–1944" (Record Group 69). The main divisions of Record Group 69 are given entry numbers like 211.5. Hereafter, records in the National Archives are cited by Record Group and Preliminary Entry Number, thus RG 69/211.5. The published indexes to RG 121 and RG 69 in the National Archives can also be found in Francis V. O'Connor, *Federal Support for the Visual Arts: The New Deal and Now*, (Greenwich, Conn.: New York Graphic Society, Ltd., 1969).

13. Cahill, "Record of Program Operation and Accomplishment," vol. 1, Art, p. 1.

14. Oral history interview with Jacob Baker, September 25, 1963, p. 45, Archives of American Art; Edward Bruce to Harry L. Hopkins, September 13, 1934, Bruce Papers, AAA Reel D85; "The Reminiscences of Holger Cahill," (Columbia Oral History Collection, Columbia University, New York, p. 326, hereafter cited as "Cahill Reminiscences"); Francis V. O'Connor, ed., *The New Deal Art Projects: An Anthology of Memoirs* (Washington, D.C.: Smithsonian Institution Press, 1972), p. 54.

15. Cahill, "Record of Program Operation and Accomplishment," vol. 1, Art, p. 3; "Cahill Reminiscences," p. 241.

16. "Cahill Reminiscences."

17. Ibid.

18. Ibid.

19. Ibid.

20. Ibid., pp. 337–38; *Who Was Who in America*, Vol. 4, 1961–1968 (Chicago: Marquis Who's Who, Inc., 1968). Holger Cahill was born in Iceland, January 13, 1887, the son of Bjorn and Vigdis Bjarnarson, but in later life, he changed his name; "Cahill Reminiscences," p. 14; Holger Cahill, *Profane Earth* (New York: Macaulay Company, 1927), pp. 15–25.

21. "Cahill Reminiscences," pp. 1–46.

22. Biographical data of Holger Cahill, Cahill Papers.

23. "Cahill Reminiscences," p. 22: Holger Cahill, *New Horizons in American Art* (New York: Museum of Modern Art, 1936), pp. 11–12.

24. "Cahill Reminiscences," p. 43: Cahill, *Profane Earth*, p. 81.

25. "Cahill Reminiscences," pp. 189, 191, 194, 199, 113–114, 148.

26. Cahill, *Profane Earth*, pp. 48–58.

27. "Cahill Reminiscences," p. 59.

28. Ibid., pp. 64–65.

29. Cahill, *Profane Earth*, pp. 305, 324; ibid., pp. 79, 382; Cahill, *New Horizons in American Art*, p. 11.

30. Cahill, *Profane Earth*, p. 114; Leo Tolstoi, *What Is Art?* and *Essays on Art* (London: Oxford University Press, 1930, pp. vi–xv, 264–67; Curt John Ducasse, *The Philosophy of Art* (New York: Dover Publications, Inc., 1966), pp. 23–24; Cahill, *Profane Earth*, p. 113.

31. Holger Cahill to Mary R. Beard, October 26, 1937, RG 69/211.5; Holger Cahill and Alfred H. Barr, Jr., eds., *Art in America* (New York: Halcyon House, 1939), pp. 89–91; Cahill, *Profane Earth*, pp. 44, 348–56, 223–25, 257; Holger Cahill, *George O. "Pop" Hart* (New York: Downtown Gallery, 1928), pp. 16–17; Cahill, *Profane Earth*, pp. 159–61; Cahill, *George O. "Pop" Hart*, p. 2; "Cahill Reminiscences," p. 21.

32. Holger Cahill, *Max Weber* (New York: Downtown Gallery, 1930), p. 1; Cahill, *Profane Earth*, pp. 37–38, 162–63; Cahill, *Max Weber*, pp. 35, 43–44.

33. "Cahill Reminiscences," p. 115; Horace M. Kallen, *Art and Freedom* (New York: Greenwood Press, 1969), pp. 658–59; Cahill, *Profane Earth*, p. 59.

34. Thorstein Veblen, *Theory of the Leisure Class* (New York: Modern Library, 1934), pp. xiv–xv; Henry Steele Commager, *The American Mind* (New Haven, Conn.: Yale University Press, 1950), pp. 239–41; Veblen, *Theory of the Leisure Class*, pp. 25–26, 116, 229–31.

35. Cahill, *New Horizons in American Art*, pp. 11–12.

36. Chalmers Hadley, *John Cotton Dana* (Chicago: American Library Association, 1943), pp. 9–11, 16–22, 33–41.

37. Ibid., pp. 52, 57–62, 67.

38. Ibid., p. 66.

39. "Cahill Reminiscences," p. 159; John Cotton Dana, *American Art—How It Can Be Made to Flourish* (Woodstock, Vt.: Elim Press, 1929), pp. 30–31.

6

Holger Cahill's WPA/FAP Program

The worker/artist, a concept defined by Harry Hopkins, was never completely realized under the Public Works of Art Project (PWAP). Edward Bruce demanded professional standards—elitist criteria difficult for many artists to maintain. In the Section of Painting and Sculpture, Bruce also required these same criteria. Under Cahill's Works Progress Administration Federal Art Project (WPA/FAP), it became possible for artists of any stylistic persuasion to participate in the program. Unlike Bruce's competitions administered by a central organization in Washington, the WPA/FAP operations were decentralized and administered in the states, allowing the artist wide creative leeway. Not even Bruce's "American Scene" theme, which had troubled academicians and abstractionists alike under PWAP, was required by WPA/FAP.[1]

The Section's centralization and the WPA/FAP's decentralization of operations reveal the separate goals that Bruce and Cahill sought to realize. Rowan's remark, "One solitary masterpiece is worth the whole project," reflecting Bruce's traditional outlook, sharply contrasts with Cahill's innovative view: "Art is not a matter of rare, occasional masterpieces." However, the decentralization of WPA/FAP on a national level largely reflects the humanitarian objectives of the second New Deal to confront the human distress that had been seriously aggravated by the Depression. To meet the crisis, a number of projects were set up under WPA/FAP to employ destitute American artists.

WPA/Federal Art Project

The WPA/FAP was organized in August 1935. Holger Cahill worked with Sol Ozer, a WPA economist, in drafting the broad policy guidelines for Federal Project Number One. During the first six months, the objectives of Cahill's own program, stressing the fine and practical arts, were developed. From his viewpoint, the integration of the fine arts and the practical arts was essential to create a fully developed art

150

movement, drawing together major art forces in America.

The office of the national director in Washington was the focal point of the WPA/FAP. Cahill's staff assumed responsibility for the following functions: (a) organizing art centers and exhibitions; (b) compiling the Index of American Design; and (c) establishing the creative arts. These were carried out by Assistant Director Thomas C. Parker, formerly director of the Richmond Academy of Arts, who was assisted by the following: Mildred Holzhaur, director of exhibitions; Ruth Reeves, coordinator of the Index of American Design; and Daniel S. Defenbacher, coordinator of WPA Community Art Centers.

Outside of Washington, regional directors were responsible for a number of state projects in designated areas. However, the selection of state art directors was one of the most important factors in carrying out the creative goals of the WPA/FAP program. In theory, the appointments of state art directors were initiated by Cahill, with the concurrence of the state administrations. In actual practice, however, he personally selected them.[2]

From August 1935 to September 1939, federal sponsorship permitted Cahill to uphold his own standards, but he encouraged community support because local participation was essential to the program. Cahill's view of Bruce's professional criteria reveals his grass-roots interest: "we have seen in art . . . the development of professionalism without a corresponding development of community participation. The Federal Art Project is devoting itself to stimulating this participation." Although various advisory committees assisted the WAP/FAP program, local committees were particularly important in the development of the WPA Community Art Center programs.

The availability of artists on relief rolls determined the projects established in the states. Because of Cahill's desire to help young and promising artists, WPA/FAP was structured not like Bruce's patron-artist system but like a medieval guild system, making it possible for the young to learn under a master artist.

Cahill started the projects quickly and efficiently in the states, exercising the unique power of staff and line authority. Because the art projects required technical competence of qualified personnel, this authority was granted to Cahill. State administrators were never too happy about this policy because it bypassed their own authority in the states. At peak employment, 5,300 artists worked in the program, and Cahill was beginning to achieve an integration between the arts and the life of the community.[3] No wonder he could say with assurance: "Art should belong to the people as a whole. For these reasons, I consider the government to be of the greatest importance."[4]

Controversies Faced by Cahill

Despite the ongoing operations of the WPA/FAP, Cahill encountered severe problems that were constantly frustrating his objectives. Bruce's controversies had been more limited in scope, but WPA/FAP, due to its greater national exposure, faced stronger opposition from conservative and anti–New Deal critics. Cahill, himself, observed: ". . . in the seven and a half years that I worked there, during which those projects I ran were under the most bitter criticisms of all kinds—everything was leaped upon to try to break us up."[5]

During the beginning of the program, Cahill was confronted by an infighting bureaucratic conflict that threatened his control over the project and foresaw an early end to his innovative goal. The problem was that Assistant Administrator Jacob Baker had decided to turn over the jurisdiction of the "White Collar" program, which included all of the art projects, to the state administrations. At first, Cahill was completely confused about the issue, except to note, "Baker was getting ready to put the skids under me." But Cahill soon discovered that Baker's authority over the "White Collar" program was being politically challenged by Ellen Woodward, head of the WPA women's projects. A protégée of powerful Mississippi Senator Pat Harrison, she maneuvered to place the "White Collar" program under her control. To avoid this impending struggle, Baker ordered his federal directors to write procedures, telling the people from the states how to set up art projects. Of course, the state administrators were anxious to take over the art projects because in the states the state administrator was "top dog" and disliked being opposed by people in Washington.[6]

Cahill vacillated between staying in and getting out because the situation with Baker galled him: "I thought we were friends and I wondered why he couldn't have taken me into his confidence." He attempted to dissuade Baker, but he met with no success. Cahill and Hallie Flanagan then decided to present the issue to First Lady Eleanor Roosevelt. Because they were professionals in the field, they preferred to resign rather than accept Baker's decision. Apparently, Mrs. Roosevelt was much impressed with the directors' calm and objective explanation of the issue. After discussing the matter with Hopkins, she suggested, "Have you ever thought that the difficulty might be with Mr. Baker?" Hopkins agreed, and Cahill borrowed from Ralph Waldo Emerson to describe the incident as "the shot *almost* heard 'round the world." Sixty state people quickly packed their bags to leave Washington as Baker's order was rescinded. Shortly thereafter, the WPA terminated Baker from federal service. Federal Project Number One was transferred to the jurisdiction of Ellen Woodward, who, as WPA assistant administrator, reorganized the programs in question as the Women's and Professional Division.[7]

With this unexpected dilemma resolved, Cahill gained valuable time in which to fully develop his program. From 1936 to 1939 he set up federal projects, such as the Community Art Centers and the Index of American Design, at the state level, employing highly trained personnel from metropolitan centers. In 1936 such a prospect would have been impossible to achieve if Baker had succeeded in his proposed action.

Although the problem over "divided authority" was settled, Cahill faced a different issue with the state administrators: timekeeping versus creativity—a dilemma generally unresolved throughout the federal period of WPA/FAP. The issue centered on the use of the WPA "force account," where a timekeeper accounts for the daily hours of a labor force on the job. Cahill strongly reacted to the system: "It's perfectly silly to put an artist on force account and have a timekeeper check up on him!" He meant that creativity was not adaptable to the control of the usual timekeeping methods.[8]

Hopkins asked Cahill for his plan for keeping track of the artist's time: "What'll you do with these artists? Would you put them under an honor system?" Cahill, of course, opted for an honor system, which permitted the artist to work in his or her own studio, and the art supervisor to visit him or her once in every three-week period. Meanwhile, an agreement would be reached about the amount of work to be produced and reported to account for the artist's time. However, the state administrators "kicked like a steer" about the honor plan. They told Cahill, "You're going to have all of us in state prison before you're through!"[9] Apparently, they were primarily concerned about spending

taxpayers' money in such a way that the public would not construe it as reckless or irresponsible.

The timekeeping problem disrupted Cahill's task to get creative work and provide opportunities for the artist to create in an environment unhampered by impractical bureaucratic procedures. In some of the states, such as New York and Illinois, a central workshop was organized and individual work cubicles were provided for painters, who checked in with a timekeeper and signed out each workday. This system, requiring that an employee give a day's work for a day's pay, reflected the time-honored American work ethic. Although Cahill reluctantly met the demands of the system, he found that rapid deterioration took place in the quality of work.[10]

Moreover, the effect of the timekeeping procedures on mural projects proved unduly troublesome to Cahill. For example, muralists painting in wet plaster often worked beyond the daily hours because their medium did not permit reworking once the plaster had set. Besides, provisions for overtime work were never established by the WPA Finance Division. If a mural painter exceeded the normal working hours in one pay period, he or she could not be credited for the extra time in the next pay period. In one instance the muralist David Fredenthal (1914–58), who worked overtime at the Detroit Naval Armory, took time off during the next pay period to compensate. The incident was investigated, and it almost cost the state art director his job. In any event, Cahill's endeavor to reconcile these timekeeping controls with the artists' needs generally proved unsuccessful. His frustration was revealed in this manner: ". . . and they can get very tough about it, and of course, they love to get tough about it."[11]

The WPA/FAP program generally received strong support from powerful artists' unions throughout the country, but an unforeseen conflict between WPA/FAP and the Artists' Union threatened to disrupt those ties. The large, decentralized operations of WPA/FAP in the states normally precluded interference from Washington, but a disturbing situation in Chicago required Cahill's intervention. The Artists' Union charged Increase Robinson, Illinois state art director, with discrimination because she neither used artists' skills creatively nor fulfilled the relief quota on the Chicago project. In answer to Cahill's inquiry, the union informed him that there was little opportunity for creative artists because Robinson had authorized work for road markers, posters, and toilet signs. Cahill investigated the project and surprisingly discovered that such talented artists as Sidney Loeb, Aaron Bohrod (1907–), Ivan Le Lorraine Albright (1897–), and Mitchell Siporin (1910–), were not on the project. Cahill told the union that one of the prime objectives of the program was to provide jobs for such high-caliber artists, but he conceded that a definite need existed to improve conditions on the project.[12]

Because Robinson's matriarchal handling of the program continued to antagonize the Artists' Union, they pressed their demands: to increase employment; to establish more creative projects; to abolish discriminatory practices against certain artists; and to allow adequate time to complete projects. Meanwhile, Cahill informed Robinson that she could have hired more than 400 artists, rather than the 283 she currently employed. Keenly aware of Robinson's problems, he advised, "I can realize that you have many difficulties keeping some of your artists in line, but that is the fate of all of us who have to deal with artists." Cahill concluded with this assessment of the situation:

Another fact, which I hope you and all our directors are bearing in mind, is that in

assigning nonrelief as well as relief personnel our sole criteria should be human need and art quality. Any other consideration of politics, personal preference, the fact that we may have been criticized, or even attacked by artists concerned should not sway our decision. We should, and I hope we all are, dealing justly and even-handedly with all groups of artists, conservative or modernist, basing our judgments solely on the criteria of relief qualification that has been established, and the quality of the artist to perform the work of the art project. We have a special duty toward the creative talent with which we are dealing, particularly the young talent which has not yet had full opportunity for development or recognition.[13]

Despite Cahill's hopes for conciliation, subsequent meetings between Robinson and the Chicago Artists' Union failed to produce results. Meantime, Loeb, unable to cope with Robinson's "self-appointed attitude of divine omnipotence," asked to be transferred to TRAP. The supervisor of the wood sculptor project, Peter Paul Ott, lost his position, and the Union accused Robinson of firing Ott because he was a Union activist.[14] Also, Gregory Orloff (1890–) was dismissed from a mural assignment, which he had in his own studio. He attributed the dismissal to his refusal to do posters in a central workshop. Orloff complained to Cahill, "Everytime she saw me at work, she was always critical, threatening, and intimidating. She was always telling me how I should paint and if I don't do things the way she wants there are plenty of others to take my place."[15]

In any event, the Artists' Union in Chicago accused Robinson of threatening artists and finally took the controversy to Cahill. The Artists' Union in Baltimore also repeated the charges and contended that Robinson operated the most reactionary and anti-union administration in the United States. Cahill attempted to temporize the situation by explaining that he had been to Chicago twice to clarify the matter. However, the Union demanded that Robinson be removed from her position at once. Cahill's problem was finally resolved when the sculptor George Thorp replaced Robinson as Illinois state art director—an action that normalized relations between WPA/FAP and the Artists' Union.[16]

Not only were specific issues troublesome to Cahill but also the broader controversies that stemmed from an undefined mood of a profoundly distressed era. This trend was revealed by public interest in Russia's Five-Year Plan, the rise of the artists' unions, and the left-leaning socioradical leaders appearing on the American scene, such as Francis Townsend, Father Coughlin, and Huey Long. When the Soviet symbol appeared in Coit Tower, the artist contended, "The paramount issue of today is social change." Rockwell Kent's post office murals, advocating radical change in Puerto Rico, also reflected the trend of the times. In the Middle West, Thomas Hart Benton detected a radical mood, but he asserted that young artists were concerned not with Communist theories but with the local scene. Whether or not Benton was right, the paintings of Mitchell Siporin—with their theme of social protest—revealed destitute people living on the wrong side of the railroad tracks.[17]

Nevertheless, conservative and anti–New Deal critics directed charges of radicalism and waste against WPA/FAP. For example, public controversy was stirred by artists who used biting satire to portray the social scene. There were charges that radical and subversive factions in the Artists' Union controlled WPA/FAP. Critics described this work as incompetent and ugly, saturated with Communist motifs. In the case of Siporin, his murals in Lane Technical High School in Chicago were singled out as being particularly Communist-oriented and un-American. For that matter, Cahill was well aware of this radical image. In New York he saw pictures of Karl Marx, V. I.

Lenin, and Joseph Stalin on the side of a building where he attended a WPA/FAP meeting, "put there by brave boys who thought this would bring down the pillars of Capitalism."[18]

Yet nothing epitomized the issue of radicalism in America more than the creation of the U.S. House of Representatives Committee on Un-American Activities, created in 1938 under the chairmanship of Martin Dies, a Democrat from Texas. Convinced that the crisis of the thirties was caused by subversive, anti-American elements, the Dies Committee was determined to suppress it. The members first investigated what was believed to be a Communist influence in WPA Federal Project Number One. The committee brought pressure to bear on the Federal Theater Project, and on June 30, 1939, that project was terminated. Fortunately, Cahill's WPA/FAP project escaped the Dies investigations, but it was not exempt from the intemperate mood of the period. The investigation bureau of the Treasury Department sent agents to Cahill's office to search every file, letter, and requisition. Although Cahill never heard from them again, he pointed out: "It's very anxiety-making to have people come in and accuse you of something which they don't name. It's like Kafka's *The Trial*. You're under accusation for something."[19]

Cahill also had to contend with the suspicions of Lieutenant-Colonel Brehon Somervell, WPA administrator of the New York project, who persisted in raising the Communist issue. Apparently, the colonel perceived Cahill as an intellectual whose sympathies might lie with the Communist party. Somervell was inclined to read subversive meanings into every painter's work. In one incident he ordered murals for the Floyd Bennett Airport in Brooklyn destroyed. This decision was based on charges of Communist propaganda leveled by the Women's International Aeronautical Association, the Flatbush Chamber of Commerce, and the Floyd Bennett Post of the American Legion. Their objections centered on the following allegations: one figure resembled Stalin; a plane similar to a Russian aircraft was depicted in flight from Moscow to California; and a United States naval hangar was identified by a Red Star.[20]

Despite charges of radicalism reflecting Communist-oriented symbols, however, the Roosevelt administration supported WPA/FAP. Cahill said, "Never once did I hear of a word of criticism from the White House . . . saying 'Why do you paint those awful pictures? Why do you allow your artist to do this?' Nothing. Never."[21]

Conservative reaction to Bruce's program stemmed primarily from the Fine Arts Commission in Washington. However, conservative opposition to Cahill's program, for the most part, came from anti–New Deal critics who decried waste and "boon-doggling." The term "boondoggling" came into vogue when it was discovered that a FERA official was teaching approximately 150 persons to make "boondoggles," his term for woven belts and linoleum-block printing. Critics viewed this as useless labor, and "boondoggling" later became the epithet used by those who strongly objected to the New Deal relief programs.[22]

In 1935, Franklin Roosevelt's Wealth Tax Act reached directly into the pockets of the rich, arousing strong oposition from the business community and conservative press. Because of the president's tax policies, Cahill experienced backlash reactions to his program: "Well, of course, every conservative person, especially the moneyed people were opposed to this. . . . They thought this was an absolute throwing away of money."[23] Publisher William Randolph Hearst, in one instance, ordered his editors to describe the New Deal as the "Raw Deal." The Hearst reporter on the *New York Mirror*, Fred McCormick, characterized WPA/FAP artists as "Hobohemian Chiselers and Squawkers." Another conservative criticism of WPA/FAP came from the all-

Illinois Society of the Fine Arts, Inc.: ". . . this work serves no real purpose in the life of an individual inasmuch as most of the work is such which tends to degrade life rather than uplift it." Wyoming Senator J. C. Mahoney was told by a Mrs. Tiechert, a constituent, that WPA/FAP had called into its ranks every would-be painter, whether drunkard, dope fiend, or incompetent. She alleged that these people could not possibly have earned a living in any other manner: "Look at the stuff. See if it's worth it, green men with purple beards, Mexican women made with not a thing human about them."[24]

The twin problem of conservative and anti–New Deal opposition to WPA/FAP may well have had the potential to undermine public support, but Cahill was shocked when the art critic Edward A. Jewell wrote, "Quantities of perfectly terrible art have been brought into existence under the WPA. . . . Many who are not in the least fitted to be artists have, through the intervention of relief, become such in name." Jewell's viewpoint also was shared by *Time:* "As usual, the mass of exhibits were exercises in mediocrity."[25] Jewell did not realize the overall effectiveness of the program, Cahill contended. Besides, Cahill strongly believed that beyond providing employment, beyond producing art, WPA/FAP could conserve and enhance fundamental values. He expressed it in this way: "In our own day it is the work of artists in all fields which concentrates and reveals contemporary American experience in its fullness. It is works of art which reveal us to ourselves."[26]

Cahill, however, tried to counteract critics like Jewell by publicizing WPA/FAP artists who gained special awards. These honors included the following: James Michael Newell, awarded the Gold Medal of the Architectural League in 1936 for his murals "The Growth of Western Civilization," painted for the Evander Childs High School in New York; and Philip Guston for his mural "Maintaining America's Skills," judged the best outdoor mural by the Mural Artists' Guild at the New York World's Fair in 1939.[27] In the summer of 1938 an exhibition entitled "Three Hundred Years of American Art," held at the Jeu de Paume Museum in Paris, was publicized by Cahill as the most important American show sent to Europe during his lifetime. Among the WPA/FAP artists represented were Francis Criss (1901–), John Steuart Curry, Morris Kantor (1896–), Yasuo Kuniyoshi (1893–), Henry Mattson (1887–), and Raphael Soyer (1899–).

In the end, Cahill's experience in public relations gained wide support for his program. Favorable reactions by such influential critics as Archibald MacLeish, John Maddox Brown, and Lewis Mumford helped Cahill to counteract charges of radicalism and waste by conservatives and anti–New Deal critics.[28]

During this ill-defined period of human distress, the effectiveness of Cahill's program—a temporary mechanism to solve unemployment—was sharply undermined by deep budget cuts and unexpected layoffs. Strong counterpressures against the administration's relief policies by the Artists' Union; and opposition to the New Deal by an intemperate, conservative Congress, also underscored the dilemma Cahill faced.

The year 1935 began with great prosperity, but signs of nationwide inflation caused the pump-priming policies to be reduced. From Cahill's viewpoint: "The President had, I think, the mistaken idea that the pump-priming in the economy had been done and that it could go on without it."[29] The author Lewis Mumford, deeply concerned about sharp dismissals, in an open letter to President Roosevelt requested support for WPA/FAP because artists could not depend on private patronage. The Artists' Union voiced the same concern, despite Ellen Woodward's statement to the contrary. Cahill, in turn, was informed by the Artists' Union that WPA/FAP meant more than relief

because the government at long last had recognized its cultural responsibility. Cahill, however, replied, "Economic need is still the primary purpose of the WPA."[30]

In April, Cahill told the Artists' Union that no personnel layoffs were contemplated for the remaining months of 1937. The president, however, concerned about inflation, sharply reduced relief rolls; and these massive cutbacks prompted threats of violence. Some of the supervisors were grimly warned that if they gave a single pink slip, terminating employment, they would have "their heads beaten off." However, dismissals took place, in the manner described tragically by Arctic explorer Vilhjalmur Stefansson in New York:

> Recipients of pink slips from the art project of the WPA were called to the platform of the New School. . . . There were dozens of cases where the discharged person had from one to five members of his, or her, family to support. In most cases their WPA earnings had been providing only the poorest kind of tenement lodging, without running water and with toilets from two to five floors away—in several cases toilet facilities so limited that people had to stand in waiting lines.[31]

The Artists' Union wanted Cahill to press Washington to rescind those tragic dismissals. First, a meeting with state art director Audrey McMahon was demanded, but she refused because of possible trouble. Then, the union met with Cahill, saying that the issue could be settled in five minutes, but not until five o'clock the next morning did the discussion conclude. Totally exhausted, Cahill refused to hold a meeting that would include McMahon: ". . . and they looked at him as though he was a very low form of animal life." Nevertheless, they held the meeting, during which time questions—some of them tearful, some denunciatory, some screaming—were directed at Cahill. With a tone of finality Cahill declared, "Congress has cut the appropriations and there is nothing I can do about it!" Large-scale dismissals continued to the end of 1937, but they tapered off in 1938.[32]

Aside from the New Deal recessionist policies, Cahill's program also was plagued by stiff opposition from a conservative Congress. For example, one clause in the 1938 Relief Bill excluded aliens from WPA/FAP assistance; and the American Artists' Congress protested this injustice to artists who were not American citizens. Reacting to this narrow policy, Stefan Hirsch, a member of the WPA/FAP National Advisory Committee, submitted his resignation to Cahill. Despite the ambivalent status of the artist, Cahill told Hirsch, WPA/FAP was still the best means to provide favorable conditions for artists.[33]

In April 1938 further congressional pressure was revealed, when the WPA considered cutting back the yearly cost per artist from $1,272 to $1,000. Strong protest by such groups as the Artists' Union and the Public Use of Arts Committee, which viewed this step as liquidating WPA/FAP, caused the proposal to be shelved.[34]

These cutbacks and restrictions showed the tenor of the 1938 congressional elections, which were damaging to the New Deal. By 1939, Congress, comprised of a strong Republican–conservative Democrat coalition, moved aggressively to dismantle the WPA. For example, through the "Eighteen Months" provision, whereby artists employed for a longer period were dismissed, WPA/FAP lost almost all of its professional and technical personnel. After the regulation was complied with, many artists were reemployed, but the process caused important works to be delayed or dropped.[35] Nevertheless, although the president received little congressional support, neither was Congress able to liquidate the New Deal entirely because of the effective system of checks and balances in the U.S. government.

Notes

1. "Cahill's Reminiscences," pp. 327, 359.

2. Memorandum of Sol Ozer, n.d.; Holger Cahill, "Report on Art Projects," February 15, 1936; Holger Cahill to Colonel Westbrook, January 30, 1936; Holger Cahill, "Federal Art Project Manual," #7120, October 1935, pp. 1–3, RG 69/WPA/FAP.

3. Holger Cahill, "Record of Program Operation and Accomplishment," vol. 1, Art (Washington, D.C.: Federal Works Agency, 1943), pp. 9, 14, 23–25; Cahill, "Federal Art Project Manual," pp. 3–5, 20; Memorandum from Agnes S. Cronin to Regional Directors, Women's Professional Projects, October 5, 1936, RG 69/WPA/FAP.

4. Holger Cahill, "Speech for Southern Women's National Democratic Organization in New York City," December 6, 1936, p. 16, Cahill Papers.

5. "Cahill's Reminiscences," p. 390.

6. Ibid., pp. 373–79.

7. Ibid., pp. 381–85.

8. Ibid., p. 355.

9. Ibid.

10. Cahill, "Record of Program Operation and Accomplishment," p. 356.

11. "Cahill's Reminiscences," pp. 37, 356.

12. Sidney Loeb to Holger Cahill, January 14, 1936, RG 69/651.315; Aaron Bohrod to Holger Cahill, November 7, 1935; Aaron Bohrod to Holger Cahill, December 17, 1935; and Holger Cahill to Aaron Bohrod, December 13, 1935, RG 69/WPA/FAP.

13. Sidney Loeb to Holger Cahill, December 19, 1935, RG 69/WPA/FAP; Holger Cahill to Mrs. Increase Robinson, January 11, 1936; and Holger Cahill to Mrs. Increase Robinson, January 28, 1936, RG/651.315.

14. Sidney Loeb to Holger Cahill, January 14, 1936; and Sidney Loeb to Holger Cahill, December 28, 1935, RG 69/WPA/FAP; Robert J. Wolff to Ellen S. Woodward, June 17, 1937; and Karl Metzler to Ellen S. Woodward, June 23, 1937, RG 69/651.315.

15. Gregory Orloff to Holger Cahill, August 21, 1937; RG 69/651.315.

16. Telegram from the Artists' Union of Chicago to Holger Cahill, August 12, 1937; and Mervin Jules to Holger Cahill, August 28, 1936, RG 69/WPA/FAP; Holger Cahill to Mervin Jules, September 10, 1936; and Lawrence Morris to Ellen S. Woodward, April 23, 1938; RG 69/651.315.

17. New York Times, February 8, 1935.

18. Chicago Tribune, December 20, 1940; "Cahill's Reminiscences," p. 460.

19. "Cahill's Reminiscences," pp. 311–13.

20. For a detailed account, see Gerald M. Monroe, "Mural Burning by the New York City WPA," (AAA Journal 16, no. 3 (1976).

21. New York Sun, July 8, 1940; "Cahill's Reminiscences," p. 390.

22. New York Journal American, February 9, 1934; William E. Leuchtenburg, Franklin D. Roosevelt and the New Deal (New York, Evanston, and London: Harper & Row, Publishers, Inc., 1963), p. 123.

23. "Cahill's Reminiscences," p. 370.

24. Chicago Tribune, December 19, 1940; New York Mirror, October 16, 1938; Mrs. Charles R. Dalrymple to Holger Cahill, December 30, 1935, RG 69/651.315; Minerva K. Teichert to Senator J. C. Mahoney, November 16, 1938, RG 69/WPA/FAP.

25. New York Times, September 20, 1936; Time, September 7, 1936, p. 35.

26. Cahill, "Speech for Southern Women's National Democratic Organization," p. 15.

27. New York Times, October 4, 1936; New York Times, September 27, 1939.

28. Cahill, "Record of Program Operation and Accomplishment," pp. 48–50.

29. "Cahill's Reminiscences," p. 421.

30. Lewis Mumford, "Open Letter to FDR," New Republic 89 (December 30, 1936), pp. 263–65; Stuart Davis to Ellen S. Woodward, June 29, 1936; Ellen S. Woodward to Stuart Davis, July 11, 1936; Stuart Davis to Holger Cahill, April 3, 1937; and Holger Cahill to Stuart Davis, April 13, 1937; RG 69/WPA/FAP.

31. Vilhjalmur Stefansson to Gerald P. Nye, July 8, 1937, RG 69/WPA/FAP; "Culture for America Is under Fire," Art Front, June–July 1937, p. 3; "Answer to Washington," Art Front, October 1937, pp. 3–5; Francis V. O'Connor, The New Deal Art Projects (Washington, D.C.: Smithsonian Institution Press, 1972), pp. 66–67, 202; "Cahill's Reminiscences," p. 421.

32. "Cahill's Reminiscences," pp. 460–61; Holger Cahill to John Gregory, July 13, 1937, RG 69/211.5.

33. Telegram from Stuart Davis to Ellen S. Woodward, July 28, 1937; Stefan Hirsch to Holger Cahill, August 12, 1937; and Holger Cahill to Stefan Hirsch, September 11, 1937; RG 69/211.5.

34. Telegram from Artists' Union of Chicago to Ellen S. Woodward, March 31, 1938, RG 69/651.315; Sidney Loeb to Holger Cahill, March 29, 1938, RG 69/651.315; "To the American People," *Art Front*, July–August 1937; Chet Lamore to Harry Hopkins, April 18, 1938, RG 69/WPA/FAP; Doris Kravis to Edward Bruce, April 19, 1938, RG 121/133.

35. Thomas C. Parker to Lawrence S. Morris, May 11, 1938, RG 69/WPA/FAP; Aubrey Williams to James H. Lewis, June 17, 1938, RG 69/651.315; Cahill, "Record of Program Operation and Accomplishment," pp. 39–40.

7

Cahill's Quest for Unity

Holger Cahill's quest for unity was diametrically opposed to Bruce's quest for permanency. Unlike Bruce's European experience, Cahill's American experience formulated his aesthetic quest to find a place not only for his unquiet personality but for the American artist in the community as well. This American experience brought about a synthesis: European origins and native development made it possible for Cahill—an Icelandic immigrant—to come to terms with American civilization.

Cahill's quest for unity had its roots in the antebellum era—a time when artist and society were not mutually excluded. To create a living present, his search meant going back into the past to restore the values of an agrarian society—shattered by the impact of the Civil War. The mechanization of America in post–Civil War times challenged his goal; the ruthless newly rich looked to the stored-up treasures of Europe for their art, and the American artist became alienated in his or her own land. In fact, the rude values of this new society, according to Cahill, had prevented his father from finding a niche in his own community. Cahill's reaction to Mark Twain's "Gilded Age" in America was comparable to that of art critic John Ruskin to the industrialism in England. Each reflected a desire—through humanistic art values—to preserve a society threatened by technology. In fact, Cahill once had a dream about machines that symbolized his unconscious concern: ". . . he walked faster, the engines must not overtake him. There had been a song in the forest, and now the machines came. . . ."[1]

Cahill owned Edward Hicks's *The Peaceable Kingdom*, a painting that depicts the white race and the Indian race, lion and lamb, living together in complete harmony. The theme expresses Cahill's philosophy about the ideal community: artist and society living in a communal setting. In his quest for unity, Cahill sought to recapture the lost innocence of Hick's *The Peaceable Kingdom*. There are precedents for his quest: William Penn, who is portrayed in *The Peaceable Kingdom*, established his "Holy Experiment" in Pennsylvania, where white and Indian lived in harmony; and the Shaker communities, founded by Mother Lee, where artisans created marvelous Shaker furniture for their communities.

Similar to Bruce's Smithsonian Gallery plan to accomplish his quest for permanency, Cahill's four phases of the Works Progress Administration/Federal Art Project (WPA/FAP) also provided a structure to realize his quest for unity. The four phases were as follows: (1) the establishment of the WPA Community Art Centers; (2) the production of WPA/FAP art for lending to tax-supported institutions; (3) the presentation of WPA/FAP art through traveling exhibits; and (4) the compilation of the Index of American Design. Through these four phases to effect the participation of artist and community in the creative process, Cahill sought to actualize the ideal of Hicks's *The Peaceable Kingdom*.

Innovative as Cahill's program became, it still coincided with President Franklin Roosevelt's objective of developing socially useful projects to enhance the quality of American life. Also, Cahill agreed with Hopkins's goal: to preserve the skills and morale of workers. His personal orientation, however, more closely related to an impoverished past and the dislocation of his father as a musician in a frontier community. Cahill wanted to redress those ills, which he had failed to comprehend in his childhood: "I think that my poor father was a man who just didn't fit into the civilization that he was connected with, the American civilization."[2]

When Cahill was planning his WPA/FAP program, the architect Frederick Kiesler wrote to him about his idea to design an art center, coordinating architecture and allied art fields. Kiesler's concept of the art center as an organic whole fascinated Cahill because he also envisioned a total program, despite his reservations about it. Kiesler, however, well aware of the difficult task of developing a practical, long-range art program, counseled Cahill, ". . . that is exactly our job: to turn the impossibilities into the possibilities." Apparently, Cahill was able to realize those "possibilities" clearly revealed by his WPA/FAP goals: (1) to conserve the talents and skills of thousands of artists who, through no fault of their own, found themselves on the relief rolls; (2) to encourage young artists of definite ability; and (3) to integrate the arts, in general, with the daily life of the community.[3]

In the same way that Cahill's mentor, John Cotton Dana, made his museum central to people's lives, Cahill planned his program so that it would integrate artist and community. The first phase—the establishment of the WPA Community Art Centers—became the keystone of his quest for unity. This step was significant because Cahill unhappily noted that cultural activities had been carried on in just a few metropolitan centers: "All over the country you'd find places that were absolutely barren."[4]

When Jacob Baker first interviewed Cahill, he asked about his plans. In his travels across the United States, Cahill noted that the South had been left far behind in the development of the arts, particularly in small rural and urban communities. To redress this wrong, he cited an incident in Chattanooga, Tennessee, where a young man who painted theater posters wanted to be an artist: "If I were to run a government project—do you realize that boy might be a real talent? But there he is, he can't get away. He's married. He's tied on that treadmill of his, and there isn't a decent picture to be seen within 600 miles of where he is, in Chattanooga." Baker liked these ideas, and, according to Cahill, this conversation sowed the seeds for the development of community art centers.[5]

In the beginning he sent his assistant director, Thomas Parker, down to the Carolinas, and to the South in general, to set up community art centers. Cahill explained his choice: ". . . he was a Virginian, a Southerner, and would be recognized by people in the South as not just a damned Yankee."[6] In the first WPA Community

Art Center organized—the Raleigh Art Center in North Carolina—artists and craftspeople gave demonstrations in the fine arts and the practical arts to encourage community participation. Also, popular classes in sketching, painting, sculpture, and crafts were offered to the community by the teaching staff. Under the guidance of the Raleigh Art Center a gallery for blacks was established in the Extension Division of Shaw University—its various art activities handled by the Raleigh staff. Eventually, the WPA/FAP operated 103 community art centers, which received strong local support throughout the country.[7]

In one instance, however, Cahill strongly reacted to adverse criticism of WPA/FAP by the musical director Walter Damrosch: "I stood up and I took that microphone and I practically danced with it." First, Cahill praised Damrosch's early work in World War I to improve the quality of American community music. Then he declared, "That is precisely what we are doing with these art centers of ours." Cahill also spoke about Rembrandt in his poverty-stricken years, which almost reduced Damrosch to tears. Damrosch was moved to say, "I feel like the man who was not understood by anybody except one man and that man misunderstood him."[8]

In the post–Civil War period the arts in America had been removed from their social context, Cahill observed. Hence came the second phase of the WPA/FAP: the production of art for lending to tax-supported institutions. This project proposed not only to open a door for the talents of artists but also to enhance community life. "A greater number and higher quality of production could occur, if the same encouragement given to utilitarian matters, were offered to contemporary artists," Cahill quoted from Dana's dictum. It was the adverse effect of industrialism on the arts in America that Cahill reacted to—a phenomenon that isolated the work of the artist from the mainstream of American life.[9] In sum, he wanted to modify the hostile environment that had prevented his father from finding a place for his talents in a raw frontier community.

As a result of Cahill's intention to find an outlet for artistic talent, by December 1936 more than 450 murals had been completed for tax-supported buildings throughout the United States; and work for public sites had been done by 500 sculptors. Easel works reflecting various aspects of the American scene had been allocated to tax-supported institutions; and artists in the graphic arts had been encouraged to select the medium most sympathetic to their vision. The print, according to Cahill, had given a fresh and vigorous interpretation to the whole kaleidoscope of American life.[10] The extensive output of tax-supported work revealed that Cahill, indeed, had found an outlet for talent and was integrating the arts with the daily round of the people.

Public presentation of WPA/FAP artworks through traveling exhibits was the third phase of Cahill's goal. He observed that art patrons in America had not been appreciative of their native environment, creating serious handicaps for the American artist. This had caused the nation to suffer a cultural erosion that was more serious than the erosion of the dust bowl, he declared. Because the nation was practically barren of art forms and interest in art, the artist had few opportunities to exhibit, except in two or three major cities.[11] To offset this cultural erosion, Cahill organized a National Exhibition Section in Washington, responsible for sending the works of the WPA/FAP artists to community art centers and federal galleries across the country.[12] In such cities as New York, Chicago, Philadelphia, Boston, and San Francisco, however, where some of the WPA/FAP artists were avant-garde, various public schools refused to accept the work. Education in art was a slow but essential process, Cahill realized. In fact, on traveling exhibits to community art centers that included experimental art, he noticed that the first two or three months were not successful, but the people were nevertheless exposed to it. "To understand is simply to participate," Cahill advised. "Go and see it. Expose yourself to it. Look at it."[13]

During the period from November 1937 to April 1938, traveling exhibits were dispatched to more than fifty community art centers, from New York to Wyoming. The exhibits ran the entire gamut, from easel paintings, watercolors, prints, mural designs, and sculpture to posters and photography. New Yorkers viewed "Art in the Middle West" in their federal art gallery. The exhibit included paintings by Illinois artists, as well as mural sketches and graphic prints. In Oklahoma City the opening of a new federal art gallery was celebrated with an exhibit of work from all parts of the country. Chicago displayed the work of its own artists in the Art Institute in a broad and comprehensive exhibit entitled "Art for the Public by Chicago Artists."[14]

In addition to traveling exhibits going to U.S. communities, Cahill also organized his first national exhibit of WPA/FAP work at the Phillips Memorial Gallery in Washington, D.C., from June 15 to July 5, 1936, presenting a cross section of WPA/FAP art that had been done in one year. Urging regional advisors and state art directors to send their best works, Cahill wrote to Increase Robinson in Illinois, "At the moment we are desperately in need of really fine works for the exhibition; please send me as many exhibits as you can and as soon as you can possibly get them off."[15] Pleased with Robinson's cooperation, he later remarked, "The Illinois project comes out very well in this exhibition. . . ." The art critic Leila Mecklin, however, reacted unfavorably to Cahill's first national exhibit: "One looks almost in vain for a spark of inspiration, a glimmer of inherent talents." Yet the *American Magazine of Art* praised the exhibit for showing works of little-known artists and concluded that WPA/FAP was concerned not only with production of work but with educational services, such as community art centers.[16]

Cahill held a second national exhibit—this time at the Museum of Modern Art in New York from September 15 to October 14, 1936. Undoubtedly, this exhibit, "New Horizons in American Art," is the most influential organized by Cahill. His sharply perceptive essay for the show states publicly for the first time the innovation of his program and quest for unity. The "New Horizons" exhibit with its broad coverage of Cahill's program was highly acclaimed by many art critics. For instance, in the *New Yorker* Lewis Mumford exclaimed, "It is all very sudden and unexpected and fabulous—enough to set one singing "The Star-Spangled Banner" aloud while walking down Fifty-third Street." The WPA/FAP artists were praised by Malcolm Vaughn in the *New York American* for taking American painting out of the cloister into the exhilarating light of day. William Germain Dooley in the *Boston Evening Transcript* was impressed by a return to realism and a close examination of the American scene. Critical reaction in the *New York Times* came from Edward A. Jewell: "Much depressing worthless or mediocre art." However, Edith Halpert, director of the New York Downtown Gallery, thought otherwise because she felt that the exhibit brought "fresh directions to native art."[17] Her observation reflects the nature of Cahill's idealism, revealed in his novel *A Yankee Adventurer*: ". . . a horseman rode westward from New York toward the Pacific. He crossed the Ohio and the Mississippi and rode out on the Great Plains. He was used to the sea and knew how to keep his course due west. He was following a dream."[18] The idealism or "mystical streak," which Cahill admits having, placed an indelible mark on the WPA/FAP program. Thus, the "New Horizons in American Art" exhibit clearly shows Cahill's quest to unite artist and society.[19]

Later, Cahill organized other exhibits to bring his broad, innovative program to the people. For the New York World's Fair of 1939–40, he planned activities as early as 1935. Bruce also participated in projects for the New York World's Fair. In 1937,

Photo of Holger Cahill and Harry L. Hopkins at the "New Horizons" exhibit in the Museum of Modern Art, New York City. (National Archives)

Cahill developed plans to decorate state buildings and to set up a typical community art center, where the public could watch artists work in all media. In 1938 plans for a comprehensive fine arts exhibit were coordinated by Cahill. After selecting art from all over the country for the exhibit, entitled "American Art Today," he remarked, "The exhibit reveals that everywhere in the country there are artists who have the technique, the discipline, and the will to maintain American art at the best of its best traditions." Early in 1940, Cahill had another chance to present his concept of artist-community participation, when fair officials contributed the use of the Contemporary Art Building to the New York City WPA. In this case four galleries were devoted to rotating art exhibits and eight galleries to workshop demonstrations, which attracted large audiences.[20]

Public interest in Cahill's traveling and national exhibits indicates his success in placing the arts into the mainstream of daily life. Moreover, it appears that his approach to the public presentation of WPA/FAP art was stemming the cultural erosion he had witnessed in his early travels throughout the country.

Compilation of the Index of American Design comprised the fourth phase of Cahill's quest for unity. His objective called for a pictorial record of American design from the Colonial period to the 19th century. However, Cahill's intent was to illuminate those dark corners of early rural America that would restore to U.S. communities those

human values in the American civilization. As he expressed it, it was "to deepen our experience and make that experience clear to us."[21]

The Index of American Design, however, defines a kind of journey that Cahill himself traveled in coming to terms with American civilization. In the summer of 1922, while on a European tour, his interest in folk art began when he visited the great museums of Norway, Sweden, and Germany. At the Konstljod Museum in Gothenburg, Sweden, he saw extraordinary examples of folk art; and on Sundays he watched the people attending church in traditional peasant garb. These events greatly impressed him.[22] Because of his interest in indigenous art, he began to realize that the relationship between European folk art tradition and native tradition created distinctive new forms. The American art critic Ernest Fenollosa succintly describes this process: ". . . alien influence is invariably at the heart of the native development."[23]

In a related way Cahill's own personality went through a synthesis of Icelandic origins and American experience. After having traveled to Canada, China, Europe, and back to the United States again, Cahill exclaimed: "I've gone too far now looking for things. This is my soil and I must stay close to it. Try to sink my roots in. Deep."[24]

The idea for a design project first occurred when Ruth Reeves, a textile designer, met with Romona Javitz, a staff member of the New York Public Library, to discuss the organization of a design project. Cahill liked Reeves's ideas, but instead of accepting her proposal to include Latin American and Indian arts, he opted to confine the Index project to North American folk materials of European origin.[25]

Dana's outlook on utilitarian objects as American art aroused Cahill's interest. For example, Dana commented:

> When I reflect on the words "American art," many things come into my mind; such, for example, as tableware, cutlery, table linen, chairs and tables; draperies and wall papers; houses, churches, banks, office buildings and railway stations; medals and statues; books, journals, signs and posters; lampposts and fountains; jewelry, silverware, embroideries and ribbons; vases and candlesticks; etchings, engravings, drawings and painting.[26]

Many of the folk art categories in the Index project reveal Dana's far-reaching ideas. For instance, Index artists were working in such areas as furniture, costume, textiles, toys, weather vanes, and cigar-store Indians, making facsimile renderings on paper in color and black-and-white. At an Index exhibit held in the Newark Museum, Cahill paid homage to Dana: "I believe that here in this exhibition of the WPA Federal Art project we have an example that proves the wisdom of Mr. Dana's judgment and the courageous clarity of his vision."[27]

Influenced by Dana's farsighted interest in objects of daily living, Cahill was deeply concerned about the possible loss of the American crafts tradition. He cited the cases of India and China, whose traditions of the finest decorative arts in the world were now displaced by a machine culture. This dilemma, he warned, could be repeated in America. However, it is evident that Cahill wanted not only to preserve but to utilize America's past in contemporary America. He did this by providing a link between early American design and modern aptitude for merchandising. Index exhibits, organized by Cahill, were shown in major department stores, such as Macy's in New York, which presented almost every phase of applied and decorative art. At Marshall Field's in Chicago the public expressed such enthusiastic interest that the nationwide Associated Merchandising Corporation requested and showed the Index exhibit to its member firms across the nation.[28]

However, a peculiar ideological dilemma took place within Cahill's program because the Index and the Design Laboratory reflected opposing aesthetic goals. In a sense it was a conflict of values similar to what had occurred between Bruce's Section of Painting and Sculpture and Moore's Commission of Fine Arts. In October 1935 the Design Laboratory was established under WPA/FAP, and Gilbert Rodhe, an industrial designer, directed the project, assisted by an advisory board that included such leading designers as Ralph Pearson and Walter Dorwin Teague. The objective of the school was to offer free courses for those unable to pay tuition, but not to compete with private schools. Apparently, the Design Lab's objectives were not realized, and its unexpected demise in June 1937 was explained in this manner by Cahill to Pearson: "I thought the idea a very good one but was not pleased with the way it was carried out and more particularly, with the fact that it was teaching many students who could have afforded to pay for their tuition at private schools."[29]

Moreover, Cahill's lack of support implied a sharp disagreement with the machine-oriented aims of the Design Lab. For instance, the machine culture, from his viewpoint, had brought about too rapid a change from craft methods to mass-production techniques, leading to deep social maladjustments. On the other hand, Rodhe declared that the purpose of the school was to modernize design in terms of a mass-production economy. He pointed out that the Design Lab focused on machine-oriented concepts, while discarding traditional craft sources. Cahill, however, believed that the indigenous craft traditions compiled by the Index could restore basic values to the community and set higher standards for the future.[30]

Cahill's personal disenchantment with the aims of the Design Lab was publicly revealed at a Junior League exhibit of machine-designed gadgets. At the League show Walter Dorwin Teague sharply criticized the WPA/FAP program. He insisted that there would be no need for the government to put a pulmotor over the arts, when industrial designers converted the public to the materials of human happiness. Of course, Cahill took a dim view of the ability of industrial designers to promote human happiness; especially when they foolishly designed cars with tail fins resembling those of airplanes. He was not about to permit Teague's criticism to go unanswered. Cahill started to speak when he unexpectedly heard one of the alarm clocks in the design exhibit winding up: "You can hear a peculiar sort of wheezing of the mechanism when it's going to ring." He suddenly realized that if the alarm went off during his talk the laughter in the audience would be directed at him. To turn that laughter against Teague, Cahill stalled a little and just as the clock was starting to go off, he said, "Well, ladies and gentlemen, there's some of the material of human happiness that Walter Teague is dealing with!" Cahill repeated, "Well, this is one of the well-designed gadgets that Walter Teague is talking about." The audience just roared with laughter.[31]

Undoubtedly, the kind of community environment that Leo Tolstoi once described as a "vital relationship," and John Dewey as "a free and enriching communion," emerges out of the four phases of Cahill's WPA/FAP program. Because of the Depression the federal support of the arts took place on an unprecedented scale—the saving of artists from economic destruction having been its primary objective. Cahill, however, enlarged the original purpose of the New Deal. Through his quest for unity—to provide a setting not unlike William Penn's "Holy Experiment" or that of Mother Lee's Shaker community—artists of all persuasions functioned and participated freely in their local communities, as well as on the broader national art scene.

Notes

1. Holger Cahill, *Profane Earth*, (New York: The Macaulay Company, 1927), p. 380.
2. "Cahill's Reminiscences," p. 21.
3. Frederick J. Kiesler to Holger Cahill, October 30, 1935; Holger Cahill to Frederick J. Kiesler, November 4, 1935; Frederick J. Kiesler to Holger Cahill, November 8, 1935; and Holger Cahill to Frederick J. Kiesler, November 12, 1935, RG 69/211.5; Holger Cahill, "Report on Art Projects," February 15, 1936, p. 3, RG 69/WPA/FAP.
4. Report from Holger Cahill to Mrs. Rebecca Reyher, December 19, 1936, p. 4, RG 69/211.5.
5. "Cahill's Reminiscences," pp. 334–35.
6. Ibid., p. 342.
7. Oral history interview with Daniel S. Defenbacher, April 16, 1965, pp. 6, 34, Archives of American Art; "First Yearbook of the Raleigh Art Center," May 15, 1936, pp. 5–10, RG 69/WPA/FAP.
8. "Cahill's Reminiscences," p. 366.
9. Cahill, *New Horizons in American Art* (New York: Museum of Modern Art, 1936), p. 12.
10. "Cahill's Reminiscences," pp. 176–78; Cahill, *New Horizons in American Art*, pp. 30, 37, 38–40; Report from Cahill to Mrs. Reyher, December 19, 1936, pp. 9–10, 11–12, 13–14.
11. "Cahill's Reminiscences," pp. 366–68; Francis V. O'Connor, ed., *Art for the Millions* (Greenwich, Conn.: New York Graphic Society, 1973), pp. 36–38.
12. Holger Cahill to Jacob Baker, June 23, 1936, RG 69/211.5; Cahill, *New Horizons in American Art*, p. 29.
13. "Cahill's Reminiscences," p. 453.
14. Progress Report from Holger Cahill to Ellen S. Woodward, November 1937–April 1, 1938, RG 69/WPA/FAP; Memorandum from Thomas C. Parker to Ellen S. Woodward, February 17, 1938; Memorandum from Thomas C. Parker to Ellen S. Woodward, July 22, 1937; and Memorandum from Thomas C. Parker to Ellen S. Woodward, November 5, 1938; RG 69/211.5.
15. Holger Cahill to Mrs. Franklin D. Roosevelt, June 5, 1936; and Holger Cahill to Mrs. Increase Robinson, May 6, 1936; RG 69/WPA/FAP.
16. Holger Cahill to Mrs. Increase Robinson, June 12, 1936; and Press release of WPA/FAP National Exhibition, June 10, 1936, RG 69/WPA/FAP; "WPA Takes Stock at Washington," *American Magazine of Art*, August 1936, pp. 505, 550.
17. Memorandum from Holger Cahill to Ellen S. Woodward, August 1, 1936; and WPA Bi-Monthly Bulletin, vol. 1, no. 1, "Excerpts from Ten Reviews," October 1, 1936, RG 69/WPA/FAP.
18. Holger Cahill, *A Yankee Adventurer* (New York: The Macaulay Company, 1930), p. 11.
19. "Cahill Reminiscences," p. 112; Typescript report of the WPA Art Program, June 30, 1939–June 12, 1940, p. 11, RG 69/211.52.
20. Francis V. O'Connor, *The New Deal Art Projects: An Anthology of Memoirs* (Washington, D.C.: Smithsonian Institution Press, 1972), pp. 250–63; Holger Cahill to Commissioner Harrington, December 15, 1939, RG 69/651.315; Brehon Somervell to Commissioner Harrington, February 16, 1940; RG 69/561.315.
21. Holger Cahill, "Speech for Southern Women's National Democratic Organization in New York City," December 6, 1936, p. 14, Cahill Papers.
22. Ibid., p. 11.
23. "Cahill's Reminiscences," p. 189.
24. Cahill, *Profane Earth*, p. 383.
25. O'Connor, *The New Deal Art Projects*, pp. 177–78; Ruth Reeves to Holger Cahill, December 22, 1936, RG 69/211.5.
26. John Cotton Dana, *American Art—How It Can Be Made to Flourish* (Woodstock, Vt.: Elim Press, 1929), p. 5.
27. Address by Holger Cahill at the Newark Museum, "American Design," November 6, 1936, p. 18.
28. "Cahill's Reminiscences," p. 359; Cahill, *New Horizons in American Art*, pp. 24–38; Memorandum from Thomas C. Parker to Ellen S. Woodward, July 5, 1938, RG 69/211.5; Memorandum from Holger Cahill to Ellen S. Woodward, February 3, 1937, and from Thomas C. Parker to Ellen S. Woodward, December 10, 1937, RG 69/211.5.
29. Holger Cahill to Bruce McClure, November 2, 1935; Holger Cahill to Jacob Baker, December 4, 1935; and Holger Cahill to Ralph M. Pearson, January 15, 1938, RG 69/211.5.
30. O'Connor, *Art For the Millions*, pp. 36–37; Holger Cahill, *American Folk Art: Art of the Common Man* (New York: Museum of Modern Art, 1934), pp. 6–7.
31. "Cahill's Reminiscences," p. 368.

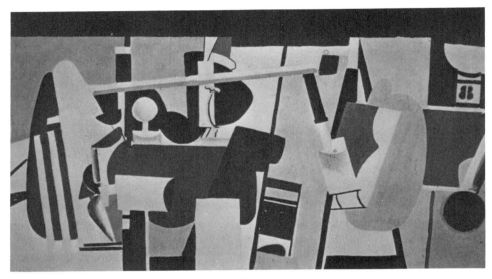

Arshile Gorky (WPA/FAP), *Aviation*, **study for mural. (National Archives)**

8

Innovation and Art of the WPA/FAP

The innovation of the Works Progress Administration Federal Art Program (WPA/FAP) stemmed from Holger Cahill's American experience. Alien to the American culture, he probed not only his own origins but the American civilization as well to understand an American scene that had ceased to exist in the post–Civil War period. As the New Deal sought to recover the American dream, Cahill endeavored to restore those antebellum values in the American scene.

The Public Works of Art Project (PWAP) concept of decentralizing its operations proved vital to Cahill's innovative approach of bringing art onto "the highways and byways of America." This goal made it possible to organize central projects in large art centers for supplying tax-poor states with works of art, but it also brought together artist and society—mirroring an American scene of the antebellum era.

Moreover, the social experiments of the New Deal were reflected in Cahill's program. He was quick to recognize the importance of Harry Hopkins's creed: "to maintain skills and to rehabilitate workers." The case of the Hispanic American sculptor Patrocino Barela (1908–64) of New Mexico is one example of WPA/FAP rehabilitation. The project not only recognized the need for self-expression by this former Emergency Relief Administration (ERA) teamster but utilized a natural talent by employing him as a sculptor.[1]

Besides, the new idealism of the New Deal to provide a more abundant life for all closely paralleled Cahill's own desire to create opportunities for artists of all stylistic persuasions. His dictum "Anything painted by an American artist is American art" expressed the kind of innovation that governed the work of WPA/FAP artists. However, his quest for unity—an imaginative approach to bridge the gap between the American artist and American society—was derived, in part, from John Dewey's philosophy about democracy as "A free and enriching communion," where everyone participates in the process. Cahill knew that American society had not yet achieved that objective, but he declared, ". . . we hold to that idea as the pattern of a program for our society and we are beginning to translate it into action."[2]

The poet Archibald MacLeish lucidly expressed the new spirit of Cahill's innova-

tion: "What the Government's experiments . . . actually did, was to work a sort of cultural revolution in America. They brought the American audience and the American artist face to face for the first time in their respective lives. And the result was an astonishment needled with excitement such as neither the American audience nor the American artist had ever felt before."[3]

Aesthetics of the WPA/FAP

The "enriching communion" spirit of Cahill's program reflected "the force of the Virgin," a theory about the Middle Ages that was expressed by the historian Henry Adams. Similar to Adams's concept—a community unified through faith, which the cathedral symbolized—the art programs expressed the unifying idealism of the New Deal. Bruce's program placed murals in post offices, which were like small art centers in people's lives. In a more innovative way, however, Cahill's program—through community art centers, federal art galleries, and traveling art exhibitions—created a broader artist-community relationship. Adams, contrasting "the force of the Virgin" with "the force of the Dynamo," concluded that "the Dynamo" could build neither cathedrals nor the faith of a community.[1] Cahill also questioned "the force of the Dynamo," a technology that tended to fragment the unity of a community in the American scene.

Bruce's professional program emphasized a patron-artist relationship, but in Cahill's program a different development occurred. The "communion" spirit, implicit in Adams's "force of the Virgin," was revealed by WPA/FAP artists responding to this artist-community relationship. For instance, Louis Guglielmi (1906–56) declared, "the time has come when painters are returning to the life of the people once again and by so doing are absorbing the richness, the vitality, and the lusty healthiness inherent in the people."[5] Julius Bloch's desire to have people come out to enjoy his pictures was fulfilled by a WPA/FAP exhibit held in Philadelphia's subway concourse: "Thousands of people streamed by from early morning until midnight, and it was gratifying and inspiring to see how closely they examined the works displayed."[6]

Other artists sought to express the origins of their relationship with the community and to grow with that experience. Referring to a native epic, which needed a mural expression, Mitchell Siporin declared, "We are only now seeking out our myth, and with our growing maturity as painters, we will develop towards a formal pattern for the things we say that will bind us closer to those to whom we speak."[7] This view was shared by Edgar Britton (1901–), who concluded, "It is important for the artist to paint where his public would see him."[8] In like manner Lucienne Bloch noted, "They wholeheartedly enjoy watching me paint. The mural was not a foreign thing to them."[9]

Sculptors like Girolamo Piccoli (1902–) and Samuel Cashwan (1900–) revealed a strong communal bond. Piccoli observed, "We on the Project no longer work blindly; nor are we isolated from society. We have a client. Our client is the American People."[10] Equally enthusiastic was Samuel Cashwan: "The greatest good a sculptor can perform is to create, not for a museum or a private collection, but for the common meeting places of men."[11]

Printmakers, too, responded to this artist-community relationship. Block-printing without an inspiring conviction is dead, Fritz Eichenberg cautioned. He strongly urged the printmaker to live among the people because the artist needs to enlighten

the masses and heal the wounds inflicted by the world.[12] Eli Jacobi (1898–) saw a time when it would not be necessary for the artist to evoke bitter truth with beauty. He proclaimed that this would happen when the artist took his or her rightful place in society.[13]

Because Cahill had been a wanderer in the American scene, he closely related to the vitality of the Ashcan school, one of the first art movements to depict the gusty vigor of contemporary American life. Reflecting the new realism of the Ashcan school, he defined the function of art in this way: "In a genuine sense, it should have use; it should be interwoven with the very stuff and texture of human experience, intensifying that experience, making it more profound, rich, clear, and coherent."[14] In the beginning Cahill discouraged any emphasis on the "American Scene"—a theme advocated by Bruce in PWAP—because he viewed it as arbitrary. Since an individual reaction to the American experience was encouraged, WPA/FAP artists approached the American scene in just that manner, their work covering a wide spectrum of styles from realism to abstraction.[15]

Easel Painting

The broad iconography used by the Coit Tower project under PWAP reappeared in WPA/FAP, revealing the following elements: social realism, Mexican influences, regionalism, social protest, social consciousness, and avant-garde. These broad directions implied an end to the kind of detachment that had removed the artist from common experience. This trend was evident in the work of the easel painters, who were critically examining their individual responses to the contemporary American scene and stating it on their own terms. For example, Louis Guglielmi, Rufino Tamayo (1899–), and Remo Farruggio (1906–), revealed haunting, lonely, almost barren qualities in their art. Sensitive, poignant—and in some ways almost surrealistic—scenes interested Guglielmi. In *Hague Street*, the figures take on the unreal quality of suspended time in a landscape otherwise devoid of human activity. A tenement on the Upper East Side of New York City provides a setting for Guglielmi's childhood experiences. The boy carrying a flowerpot on "Hague Street" is symbolic of escape from the horror of life on a mean street under the arched approach of the Brooklyn Bridge.[16] In a work by the Mexican painter Rufino Tamayo, a "Waiting Woman" in a square stone enclosure with barren tree branches quietly waits. The silent figure below and the ominous sky above seem to symbolize a lack of hope in surviving the barren environment of the Depression. In the composition there are two diagonally cut logs leading into the distance, which appear to serve as a memory bridge. The scene of mountain, moon, and sky perhaps is a reflection of Tamayo's own longing for his native land. Remo Farruggio's *Street Scene* shows a solitary figure in a surrealistic setting; the shadows create an ambivalent mood, revealing cubelike buildings and empty streets; and a one-point perspective narrows the direction of the walking figure to a vanishing point of no return in a Depression scene of little hope.

Other work reflecting personal reactions to the ambiguities of the Depression was expressed by Raymond Breinin (1910–) and Jack Greitzer (1910–). Breinin's group of houses, in a constricted perspective, appears to take on an ominous note. A strong diagonal thrust of a stone wall parallels the "White House," bordering on a street that seems to point nowhere. Greitzer's *Memory* depicts a solitary figure, in a waking dream, climbing steps that lead to an endless unknown destination. The

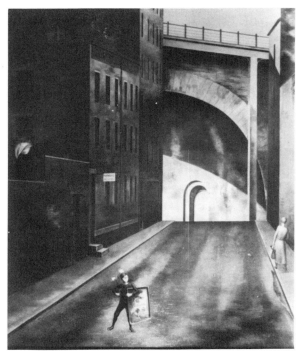

Louis Guglielmi (WPA/FAP), *Hague Street.* **(National Archives)**

Rufino Tamayo (WPA/FAP), *Waiting Woman.* **(National Archives)**

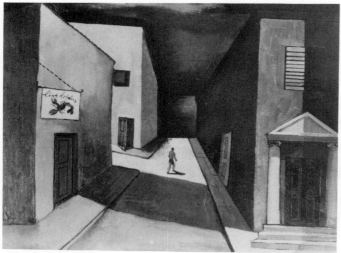

Remo Farruggio (WPA/FAP), *Street Scene.* **(National Archives)**

Raymond Breinin (WPA/FAP), *White House.* **(National Archives)**

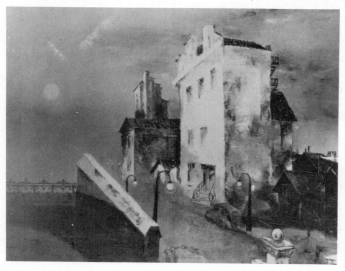

landscape is barren, rockhewn, and sparsely detailed; the large expanse of somber sky intensifies the emptiness of the scene.

The inner reactions of artists to human suffering have been described in this fashion:

> I have tried to look beneath the surface of things: to paint the parched fields thirsting for rain; the shattered hopes of multitudes of men and women who walk jobless through town and country.[17]

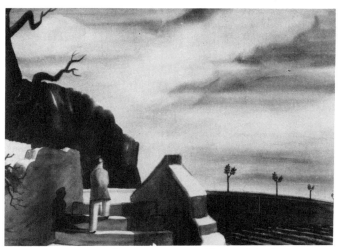

Jack Greitzer (WPA/FAP), *Memory.* **(National Archives)**

In such a manner Joseph Vavak (1899–), Mitchell Siporin (1910–), and Louis Guglielmi responded to the impact of human desolation in a dispirited land. Vavak's *The Dispossessed* shows a frontal view of a two-story house being ruthlessly demolished by workers. The theme is depicted as if the foundations of a total society are being uprooted by blind forces not of its making. A helpless mother and child sit passively on the second floor, with only a roof over their heads, before the two are thrown into the unknown void of the Depression. Siporin, however, depicts the under-privileged who live "on the wrong side of the tracks." His *Polish Family on the Prairie* reveals elements of this desolate urban scene: a threatening sky, torn shapes, and half-buried debris. A man, woman, and child, with haunting facial expressions, appear to have little chance of escape from the harsh environment of the Depression. The gaunt faces of the underprivileged painted by Siporin, which confront the viewer, strongly emphasize the social protest of the period. In *The Hungry*, Guglielmi cap-tures the mood of the Depression: the deep-rooted resignation of human beings, enduring inexorable events, with no relief in sight. In the same composition, within an elongated shape (that might be interpreted as a hole in a wall, or a large mirror through which "one sees but darkly"), is a destitute figure seeking relief, but cowering before a pitiless, awesome relief official. The realistic treatment of detail heightens the effect of a surrealistic dream—or waking reality—of the Depression.

The individual faced with the problem of survival is shown by Aaron Bohrod (1907–) in his *Landscape in Winter*. A warmly dressed figure in the left foreground, crossing a street, is seemingly caught in the bare branches of a tree that offers no shelter. Bohrod portrays factories, derricks, and buildings—anonymous and uncom-promising shapes—bearing down on the figure, facing these harse elements of urban life with little hope of survival.

Other kinds of subject matter are revealed by Jack Levine's (1915–) social realism and Philip Evergood's (1910–73) social history. The social realism stated by Levine's theme is as sharp and satirical as that of the European expressionists Chaim

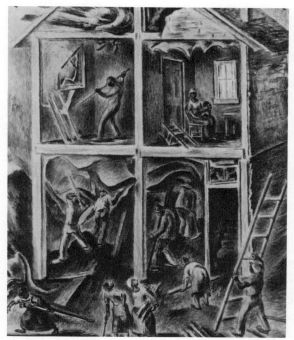

Joseph Vavak (WPA/FAP), *The Dispossessed.* **(National Archives)**

Mitchell Siporin (WPA/FAP), *Polish Family on the Prairie.* **(National Archives)**

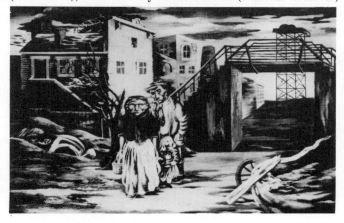

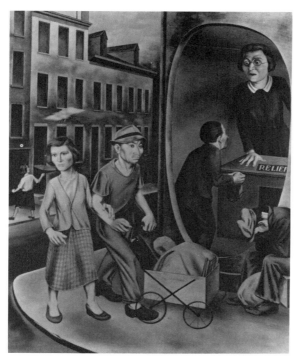

Louis Guglielmi (WPA/FAP), *The Hungry.* **(National Archives)**

Aaron Bohrod (WPA/FAP), *Landscape in Winter.* **(National Archives)**

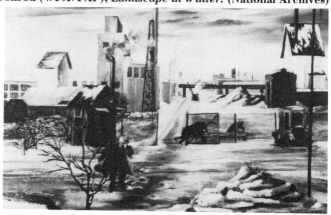

Jack Levine (WPA/FAP), *The Street.* **(National Archives)**

Soutine and George Grosz. In *The Street,* a work that reveals the influence of Soutine's bold, swirling brush technique, Levine criticizes the conditions of humanity's social plight. The theme suggests Franklin D. Roosevelt's "One third of a nation . . . ill-housed, ill-clad, ill-nourished." Levine reacts to the poverty of the underprivileged in this fashion:

> I feel the sordid neglect of a slum section strongly enough to wish to be a steward of its contents, to enumerate its increment—newspapers, cigarette butts, torn posters, empty match cards, broken bottles, orange rinds, overflowing garbage cans, flies, boarded houses, gas-lights and so on—to present this picture in the very places where the escapist plans his flight. [18]

The social roots of the American scene are delineated by Evergood. In his composition a teacher in a classroom surrounded by students of many different races explains how immigration movements shape American history. The work revealing an image of the Statue of Liberty against a sky filled with clouds rests on a classroom easel. Evergood repeats the cloud motif in the upper part of the composition to suggest an historic, steady stream of immigrants coming to America from the Old World.

The WPA/FAP artists responded not only to the reality of the Depression but also to the realism of the American landscape. Their work reflected the kind of free expression that may have occurred because of a release from the traumatic pressures of the early part of the Depression. These painters, perhaps, would have been described by a social realist like Jack Levine as "Ivory Tower artists" for lacking a social theme. However, the work revealed a definite search for personal motifs on the contemporary scene. For instance, Cameron Booth (1892–) and Edward Lewandowski (1913–) responded to a literal realism on the American scene. Booth's *The Bridge* shows a simple, bold treatment of dark and light masses against which the shapes of small moving vehicles can be seen. A simple, realistic modeling of form is used by Edward Lewandowski in *Grain Elevators, Number 1,* to emphasize the difference between the cylinder forms of grain elevators and the flat surfaces of a train.

An expressionistic image of the American scene emerges from Jean Liberté's

Philip Evergood (WPA/FAP), *Classroom History.* (National Archives)

Cameron Booth (WPA/FAP), *The Bridge.* (National Archives)

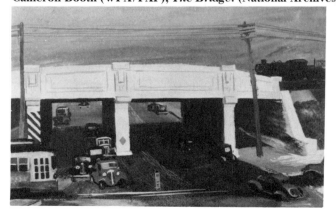

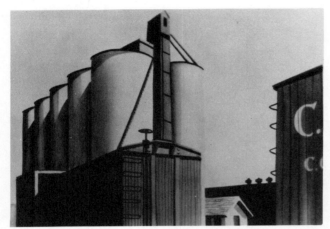

Edmund Lewandowski (WPA/FAP), *Grain Elevators.* **(National Archives)**

Jean Liberté (WPA/FAP), *Off the Coast.* **(National Archives)**

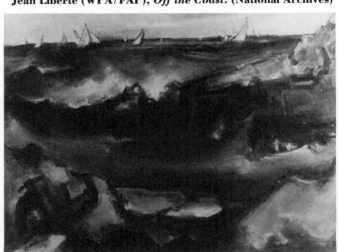

(1895–1965) *Off the Coast.* The heavy mood of the sea, with waves dashing against the rocks, crosses the composition like a monstrous beast. The triangular shapes in the upper part of Liberté's painting appear to be either the sails of a boat or the fins of a shark, reflecting the kind of enigmatic imagery found in the work of playwright Samuel Beckett.[19]

The work of Pedro Cervantez (1915–) repeats the literal realism seen in Cameron's painting, but it is stated in more exacting terms. Cervantez's stark realism in *Pump House* accents the white cubelike building with the dark shape of another

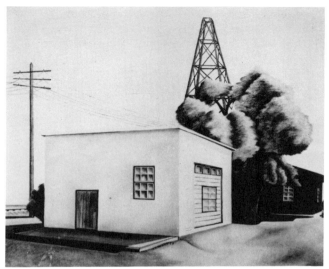

Pedro Cervantez (WPA/FAP), *Pump House.* **(National Archives)**

Loren MacIver (WPA/FAP), *Four O'Clock in N.Y.* **(National Archives)**

Karl Knaths (WPA/FAP), *Composition.* **(National Archives)**

building in the background. Between the two buildings a tree in full foliage contrasts with the geometric forms.

Differing from Cervantez's precise statement, Loren MacIver's (1909–) American scene reveals an ingenuous, almost childlike image that is reminiscent of the imaginative work of the European artist Paul Klee. The facade of the metropolis in her *Four O'Clock in New York* appears to be a cardboard city of simple, linear structure. (A whimsical touch is added by the phrase "Love Nest," lettered on one of the buildings.)

The trend in experimental art that had been initiated in PWAP continued under WPA/FAP. In the case of Karl Knaths' (1891–1971) *Composition*, a political subject is depicted, but with an abstract style. He shows various activities in an interior room: two men—one an intellectual, the other a worker—engaged in conversation on the eve of election night; a woman sweeping the floor; and a cat scratching behind its ear. Within a simplified construction, Knaths creates dominant tension between the frontal plane of a back wall and the diagonal lines of the floor. The placing of the cat in the right foreground, with its rhythmic, linear pattern, offers a balance to the geometric construction.

A similar experimental approach was utilized by Hilaire Hiler (1898–1966) and Morris Graves (1910–). Hiler develops an overall pattern of solid and linear shapes in his *Fishing Port*. The hauling of nets and the docking of vessels convey a lively, visual sense of the fishing activity. Graves, in his *Message Number 6*, attempts to portray the mysterious reality of the inner world. He explains, "I paint to rest from the phenomena of the external world—to pronounce it—and to make notations of its essences with which to verify the inner eye."[20] His art seems to evolve out of the Eastern philosophy, where reality transcends the sensory realm of the Western world.

Joseph Stella's (1880–1946) abstract *Metropolitan*, seen from an aerial view, ex-

Hilaire Hiler (WPA/FAP), *Fishing Port.* **(National Archives)**

Morris Graves (WPA/FAP), *Message, No. 6.* **(National Archives)**

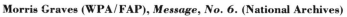

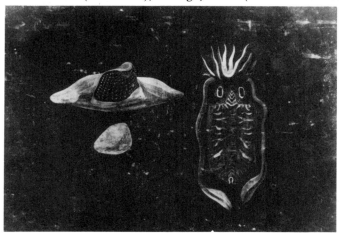

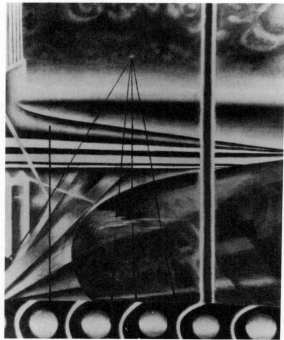

Joseph Stella (WPA/FAP), *Metropolitan.* **(National Archives)**

presses homage to the speed, lights, and streamlined forms of the modern city. In the composition the crisscross patterns of light, the sharp sweep of runways, and airport tower communication signal a plane in flight. The mélange of abstract shapes dramatizes Stella's version of twentieth-century technology in the American scene.

Murals

The WPA/FAP muralists created a body of work for public buildings that touched on the life of the community. The idea of a WPA/FAP "people's art" was summed up in this manner: "These murals belong to the community. They are your bequest to the future; a vital, integrated expression of today, giving a permanence to our own time."[21] Of course, the Mexican mural movement of the 1920's provided a precedent for a "people's art," influencing the American artist during the Depression era.

The relief aspects of WPA/FAP permitted great freedom, but a patron-artist relationship, similar to that of the Section of Painting and Sculpture, confronted the WPA/FAP muralist. For example, in the New York mural division, sketches and color detail were subjected to approval by the WPA/FAP Reviewing Board and the Municipal Art Commission. The question of review procedures arose when Cahill cautioned Maxson Holloway, the WPA/FAP supervisor in Alabama: "It has come to my attention that a number of mural projects are being carried forward by some of our

directors, sketches for which have not been passed upon by the Art Director, Advisory Committee and Co-operating Sponsor. It is most essential that on all mural projects these sketches be approved before any actual work is undertaken."[22]

On the other hand, however, Cahill insisted that artists be given as much leeway as possible in the interpretations of mural themes. Thomas Parker expressed Cahill's viewpoint in this way: "Of course stark presentation of our social and economic life may be repulsive, but if such a thing exists, I can see no reason why it should not be presented in a mural design. I feel that this department should be mainly concerned with the aesthetic and technical merit of the design."[23] The end result of this liberal approach encouraged a wide range of themes and styles for murals in public buildings across the country.[24]

However, the kind of social protest that had been painted by PWAP muralists Clifford Wight and Bernard Zakheim in Coit Tower—explicit and strident in tone—no longer seemed to interest the WPA/FAP artists. Their work pointed to the optimism and confidence that had been generated by the New Deal recovery programs. For instance, American history themes expressed the values that had shaped the nation— those which the New Deal would foster to revive the American dream. Other subject matter related to social consciousness, celebrating the ideals of such great humanitarians as Jane Addams and Susan B. Anthony—ideals exemplifying the concern of the New Deal for the "forgotten man." President Roosevelt himself voiced that concern: "In spite of our efforts . . . we have not effectively lifted up the underprivileged."[25]

The theme of social consciousness was revealed by the murals of Seymour Fogel (1911–), Mitchell Siporin, and Edward Millman (1907–64). At the New York World's Fair, Fogel's mural depicts "Rehabilitation of the People," pointing to the impact of the Depression on society. His theme suggests Hopkins's creed: to maintain skills and to rehabilitate workers. Fogel contrasts the security of a worker on the job with the tragedy of a destitute family, lacking food and work. The idea that family life can be rehabilitated through New Deal planning and work projects is implied by a large symbolic hand that holds a triangle, pickax, and sledge hammer, offering a solution to an unemployed man with empty hands.

The Mexican muralists Diego Rivera, José Clemente Orozco, and David Alfaro Siqueiros had established their pantheon of revolutionary heroes, such as Benito

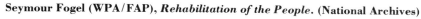

Seymour Fogel (WPA/FAP), *Rehabilitation of the People.* **(National Archives)**

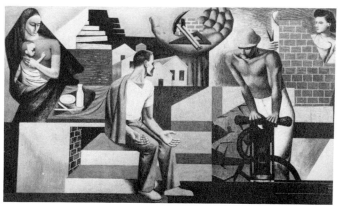

Mitchell Siporin (WPA/FAP), *Jane Addams.* **(National Archives)**

Juárez, the first Indian Mexican president, and Emiliano Zapata, an agrarian leader of the Revolution. A pantheon of folk-culture humanitarians also appeared in the WPA/FAP program. Siporin, for instance, painted an epic of the social worker Jane Addams among downtrodden and dispossessed peoples. (Jane Addams [1860–1935], humanitarian and social reformer, was a founder of Hull House in Chicago [1889], a settlement house devoted to the improvement of community and civil life in the Chicago slums. Active [1915–34] as a crusader against war, she was named chairperson in 1915 of the Women's Peace Party and president of the International Congress of Women at the Hague.)[26] In Siporin's mural her influence as a sociocultural force is symbolized by a soldier breaking his sword in half; a farmer shaking hands with a laborer; mothers with children seeking Addams's help; and a construction worker erecting what may be interpreted as a new society. These figures are organized into a closely knit composition, with a banner above showing the symbolic handshake of cooperation. The whole concept takes on the appearance of a ship; its banner is a sail, guiding the social aspirations of Jane Addams for her people. The dramatic impact of Orozco's work, with its strongly rendered forms, influenced the Addams mural. Siporin acknowledged, "Through the lessons of our Mexican teachers, we have been made aware of the scope and fullness of the soul of our environment."[27]

Also stylistically reminiscent of the Mexican muralists and related to a pantheon of folk-culture figures is Edward Millman's *Susan B. Anthony*, from the series entitled "Women's Contribution to American Progress," painted for the Lucy Flower Technical High School in Chicago. (Susan B. Anthony [1820–1906], a social reformer and woman suffrage leader, devoted her first efforts to temperance. She also participated in the abolitionist cause, but gradually she dedicated herself to the woman suffrage movement. She became president [1869] of the National Woman Suffrage Association and was president [1892–1900] of the national American Woman Suffrage Association.)[28] In Millman's mural the figure of Anthony assumes the appearance of a militant archangel, asserting women's rights in all stations of life, whether it be a mother with her child, a young girl looking to the future, or a farmer's wife working in the fields. Millman contended that the use of valid symbolism in itself was not enough; it was

Edward Millman (WPA/FAP), _Susan B. Anthony_. (National Archives)

important to give plastic symbols meaning through substance, texture, color, and tone: ". . . the essence of the realistic form must be carefully selected in order to create the particular mood and spirit, which itself then becomes the ultimate symbol."[29] Rendered in profile, Susan Anthony appears like a figurehead on a ship, symbolically pursuing a determined course. In the composition the curved lines of various women accentuate the stern, uncompromising figure of Anthony, whom Millman sees as an "ultimate symbol."

The inexorable cycles of human life are delineated in the murals of Lucienne Bloch (1909–) and Harold Lehman (1913–). These cyclical processes of life, seen in Bloch's mural for a women's prison and Lehman's for a men's prison, express similar family values essential to individual survival in a society. The themes also focus on the significance of the child—central to family life in society. "Cycle of a Woman's Life" was the theme chosen by Lucienne Bloch for the Women's House of Detention in New York. Because its occupants are generally products of poverty and the slums, the artist chose a subject familiar to them—children playing in a familiar New York scene. The favorable response of the inmates clearly revealed that a mural could act as a healthy tonic.[30] Chldren of various races are depicted on the field, on the slides, and on the swings. Bloch creates a children's world, using clusters of compositional triangles to portray an old man with his fruit stand, children at play, and a woman watching three youngsters. The triangular shape of a swing frame is repeated in the triangular structure of a slide—motifs that complete this cycle of a woman's life.

Harold Lehman's design for the mess hall in Riker's Island Penitentiary, New York, was conceived as the human triumph over the forces of nature, sustaining that which is central to life—the family. The harnessing of nature's forces in _Bread and Family_ implies human technological control over the resources of the land and expresses President Roosevelt's concept of "a more abundant life for all." Resembling a

Lucienne Bloch (WPA/FAP), *Cycle of a Woman's Life.* **(National Archives)**

Harold Lehman (WPA/FAP), *Bread and Family.* **(National Archives)**

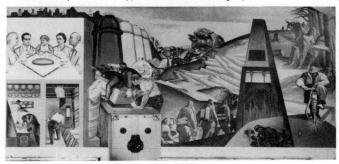

montage, the composition shows a cluster of agricultural themes: the planting of grain; the harvesting of crops; and the related activities of processing, transporting, and storing. The family—grandparents, parents, and child—sit at a table, which holds an oversized loaf of bread, symbolizing the staff of life. The child—centrally located—is symbolic of the continuity of humankind.[31]

A cyclical theme that relates to the basic values in society was developed by Philip Guston. His mural *Work and Play* shows not only community life but the importance of the family. Created for the Queensbridge Housing Project in New York, it depicts the following activities that integrate family life: workers, symbolizing new building; basketball players, expressing community recreation; musicians and dancers, representing public cultural interest; a doctor and child, depicting public health; and youngsters engaged in creative individual activities.[32] A strong interplay of organic forms and a lively pattern of lights and darks creates this dramatic story of community life. The overall design is stylized but realistically treated by Guston.

Under Bruce's program the Section artists had painted a broad panorama of American history to describe departmental activities. The history murals under WPA/FAP, on the other hand, reveal a broader purpose—to reflect the confidence of the New Deal in a democracy sorely battered by the Depression. To achieve this purpose, the WPA/FAP artists went back into world history—to interpret not only the origins of

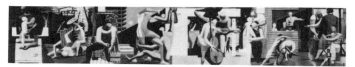

Philip Guston (WPA/FAP), *Work and Play.* **(National Archives)**

James Michael Newell (WPA/FAP), *Evolution of Western Civilization.* **(National Ar-chives)**

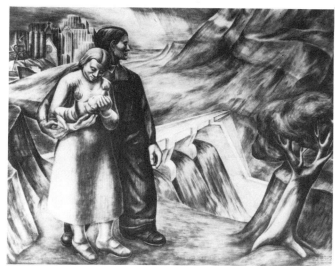

Edgar Britton (WPA/FAP), *Evolution of Man.* **(National Archives)**

American civilization but the meaning of democracy during an economic crisis.

Cyclical themes drawn from world history were emphasized by James Michael Newell (1900–) and Edgar Britton. Their work underscored the past uses of history to depict what the New Deal wanted to restore: confidence in the American system. The epic sweep of history was represented by Newell's work for the Evander Childs High School in New York City. His theme, "The Evolution of Western Civilization," depicts humanity's development from the primitive state to modern times. Newell intercepts the important historical forces that determine the evolution of Western civilization. On the one hand, he presents scientific discoveries in chemistry, electricity, and steel. On the other, he shows the development of railroads, oil fields, farming, and mining in the New World. The origins of American civilization the artist described in this manner: "Then come the beginnings of scientific experiment and the awakening of the people to nature, the force of which destroys their bondage and leads to the great flowering of the Renaissance. The exploration which follows founded a new country to which all nations and all time have contributed, and which has developed into a varied, dynamic, and powerful civilization."[33] Newell's mural style was influenced by Rivera's work, particularly in the use of minute brush strokes to build large and simple forms.

To show that the New Deal was a culmination of humankind's quest for freedom through a type of collectivism, Edgar Britton utilized world history. His frescoes for the Lane Technical High School in Chicago cover the broad theme the "Evolution of Man": Primitive, Egyptian, Grecian, Middle Ages, Renaissance, and Modern. Britton explained that each epoch "is represented as a movement that interprets the spirit of man in his periods of freedom or oppression."[34] "Modern man," depicted by a worker with his family looking at the swift flow of waters from Boulder Dam, suggests that the New Deal has brought a sense of individual freedom through collective effort. Britton also implies that scientific progress in world history is to be continued by the social progress of the New Deal—emphasizing the individual worker and the family as a symbol of America's strength. That concept of social evolution had been expressed in Rivera's murals for the Chapingo Agricultural and Military College in Mexico, showing the parallel progress of biological and social evolution. Britton, however, offers a parallel progress of scientific and social evolution culminating in the New Deal.

James Brooks's (1906–) *Flight* seems to symbolize the spirit of Robert Browning's verse: "A man's reach should exceed his grasp, or what's a heaven for?"[35] The mural is dominated by a large, idealistic figure looking up into the dark night and beyond the stars. Does the figure indicate that having a faith in America's technological achievements would end the Depression? Similarly, in Rockefeller Center in New York, Rivera had used the motif of a large central figure, standing at the crossroads in society. His theme—faith in science and technology—implied a new society. Brooks's mural also suggests a new dawn for America through the evolution of technology.

At the North Beach Airport Marine Terminal in New York, Brooks unfolds the history of aviation as an evolutionary process. He begins by showing the superstitious nature of primitive humans, frightened by unknown forces of nature—a setting accentuated by a vertical cluster of symbols, denoting fear and worship of the unknown. Ancient humanity liberates itself from superstition through early experiments in flight. An instance is the legend of Daedalus, who succeeds; while Icarus, flying too close to the sun, falls into the sea. Numerous diagrams of flying devices, experiments with wind, and bird studies by modern humans are shown. An interesting use of distortion,

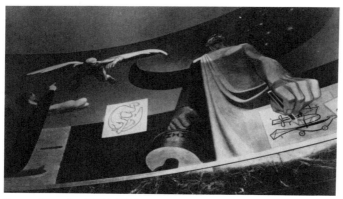

James Brooks (WPA/FAP), *Flight*, detail of mural. (National Archives)

James Brooks (WPA/FAP), *Flight*, detail of mural. (National Archives)

stylized realism, abstraction, and diagrammatic designs tells the fascinating story of *Flight*. For example, the dynamic perspective of the central figure dramatizes the human flight toward freedom. Brooks also employs an abstract style to show the soaring sweep of airplane propellers and architectural towers, symbolizing the new technological society.[36]

James M. Newell had used world history as a setting for the American civilization, but Edward Laning (1906–) utilizes the American scene to show how immigrants— coming to the New World—contribute to the growth of the American nation. His murals for the Administration Building for Ellis Island, New York, trace the "Role of the Immigrant in the Industrial Development of America." In one of the major themes, various immigrant groups are laying railroad ties and expanding the railroads as a train follows its serpentine path. Laning's figures, in the robust style reminiscent of the Renaissance tradition, show the interlacing arms and muscular body action of workers—an image that symbolizes the linking up of the West and the East through the railroads.[37]

Walter Quirt's (1902–68) art reflects neither the Mexican precedent nor the Renaissance tradition but the dreamworld of the surrealists to express his theme, "The Growth of Medicine from Primitive Times," for Bellevue Hospital in New York City.

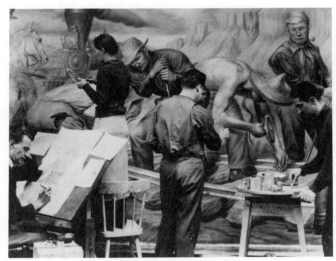

Edward Laning (WPA/FAP), *Role of the Immigrant in the Industrial Development of America*, detail of mural in progress with Edward Laning and assistants at work. (National Archives)

Edward Laning (WPA/FAP), *Role of the Immigrant in the Industrial Development of America*, detail of mural. (National Archives)

The setting of world history is utilized to portray human mental illnesses. The human being is the never-ending victim: in the past by superstition; in the present by charlatans. Yet Quirt believes in the idea of progress for the betterment of society. Employing a Hegelian notion, he shows a thesis—the foibles of humans and medicine; an antithesis—the age-old struggle against superstition and intolerance; and synthesis—the affirmation of science for the benefit of humankind. His landscape, not unlike the imagery of a Hieronymus Bosch painting, contains wide-eyed monsters and islands, with little hope of escape. Quirt's environment, however, closely resembles the Depression scene with its human desolation. At least, his imagery is similar to what the artist Eli Jacobi had witnessed when he described Depression artists as "a scattered, heterogenous mass in an overcrowded boat" that was about to capsize before reaching shore. In Quirt's concept of world history, a visual time progression shows a landscape that contains prehistoric animals and Renaissance architecture, appearing like recesses of the mind. In the modern period,

Walter Quirt (WPA/FAP), *The Growth of Medicine from Primitive Times.* **(National Archives)**

however, interspersed with symbols of superstition, a hooded figure of intolerance is contrasted with a patient treated by scientific methods. In Washington a Section mural by Emil Bisttram for the Justice Department also shows a hooded figure of intolerance, which has shackled the rights of women.

Whereas Lucienne Bloch had depicted a child's world for the inmates of a women's prison, Hester Miller Murray (1903–) painted a child's world for the children in Irving School, Oak Park, Illinois. She created an appealing mural that related directly to their environment. The theme, "Farm Animals," depicts with realistic charm a pony, a puppy, and a kitten in the foreground, and, in the middle ground, a stretch of farmland, with birds flying overhead. In another work, *World of Children*, Murray painted young people from different countries, displaying their native habitats and dress. The same ingenuous appeal was achieved by placing the children in random spaces, creating a lively sense of movement. The broad interest of WPA/FAP in children's activities, and in an environment for a child to develop creative interests, is revealed through the murals of artists like Hester Murray.

The experimental trend in PWAP flourished under WPA/FAP. Moreover, a type of imaginative work developed that did not evolve under Bruce's program. For example, Duncan Phillips, a member of the National Advisory Committee in the Treasury Art Program, had suggested to Bruce a broader criterion to set "the spirit free." Emphasizing the use of decorative murals, he believed that the abstractionist Augustus Tack should be given a commission: "Tack sets the spirit free—leads the mind on flights to mountain tops and cloud capped pinnacles." Phillips also recommended the work of another abstractionist, Arthur Dove, whose "grand patterns" were described as of the essence of America.[38]

Whereas Phillips's criterion was not fully embraced in the Treasury program, WPA/FAP came closer to it, permitting artists in their work to set "the spirit free." For instance, an experimental approach was used by abstractionists to paint decorative murals for the Health Building at the New York World's Fair of 1939. Ilya Bolotowsky's (1907–) abstract theme reminiscent of Joan Miró's organic shapes, used a rectangular mass at the bottom center of the composition to control rhythmic movements of various free forms and linear elements. Byron Browne (1907–61) employed specific subject matter, such as a microscope and test tubes, to develop an abstract mural, contrasting vertical and horizontal shapes with the circular elements of laboratory equipment. A semiabstract approach was used by Louis Schanker (1903–) to represent life-giving solar energy and the cellular structures found in

Hester Miller Murray (WPA/FAP), *Farm Animals.* **(National Archives)**

Hester Miller Murray (WPA/FAP), *World of Children,* **mural design. (National Archives)**

human beings and nature. Dominated by a large, truncated triangular mass, Schanker's composition is balanced by smaller rectangular forms along the bottom edge of the triangle. Within the triangle an abstract outline of a man's head is shown receiving the solar energy of life. A purely abstract style was employed by Balcomb Greene (1904–) to paint decorative murals. Formal geometric relationships are counterbalanced with asymmetric rectangular forms.

Abstract murals also were planned for the playrooms and public areas of the

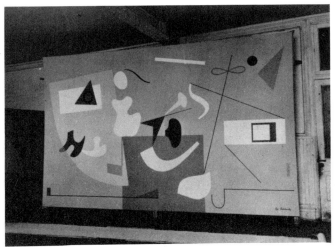

Ilya Bolotowsky (WPA/FAP), *Abstraction.* **(National Archives)**

Byron Browne (WPA/FAP), *Abstraction.* **(National Archives)**

Williamsburg Housing Project in New York. WPA/FAP mural supervisor Burgoyne Diller wanted these murals to convey a social, therapeutic value for the benefit of the 5,000 tenants in the low-cost housing project. He contended that its tenants, after a day's work among machines and factory stacks, would not be comforted by murals depicting more machines and more factory stacks. The use of abstract murals was discussed with architect William Lescaze, who agreed that stimulating abstract patterns would add to the enjoyment of the tenants. Diller commented, ". . . we would probably have these abstract painters do things that would be very decorative, very colorful, and probably people moving into this housing project might need that touch of color and decoration around, something to give a little life and gaiety to these rather bleak buildings."[39]

Louis Schanker (WPA/FAP), *Abstraction*. (National Archives)

Balcomb Greene (WPA/FAP), *Abstract*. (National Archives)

In the Williamsburg Housing Project different experimental styles were used. For example, Balcomb Greene, in his *Abstraction*, employed flat, rectangular shapes, connecting and overlapping to break the quiet rhythms by use of diagonal line and form. He reiterated this harmony by introducing a circle to the right of the composition.

Specific subject matter found in the American scene is depicted in Stuart Davis's (1894–1964) *Abstraction*. He converted the elements of a tower, house, cloud, smoke, ladder, and rope into an abstract "swing" rhythm, conveying a lively scene of gaiety.

Francis Criss (1909–) transformed the elements of the "El" train station—girders, station, and related accessories—into an abstract geometric pattern. Although he employed perspective to show distance between various architectural objects, a flat, frontal plane is maintained.

In one instance, however, Diller encountered conservative opposition to an experimental mural proposal. This project, presented to the art commission of the city of Newark, was the work of Arshile Gorky (1904–48) for the Newark Airport. Diller

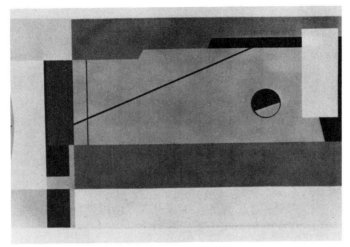

Balcomb Greene (WPA/FAP), *Abstraction.* **(National Archives)**

Stuart Davis (WPA/FAP), *Abstraction.* **(National Archives)**

described the cool, forbidding characters in this manner, "I deliberately presented it as a decoration, so they wouldn't quibble about art. But one of them, probably brighter than the rest, said, 'Well, that's abstract art, isn't it!' That unleashed the devil." The committee carried on a tirade against abstract art for half an hour. Beatrice Winser, director of the Newark Museum and sponsor of the mural proposal, finally banged on the table and exclaimed, "Gentlemen, I'm amazed at you!! Sitting here talking about something you know nothing about." She firmly told the committee that they should rely on the judgment of Diller, an expert, and simply vote on the proposal. After this outburst, Diller commented, the committee members were so deflated that they just sat there and agreed, "Well, it's all right."[40]

Vastly different from James Brooks's *Flight*, depicting the human aspiration toward freedom, Arshile Gorky created a more experimental reality to show modern flight in the American scene. In his "Aviation: Evolution of Forms under Aerodynamic Limitation," Gorky transposed the static observation of airplane data into visual language,

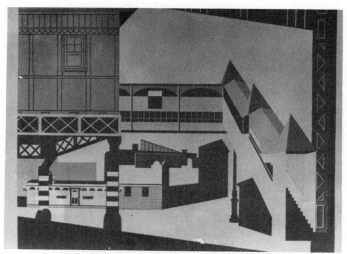

Francis Criss (WPA/FAP), *Sixth Avenue E1.* **(National Archives)**

Arshile Gorky (WPA/FAP), *Aviation: Evolution of Forms under Aerodynamic Limitation,* **artist at work. (National Archives)**

detaching the various segments of an airplane and reorganizing the parts to heighten the aesthetic realism of his subject. In his PWAP mural theme, a similar method had been used to give greater realism to his concept. This approach stemmed from Gorky's childhood in a Russian house, where a ceiling had a hole, above which was placed a wooden cross. An onion was suspended from a string, onto which seven feathers were attached, serving as a calender. To denote passage of time, a feather was removed as

Arshile Gorky (WPA/FAP), photo source for *Aviation—Derivative and Design for Newark Airport*. (National Archives)

Arshile Gorky (WPA/FAP), *Aviation—Derivative and Design for Newark Airport*, detail of mural. (National Archives)

Arshile Gorky (WPA/FAP), photo source for *Aviation—Derivative and Design for Newark Airport.* **(National Archives)**

Arshile Gorky (WPA/FAP), *Aviation—Derivative and Design for Newark Airport,* **detail of mural. (National Archives)**

each Sunday ended. For Gorky, this floating feather-and-onion device revealed that the common could be used to create the uncommon.

In developing his Newark Airport theme, Gorky studied actual photographs of airplanes to compose a complexity of abstract objects in new relationships. In one of the studies he depicts motor, propeller, and landing wheel to express this morphic relationship: ". . . the engine becomes in one place like the wings of a dragon, and in the other, the wheels, propeller, and motor take on the demonic speed of a meteor

cleaving the atmosphere." It is an image that goes back to the fury of demonic, winged creatures found in ancient Etruscan murals. In another study, by contrast, Gorky redesigns some of the components to show "a modern airplane simplified to its essential shape and so spaced as to give a sense of flight."[11] Gorky's work depicts what Rivera had expressed in his Detroit frescoes—homage to the machine in the American scene. Based on careful studies of Henry Ford's assembly line, Rivera ritualistically transformed the machine into a fiery fantasy of light and fire. Also, based on careful observation of the airplane, Gorky composes a new visual complexity—celebrating an American achievement in the American scene.

Sculpture

The sculptors used different approaches, ranging from traditional to experimental, to relate their art to community life. In some instances, tax-supported institutions were recipients of freestanding sculpture. A pensive figure of a *Young Girl Reading* by Concetta Scaravaglione (1900–) was conceived for the Evander Childs High School in New York. A *contrapposto* movement and simple rendering reveal an awakening of life through biological and intellectual growth. The work, sensitive and modern in its concept, relates to an architectural environment, much in the manner of the PWAP sculpture by John Flannagan for a contemporary building. Charles Umlauf (1911–) also did a freestanding sculpture, which was developed as part of a fountain for the Cook County Hospital in Chicago. His classic figure of a standing woman, traditional in style, symbolized "Protection." Conceived as a compact vertical

Concetta Scaravaglione (WPA/FAP), *Girl Reading.* **(National Archives)**

mass, the sculpture emphasized the protective relationship between a mother and her children.

Sculpture relating to outdoor community life was completed for PWA housing projects. In New York, Hugo Robus (1885–1964) sculpted a sharply curved body of a dog with interlocking legs and a downward thrust of the head. As a rough-textured mass boldly conceived, the work expressed a disarming simplicity. Robus's imaginative work revealed the monumental solidity of Egyptian sculpture.

"Our function is the social scheme of things . . . to widen and embrace a whole

Charles Umlauf (WPA/FAP), *Protection.* **(National Archives)**

Hugo Robus (WPA/FAP), *Dog.* **(National Archives)**

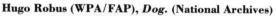

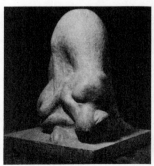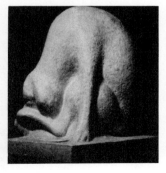

Donal Hord (WPA/FAP), *Guardian of the Water.* **(National Archives)**

John Palo-Kangas (WPA/FAP), *Fray Junipero Serra.* **(National Archives)**

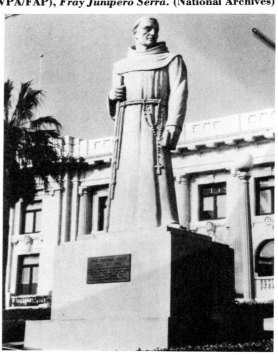

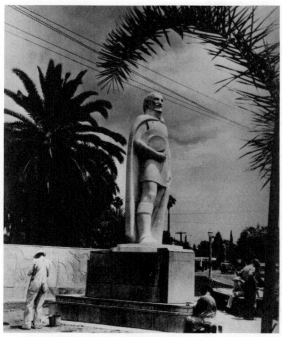

Sherry Peticolas (WPA/FAP), *Juan Bautiste de Anza.* **(National Archives)**

society," sculptor Samuel Cashwan observed.[12] This trend was being realized on the West Coast, where sculptors executed large works for a community environment. From a single thirteen-foot granite block, Donal Hord (1902–66) carved a fountain, *Guardian of the Water* (a woman's figure) for the San Diego City Hall. Under his direction a crew of artists, blacksmiths, and workers, toiled eighteen months to complete the project. Hord's theme was symbolically appropriate for the relentless sun and sparsely watered hills of Southern California. He used direct carving to minimize the use of sharp turns; the light was too bright and the shadows too deep to permit any angles in his sculpture. Spiked native plant designs decorate the fluted column on which the figure stands. The base for the "Guardian"—a rich pattern of water motifs and cactus—offers sharp contrast to the simple elegance of the symbolic figure.

In California sculptors also met the wishes of municipalities to commemorate pioneers and historic events. For example, the heroic figure of Fra Junípero Serra by John Palo-Kangas (1904–　　　), stands in front of the Ventura Court House. Produced in cast concrete, the quiet, stoic mood of Fra Serra is accented by a decorative rosary design suspended from his rope belt and a book held in his left hand.

In the public square in Riverside, there stands a fifteen-foot-high figure of the Spanish conquistador, De Anza, who made a historic pilgrimage from Tubac, Arizona, to Riverside. Sherry Peticolas carved the figure in granite; and sculptress Dorr Bothwell did a bas-relief of De Anza's procession for a wall forty feet long and seven feet high in the public square.[43]

Beniamino Bufano (WPA/FAP), *Sun Yat-Sen.* **(National Archives)**

An impressive figure of Sun Yat-sen for the Chinese quarter in San Francisco was sculpted by Beniamino Bufano (1898–1970). With red granite for the head and hands and aluminum for the body, the figure takes on a simplicity of form, characteristic of the sculptor's penchant for clarity and expanse, which he found in the American scene. For instance, Bufano achieved an economy of line expressive of bridges and dam designs that he declared were so remarkably beautiful.[14]

In an entirely different vein, the wood carving of Patrocino Barela revealed neither the monumental approach of the West Coast sculptors nor the experimental style of Hugo Robus, but the intimate mysticism of the Hispanic church in New Mexico. This unique, indigenous expression stemmed from the tradition of the "Santero," or the maker of saints, who carved primitive wood images for the Catholic church. This same primitive mysticism is seen in Barela's work, but he also conveys a personal faith and sense of fatalism. In the wood carving *Hope or the Four Stages of Man,* the evolutionary phases of life are shown: childhood, youth, middle age, and old age. The evolution of humankind is compared to a tree, changing from the emerging foliage of childhood to the bare branches of old age. There is a search by Barela for creative forms that give shape to his inner feelings.[15] In another work, *Holy Family,* the child—centrally

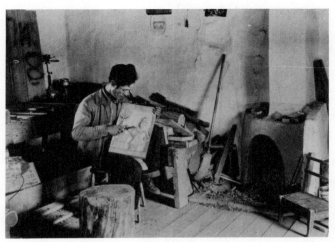

Patrocino Barela (WPA/FAP), photo of Patrocino Barela in his studio. (National Archives)

Patrocino Barela (WPA/FAP), *Hope or the Four Stages of Man*. (National Archives)

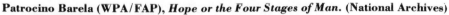

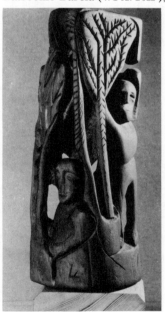

placed as a focal point in the parent's lives—exhibits a rude, primitive strength. Family unification and treelike continuity of life is conveyed by the outstretched arms of the child; and the frontal, flat relationship of the "Holy Family" resembles an icon. Barela's sense of mysticism and the fatalism of life is heightened by his use of textured surfaces and foreshortened figuration.

Patrocino Barela (WPA/FAP), *Holy Family*. (National Archives)

Aaron Goodelman (WPA/FAP), *Homeless*. (National Archives)

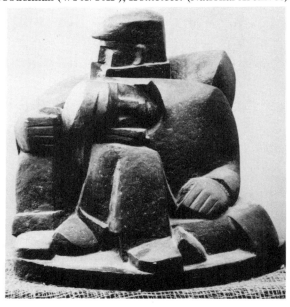

Some other sculptors reflected Barela's personal expression but were more experimental in concept. For example, Aaron Goodelman's (1890–) cubistic sculpture *Homeless* suggests the futility in the Depression scene. A deep sense of ennui is felt in the two closed, huddled figures; the burden of one is superimposed on the other. A severe reduction of forms—abstract and interconnected—sharpens this image of futility. The interlocking of torsos, arms, and legs stresses the desperate loneliness of human beings who have nowhere to go in the American scene.

Harry Ambellan's (1912–) *Youth*, however, offers a contrast of optimism to Goodelman's pessimism. In a relief sculpture of two figures, Ambellan uses flat, convex, and concave carving to achieve a variety of form and rhythmic movement. A cubistic approach is used in this innovative treatment of anatomical details.

Similar to Ambellan's creative style, Samuel Cashwan's figure of St. Francis employs simple, sweeping lines of robes and bird wings. Austere but complex pantheistic interrelationships between humans and nature are conveyed by a sharp reduction of flat planes. The wings of a bird provide a halo treatment above the head of St. Francis, symbolizing his profound love for all creatures.

Another experimental sculpture, Robert Lemke's *Hand of Destiny*, reveals an abstract design reduced to its simplest form. The strength of a worker's hand is expressed, perhaps, a symbol of America's creative power. At least, the simple expression of Lemke's sculpture suggests an image of Democracy, found in the pages of Walt Whitman's *Leaves of Grass*.

Harry Ambellan (WPA/FAP), *Youth*. (National Archives)

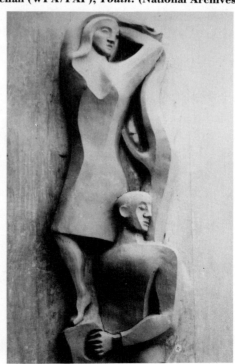

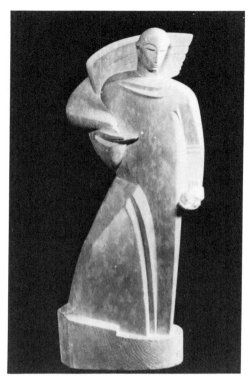

Samuel Cashwan (WPA/FAP), *St. Francis.* **(National Archives)**

Robert Lemke (WPA/FAP), *Hand of Destiny.* **(National Archives)**

José Ruiz de Rivera (WPA/FAP), *Flight,* **drawing for sculpture. (National Archives)**

America's technological achievement is defined by José Ruiz de Rivera's (1904–) polished, steel sculpture. His abstract work *Flight* captures the reflections of light and movement on its polished surfaces. An upward effect of soaring flight is enhanced by the elegant proportions of winglike forms. This quality of de Rivera's free flow of movement is reminiscent of European sculptor Constantin Brancusi's pure form.

Graphic Arts

The diverse subject matter that Cahill once described as the total "kaleidoscope of American life" is found in the graphic arts.[16] Themes of social consciousness reveal the deep concern of printmakers about the economic crisis. Nan Lurie (1910–), in a lithograph *Technological Improvements,* points to the contradictions in the industrial scene—the existence of machinery but not of jobs. Steam shovels are shown overhead, while below, an empty mine shaft with hand shovels lies in the pathway. A line of men are huddled in the street; nearby, on the door of a large brick building, a posted sign gives its grim message, "No Help Wanted." Lurie uses strong contrast of black and white to stress the dramatic, somber plight of the unemployed, some of whom are shown without shoes.

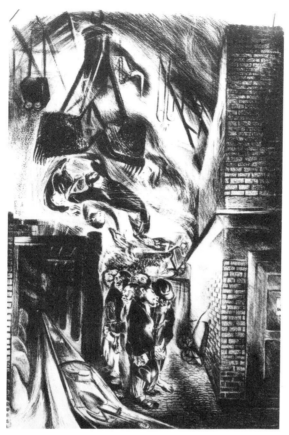

Nan Lurie (WPA/FAP), *Technological Improvements.* **(National Archives)**

Mabel Dwight (WPA/FAP), *Banana Men.* **(National Archives)**

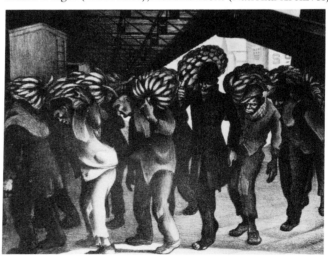

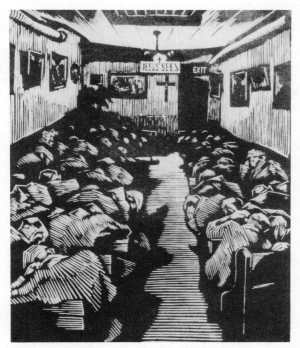

Eli Jacobi (WPA/FAP), *All Night Mission.* **(National Archives)**

The figures in Mabel Dwight's (1876–1955) *Banana Men*, under an overhead railway, are silhouetted with their heavy loads, symbolic of burdened masses—dark forms against the cold white light of early morning. The ominous-looking structures of the overhead girders seem to bear down on the workers, as if there were no relief from the pressures of the Depression.

The Street of Forgotten Men, a series of linoleum prints by Eli Jacobi (1898–), vividly delineates the world as he experienced it: a "mass of foundering humanity." In *All Night Mission*, an anonymous mass of tragic men are emerging from the shadows into the half-light of a single overhead fixture. The interior of the mission, viewed from one-point perspective, focuses on a sign, "Jesus Sees," while beneath it a cross symbolizes the supreme sacrifice. An ominous opening with a different sign marks the "Exit." In sum, Jacobi's stark, uncompromising theme epitomizes "man's inhumanity to man."[47]

A portrait of a little girl drawn by George Constant (1892–) in drypoint is indebted to the A. A. Milne book the child is reading, *When We Were Very Young*. The circular movement of the child's head is emphasized by the heavy, striped pattern of her sweater and the irregular, linear design of the chair. Constant's theme suggests the innocence of a child before she becomes aware of the reality of the Depression.

A pathway of strong sunlight, tiny human figures, and two oversized linear rulers—projecting ambivalent shadows—comprise the haunting, surrealistic image of Lucien Lebaudt's (1880–1943) *False Dimensions*. In his lithograph the uncertainty of the

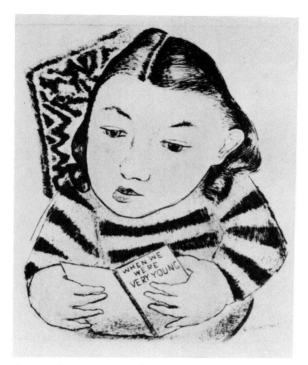

George Constant (WPA/FAP), *When We Were Very Young*. (National Archives)

Lucien Labaudt (WPA/FAP), *False Dimensions*. (National Archives)

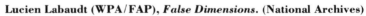

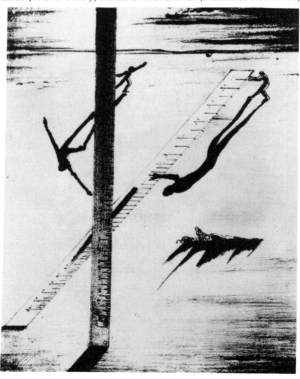

Elizabeth Olds (WPA/FAP), *Forging Axles.* **(National Archives)**

Raphael Soyer (WPA/FAP), *Men Eating.* **(National Archives)**

Depression is portrayed by this grotesque imagery—a period when there was no measuring scale to arrive at a solution to the economic crisis.

Other themes, however, express confidence in the American system. An optimistic outlook in New Deal America is depicted by Elizabeth Olds's (1897–) lithograph *Forging Axles*. Hot, molten metal illuminates the faces and bodies of the workers, delineated by a heavy line, suggesting a renewal of life in the industrial system.

A lithograph by Raphael Soyer (1899–), *Men Eating*, shows the bitterness of the Depression on the faces of the subjects. However, one raises a cup of hot liquid to his lips, implying by his upward gaze that a hopeful change may come, perhaps from the New Deal relief programs.

Some artists depicted the American scene without introducing social consciousness. Their work revealed not the human content in the landscape but the technical

Ruth Chaney (WPA/FAP), *Elevated.* **(National Archives)**

Anthony Velonis (WPA/FAP), *Unloading Fish.* **(National Archives)**

Lala Foe Rival (WPA/FAP), *Petroglyphs.* **(National Archives)**

exploration of the scene. Ruth Chaney's silk-screen print *Elevated* offers a bird's-eye view of a street scene, with a traffic light dominating the foreground; and a facade of row houses converges toward iron columns that support an elevated train.

Anthony Velonis's (1911–) silk-screen print *Unloading Fish* is carefully composed of rectangular shapes cutting across the composition, counterpoised by a curved vertical form of the workman with a dolly. Other elements, such as a rope, a chain, and a smokestack, achieve a variety of textures—line, flat, and mottled surfaces.

Other artists explored very personal directions in their work. Lala Foe Rival's lithograph *Petroglyphs* harkens back to prehistoric rock carvings. Human configurations on a field contain multiconcentric circles, symbolically bounded by vertical abstract forms.

Hilaire Hiler (1898–1966) attempted an experimental X-ray approach in his lithograph *Zebras*, where two transparent animals of vertically striped patterns form the animals' bodies as well as the grass stalks rising from the ground. The vertical patterns are counterbalanced by the horizontal forms of farmhouses; in turn, these are modified by abstract clouds. Hiler seems to view the natural world with the innocent eye of a child.

In the organization of New Deal art programs, Cahill's innovation contrasted with Bruce's tradition. Bruce's direction encouraged professionalism, but Cahill's approach was transformed into a creative program—broader in vision—where the American artist freely experimented with new ideas and new styles. Also, Cahill's innovation was evident in imaginative projects to unite artist and society. His quest for unity provided for participation by artist and community in the creative process of art, a process described by John Dewey as "a free and enriching communion."

The innovative phases of Cahill's program supported art styles of all persuasions, but he himself revealed a special preference for the art of social realism—a relevance of art to life. For example, he cited the work of Jack Levine, Eli Jacobi, and Joseph Vavak—somber in mood, but powerful in social vision. Referring to works by other

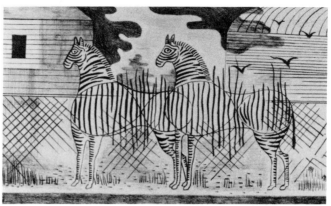

Hilaire Hiler (WPA/FAP), *Zebras.* **(National Archives)**

artists like Louis Guglielmi, Raymond Breinen, and Hester Miller Murray, Cahill commented, "It does seem to me that fresh poetry of the soil appears in the work of many of these artists.[18]

Cahill's interest in an art of social vision, however, was noted by New York mural supervisor Burgoyne Diller: "Well, I remember some of the ones he [Cahill] was very, very enthusiastic about, were some of the Chicago painters. He had a feeling, you know that Chicago was sort of the middle of this country, and they had a sort of Mexican-inspired renaissance of mural painting in Chicago." Although Cahill had special enthusiasms in art, he never exerted pressure on artists to accept his ideas, as Diller observed:

> First, he was aesthetically aware enough not to want to impose his will, which is the important thing; perhaps, as a politician, he was aware of the fact that he couldn't direct these things completely and that some way or other, a happy medium had to be found between the desire of an artist to do a good thing, and a fine thing, and the thing that people would ask for. Believe me, it a very precarious sort of thing.[49]

Nevertheless, it is apparent from the work produced under WPA/FAP that Cahill succeeded in stimulating "the desire of an artist to do a good thing, and a fine thing." Moreover, he encouraged the creativity of young artists—providing opportunities for them to produce a distinctively American art. The best of the WPA/FAP work reflects the full range and vitality of American life, former WPA/FAP artist Jacob Kainen observed. The art of Louis Guglielmi and Walter Quirt, showing sensitive, poignant, and surrealistic imagery in the American scene, pointed in this direction.

Other artists focused their attention on the social climate of the Depression—a response seen in the powerful realism of such artists as Edward Millman and Mitchell Siporin. The abstract works of Ilya Bolotowsky, Byron Browne, Balcomb Greene, Arshile Gorky, and Stuart Davis were notable for the new aesthetic stirrings of the period, and for their indebtedness to European roots, such as the Bauhaus, surrealism, Piet Mondrian, and Fernand Léger. Undoubtedly, Cahill's innovative approach encouraged James Brooks to describe WPA/FAP in this way: "A large garden with plentiful random seedlings that produced a number of good fruits."[50]

Notes

1. Holger Cahill to Colonel Westbrook, January 30, 1936, RG 69/WPA/FAP; WPA Circular No. 1, "Preliminary Statement of Information for Sponsors," June 15, 1935, RG 69/WPA/FAP; Francis O'Connor, ed., *Art for the Millions* (Greenwich, Conn.: New York Graphic Society Ltd., 1973) p. 98; Documents of the original manuscript (planned by WPA/FAP to be published as "Art for the Millions") in the Archives of American Art, Washington, D.C.

2. Holger Cahill to Mary R. Beard, October 25, 1937, RG 69/WPA/FAP; Address by Holger Cahill at the Newark Museum, "American Design," November 6, 1936, p. 6; Holger Cahill, *New Horizons in American Art* (New York: Museum of Modern Art, 1936), pp. 21–29; O'Connor, *Art for the Millions*, p. 36.

3. "Unemployed Arts," *Fortune*, May 1937.

4. Henry Adams, *The Education of Henry Adams* (New York: Modern Library, Inc., 1931), pp. 383, 388.

5. Louis Guglielmi, "After the Locusts," in *Art for the Millions*, ed. O'Connor, p. 114.

6. Julius Bloch, "The People in My Pictures," in *Art for the Millions*, ed. O'Connor, p. 115.

7. Mitchell Siporin, "Mural Art and the Midwestern Myth," in *Art for the Millions*, ed. O'Connor, p. 67.

8. Edgar Britton, "A Muralist Speaks His Mind," in *Art for the Millions*, ed. O'Connor, p. 67.

9. Lucienne Bloch, "Murals for Use," in *Art for the Millions*, ed. O'Connor, p. 77.

10. Girolamo Piccoli, "Report to the Sculptors of the Federal Art Project," in *Art for the Millions*, ed. O'Connor, p. 85.

11. Samuel Cashwan, "The Sculptor's Point of View," in *Art for the Millions*, ed. O'Connor, p. 88.

12. Fritz Eichenberg, "Eulogy on the Woodblock," in *Art for the Millions*, ed. O'Connor, p. 150.

13. Eli Jacobi, "Street of Forgotten Men," in *Art for the Millions*, ed. O'Connor, p. 157.

14. Cahill to Beard, October 25, 1937, RG 69/WPA/FAP; Cahill, *New Horizons in American Art*, p. 40.

15. Cahill, *New Horizons in American Art*, p. 30.

16. Guglielmi, "After the Locusts," p. 113.

17. E. M. Benson, "Art on Parole," *American Magazine of Art*, November 1936, p. 770.

18. Dorothy C. Miller, ed., *Americans 1942* (New York: Museum of Modern Art, 1942), p. 86.

19. Samuel Beckett, *Endgame* (New York: Grove Press, Inc. 1958), p. 30.

20. Miller, ed., *Americans 1942*, p. 51.

21. Brochure "Murals for the Community," May 24–June 15, 1937, p. 2, RG 69/WPA/FAP.

22. Ibid., p. 21; Holger Cahill to Maxson Holloway, December 21, 1935, RG 69/ WPA/FAP.

23. Thomas C. Parker to Jessica Farnham, June 8, 1936, RG 69/WPA/FAP.

24. "Murals for the Community," p. 3.

25. Dexter Perkins, *The New Age of Franklin Roosevelt, 1932–45* (Chicago: University of Chicago Press, 1957), p. 29.

26. Richard B. Morris, ed., *Encyclopedia of American History* (New York: Harper & Brothers, 1953), p. 630.

27. Siporin, "Mural Art and the Midwestern Myth," p. 64.

28. Morris, *Encyclopedia of American History*, p. 631.

29. Edward Millman, "Symbolism in Wall Painting," in *Art for the Millions*, ed. O'Connor, p. 67.

30. Bloch, "Murals for Use," p. 77.

31. "Murals for the Community."

32. *New York Herald Tribune*, March 13, 1941, RG 69/Division of Information Files, hereafter cited as RG69/DI.

33. James Michael Newell, "The Evolution of Western Civilization," in *Art for the Millions*, ed. O'Connor, p. 62.

34. Brochure "Epochs in the History of Man," Frescoes by Edgar Britton in the Lane Technical High School, Federal Art Project of Illinois, RG 69/WPA/FAP.

35. Robert Browning, *The Complete Poetical Works of Robert Browning* (New York: Macmillan Company, 1927), p. 451.

36. New York City WPA Public Information Press Release, July 24, 1940, RG69/DI.

37. New York City WPA Public Information Press Release, May 24, 1937, RG69/DI.

38. Duncan Phillips to Edward B. Rowan, February 22, 1935, RG 121/122.

39. William Lescaze to Audrey McMahon, November 2, 1936, RG 69/211.5; Oral history interview with Burgoyne Diller, October 2, 1964, pp. 32–33, Archives of American Art.

40. Oral history interview with Burgoyne Diller, October 2, 1964, pp. 54–56.

41. Brooks Joyner, *The Drawings of Arshile Gorky* (College Park, Md.: University of Maryland Art

Gallery, 1969), p. 12; *Murals without Walls: Arshile Gorky's Aviation Murals Rediscovered* (Newark, N.J.: Newark Museum, 1978).

42. Cashwan, "The Sculptor's Point of View," p. 89.

43. Donal Hord, "Symphony in Stone," in *Art for the Millions,* ed. O'Connor, p. 106; Stanton Macdonald-Wright, "Sculpture in Southern California," in *Art for the Millions,* ed. O'Connor, pp. 101–2. ed. O'Connor, pp. 101–2.

44. Bufano, "For the Present We Are Busy," in *Art for the Millions,* ed. O'Connor, p. 109.

45. Vernon Hunter, "Concerning Patrocino Barela," in *Art for the Millions,* ed. O'Connor, p. 96.

46. Cahill, *Now Horizons in American Art,* p. 39.

47. Jacobi, "Street of Forgotten Men," p. 157.

48. Cahill to Beard, October 25, 1937, RG 69/WPA/FAP.

49. Oral history interview with Diller, October 2, 1964, pp. 27–29.

50. Francis V. O'Connor, *Federal Support for the Visual Arts: The New Deal and Now* (Greenwich, Conn.: New York Graphic Society, 1969), Appendix no. 2: questionnaire of Jacob Kainen, January 17, 1968; ibid., Appendix no. 2: questionnaire of James Brooks, June 15, 1968.

9

End of an Era

By the end of 1938, Bruce had firmly established professional criteria in the Treasury program, but he continued to work toward his plan to house the Section of Painting and Sculpture in a permanent Smithsonian Gallery of Art.[1] Meanwhile, Cahill persisted in his efforts to integrate artist and society, despite the attempt of Congress to dismantle the WPA relief projects.

Nevertheless, ominous signs from Europe and dramatic political changes in America presaged the decline of the New Deal art programs. For example, the 1938 elections marked a retrenchment of the New Deal; the president made concessions to a conservative Congress by not pushing through some of his most controversial domestic experiments to avoid defeat of his foreign policy. His decision was predicated on the premise that the totalitarian powers of Adolf Hitler in Germany and Benito Mussolini in Italy constituted imminent threats to democracy. Thus, the creative period of the New Deal was coming to a close as the Roosevelt administration sought to reduce domestic tensions and consolidated national unity to achieve collective security and national defense.

Bruce himself referred to the dark clouds from Europe: "If we could only make the world a little more art-minded, some of these so-called statesmen would forget some of their nasty designs to destroy civilization."[2]

Unfortunately, those "nasty designs" materialized on September 1, 1939, when the armies of Nazi Germany marched into Poland—the beginning of World War II. Malcolm Cowley, a writer and expatriate, declared that it marked the end of the New Deal era.[3]

During this period of national defense there were doubts that the fine arts programs could survive. The San Francisco Art Association, for instance, informed Bruce about its resolution to urge continued government support, to which Bruce replied, "Now, if ever, is the time to keep a little culture alive in the world when art is a complete blackout everywhere else."[4] However, Francine Baehr, secretary of the National Society of Mural Painters, was becoming apprehensive about public reaction to the arts;[5] and Mildred Rosenthal, editor of the San Francisco Art Association *Bulletin,*

219

warned Bruce that the government art program was in a perilous position.[6]

Nonetheless, Bruce had been confronted by the overwhelming problems of government support of the arts during the Depression; he now viewed the defense crisis as just another hurdle to cross. Yet, he was entertaining some doubts when he wrote to Charlotte Partridge, director of the Layton Art Gallery in Milwaukee: "I am trying my best to keep the project going, but it is more and more difficult as the tendency is to give preference to everything connected with the rearmament program."[6] His doubts were shared by such artists as Lloyd Goff, who wrote to Bruce: "Now *surely* there is *something* that we, who have had such highly specialized training—mine has been over twenty years—can do to contribute to National Defense which would be of more value to our Nation than a training in military so incompatible with our talents."[7] Richard Guy Walton asked the Section: "Just what part does an artist's skill play in National Defense? If no such word is forthcoming, I can presume we are all useless today."[8] Forbes Watson replied:

> His use depends on doing his very best as an artist in a manner that makes clear to other people that he can keep his chin up. That undaunted by the world's tragedy he can continue to play his role of being a champion of the things of the spirit.[9]

However, J. S. Lankes, who questioned that military training could enhance creative talent, required more than Watson's reflections on spiritual strength. He told the Section that an artist friend, who could quote Dante in the original, had now been promoted to "a bigger gun in New England."[10] It was apparent that the apathy expressed by the American artist pointed to an ambivalent role in a changing America, as the Roosevelt administration prepared for national defense.

What Malcolm Cowley had to say about the end of the New Deal era paralleled the fate of the New Deal art programs. When Congress passed the president's Reorganization Act of 1939, the programs of Bruce and Cahill were transferred to the newly created Federal Works Agency (FWA), headed by administrator John M. Carmody. In the case of Bruce, the Section lost its permanent status and the strong support of Secretary and Mrs. Henry Morgenthau; and Cahill lost central control of his program when WPA/FAP was placed under the jurisdiction of the states, where it became known as the WPA Art Program. The bill, in effect, forecast the end of Bruce's quest for permanency and Cahill's quest for unity. Even the nationalism of the American scene—the basis for the New Deal art—was altered by the internationalism brought over by European refugees including abstractionists Piet Mondrian, Josef Albers, and Laszlo Moholy-Nagy. Not only was the Office of the Supervising Architect placed under FWA but also the Works Progress Administration, which ceased to exist as a separate relief agency and had its official name changed to Works Project Administration.[11] This implied that relief was no longer a national priority, and Hopkins's policy to preserve human skills and talents—which gave impetus to Cahill's goal to provide opportunities for all artists—came to an end.

Despite the fact that Carmody expressed interest in the Section, Bruce encountered little support under the new setup. For example, in November 1939, the supervising architect, Louis Simon, recommended that the one percent funds for embellishing federal buildings be reduced when construction projects exceeded $5 million—an action seen by Bruce as a threat to his program. When Eleanor Roosevelt inquired about his program, he explained, "It is disheartening to have no funds authorized for murals on three big San Francisco buildings—the $4,000,000 Customs House, the

$1,250,000 Mint, nor the $2,000,000 Rincon Postal Station, to say nothing of the $14,000,000 Social Security Building"[12]

On November 25, 1939, newspaper columnists Drew Pearson and Robert S. Allen reported that Bruce had resigned—his life having been made miserable under the FWA.[13] While he denied these allegations, Carmody wrote to the president that Bruce was getting support for his program. However, Paul Manship, president of the National Sculpture Society, informed the president that Bruce planned to resign.[14] Roosevelt, learning of this surprising bit of news, warmly supported Bruce:

> What is all this nonsense about your contemplated resignation? When a fellow turns up in Washington and proves that he can make bricks out of straw, that the bricks are durable and artistic and that nobody else can make them, the President puts a Marine Guard around him and does not let him leave. Do be a good fellow and write to Paul Manship that you have been chained to the Government of the United States and cannot get away even if you want to.[15]

Perhaps because of this correspondence, Bruce remained loyal to the president and stayed in his post. His battle ended when Carmody, on April 12, 1940, approved the permanent status of the Section under the FWA, where it became known as the Section of Fine Arts.[16]

Cahill's program also faced administrative problems. Because the state administrators now controlled the former federal art projects, Cahill did not have direct access to state art directors; and by November 1940 the art supervisors were no longer consulted on technical decisions. The situation deeply concerned Cahill because state administrators tended to place art projects under the direction of nonprofessional staff members, who lowered the previously high creative standards. The closing lines of communication between the Washington office and state projects also disturbed Cahill. In his view, "If we are to be further circumscribed in our contacts, it would seem that we would rapidly approach the state of interior monologue. Possible that is a desideratum."[17]

Not only were technical standards affected by the new command procedures, but by November 1941 all creative phases of the WPA Art Program were questioned unless they served the practical needs of national defense. The Washington office suggested that all creative personnel be assigned to wartime projects, unless the military and civilian defense organizations specifically requested fine arts media.[18] The changing mood of the public Bruce wryly summed up in this manner: "Frankly, with all the horror which the world is going through these days life doesn't seem very significant. . . . Of course there are an awful lot of people around today who think that now that the world is aflame we ought to drop this so-called 'art bunk'."[19] In a way, the answer partly depended on whether or not the fine arts could be enlisted to define the wartime aims of a democracy at bay.

Because their original goals were no longer valid, Bruce and Cahill decided to reorient the programs. The Section of Fine Arts would be available to perform useful services in camouflage and poster work, Bruce advised Carmody. Because the Section had no funds for that activity, Carmody suggested that the Navy and War departments should be approached. Bruce wrote to the secretary of the navy:

> I am very anxious for our Section of Fine Arts to be of some practical use to the country during the present crisis. As you know, we are in touch with all the leading

artists in the country and several of them have talked with me with the thought that they could be particularly useful in connection with camouflage work.[20]

However, the Navy Department declined Bruce's overtures because experienced naval personnel were already available for camouflage work. Bruce then wrote to the secretary of war, but his offer was rejected for the same reason.[21]

Bruce used another tactic when he discussed with Senator Millard E. Tydings of Maryland the idea that American artists could contribute useful services by making visual records of the defense effort. Apparently, nothing resulted from this suggestion because Bruce noted, ". . . it has been a source of great regret to me that it hasn't been felt that the artists could render a service in connection with the National Defense program."[22] Undoubtedly, it was difficult for Bruce to establish new objectives because the Section had never developed the practical skills found under the former WPA/FAP program.

The WPA Art Program adapted more easily to national defense. By February 1941 the program was developing for the military (1) models for teaching aircraft operations; (2) class charts in military instruction; and (3) decorations for army recreation halls. In Washington State the WPA Art Program also conducted art classes at military installations, and at Fort Lewis, an exhibit program for the recreation center.[23] Throughout the national defense period the WPA Art Program adapted its practical skills to military needs, but Cahill still faced Bruce's dilemma—finding a niche in America for the creative artist.

Bruce failed to convert the Section to national defense needs, but he was not deterred from continuing a professional program. In October 1939 the Section announced a 48-state competition for post office murals. The outcome was described by Watson as having brought "a breath of fresh air into American painting." Bruce, however, uneasy about the future of his program, asked Roosevelt for his support.[24] The president replied:

> At this time when it is so essential to emphasize the arts of peace, I think it all the more significant that the Section of Fine Arts should hold a public exhibition of the mural designs and sculpture models which have been or are being accepted for the decoration of federal buildings, and on this anniversary of your work I again wish you and the Section every success.[25]

Greatly encouraged, Bruce continued with his program. In March 1940 a competition was held for murals in the Social Security Building in Washington. After the Section reviewed the work of 375 artists, Ben Shahn, Philip Guston, and Seymour Fogel were chosen for the work. During the fall of 1940, in a competition to install watercolors in Federal Marine hospitals, events took a curious twist. The artist John Marin, who was not inclined to be a jury member, wrote to Bruce:

> Generally speaking—I must say I disapprove of art juries—you find the same names of those who from one cause or other—*want* to be *placed* on *juries*. Your cause in all probability is a very worthy one. Why—for a change, cannot you get a few youngsters on the juries? I guess their *say so* would produce an output which *might* compare favorably with the *say so* of those whose—say so—is to me *not above suspicion*. It is an awful *thing* to awaken to find yourself in bed with strange bed fellows—they may be better than you but still—Thanking you and just asking you to try and think of me as—just one of those cusses.[26]

Yet, Marin became upset because his letter of invitation had not been signed by Bruce. Once the oversight was explained, Marin decided to accept: "Your kind letter shows me you know how to deal with obstreperous critters like myself who mean well but go off the handle. To me you are the right sort."[27] Bruce was so pleased that he informed Marin, "I hope you will feel, after attending the jury, that we are a pretty decent bunch and trying to do a good job."[28]

In 1941 other Section activities followed: the Marian Anderson Commemorative mural competition, won by Mitchell Jamieson because he successfully conveyed "the mood of the multitude at the historic event"; and the War Department mural competition, awarded to Kindred McLeary, whose concept Bruce declared effectively depicted the president's stirring call, ". . . the freedom of the human spirit shall go on."[29] These mural activities took place in Washington, but the Section also conducted sixteen mural competitions in other parts of the country: one national, the others regional. The national competition for decorating the Rincon Annex in the San Francisco Post Office was won by Anton Refregier.[30]

Yet the continuing activities of the Section did not make Bruce any less concerned about finding a permanent site for his fine arts program. To achieve his Smithsonian Gallery plan, he sought private funding from Mellon, Guggenheim, and Rockefeller interests, but he failed in his efforts. Bruce also approached millionaire Representative Bruce Barton with a plan to raise a total of $1 to $2 million in small amounts. The congressman offered no encouragement, however. He reported: "In nearly every money raising campaign about 98 percent of the total gifts come from 2 percent of the givers. These givers now have no money to give."[31]

Bruce's failure to get financial backing was compounded by the harsh criticisms his gallery plan received from influential architects. In one instance, he bitterly complained, "I find the design is contemptuously referred to in New York as a piece of tripe of the Ellis Island School of Architecture."[32] Moreover, the Fine Arts Commission condemned the gallery design because its modernity was considered totally unsuited to the location on the Mall. Commission Chairman Gilmore D. Clarke commented:

It is factory-like in appearance and construction, quite obviously a steel frame with a thick stone and glass veneer, whereas all of the other buildings have, or appear to have, structural bearing walls. The ribbon windows on the Mall elevation are offensive.[33]

Eero Saarinen's gallery design also was attacked by Supervising Architect Louis Simon as the work of a radical.[34]

Because Bruce lacked support for his concept, his gallery plan was doomed to fail. In March 1941 the *Washington Times-Herald* reported that idealistic projects, such as Bruce's exciting hope for a new gallery, "have begun with the delight of generosity in its early stages, and then died."[35] The failure of the Smithsonian Gallery plan also meant the end of Bruce's dream to find a permanent home for the Section. By April 1941 even the Treasury funds that the Section depended on, were coming to an end. Bruce sadly commented:

Already the President has ordered the discontinuance of federal buildings not already under construction. Fortunately, a group are now being constructed and we can go ahead, I believe. I'm anxious to decorate this group of buildings as I'm afraid

they will be maybe the last group we can decorate as long as this horrible war business lasts.[36]

Looking back on this period of the New Deal, it seems clear that Congress had wanted to see the art programs survive by placing them under a permanent Bureau of Fine Arts. The various congressional bills reflect this trend, but in the end there was not enough support on the part of Congress, the president, and the directors of the art programs for any of these bills to pass. As early as 1935, Representative William I. Sirovich of New York, chairman of the Committee on Patents, initiated a bill to organize a federal Department of Science, Art, and Literature. The bill, however, received mixed reactions. Instead of a department, Bruce wanted to see an advisory group, but Watson contended that the bill was too confused for anyone to understand. He suggested that the bill "be laughed out of Congress." The bill also was opposed by such artists as Charles Burchfield, Arnold Blanch, and Allen Tucker because they viewed it as a threat to the freedom of artists. In 1936 some of the WPA/FAP supervisors advocated making the program permanent to offset the ill effects of mass dismissals. Cahill, however, quickly discouraged those talks because WPA/FAP was only a temporary relief program, he contended; and at this time it was not proper to talk about a permanent organization.[37]

By 1937 the art bills under consideration by Congress included the following: Representative William I. Sirovich's Joint Resolution (introduced in January 1937); the so-called Coffee Bills, proposed by Representative John M. Coffee of Washington in August 1937 and revised in January 1938; and the Pepper Bill, its Senate counterpart, introduced by Senator Claude Pepper of Florida in January 1938. These bills, in one form or another, recommended merging the Section and WPA/FAP under a permanent Bureau of Fine Arts. However, mixed reactions—pro and con—occurred over these bills. Strong support came from various liberal groups: the Artists' Union; the Artists' Congress; the American Society of Painters, Sculptors, and Engravers; the Mural Painters' Society; and the Mural Artists' Guild. Yet, strong opposition came from the conservative Fine Arts Federation, comprising the National Academy of Design, the American Water Color Society, the Architectural League, and the National Sculpture Society.[38]

The Section, however, supported the conservative position of the Fine Arts Federation, in the belief that any of the congressional bills would only encourage mediocrity. Museum director Francis H. Taylor, who disparagingly referred to the Coffee-Pepper bills as "Pork-Barrel Renaissance," shared the conservative viewpoint of the Fine Arts Federation. However, Taylor raised the old PWAP issue—where does relief end and quality begin—which pointed up the ambiguity of ever trying to establish a permanent art bureau.[39]

The question of government responsibility to the arts came up again in July 1939, when Senator Pepper sent a copy of his bill to the president. Deeply concerned about the Dies Committee's wanting to end the projects, the senator urged that the art programs be placed under statutory law. The president, however, informed Pepper that he did not want to recommend the creation of an art bureau without a clarification of its functions. On the other hand, he praised Bruce's Smithsonian plan as an example of what was being done for the arts.[40] The president's lack of interest, however, discouraged any further congressional action for a permanent art bureau. Moreover, the Reorganization Plan of 1939, placing the art programs under FWA, strongly suggested that the arts had become a political liability to the administration during national defense.

The attitude of the administration to disengage itself from any responsibility to the arts—revealed by the president's noncommitment to the congressional art bills—was seen again when Roosevelt tried to transform a waning federal interest in the arts into active community support. In the wake of an economic recovery, the president wanted the American people to support their own cultural life as the New Deal had done during the Depression. Hence, Roosevelt in 1940 and 1941 sponsored "Art Week," a nationwide activity to encourage local art sales by artists and craftspeople. "Art Week" was inadvertently inspired by Edward Bruce's comment to Roosevelt that artists were returning to rural areas to live because there, at least, the possibility of a modest patronage existed.[41] Yet, the dismal outcome of "Art Week" forecast a bleak future, indeed, for the arts—if they were dependent on the kind of community participation initiated under Cahill's program.

In August 1940 the president asked Francis H. Taylor, director of the Metropolitan Museum of Art, to serve as chairman of "Art Week"—a nationwide observance of artists and craftspersons—and to form a National Council, comprised of leaders in the art world and the federal government. The assistant commissioner of the WPA, Florence Kerr, was asked to assume major responsibility for promoting "Art Week." From November 25 to December 1, approximately 1,600 exhibits were held in 500 communities, ranging from large metropolitan shows to small rural displays in schoolhouses at remote crossroads. The administration anticipated that $5 million worth of arts and crafts would be sold, but despite the attendance of nearly five million persons the total sales of "Art Week" approximated $100,000.[42]

Based on procedures used in 1940, the administration made another effort to encourage art sales during the week of November 17–23, 1941. The total sales of that "Art Week" reached $130,000.[43] From the meager results of "Art Week," it is evident that the Roosevelt administration had failed to transfer a federal cultural activity over to state and local levels. Perhaps this lack of public interest reflected the mood of the American people that art had become nonessential during national defense. In any event, this was the last effort of the administration to involve itself with the cultural life of the nation.

The Japanese attack on Pearl Harbor terminated the creative goals pursued by Bruce and Cahill. During this period of national emergency, all nonessential building construction was stopped, thus calling to a halt Bruce's program. The crisis also concluded Cahill's creative projects under the WPA Art Program. Whether or not the administration would now find alternative means of utilizing the skills of artists remained very much in doubt. As Cahill observed, such a question could only be answered by the American people.[44]

On balance, the era after Pearl Harbor proved perplexing to American artists. There were some who endeavored to contribute their skills to the war effort. William Schwartz donated a painting to the government to express his reaction to the brutality engulfing the world. If an art project developed overseas, Myron Lechay informed Cahill, he wanted to be considered. A similar idea was suggested by Stuyvesant Van Veen to the War Department with an offer to serve in the front lines. Volunteering his services to the Office of Civilian Defense (OCD), Henry Billings suggested that New York City have a war pageant to explain the work of various defense agencies. To dramatize the war pageant, he recommended the use of tape strips on store windows and sandbags around public statues. In San Francisco the Open-Air Art Show Committee offered OCD the names of artist volunteers.[45]

However, there were others who felt terribly estranged during the national

emergency. Concerned about the nonuse of art, Charles R. Knight told the Section, "Art from my point of view is absolutely dead, as no one has any money to spend on such things. I trust that you may be able to locate me some sort of work that I might do in making camouflage designs, posters, or other things for war use."[46] Philip Evergood looked for camouflage work, but he was told that artists were incapable of adapting to the new media. David Fredenthal wanted to follow the troops as an artist-correspondent to help the war effort; meanwhile, he became a laborer in a defense plant. Finding the proper niche was difficult, as Henry V. Poor recognized:

> I've also been painting at Carmel, keeping a wary eye out for subs and Japs at the same time. You know I'm not one who deceives himself that artists are any good during war time. They just have to stick it out the best way they can until there might be an actual need for them as fighters, or machine tenders. I think I can do either fairly well, but I don't feel very successful at making art contribute to winning the war.[47]

The alienation of the American artist reflected the kind of dilemma the Section faced—dislocation in a changing America. In June 1941, Bruce had proposed that the appropriation of $50,000 be used to repair and decorate old buildings in areas surrounding Washington. After receiving word that his plan was being considered, he told Rowan, "I hope it is, but I have my fingers crossed in the fear that it isn't."[48] In January 1942, however, the Senate Appropriations Committee denied Bruce's request for $50,000. Senator Kenneth McKellar, a committee member, remarked, "Suppose the Germans or Japs come over here and bomb us, the fine arts would be a waste of money." E. R. Witman, fiscal manager in the Public Buildings Administration, tried to explain that the work done by the Section would raise public morale, but McKeller ignored the plea: ". . . one battleship will increase the morale more than all the art in America."[49] The Senate view proved distressing to Bruce, who saw his hard-won federal art program disintegrating.[50]

In November 1941 another effort was made to sustain the Section. Henry V. Poor, a painter member of the Fine Arts Commission, submitted a proposal to the commission, calling for the decoration of the new Pentagon building of the War Department in Virginia under the supervision of the Section. After Pearl Harbor, Bruce urged the Fine Arts Commission to adopt Poor's proposal, emphasizing that the war was being waged to preserve civilization. The commission rejected Poor's mural proposal, however, because the members felt that the public would severely criticize the venture as nonessential during the war crisis.[51]

The view of the Fine Arts Commission was being similarly expressed in the states. In January 1942, for instance, in Salina, Kansas, the postmaster warned, ". . . the public sentiment of the citizens of Salina, Kansas, is very decidedly opposed to any murals. It is going to make it very difficult for us to talk 'Buy Defense Bonds and Stamps,' when people see money being spent for things which they consider as unnecessary."[52]

Another patriotic controversy surfaced in Yakima, Washington, when citizens became incensed over a newspaper report that the government was sending an artist to paint murals in their post office. (Actually, Robert Penn had been commissioned to do a post office sculpture for $1,850.) Because the public was giving its last dollar for Defense Savings Bonds, George H. Gannon, area director of Defense Savings, strongly objected to spending this money for artwork. The use of $1,850 for post office art was criminal, Ted Robertson, a newspaper editor, told Congressman Knute Hill.

George Baer, manager of the Chamber of Commerce, also complained to the congress-man that news about the post office competition had adversely affected the sale of defense bonds. These objections were brought to Bruce's attention, who tried to convince the Yakima citizens that art could preserve public morale and stimulate patriotic spirit. However, due to majority opposition, the Section postponed the post office sculpture project indefinitely.[54]

In Ashland, Wisconsin, patriotic opposition developed over a post office mural that Lucia Wiley had been commissioned to paint. By February 1942 the Section urged Wiley to proceed quickly because the work could be curtailed. In August, however, Postmaster C. McGeehan informed Wiley, ". . . one can't get too excited about the painting of a mural at this time for if Hitler wins the War he will have his own ideas as to a subject and he won't consult me."[55] He also warned the Section, "As Postmaster, Commander of the Local American Legion Post, and a member of the Local Selective Board, I am absolutely against the project at this time and refer you to statements made by Government officials that we are on an all-out war." Thus Bruce had no choice but to postpone the Ashland mural project for the duration of the war.[56]

Based on the mood of the nation, it seemed as though the Section had nowhere to go. Nevertheless, Bruce made two final but futile efforts to save his program from disintegrating altogether: first, setting up a poster program to define the wartime objectives of the administration; and second, forming an artists corps to record front-line activities.

In January 1942 the Section announced an American Red Cross poster competition to depict the global goals of the Red Cross. However, the entries submitted by the artists proved disappointing to the Section.[57] Apparently, the work lacked the direct, forceful appeal expected of poster art.

Yet another possibility that the Section could contribute to the national emergency arose when Archibald MacLeish, director of the Office of Facts and Figures (OFF) wanted to organize a poster program, which would make an appeal for public support of the war effort. Bruce, as advisor to OFF, commented that an effective poster was simply "a question of the simplicity and carrying power of the visual statement. I believe that a good picture can at the same time be a good poster."[58] Meanwhile, Max Stern, a member of the Federal Security Agency and a friend of Bruce's, urged MacLeish to use the resources of the Section. Only the Section could provide the emotional appeal that posters had lacked, he declared. Stern expressed the problem in this manner: "To fight and win wars requires anger, fear, ambition and other raw emotions that arise not between the ears, but from the glands. We have not yet stirred the will to win and to survive with all that this implies."[59] Yet, the Graphics Division of OFF contended that the Section could not develop an effective program, and it viewed Bruce's use of competition as a procedure too cumbersome for wartime. The associate director of OFF, Allen Grover, explained to Stern, "It is the belief of the Graphics Division that the production of posters is a highly technical undertaking more closely allied to the commercial world of advertising than that of the fine arts."[60] Hence, the Section did not develop a poster program for OFF.

The Fine Arts Commission, however, reflecting Stern's noncommercial approach, wrote to MacLeish:

We feel that the artists of America have not been enlisted; that whatever the reasons may be, you have not taken effective steps to call into existence a force which could be one of the most potent of all—the force for unity and for action which lies in deeply stirring, beautiful and thoughtful war posters.[61]

MacLeish conceded that utilizing the skills of American artists in poster work was exceedingly difficult; and using the commercial media had not solved the problem of getting "stirring, beautiful and thoughtful war posters."[62] At the Whitney Museum in New York, MacLeish met with artists to discuss this issue. Artists including William Gropper, Henry V. Poor, and Rockwell Kent declared that the special talents of the American artist should be utilized for the war effort, but no one could agree on the approach. Perhaps, the reason was what Kent had contended: namely, that the government assumed erroneously that advertising art—developed for the selling of commercial goods—could also be used for the selling of a faith.[63]

The problem discussed at the Whitney Museum was more clearly revealed when the Treasury Department invited artists to submit poster ideas to stimulate war-bond sales—a program coordinated by Olin Dows. One of the artists, William Gropper, faced with the same contradiction left unresolved at the Whitney, told Dows:

> I can't understand it, we have thousands of good artists who are eager to draw and paint vivid pictures to awaken and lift the morale of the country, many of these artists are willing to do this for nothing. Just think of it, war murals on trains and trucks, pictorial incidents of Nazi terror, cartoons in shops and office buildings, posters and sketches of every possible phase that concerns the people at home and the boys in camp. Why do you know that this is the only country in the world where the Army has not engaged and commissioned the artists to portray the heroic deeds and incidents when we are fighting for a better world.[64]

Dows conceded that the talents of good artists were being wasted. He had no real solution to Gropper's question except to observe that the actual machinery for using their art had not yet been invented.[65] In fact, Bruce's aborted efforts to develop a poster program that could contribute to the war effort only revealed the dilemma that was clearly stated by Kent—the inability to translate the talents of creative artists into communicative skills either to sell war bonds or to define the nation's wartime objectives. For that matter, Dows's reaction to the results of the Treasury war-bond posters added credence to Kent's viewpoint: ". . . I don't believe any of them are outstanding nor are they up to the quality which I believe the artists of this country can produce."[66]

To sustain the Section another approach was taken, although Bruce's aggravated illness prevented him from taking an active part. Dows, OCD art consultant, and Mrs. Henry Morgenthau, OCD deputy assistant, planned a national art competition—stressing defense activities—to be administered by the Section. In January 1942, working with the Office of Emergency Management (OEM), the Section received 2,582 paintings, from which a traveling exhibit, "Art in War," comprised of 109 works purchased by OEM, toured the country. As suggested by the Section, OEM commissioned 8 artists to depict the restricted activities of war plants. In March 1942 the exhibit "Soldiers of Production" was shown at the National Gallery of Art in Washington.[67]

The OEM activities established a precedent for planning an artists' corps to support the Section during the war. On December 31, 1941, Dows had outlined a plan to Mrs. Morgenthau, using 200 artists under the Section's supervision, which she then discussed with the president. In January 1942, at a cabinet meeting, Roosevelt suggested that Bruce was the person most qualified to administer the artists' corps program.[68] Meanwhile, the War and Navy departments were contacted, but they revealed no interest in the proposal. In May 1942, Philip Fleming, administrator of

FWA, sent to the Bureau of the Budget the proposal to begin an artists' corps program under the Section. Dows then wrote to Eleanor Roosevelt, asking for White House backing of the program. The Fine Arts Commission also urged the president to support the plan because the most talented artists would be employed.[69]

But on July 14, Wayne Coy, acting director of the Bureau of the Budget, informed Fleming:

> I have presented your proposed program to the President for his consideration. He has determined that adequate provision has either been made, or is contemplated for this activity by the War and Navy Departments, taking cognizance of the work being done by commercial artists and publishers in their normal pursuit of war time subjects. Consequently, I cannot approve your request for funds to finance this program.[70]

The president ostensibly rejected the proposed program because adequate provisions had been made previously through defense agencies and private outlets. However, in the view of W. E. Reynolds, commissioner of the public buildings in FWA, the proposal was turned down because Congress would become hostile to it. Nevertheless, Dows viewed the president's rejection of the plan as the end of the Section and its program. The Section of Fine Arts was officially liquidated on June 30, 1943.[71]

A brave soldier to the end, Bruce died on January 26, 1943, from the aggravated effects of a stroke in Hollywood, Florida. A group of artists contributed to a memorial exhibition as a last tribute to Bruce in September 1943. Held at the scene of Bruce's first success, the Corcoran Gallery of Art in Washington, D.C., the exhibit evoked Watson's comment: "It sprang to life as a tribute of affection and understanding from the artists of whose works it is composed, to a fellow artist, who, as administrator of the United States Section of Fine Arts, has left a permanent imprint upon the American civilization."[72]

Just as the national emergency ended Bruce's program, so did Cahill's program suffer the same fate. In May 1941, when the British exhibit "Britain at War" opened at the Museum of Modern Art in New York City, Cahill commented that it revealed the will of the British people to survive and to defend their way of life.[73] Inspired by the British exhibit, he organized a special Index exhibit, "Emblems of Unity and Freedom," at the Metropolitan Museum of Art in New York. To arouse the patriotic idealism of the American people, he suggested that the public should familiarize themselves with these popular symbols in folk art, such as the American flag, the American eagle, and George Washington, to arouse patriotic idealism. He also cited Britain's wartime use of artists as a precedent for the U.S. government to follow in utilizing its artistic resources.[74]

Despite Cahill's efforts to find a place in America's "Arsenal of Democracy" for creative artists, his approach was doomed to fail. Somehow, he could not reconcile the contradiction between his idealism and the reality of the national emergency. For example, in January 1942, the artist Walter Quirt told Cahill; "The bulk of the creative artists on the New York Art Project have been assigned to non-creative work. This ranges from making frames to efforts to convert experienced and recognized artists into commercial people."[75] In May 1942, the artist George Z. Constant was so disenchanted with the new objectives of the program that he sent a petition of protest to Rowan in the Section, signed by Polygnotis Vagis, Reuben Nakian, C. Jean Liberté, Albert Swinden, Byron Browne, Earl Kerkam, and Jackson Pollock:

Since the New York W.P.A. Art Project stopped functioning creatively, as Mrs. A. M. McMahon informed us, we the undersigned artists appeal to you, on behalf of our profession.[76]

The petition ended with an appeal to do something about the conditions that permitted artists to contribute neither to the war effort nor to the nation's culture. Rowan, however, replied that the Section was in no position to change those conditions.[77] Margaret Davis Clark, state supervisor of the WPA Art Program, also referred to this problem:

. . . the art program in WPA is changing, like the rest of the organization, to serve entirely on a defense basis. Consequently, we are unable to proceed with work in fine arts, excepting where such work made a direct contribution to the war situation.[78]

Britain's wartime use of artists Cahill hopefully saw as a precedent for the administration to follow. Instead, he witnessed the end of his fine arts projects, which had provided opportunities for every artist in the American scene.

The WPA Community Art Centers were confronted by the same dilemma as that of the fine arts projects. Under the New Deal, Cahill had declared that the Community Art Centers program was on the threshold of great development. In February 1942, however, the program of the South Side Community Art Center in Chicago was disrupted when the instructors were transferred from the center to the U.S. Army to work as map tracers. A center official, Patrick D. Prescott, Jr., commented, ". . . though we will still have a Center, we will not have the integration of the artists in the community, teaching and directing the talents of the people in the community."[79] Mary McLeod Bethune, a board member of the National Youth Administration, agreed with this criticism, but an official at the WPA headquarters replied: "I am sure both you and Mr. Prescott will agree that under the present circumstances the needs of the armed forces must take precedence over all other activities."[80] To save the project the South Side Community Art Center was converted into the Wartime Art Service Center, which became a model for other community centers throughout the country. Thus the keystone of Cahill's program, the WPA Community Art Center program—organized to achieve his "quest for unity"—became a casualty of the war crisis.[81]

Besides the wartime conversion of Cahill's community art centers, the National Exhibition Section—established to send traveling exhibits to the art centers—underwent extensive changes. In May 1942 it ended, but in its place the Central Exhibition Unit was organized in Chicago. The unit circulated posters and other graphic materials about the war effort throughout the country.[82]

The Index of American Design—established to illuminate the dark corners of America's past—also became a casualty of the war. By 1941 the Index numbered more than 20,000 drawings, and Cahill wanted to make this heritage available to U.S. communities through publication of this material in full-color portfolios. The heavy initial investment had discouraged some of the publishers, but when Mrs. Roosevelt expressed an interest, Cahill prepared a prospectus for her review. His plan called for official sponsorship by the Franklin D. Roosevelt Library in Hyde Park, New York, which would ensure the success of and lend distinction to the publication. Eleanor Roosevelt brought the Index prospectus to the president's attention, but he turned down the plan, saying, ". . . it occurs to me that the project could perhaps be

sponsored by the Archivist of the United States, or by the Library of Congress."[83] The president's decision, in effect, ended Cahill's goal of making this heritage available to the American people through printed portfolios.

By May 1942 it became necessary to allocate the Index to an institution best able to preserve it because the project was closing down. The librarian of Congress, Archibald MacLeish, wanted the Index, but Cahill objected because the library offered only a repository with little chance for publication. By gaining Harry Hopkins's support he avoided confrontation with MacLeish; and in September 1942 he transferred the Index to the Metropolitan Museum of Art, which offered the possibility of eventual publication. At present, the Index of American Design is housed in the National Gallery of Art in Washington. However, what Cahill envisioned—printing the Index in full-color portfolios—has not been realized to date.[84]

Although Cahill's quest for unity through his fine arts project ended, the WPA Art Program redirected the practical talents of artists in providing diversified visual services for army and navy agencies. The project proved so successful that Hopkins was moved to exclaim, "See, that fellow Cahill has got the artists right down in the front line trenches!"[85] In March 1942 the WPA Art Program was reorganized as the Graphics Section of the War Services Program, and Cahill was designated as national consultant. In addition to visual aids, he planned a series of graphics about wartime America that included labor force, industrial, and port activities. On April 30, 1943, by presidential order, all of the art activities directed by Cahill were liquidated.[86]

After a decade of New Deal art programs, unquestionably these activities seriously affected Bruce and Cahill—the pressures and contradictions exerting an extreme physical and spiritual toll on them. In the case of Bruce, his energies were severely debilitated by his inability to adjust to a slower tempo. Perhaps this contributed to the stroke from which he never recovered. Cahill, while directing the WPA/FAP program, also suffered pressures damaging to his health. He commented, "I had worn myself out. I had blown out more fuses in my system than any man should in this job."[87]

The separate goals of "tradition" under the Treasury art program and "innovation" under the WPA/FAP program had created a natural rivalry. There existed nonetheless a great admiration by Bruce for Cahill's accomplishments, and vice versa. In one instance, Bruce complimented Cahill, ". . . I very honestly and genuinely believe that in your address 'Old and New Paths in American Design' and in your foreword to the Modern Museum show you have made a very genuine and important contribution to the literature on American art."[88] Cahill, after looking at Bruce's San Francisco mural in the Stock Exchange Building, praised Bruce: ". . . the picture expressed, if you will permit me to say so, the things that you have given so richly to the artists of America, a love for their art and a love for the greatest subject that any American artist can have, the places, the people, the history, and the ideals of our own land."[89]

The decline of the New Deal era in 1939 led to an end of the art programs in 1943. However, the influence of Bruce and Cahill has continued into the post–World War II period. The two men gave to the nation a legacy that reflects the New Deal objective to provide "a more abundant life for all" during the worst economic crisis in U.S. history. Moreover, a precedent was established by Bruce and Cahill, which future generations can follow to articulate through art forms their own tradition and innovation.

Notes

1. Edward Bruce to John Hanes, October 30, 1939, Bruce Papers, D86.

2. Edward Bruce to Mrs. Henry Morgenthau, Jr., March 18, 1938, RG 121/122.

3. Malcolm Cowley, "A Farewell to the 1930's," *The New Republic*, November 8, 1939, p. 42.

4. Anne Dodge Bailhache to Edward Bruce, June 4, 1940; and Edward Bruce to Anne Dodge Bailhache, July 8, 1940, RG 121/122.

5. Francine Baehr to Edward Bruce, September 7, 1939; Edward Bruce to Francine Baehr, September 18, 1939; and Mildred Rosenthal to Edward Bruce, May 20, 1940, RG 121/122.

6. Edward Bruce to Charlotte Partridge, January 8, 1941, RG 121/122.

7. Lloyd Goff to Edward Bruce, April 7, 1941, RG 121/132.

8. Richard Guy Walton to Edward B. Rowan, n.d., RG 121/126.

9. Forbes Watson to Richard Guy Walton, June 18, 1940, RG 121/126.

10. J. J. Lankes to Edward Bruce, July 24, 1941; and J. J. Lankes to Edward B. Rowan, August 9, 1941, RG 121/126.

11. Arthur E. Burns and Edward A. Williams, *Federal Work, Security, and Relief Programs*, research monograph 24 (Washington, D.C.: Government Printing Office, 1941), p. 72.

12. Edward Bruce to Peyton Boswell, September 19, 1939; Mrs. Franklin D. Roosevelt to Edward Bruce, November 8, 1939; and Edward Bruce to Mrs. Franklin D. Roosevelt, December 7, 1939, RG 121/122.

13. Drew Pearson and Robert S. Allen, "Washington Merry-Go-Round," November 25, 1939, *Buffalo (N.Y.) Courier Express*.

14. Release statement of Edward Bruce, November 25, 1939; John Carmody to Franklin D. Roosevelt, December 26, 1939; and Paul Manship to Franklin D. Roosevelt, December 27, 1939, RG 121/122.

15. Franklin D. Roosevelt to Edward Bruce, December 28, 1939, RG 121/122.

16. Federal Works Agency #12, Administrative Order, April 12, 1940, Bruce Papers, AAA Reel D86; the WPA Art Program, June 30, 1939–June 12, 1940, RG 69/211.5.

17. Memorandum of Holger Cahill to Clayton E. Triggs, November 2, 1940, pp. 1, 4, RG 69/211.5.

18. Memorandum of Holger Cahill to Olin Dows, n.d., RG 69/211.5.

19. Edward Bruce to Florence Kerr, June 11, 1940, RG 121/133.

20. Edward Bruce to John Carmody, September 20, 1939, RG 121/122; John Carmody to Edward Bruce, September 21, 1939; and Edward Bruce to Charles Edison, September 25, 1939, RG 121/132.

21. Charles Piozet to Edward Bruce, October 3, 1939; and R. R. Arnold to Edward Bruce, October 20, 1939, RG 121/132.

22. Edward Bruce to Millard E. Tydings, March 28, 1941, and Edward Bruce to Edward B. Rowan, August 10, 1941, RG 121/132.

23. Field Report by Holger Cahill, Covering Visit to Washington, September 4–8, 1941, and Field Report by Holger Cahill, Covering Visit to Washington, September 14–16, 1941, RG 69/211.5.

24. "Winners in Government's 48-States Competition Shown at Corcoran," *Art Digest*, November 14, 1939, p. 12; Edward Bruce to Franklin D. Roosevelt, October 14, 1939, RG 121/122.

25. Franklin D. Roosevelt to Edward Bruce, October 19, 1939, RG 121/122.

26. John Marin to Edward Bruce, August 31, 1940, RG 121/122.

27. John Marin to Edward Bruce, September 19, 1940, RG 121/122.

28. Edward Bruce to John Marin, September 11, 1940, RG 121/122; Federal Works Agency, *American Water Colors* (Washington; D.C.: National Gallery of Art, May 15–June 4, 1941).

29. Federal Works Agency, press relese PBA-FA-88, October 9, 1940, p. 2. At that time the only auditorium available for concerts in the nation's Capital was Constitution Hall, originally constructed by the Daughters of the American Revolution (DAR) for their annual conventions. One of several so-called patriotic organizations, the DAR is composed of descendents of members of the American Revolutionary Army. As an early symbol of black protest against racial discrimination, Miss Anderson's performance was held at the Lincoln Memorial after DAR members refused the use of their hall to a black singer. See Federal Works Agency, press release, PBAFA-117, April 9, 1941, RG 121/122; Federal Works Agency, *Bulletin No. 21*, March 1940, pp. 3–11, RG 121/130.

30. "News and Comment," *Magazine of Art*, April 1941, pp. 221–222.

31. Edward Bruce to Maurice Sterne, November 23, 1937; Paul Mellon to Edward Bruce, March 11, 1938; Frederic A. Delano to Bruce Barton, May 13, 1940; and Bruce Barton to Frederic A. Delano, May 14, 1940; RG 121/133.

32. Edward Bruce to John A. Holabird, March 26, 1940, RG 121/133.

33. Gilmore D. Clarke to Frederic A. Delano, July 22, 1939, RG 121/133.

34. Edward Bruce to Joseph Hudnut, December 5, 1939, RG 121/133.

35. *Washington Times Herald*, March 20, 1941.

36. Edward Bruce to Maurice Sterne, April 12, 1941, RG 121/133.

37. "Comment and Criticism," *American Magazine of Art*, August 1935, pp. 489–91; telegram of Audrey McMahon to Holger Cahill, November 27, 1936, and telegram of Thomas C. Parker to Audrey McMahon, November 29, 1936, RG 69/WPA/FAP.

38. "A Federal Bureau of Fine Arts," *American Magazine of Art*, February 1938, pp. 118–119; "Fine Arts Federation Opposes Coffee-Pepper and Sirovich Bills," *American Magazine* of Art, March 1938, pp. 173–174.

39. Memorandum of Forbes Watson to Edward B. Rowan, February 1, 1938, RG 121/133; Francis Henry Taylor, "Pork Barrel Renaissance," *American Magazine of Art*, March 1938, pp. 157, 186–87; 75th Cong., 3d Sess., H.R. 9102, January 21, 1938, pp. 5–7; 75th Cong., S. 3296, January 5, 1938, pp. 5–7.

40. Claude Pepper to Franklin D. Roosevelt, July 8, 1939, and Franklin D. Roosevelt to Claude Pepper, July 28, 1939, RG 121/133.

41. Franklin D. Roosevelt to Francis H. Taylor, September 5, 1940, and Edward Bruce to Franklin D. Roosevelt, January 20, 1940, RG 121/122.

42. Roosevelt to Taylor, September 5, 1940, and Francis H. Taylor to Franklin D. Roosevelt, September 10, 1940, RG 121/122; "Art Week," November 25, to December 1, 1940, *National Report* (Washington, D.C.: Works Projects Administration, 1940), pp. 1, 11, 21.

43. National Council for "Art Week," press release, November 16, 1941, and Florence Kerr to Edward Bruce, December 22, 1941, RG 69/211.5.

44. Holger Cahill, typescript report on "WPA Art Program," September 10, 1941, RG 69/211.5.

45. William S. Schwartz to Edward B. Rowan, December 7, 1941, RG 121/122; Myron Lechay to Holger Cahill, February 2, 1942; Stuyvesant Van Veen to Robert Patterson, January 30, 1942; Henry Billings to Olin Dows, January 30, 1942; and H. Mallette Dean to Eric Cullenward, December 13, 1941, RG 121/122.

46. Charles R. Knight to Edward B. Rowan, March 21, 1942, RG 121/122.

47. Philip Evergood to Holger Cahill, April 6, 1942; David Fredenthal to Olin Dows, June 12, 1942; and Inslee A. Hopper to J. Burn Helme, February 17, 1942, RG 121/122.

48. Edward Bruce to W. E. Reynolds, June 20, 1941, and Edward Bruce to Edward B. Rowan, August 9, 1941, RG 121/122.

49. Federal Works Agency, Statement of E. R. Witman before Senate Committee on Appropriations, January 2, 1942, RG 121/122.

50. Edward Bruce to Paul Manship, March 19, 1942, RG 121/122.

51. Minutes of the meeting of the Commission of Fine Arts, November 14, 1941; Minutes of the meeting of the Commission of Fine Arts, December 18, 1941; RG 121/122.

52. F. J. Buckley to W. E. Reynolds, January 20, 1942, RG 121/122.

53. John McDuffie to Edward Bruce, January 16, 1942; Edward Bruce to John McDuffie, January 20, 1942; John McDuffie to Edward Bruce, January 23, 1942; RG 121/122.

54. Federal Works Agency, press release, PBA-FA 121, December 20, 1941; George H. Gannon to Henry Morgenthau, Jr., January 2, 1942; George C. Baer to Monrad C. Wallgren and Knute Hill, January 7, 1942; G. W. Vann Horn to Homer T. Bone, January 12, 1942; and Inslee A. Hopper to Meade G. Elliott, January 15, 1942, RG 121/122.

55. Edward B. Rowan to Lucia Wiley, February 16, 1942, and C. McGeehan to Lucia Wiley, August 5, 1942, RG 121/122.

56. C. McGeehan to Walter Myers, January 8, 1943, and Edward B. Rowan to Walter Myers, January 16, 1943, RG 121/122.

57. Federal Works Agency, "Red Cross Art Bulletin, No. 1," January 15, 1942; Olin Dows to S. D. Mahan, June 24, 1942; RG 121/122.

58. Edward Bruce to Mrs. Henry Morgenthau, Jr., February 16, 1942, RG 121/122.

59. Max Stern to Archibald MacLeish, March 23, 1942, RG 121/122.

60. Allen Grover to Max Stern, March 25, 1942, RG 121/122.

61. Gilmore D. Clarke to Archibald MacLeish, May 8, 1942, RG 121/122.

62. Archibald MacLeish to Gilmore D. Clarke, May 14, 1942, RG 121/122.

63. Bartlett H. Hayes, Jr., to Archibald MacLeish, n.d.; Bartlett H. Hayes, Jr., to Thomas D. Mabry, June 13, 1942; and Rockwell Kent to Olin Dows, May 26, 1942, RG 121/122.

64. Treasury Department, Washington: memorandum to artist to obtain poster ideas for selling war bonds, n.d.; Olin Dows to Betty Chamberlain, May 18, 1942; William Gropper to Olin Dows, May 27, 1942; and William Gropper to Olin Dows, June 20, 1942, RG 121/122.

65. Olin Dows to William Gropper, June 29, 1942, RG 121/122.

66. Olin Dows to Bartlett H. Hayes, Jr., June 22, 1942, RG 121/122.

67. "A Call to Action," *Magazine of Art*, March 1942, pp. 96–97; "OEM Art Bulletin No. 1," December 15, 1941; Forbes Watson, "Art in War," Federal Works Agency, Washington, D.C., n.d.; and Forbes Watson, "American Artists' Record of War and Defense," National Gallery of Art, Washington, D.C., 1942, RG 121/122.

68. Olin Dows to Mrs. Henry Morgenthau, Jr., December 31, 1941; and excerpt from memorandum on a cabinet meeting, January 16, 1942, RG 121/122.

69. Edward Bruce to Franklin D. Roosevelt, March 6, 1942; Baird Snyder to Frank Knox, April 4, 1942; A. J. Hepburn to Baird Snyder, April 14, 1942; John J. McCloy to Olin Dows, May 4, 1942; Olin Dows to Marvin McIntyre, June 1, 1942; Olin Dows to Mrs. Franklin D. Roosevelt, June 11, 1942; and Gilmore D. Clarke to Franklin D. Roosevelt, June 27, 1942, RG 121/122.

70. Wayne Coy to Philip B. Fleming, July 14, 1942, RG 121/122.

71. Forbest Watson to Olin Dows, July 18, 1942; Olin Dows to Forbes Watson, July 18, 1942; Elbert D. Thomas to Mrs. Edward Bruce, June 28, 1943; and Edward B. Rowan to Mrs. J. Glen Siston, July 20, 1943, RG 121/122.

72. *New York Times*, January 27, 1943; *The Edward Bruce Memorial Collection* (Washington, D.C.: Corcoran Gallery of Art, 1943), p. 6.

73. Monroe Wheeler, ed., *Britain at War* (New York: Museum of Modern Art, 1941); speech by Holger Cahill, "Unity," given before the League of New Hampshire Arts and Crafts in Durham, June 17, 1941, printed in magazine published by Handcraft Cooperative League of America, n.d., pp. 22–23, RG 69/651.315.9.

74. Merle Colby, "Emblems of America," *American Magazine of Art*, October 1942, pp. 205–7; Holger Cahill, *Emblems of Unity and Freedom* (New York: Metropolitan Museum of Art, n.d.).

75. Walter Quirt to Holger Cahill, January 5, 1942, RG 69/615.315.9.

76. George Z. Constant to Edward B. Rowan, March 23, 1942, RG 121/133.

77. Edward B. Rowan to George Z. Constant, April 29, 1942; George Z. Constant to Edward B. Rowan, May 5, 1942; Edward B. Rowan to George Z. Constant, May 19, 1942; RG 121/133.

78. Margaret Davis Clark to Edward B. Rowan, March 9, 1942, RG 121/133.

79. Memorandum of Holger Cahill to Ellen S. Woodward, September 21, 1938, RG 69/211.5; Patrick D. Prescott to Mary McLeod Bethune, March 2, 1942, RG 69/651.311.6.

80. Mary McLeod Bethune to Florence Kerr, March 7, 1942, and Florence Kerr to Mary McLeod Bethune, April 1, 1942, RG 69/651.311.5.

81. Walter K. Kiplinger to Mildred Holzhauer, April 28, 1942; Mary Gillette Moon to Florence Kerr, June 24, 1942; typescript copy of proposed plan for continuance of South Side Community Art Center, n.d.; Florence Kerr to Mary Gillette Moon, August 1, 1942; RG 69/651.311.5.

82. Jay du Von to Walter H. Burmmett, Jr., May 25, 1942 and Francis R. White to Walter M. Kiplinger, August 31, 1942, RG 69/651.311.5; Holger Cahill to Charles P. Casey, September 11, 1942, and Report for War Service Exhibition Unit, Chicago, Ill., August 31, 1942, RG 69/651.311.5.

83. Walter M. Kiplinger to Florence Kerr, September 24, 1941; Memorandum for Holger Cahill to D. H. Daugherty, February 20, 1941; Prospectus for publication of the Index of American Design, September 24, 1941, pp. 1–3; Florence Kerr to Mrs. Franklin D. Roosevelt, October 4, 1941; and Franklin D. Roosevelt to Florence Kerr, November 22, 1941, RG 69/211.55.

84. Walter M. Kiplinger to Florence Kerr, May 7, 1942, RG 69/211.55; "Cahill Reminiscences," p. 526. Note: All 15,000 Index plates are being published in microfiche with printed catalogs by the National Gallery of Art, Washington, D.C.

85. Summary of services rendered to Armed Forces and O.C.D. by the Visual Aids Unit of the Illinois War Services Section, October 9, 1942, RG 69/651.311.5; Cahill, "Record of Program Operation and Accomplishment," vol. 1, Art (Washington, D.C.: Federal Works Agency, 1943), pp. 42–43; "Cahill Reminiscences," p. 541.

86. Cahill, "Record of Program Operation and Accomplishment," p. 1.

87. "Cahill Reminiscences," p. 522.

88. Edward Bruce to Holger Cahill, February 18, 1937, RG 121/133.

89. Holger Cahill to Edward Bruce, March 24, 1937, RG 69/211.5.

10
New Deal Legacy

The New Deal art programs made a vastly important contribution to the cultural history of the United States. For example, to the American people was bequeathed a living heritage of the nation's ability to survive during "the worst of times" and to renew faith in the American dream. However, Edward Bruce's New Deal legacy was twofold: first, it left a significant body of high-quality art; and second, it established a precedent for the federal support of the arts in post–World War II America.

Bruce's Legacy

The character of Bruce's art programs closely related to the New Deal ideology of proposing "a more abundant life for all." The murals in the Social Security building in Washington uniquely expressed this New Deal concept. In addition, post office murals throughout the country underscored Bruce's dictum of bringing beauty into the daily lives of the people. Many notable artists—becoming household names in post–World War II times—worked under Bruce's program: such names as Adolph Gottlieb, James Brooks, Willem de Kooning, Philip Guston, Arshile Gorky, Lee Gatch, Karl Knaths, and Bradley Walker Tomlin. Of course, Bruce's emphasis on professionalism and quality standards, which created an orthodox environment, prevented artists from freely experimenting with new ideas in the 1930s. His goal was related to a drive for the kind of art that expressed succinctly the viewpoint of the art critic Bernard Berenson, "It's got to have the goods." Yet, Bruce constantly questioned his own norm of quality—an attitude that led to an important body of New Deal art.

Nevertheless, Bruce's quest for permanency became a reality that established not only a precedent but a mechanism for subsequent federal art activities. His goal of a federal gallery of American art on the Mall never materialized, but the quest for the permanency of his program was realized when the National Collection of Fine Arts (NCFA) in Washington opened its doors to the public in 1968.

The major breakthrough in the NCFA development occurred in 1937 through Bruce's plan for a proposed Smithsonian gallery:

> . . . It will consider its province to be the cultural life of the communities all over the United States, and it will consider its obligation to be the encouragement of a high standard of quality among artists in the fields of both the fine and practical arts.[1]

Again, in a 1953 report, "Art and Government," submitted by the Commission of Fine Arts to President Dwight D. Eisenhower, the role of NCFA was further defined by a paragraph from Bruce's 1939 Smithsonian Gallery competition:

> . . . it will be its purpose to strive, through a recognition of all that is essentially indigenous in the work of our artists, to stimulate a confidence in American art, a healthy relationship to the life of the community.[2]

However, not until 1958 was a permanent home for NCFA provided in the Old Patent Building in the nation's capital. On April 6, 1968, President Lyndon B. Johnson inaugurated this first national museum for native American art.[3] Thus, as Bruce envisioned, American art was given a permanent national gallery of its own through NCFA. In the museum a collection of more than 17,000 paintings, sculptures, and prints of the eighteenth, nineteenth, and twentieth centuries is exhibited.[1] The twentieth-century art includes a special collection of PWAP work that was shown by Bruce at the Corcoran Gallery of Art in 1934—the first major exhibit of New Deal art.

Other developments of federal support were influenced by Bruce's legacy. In 1964, based on Bruce's Smithsonian plan, NCFA proposed the following programs:

1. To circulate high quality educational exhibits to American communities in all parts of the country, and to help them to build their own art centers and museums;
2. To display both indigenous and contemporary art in its expanded gallery;
3. To establish an archive and library center to further the study of American art;
4. To study a means of recognizing and developing young talent and of employing mature artists productively;
5. To record and care for government art and to develop adequate conservation facilities to promote its preservation; and
6. To strengthen the art collections to present a great national survey of American and contemporary art to the people.[5]

The NCFA director, David W. Scott, delared: "A broad mission has been envisaged for the National Collection of Fine Arts. It must extend its efforts to effect a broad enrichment of American life. It must make a substantial contribution to the cultural life of all American Communities."[6]

Nevertheless, not all of Bruce's goals were accomplished under the aegis of NCFA. For example, the program to record and conserve the art of the Section of Fine Arts and the Works Progress Administration Federal Art Project (WPA/FAP) became the responsibility of the General Services Administration (GSA). Back in 1943, Forbes Watson, Treasury art advisor, had warned future generations not to throw away the record of the most interesting decade in American history.[7] In 1971 a National Fine Arts Inventory was launched under GSA. To locate, catalog, and preserve New Deal

art was the principal objective of the inventory. In some cases GSA made dramatic last-minute efforts to save almost forgotten works from the collector or the demolition squad. Among the important rescues of Section art were two William Gropper mural panels, located in the Northwestern Postal Station in Detroit, Michigan. GSA decided to salvage the Gropper murals after state officials planned to demolish the building on a date set earlier than scheduled. In a flurry of last-minute detail, while demolition crews stood idle, the salvager removed the murals without damage. Subsequently, they were restored and installed at Wayne State University, Detroit.[8]

Another NCFA proposal—to study the best means of recognizing new talent and employing mature artists—GSA accomplished under the "Art in Federal Buildings" program. In 1963, GSA decided to provide one-half of one percent of construction funds to embellish federal buildings throughout the nation. Since 1972, however, when the program was revitalized, GSA has worked with the National Endowment for the Arts (NEA) to nominate artists through a panel of experts—a procedure used by Bruce to ensure quality art.[9]

The "Art in Federal Buildings" program covers a wide range of projects, from Alexander Calder's sculpture in Chicago, Illinois, to George Rickey's kinetic, stainless-steel sculpture in Honolulu, Hawaii, and Isamu Noguchi's sculpture in Seattle, Washington. The Calders—father and son—contributed a precedent of family participation in federal programs. In 1935, under the Section of Painting and Sculpture, Stirling Calder executed a sculpture, *Continental Post Rider*, for the Post Office Department in Washington. In 1974 his son Alexander completed a red stabile sculpture, *Flamingo*, for the Plaza-Federal Building in Chicago.[10]

Noguchi had established his federal career with the Public Works of Art Project (PWAP), the first New Deal art program. In 1934, Noguchi submitted a proposed sculpture, *Play Mountain*, for the children of New York. The PWAP Central Office rejected his plan, but under GSA in 1975 he completed his environmental sculpture, *Landscape of Time*, for the Plaza-Federal building in Seattle. Noguchi commented:

> I am very pleased. It's a site that invites what I would like to do. That building needs a loving shape. I don't want to make it one of those prideful gestures people go in for these days.[11]

Cahill's Legacy

Unlike Bruce, Cahill's legacy did not establish a mechanism for continuing federal support, but it focused federal attention on providing opportunities for artists in fine arts and native crafts, and bringing art to the people through traveling exhibits. Moreover, in post–World War II times, his legacy initiated the breakthrough for American art on the national and international scene.

The responses of former WPA/FAP artists have revealed the impact of Cahill's legacy on the post–World War II art scene. For Max Spivak, it meant that the programs provided an outlet for an outburst of creative activity and the possibility of survival for those who continued to work, long after the project had ended. Perhaps outstanding artists, such as Adolph Gottlieb, could have survived without the project, but for other artists, such as Moses Soyer, James Brooks, and Eli Jacobi, the relief program was necessary for their survival.[12] Chet La More shared Spivak's view: "I shall say that it [WPA/FAP] saved two generations, mine and that immediately ahead

that of Kuniyoshi and S. Davis. It touched the edge of the younger generation in their twenties. That's a lot."[13]

The climate of Cahill's legacy also encouraged experimental art. The major virtue of WPA/FAP was its freedom, Max Spivak declared: "The security of regular pay, the spontaneous creative atmosphere, the understanding and sympathy of the supervisors, who were fellow artists."[14] Working for WPA/FAP, according to George Constant, brought artists together to exchange ideas and promulgate innovative movements. For Rosalind Browne it became possible to benefit from the exciting ideas stirring abroad.[15]

The experimental work of such artists as Arshile Gorky, Jackson Pollock, Mark Rothko, Franz Kline, Willem de Kooning, and Bradley Walker Tomlin, who dominated the art scene of the 1940s and 1950s, attests to the special character of Cahill's legacy. Very much like the Ashcan school, this new movement broke with America's past, and an American art form—abstract expressionism—for the first time became so significant that it influenced the international art scene.[16] Cahill himself looked on the post–World War II art scene as the most exciting happening of the twentieth century. Even in the Soviet Union, he noted, where decadent bourgeois art was an anathema, there existed underground interest in American works. Moreover, American exhibitions were sent on tour around the world, not only to Europe and Latin America but to the Far East as well. Cahill observed that this period differed greatly from the 1920s, when the American artist was almost unrecognized even in his or her own country.[17]

The significance of Cahill's legacy was particularly seen when the Museum of Modern Art (MOMA) held a series of survey exhibitions. (MOMA had been the scene of Cahill's important national exhibit, "New Horizons in American Art," in 1936.) The survey exhibit, "Americans 1942," organized by Dorothy Miller, director of the MOMA exhibit, displayed the work of former WPA/FAP artists Darrell Austin, Hyman Bloom, Raymond Breinin, Samuel Cashwan, Morris Graves, Joseph Hirsch, Donal Hord, Charles Howard, Jack Levine, Helen Lundeberg, Fletcher Martin, and Mitchell Siporin.[18]

In 1946 the MOMA exhibit "Fourteen Americans" included former WPA/FAP artists Arshile Gorky, I. Rice Pereira, Loren MacIver, Isamu Noguchi, C. S. Price, Theodore Roszak, and Mark Tobey. The individual search for personal creative expression encouraged under WPA/FAP was revealed by this exhibit.[19]

The MOMA exhibit of 1952, "15 Americans," showed the breakthrough of such artists as Mark Rothko and Jackson Pollock; and the emergence of abstract expressionism, which the art writer Harold Rosenberg described as "action painting." Also, Miller observed, "Rothko . . . much of Pollock . . . fall within the category usually called abstract, which, as many competent observers have remarked, is the dominant trend in mid-century American painting."[20]

MOMA's 1956 exhibition of "12 Americans" included the works of former WPA/FAP artists James Brooks and Philip Guston. During the Depression they painted in a bold, realistic style, but now they revealed the experimental style of the new American idiom. Commenting about their new work, Brooks referred to the impulses of spirit and image that color and shape transmit; and Guston, to the unfettered, irrational paths of emotional color.[21]

The Smithsonian Institution Traveling Exhibit Service (SITES), organized by NCFA in 1953, reflects another phase of Cahill's legacy. SITES established the kind of community traveling exhibits that Cahill developed to encourage contemporary art and native crafts. Although SITES continues Cahill's legacy, important differences are noted. Similar to WPA/FAP, the SITES mission is to circulate educational exhibits to

U.S. communities; help them augment their art centers and museum collections; and use artmobiles to reach far-flung communities. Unfortunately, at this point in time, SITES lacks staffing and funding to fulfill all of these goals. SITES's funding largely depends on rental fees institutions are required to pay for traveling exhibits.[22]

Cahill's legacy also touches on the arts and crafts, which the Renwick Gallery in Washington reveals through its program activities. Known as the old Corcoran Gallery—later used as the Claims Court—the building was to be demolished, making way for a larger court. In 1965, however, President Johnson authorized the renovation of a badly deteriorated 'structure, which would be used to exhibit craft and design. An example of Second Empire French architecture, the building was renamed the Renwick Gallery for its architect, James Renwick.[23]

The Renwick Gallery, in its programs, emphasizes traditional crafts and contemporary design—the kind of exhibits Cahill featured in WPA federal art galleries across the country. For example, "Pueblo Pottery" displays the bold, ritualistic designs of native American craftspersons. The artisan's ability to make simple, utilitarian objects beautiful is seen in "Wooden-works." This exhibit approximates Cahill's WPA/FAP project at Timberline Lodge, Mount Hood, Oregon, where local artisans created imaginative designs for wall hangings, rugs, and furniture. The Renwick exhibit, "Arts and Crafts Movement in America" also is indebted to Cahill's encouragement of the practical arts. Covering the period from 1876 to the 1970s, this exhibit stresses American admiration for fine craftsmanship, or what Cahill describes as "thinking with the hands."[24]

The mandate of the National Endowment for the Arts (NEA) largely expresses Cahill's legacy—that of providing the arts a place in society. This is evident by the NEA major goals:

1. to make the arts more widely available to millions of Americans;
2. to preserve our cultural heritage for present and future generations;
3. to strengthen cultural organizations; and
4. to encourage the creative development of our nation's finest talent.

Under this mandate federal grants are awarded to individuals, state art agencies, and other nonprofit, tax-exempt organizations for the highest achievements in art and art-related fields.[25]

In 1962, NEA had its origins when President John F. Kennedy appointed August Heckscher as his special consultant on the arts; a year later, an Advisory Council was established to administer grants-in-aid. On September 3, 1964, Congress passed—and then President Johnson signed into law—a bill organizing the National Council on the Arts. In his address to this advisory body President Johnson declared that the nation was looking to the council for ways "which will permit the arts to flourish and to become a part of everyone's life." Cahill's quest to unite art and society was reflected in Johnson's statement. The next year Congress passed—and the president signed—Public Law 890209, creating the National Foundation on the Arts and Humanities under the executive branch of the government. (The National Endowment for the Arts [NEA] and the National Endowment for the Humanities [NEH] were organized as two separate but equal components of the National Foundation.)[26]

The NEA is providing a stimulus for communities in fifty states to survey and to develop their own cultural assets. The Roosevelt administration's "Art Week" activity offered a precedent for this NEA phenomenon of encouraging the American people to

assume responsibility for their cultural life. Although "Art Week" had limited success, the NEA is getting results under its broad program. Similar to the plan of the WPA Federal Project Number One, the NEA program includes theater, art, writing, and music. Under the NEA the number of cultural institutions in the nation has been expanding.[27]

On the question of federal support for creative artists, the first NEA chairman, Roger L. Stevens, recalled, "One of the most controversial subjects under discussion was how far we could go with individual grants to artists. The Council felt strongly in favor of direct support."[28] This problem also was recognized by another former chairperson of NEA, Nancy Hanks: "Many able artists must choose between using their talents or finding other means of support for themselves and their families." She concluded, "I think it's very important to give money to individual artists in fellowships. My gosh, what is art if you don't have an individual somewhere? And the artists need an opportunity to take time, they need materials to advance their art."[29]

Nevertheless, this question of federal support for creative artists, raised by Stevens and Hanks, has not been resolved. For example, in 1976, based on the NEA budget of $91.6 million, grants were given to 152 individual artists in the country that totaled $571,000. Of that amount, 12 artists received $10,000 each; 57 artists, $5,000 each; and 83 artists, $2,000 each.[30] Undoubtedly, on a national level, that is not a very promising prospect for creative artists or young talents. Perhaps the NEA may have been inhibited by public criticism and thus been unwilling to take risks on creative artists—a situation that did not hinder Cahill under WPA/FAP.

The Depression notwithstanding, the New Deal initiated art programs that made it possible for Americans everywhere to participate in the creative process. Bruce's philosophy—to bring beauty into the lives of the people in small communities—and Cahill's—that the artist and society need not be mutually exclusive—provided the widespread grass-roots movement that extended throughout the United States. The New Deal programs also provided a role and a niche in society for the creative artist. Never in American history, either before or since the Depression era, has the artist found a place where his or her talents could be more congenially employed to serve the needs of the community. The artist and society were complementary in providing a meaningful cultural environment for the entire nation. Hence, the New Deal established a far-reaching precedent for contemporary federal programs. Yet, there still exist many unfulfilled promises for the creative artist. An impressive array of federal activities—especially in the performing arts—enhance the cultural life of the nation, but the roles advocated by Bruce and Cahill for the individual artist have not been realized in our time.

In its rush to provide culture for the masses the federal government has not established an environment in which the creative artist can contribute to a living tradition. During the Depression era every artist was permitted the freedom to participate in an environment that was more conducive to the creative process. It is difficult to predict at this point whether or not such an atmosphere can be created. However, the GSA and the NEA programs offer the possibility of accomplishing the goals the New Deal art programs so richly achieved under Edward Bruce and Holger Cahill.

Notes

1. "American Art: a Home of its Own," *U.S. News*, May 13, 1968, p. 104; David Winfield Scott, "Federal Programs Related to the Arts," *The Arts: A Central Element of a Good Society*, Eleventh National Conference of the Arts Councils of America, Washington, D.C., June 16–19, 1965, pp. 61, 62.

2. Scott, "Federal Programs Related to the Arts."

3. David W. Scott, "The National Collection of Fine Arts," *Antiques* 94, no. 5 (November 1968), p. 730; "Museums," *Time*, May 10, 1968, p. 68; David W. Scott, "The Mission and the Projects of the National Collection of Fine Arts," Smithsonian Institution, October 1964, pp. 3, 10–11.

4. Data given by Richard Murray, assistant to the director, National Collection of Fine Arts, December 23, 1976.

5. Scott, "The Mission and the Projects."

6. Ibid., p. 7; "The Heritage of American Art," ceremony held by the General Services Administration at the National Archives, Washington, D.C., November 23, 1971.

7. Edward B. Rowan to Florence Kerr, January 20, 1943 (with attached statement by Forbes Watson), RG 69/211.15.

8. General Services Administration, news release, GSA #5455, November 23, 1971; "Art 30's Now," General Services Administration, Washington, D.C., n.d.

9. GSA information release, "Fine Arts in Federal Buildings," n.d., p. 2; "Fine Arts in New Federal Buildings," an exhibition organized by General Services Administration, Washington, D.C., New Orleans Museum of Art, April 1–May 16, 1976.

10. GSA information release, pp. 3–8.

11. GSA brochures, "Noguchi-Seattle," n.d.

12. Questionnaire of Max Spivak, December 15, 1967, in the files of Federal Support for the Visual Arts: The New Deal and Now (Library of the National Collection of Fine Arts, Smithsonian Institution, Washington, D.C.), p. 6. The questionnaires are part of a research report submitted by Francis V. O'Connor to the National Endowment of the Arts, Washington, D.C., October 1968, hereafter cited as files of Federal Support for the Visual Arts; Adolph Gottlieb, March 5, 1968, p. 5; Moses Soyer, March 28, 1968; James Brooks, June 15, 1968, p. 5; Eli Jacobi, April 7, 1968, p. 7.

13. Chet LaMore, March 6, 1968, files of Federal Support for the Arts, pp. 5–6.

14. Questionnaire of Max Spivak.

15. George Constant, March 6, 1968, files of Federal Support for the Arts, p. 7; Rosalind Browne to author, August 20, 1964.

16. Barbara Rose, *American Art since 1900* (New York and Washington: Frederick A. Praeger, 1967), p. 155.

17. "Cahill Reminiscences," pp. 568–88.

18. *Americans 1942: 18 Artists from 9 States*, ed. Dorothy C. Miller (New York: Museum of Modern Art, 1942), p. 10.

19. *Fourteen Americans*, ed. Dorothy C. Miller (New York: Museum of Modern Art, 1946), p. 8.

20. Harold Rosenberg, "The American Action Painters," *Art News*, 51, no. 8 (December 1952) pp. 22–23; *15 Americans*, ed. Dorothy C. Miller (New York: Museum of Modern Art, 1952), p. 5.

21. *12 Americans*, ed. Dorothy C. Miller (New York: Museum of Modern Art, 1956), p. 6.

22. "Sites Catalogue: 1956–1957" (Smithsonian Institution Traveling Exhibition Service), Smithsonian Institution, Washington, D.C.; Scott, "Federal Programs Related to the Arts."

23. "The Restoration: Eyesore to Art Museum," News Release from Office of Public Affairs, Smithsonian Institution, September 30, 1971, p. 2; "Chronology of the Renwick Gallery, news release from Office of Public Affairs, Smithsonian Institution, September 30, 1971, p. 4.

24. "Chronology of the Renwick Gallery"; "Cahill's Reminiscences," p. 159.

25. "Government and the Arts," *The Cultural Post*, National Endowment for the Arts, Washington, D.C. September 1975, p. 2.

26. Ibid.

27. "What It Is," National Endowment for the Arts, Washington D.C., 1974, p. 1; "What It Does," National Endowment for the Arts, pp. 3–4.

28. Roger L. Stevens, "The Early Years," *Cultural Post*, Washington, D.C., 1974, p. 4.

29. "Nancy Hanks Explains Arts Movement," *The Washington Star*, September 29, 1975, p. 12.

30. Data showing fiscal year (FY) 1976 total obligations for the NEA arts programs furnished by the NEA Budget Office in Washington, D.C., February 1, 1977; NEA Report, "Artists' Fellowship Grantees FY 1976," National Endowment for the Arts, Washington, D.C., n.d., pp. 1–6.

Notes on Sources

Introductory Note

An important phase of my research in collecting background data was to look at murals in Mexico and the United States. In Mexico City I spent considerable time studying the murals of Diego Rivera, José Clemente Orozco, and David Alfaro Siqueiros, particularly those which were initially painted in 1922 at the National Preparatory School (site of Mexico's mural Renaissance). These were the murals that influenced such American artists as George Biddle and Reuben Kadish, who went down to Mexico to look at this work and during the 1930s painted murals in the United States under the New Deal art programs.

In the same city I viewed other work by Rivera, Orozco, and Siqueiros in the Ministry of Education Building, the National Palace, the Supreme Court, the National Museum of History, and the Palace of Fine Arts. In Cuernavaca I went to the Palace of Cortés; and in Chapingo I visited the Agricultural and Military College, where I saw impressive murals by Rivera.

While in Mexico City I visited University City and met with Dr. Justino Fernandez, art historian and biographer of José Clemente Orozco, who informed me about various aspects of the Mexican mural movement. On his suggestion, I made a trip to Guadalajara, and at the University of Guadalajara, the Government Palace, and the Hospicio Cabañas I saw the great murals of Orozco.

In the United States the murals in the Capitol and the Library of Congress in Washington, D.C., and those in the Boston Public Library and Trinity Church were examined as expressions of nineteenth-century mural art.

For the period of the 1930s, in New York City I studied the murals of Thomas Hart Benton and Orozco at the New School for Social Research; and in Detroit I examined the murals of Diego Rivera at the Institute of Art. In New York City I viewed Reginald Marsh's murals in the Customs House; Ben Shahn's work in the Bronx Post Office; and Kindred McLeary's murals in the Madison Square Post Office.

In San Francisco I looked closely at the PWAP murals in Coit Tower, notable not only for their artistic merit but also for their iconography of the American scene, which is reflected throughout the New Deal art programs. I also had the keen pleasure of meeting one of the Coit tower artists, Bernard Zakheim, at his farm in Sevastopol,

near San Francisco, where we talked about the New Deal art projects. In San Francisco I saw Rivera's fresco in the Stock Exchange and his mural for the World's Fair on Treasure Island (the work is now located at the San Francisco City College); and I viewed Lucien Labaudt's murals in the Beach Chalet. My cultural tour of San Francisco was graciously facilitated by Masha Zakheim Jewett, who has written a well-documented book about the murals in Coit Tower.

In Washington, D.C., there are located some of the most important murals completed under the Section of Painting and Sculpture. At one point Edward Bruce had contemplated calling this body of work "Roosevelt's Art Museum." I carefully studied this extensive work in the following federal buildings: the Post Office Department, Justice Department, Interior Department, Procurement Division, Social Security (Health, Education and Welfare Department), and State Department.

Primary Sources

Unpublished Documents

Of the vast resources of textual records in the National Archives, Washington, D.C., Record Group 121 (RG 121) and Record Group 69 (RG 69) are invaluable and essential for any in-depth study of the New Deal art programs. The general contents of these record groups have been described in explanatory footnotes (chaps. 1 and 5). The records of the Public Buildings Service (RG 121) contain forty-one sets of file boxes (entry nos. 104–45). The boxes in these sets have thousands of documents that relate to PWAP, the Section and TRAP.

Unlike the well-organized files of RG 121, the filing system of RG 69 resulted in considerable confusion; in some instances two or more classifications were used for the same subject or a new classification was instituted, and the classification was never coordinated in an overall scheme. Besides, some of the bulky records were placed in warehouses at different times, and others were never sent to storage.

Nevertheless, I systematically investigated the documents of RG 121 and RG 69; and this study is largely based on the materials contained therein. In addition, many of the photographs relating to PWAP, the Section, TRAP, and the WPA/FAP and used in this research come from the RG 121 and RG 69 collections in the Audio-Visual Division of the National Archives, Washington, D.C.

At the Archives of American Art (AAA) in Detroit, various taped interviews of artists and administrators conducted under its "New Deal and the Arts" program proved invaluable in getting a sense of the dire distress of artists during the 1930s. In addition, the Edward Bruce Papers (in the AAA) were an extremely important source for providing insights into Bruce's life—that of businessman, professional painter, and later director of the Treasury art programs.

George Biddle invited me to his house at Croton-on-Hudson, N.Y., where he granted an interview and I was given access to his important diaries, covering the cultural period of the New Deal. In Washington, D.C., there were talks about the programs with Maria Ealand (staff member of the Section) and Olin Dows, who answered questions about the aesthetics and operations of the Treasury art programs. Also, at the Museum of Modern Art in New York, Dorothy C. Miller Cahill discussed aspects of the WPA/FAP and permitted me access to photographs of the "New Horizons" exhibit.

The author was the recipient of letters relating to the New Deal from the following persons: George Biddle, Alfred D. Crimi, Rosalind Browne, Chet La More, Isamu Noguchi, William M. Milliken, George L. K. Morris, Henry Varnum Poor, Harold Weston, Thomas Munro, Merle Curti, Alfred Frankfurter, Lewis Mumford, Horace M. Kallen, Archibald MacLeish, Rockwell Kent, Thomas Hart Benton, John I. H. Baur, William Agee, Dorothy C. Miller Cahill, Olin Dows, and Justino Fernandez.

In a meeting with David W. Scott, former director of the National Collection of Fine Arts (NCFA) in Washington, D.C., he kindly gave me a copy of "The Mission and the Projects of the National Collection of Fine Arts," explaining that the intent of the NCFA program was to realize Bruce's vision of a permanent place for American art.

At Columbia University in New York City, a 600-page manuscript, "The Reminiscences of Holger Cahill" (part of the Columbia Oral History Collection), was invaluable in detailing Cahill's early life, his alienation toward American civilization, and his coming to terms with it. Important papers from Cahill's personal files are located in the files of "Federal Support of the Visual Arts: The New Deal and Now," in the NCFA Library, Smithsonian Institution, Washington, D.C.

Published Documents

Edward Bruce wrote two informative articles: "Public Works of Art Project," printed in the *Congressional Record* (January 17, 1934); and "Implications of the Public Works of Art," in the *American Magazine of Art* (March 1934), which touches on his aesthetic philosophy and his indebtedness to the tradition of the Renaissance.

Important articles by Forbes Watson discuss the role of the artist in society and articulate the aesthetic goals that governed the Treasury art programs. These include the following: in the *American Magazine of Art*, "Return to the Facts" (March 1936), "Chance in a Thousand" (August 1935), and "Steady Job" (April 1934); and in the *Forum*, "Artist Becomes a Citizen" (May 1934).

Art Guide, No. 1 and *Art Guide, No. 2*, published by Art in Federal Buildings, Inc. (Washington, 1938), give a good description of the work installed in the Post Office Department and the Justice Department—the result of the first national competition conducted by the Section. The *Bulletin*, no. 1 (1935) through no. 24 (1942), edited by Forbes Watson, offer important data about the nationwide Section competitions, articles on the aesthetics of the program, and biographies of artists participating in the Treasury art programs.

The catalog for the first PWAP show organized by Bruce at the Corcoran Gallery in Washington, D.C., *National Exhibition of Art by the Public Works of Art Project* (Washington, 1934), is important for the public interest generated by this first New Deal experiment. However, later Section exhibits are seen as an effort by Bruce to offset a waning public interest in his program. Some of the following catalogs cover these exhibits: *Mural Designs for Federal Buildings* (Washington, 1939); *Exhibition of Painting and Sculpture Designed for Federal Buildings* (Washington, 1939); *Loan Exhibition of Mural Designs for Federal Buildings from the Section of Fine Arts* (New York, 1940); and *An Exhibition of Two Hundred American Water Colors* (Washington, 1941).

A good profile study of Bruce is written by Olin Dows, "Bruce, An Appraisal," in the *Magazine of Art* (January 1937), with reproductions of Bruce's art, revealing the kind of painting he did in Italy and France in the 1920s and later in the United States. Olin Dows's "The New Deal's Treasury Art Programs: A Memoir," in *Arts in Society*,

vol. 2, no. 4, n.d., gives a well-balanced, personal account of the Treasury programs.

Early articles by George Biddle—"Art Renascence under Federal Patronage," *Scribner's Magazine* (June 1934), and "Mural Painting in America," *American Magazine of Art* (July 1934)—reveal a confidence in the objectives of the Treasury program; and later, his "Art under Five Years of Federal Patronage," in *American Scholar* (July 1940), contrasting the Section and the WPA/FAP, reiterates support for the goals of the Section.

An excellent article by E. M. Benson, "Art on Parole," *American Magazine of Art* (November 1936), discusses significant differences between the objectives of the Section and the WPA/FAP. "Unemployed Arts," *Fortune* (May 1937), written by Archibald MacLeish, reveals a sensitive portrayal of the WPA art programs that enthused Holger Cahill.

Leo Tolstoi, *What Is Art?* (London: Oxford University Press, 1930), and John Cotton Dana, *American Art—How It Can Be Made to Flourish* (Woodstock, Vt., Elim Press, 1929), are useful for understanding Cahill's artistic outlook. Cahill's social viewpoint also was influenced by the philosophy of Thorstein Veblen. See his *Theory of the Leisure Class* (New York: Modern Library, 1934).

A series of important publications—*Americans 1942* (New York: Museum of Modern Art, 1942), *Fourteen Americans* (New York: Museum of Modern Art, 1946), *15 Americans* (New York: Museum of Modern Art, 1952), and *12 Americans* (New York: Museum of Modern Art, 1956), edited by Dorothy C. Miller Cahill and related to exhibitions held at the Museum of Modern Art in New York—appear to reveal Cahill's legacy to provide a place for the creative artist in the American scene.

The official organ of the militant Artists Union, *Art Front*, in its lively issues from November 1934 to November 1937, reflects the economic, social, and aesthetic questions pertinent to the 1930s.

Books

Edward Bruce and Forbes Watson, *Art in Federal Buildings, Mural Designs, 1934–1936* (Washington, D.C.: Art in Federal Buildings, Inc., 1936), presents a good introduction to the history of U.S. mural painting and perhaps the best explanation of the Section's procedures to get mural art for federal buildings, showing architectural plans of post offices in conjunction with mural designs of commissioned artists.

An interesting tract by Charles Moore, *Personalities in Washington Architecture* (Washington, D.C.: Columbia Historical Society, 1937), reveals a basis for the aesthetic battles between the Commission of Fine Arts and the Section. George Biddle generally supported the artistic goals of the Section, but in his *An American Artist's Story* (Boston: Little, Brown and Company, 1939) he elects to describe the mentality of the Procurement Division as that of "a grocer"—concerned that it will be cheated in a bargain—an attitude that he believed inhibited the creativity of artists under the Treasury art programs.

Holger Cahill was a prolific writer. Aside from the "Reminiscences," his autobiographic novel, *Profane Earth* (New York: Macaulay Company, 1927), offers a good insight into his social and aesthetic philosophy. Dr. Horace Kallen, Cahill's professor at the New School for Social Research in New York, suggested that I read *Profane Earth*.

Cahill's broad grasp of the art trends in the American scene is revealed by his following publications: the monographs *George O. 'Pop' Hart* (New York: Downtown

Gallery, 1928) and *Max Weber* (New York: Downtown Gallery, 1930); "American Art Today," an article in *America as Americans See It* (New York: The Literary Guild, 1932); *Art in America in Modern Times* (New York: Reynal & Hitchcock, 1934); and *Art in America* (New York: Halcyon House, 1935).

New Horizons in American Art (New York: Museum of Modern Art, 1936) by Holger Cahill makes a notable contribution to the literature of American art. At one point Cahill believed that he was not going to survive the pressures of his job: running the daily operations of the WPA/FAP; organizing the "New Horizons" show, and writing a lengthy essay for the exhibit catalog.

Another important publication by Cahill, *American Folk Art* (New York: Museum of Modern Art, 1934), expresses his deep interest in the indigenous sources of American art, which culminated in the WPA/FAP Index of American Design. Cahill's effort to publish the Index in full-colored portfolios was never realized, but Clarence P. Hornung, *Treasury of American Design* (New York: Harry N. Abrams, 1972), reproduces many Index plates and reprints Cahill's introduction, which was first published in Edwin O. Christensen, *The Index of American Design* (New York: Macmillan Company, 1950).

Lillian B. Miller, *Patrons and Patriotism* (University of Chicago Press, 1966), delineates the early rise of American art in the United States; Lois M. Fink and Joshua C. Taylor, *Academy* (Washington, D.C.: Smithsonian Institution Press, 1975), trace the academic tradition in the United States.

Of course, Franklin D. Roosevelt's own legacy is documented in *The Public Papers and Addresses of Franklin D. Roosevelt*, edited by Samuel Rosenman (New York: Random House, Macmillan, and Harper, 1938–50). In addition, the papers of Roosevelt and Harry Hopkins (deposited in the Roosevelt Library, Hyde Park, N. Y.) that relate to the New Deal art projects are to be found in the microfilm collection of the AAA.

Secondary Sources

General

Standard secondary sources of particular merit include Frederick Lewis Allen's lively account, *Since Yesterday* (New York: Bantam Books, 1940), and *Only Yesterday* (New York: Harper & Brothers, 1957); Arthur M. Schlesinger, Jr.'s broad treatment of Franklin D. Roosevelt, *The Age of Roosevelt* (Boston: Houghton Mifflin Co., 1957–60); Dixon Wecter's excellent social history, *The Age of the Great Depression, 1929–1941* (New York: Macmillan Company, 1948); William E. Leuchtenburg's well-documented book on the political scene, *Franklin D. Roosevelt and the New Deal, 1932–1940* (New York: Harper & Row, 1963); Charles and Mary Beard's cultural history of the 1930s, *America in Midpassage* (New York: Macmillan Company, 1939); and Merle Curtis's broad account of the 1930s in the later chapters of *The Growth of American Thought* (New York: Harper & Brothers, 1951). Arthur E. Burns and Edward A. Williams's monograph, *Federal Work Security and Relief Programs* (Washington: Government Printing Office, 1941), gives a good accounting of the federal relief programs.

For some of the excellent literary contributions that touched on the mood of the 1930s, see Don Congdon, ed., *The Thirties: A Time to Remember* (New York: Simon

and Schuster, 1962); and Harvey Swados, ed., *American Writers and the Great Depression* (New York: Bobbs-Merrill Company, Inc., 1966). James Agee and Walker Evans, *Let Us Now Praise Famous Men* (Boston: Houghton Mifflin Company, 1939 and 1960), and John Steinbeck, *The Grapes of Wrath* (New York: Viking Press, 1939), are noteworthy for their haunting imagery of the human plight during the Depression era.

Idols behind Altars (New York: Biblo and Tannen, 1967) by Anita Brenner offers a broad treatment of the Mexican cultural scene, culminating in the 1922 mural renaissance of Mexico. For an excellent photographic essay of the Mexican Revolution of 1910, see Anita Brenner, *The Wind that Swept Mexico* (New York: Harper & Brothers, 1943). David Alfaro Siqueiros, in his memoirs, *Me Llamban El Coronelazo* (Mexico: Biografías Gandesa, 1977), describes his role in initiating the Mexican mural movement of the 1920s. *José Clemente Orozco: An Autobiography*, trans. Robert C. Stephenson (Austin, Tex., University of Texas Press, 1962), is a significant contribution to the literature of the Mexican mural movement. One of the best novels to describe the mood of the Mexican Revolution is *The Underdogs* (New York: New American Library, 1963) by Mariano Azuela, illustrated by Orozco. Bernard S. Myers gives a good survey of the Mexican movement in Mexico and the United States in *Mexican Painting in Our Time* (New York: Oxford University Press, 1956).

Useful for a description of American art are the following: Virgil Barker, *American Painting* (New York: Macmillan Company, 1950); Milton W. Brown, *American Painting from the Armory Show to the Depression* (Princeton, N.J.: Princeton University Press, 1955); Oliver Larkin, *Art and Life in America* (New York: Rinehart & Company, Inc., 1950); Edgar P. Richardson, *Painting in America* (New York: Crowell, 1956); John I. H. Baur, *Revolution and Tradition in American Art* (Cambridge: Harvard University Press, 1951); and Sam Hunter, *Modern American Painting and Sculpture* (New York: Dell Publishing Company, 1959).

Studies of the Federal Art Projects and of the Artists Associated with It

For a good comprehensive administrative history of the federal relief art programs, see William F. McDonald, *Federal Relief Administration and the Arts* (Columbus, Ohio: Ohio State University Press, 1969). Some of the early studies of special merit in the federal patronage of the arts include Grace Overmyer, *Government and the Arts* (New York: W. W. Norton & Company, Inc., 1939); Ralph Purcell, *Government and Art* (Washington, D.C.: Public Affairs Press, 1956); Erica Beckh Rubenstein, "Tax Payers' Murals" (Ph.D. dissertation, Harvard University, 1944); *Art as a Function of Government* (New York: Supervisors Association of Federal Art Projects, 1937); and *Collier's Yearbook: 1935 to 1943*, containing yearly articles on the New Deal art projects by Dorothy C. Miller Cahill.

Subsequent noteworthy studies include Richard D. McKinzie, *New Deal for Artists* (Princeton, N.J.: Princeton University Press, 1972), a good administrative account with detailed description of public reaction to the New Deal art programs; Jane De Hart Mathews, *The Federal Theater, 1935–1939* (Princeton, N.J.: Princeton University Press, 1967), a lucid portrayal of a cultural phase in the 1930s; and Jerre Mangione, *The Dream and the Deal* (Boston: Little, Brown and Company, 1972), a sensitive study of the Federal Writers' Project. Other investigations of special importance include Karal Ann Marling, "Federal Patronage and the Woodstock Colony" (Ph.D. dissertation, Bryn Mawr College, 1971); Gerald M. Monroe, "The Artists Union of New York" (Ed.D. dissertation, New York University, 1971), and his AAA

Journal articles, "Mural Burning by the New York City WPA" (vol. 16, no. 3, 1976) and "Artists on the Barricades" (vol. 18, no. 3, 1973), as well as an *Arts in America* article, "The 30's: Art, Ideology and the WPA" (November-December 1975); Eleanor Carr, "The New Deal and the Sculptor" (Ph.D. dissertation, New York University, 1969); and Greta Berman, "The Lost Years: Mural Painting in New York City under the WPA/FAP, 1935–1943" (Ph.D. dissertation, Columbia University, 1975).

Francis V. O'Connor has made notable contributions to the literature of the New Deal art programs, such as *Federal Art Patronage: 1933 to 1943* (College Park, Md.: University of Maryland Gallery: 1966); *Federal Support for the Visual Arts: The New Deal and Now* (Greenwich, Conn.: New York Graphic Society, 1969); *The New Deal Art Projects: An Anthology of Memoirs* (Washington, D.C.: Smithsonian Institution Press, 1972); such articles as "New Deal Murals in New York" (*Artforum*, November 1968); "The New Deal Art Projects in New York" (*American Art Journal*, Fall 1969); and *Art for the Millions* (Greenwich, Conn.: New York Graphic Society, 1973). The lost manuscript of "Art for the Millions," comprised of essays by WPA/FAP artists and edited by E. M. Benson, was traced to Dorothy C. Miller Cahill by Dr. O'Connor. These original essays are available to researchers in the files of "Federal Support for the Visual Arts: The New Deal and Now," in the Library of the Smithsonian's National Collection of Fine Arts.

For important studies of artists associated with the federal art projects, see Thomas B. Hess, *Willem de Kooning* (New York: George Braziller, Inc., 1959); Frank O'Hara, *Jackson Pollock* (New York: George Braziller, Inc., 1959); E. C. Goossen, *Stuart Davis* (New York: George Braziller, Inc., 1959); Harold Rosenberg, *Arshile Gorky* (New York: Horizon Press, 1962); Laurence E. Schmeckebier, *John Steuart Curry's Pageant of America* (New York: American Artists Group, 1943); Charlotte L. Mayersen, ed., *Shadow and Light: The Life, Friends and Opinions of Maurice Sterne* (New York: Harcourt, Brace & World, Inc., 1952); and Selden Rodman, *Ben Shahn: Portrait of the Artist as an American* (New York: Harper & Brothers 1951). For an excellent chronology on Jackson Pollock, see Francis V. O'Connor, *Jackson Pollock* (New York: Museum of Modern Art, 1967); and the well-documented raisonné of Pollock's art, *Jackson Pollock*, edited by Francis V. O'Connor and Eugene V. Thaw (New Haven, Conn.: Yale University Press, 1978). Other studies include Bruce St. John ed., *John Sloan* (New York: Harper & Row, 1971); Darrell Gar Wood's biography of Grant Wood, *Artist in Iowa* (New York: W. W. Norton & Company, Inc., 1944); Thomas Hart Benton's autobiography, *An Artist in America* (New York: Robert M. McBride, 1937); and August L. Freundlich, *William Gropper* (Los Angeles: W. Ritchie Press, 1968).

Index of American Artists

Subject Index

Dont
086257
27/10/86.